THE COMICS

THE COMICS

BY
COULTON WAUGH

With an introduction by
M. THOMAS INGE

*Pieces of pleasantry and mirth have a strange power
in them to allay the heats and tumults of our spirits.*
—BENJAMIN FRANKLIN

UNIVERSITY PRESS OF MISSISSIPPI
Jackson & London

Studies in Popular Culture
M. Thomas Inge, General Editor

Introduction copyright © by M. Thomas Inge
All rights reserved
Manufactured in the United States of America
94 93 92 91 4 3 2 1

The paper in this book meets the guidelines for permanence and durability of the Committee on Production Guidelines for Book Longevity of the Council on Library Resources.

Library of Congress Cataloging-in-Publication Data

Waugh, Coulton, 1896–1973.
 The comics / by Coulton Waugh ; with an introduction by M. Thomas Inge.
 p. cm.
 Reprint. Originally published: New York : Macmillan, 1947.
 Includes index.
 ISBN 0-87805-498-7 (alk. paper).—ISBN 0-87805-499-5 (pbk. : alk. paper)
 1. Comic books, strips, etc.—United States—History and criticism. I. Title.
PN6725.W3 1991
741.5′0973—dc20 90-28685
 CIP

First published in 1947 by The Macmillan Company
Copyright © 1947 by Coulton Waugh
Reprinted by arrangement with Odin Waugh Buchanan

The four plates reproduced in color in the original edition are here in black and white. The index in this edition has also been revised.

British Library Cataloging-in-Publication data available

For

ODIN WAUGH

CONTENTS

CHAPTER		PAGE
	INTRODUCTION	xi
	ACKNOWLEDGMENTS	xvii
I.	IN THE BEGINNING	1

The Yellow Kid—The Little Bears and Tigers—Lil Mose—Buster Brown—The Katzenjammer Kids—Little Jimmy

II.	THE ROAD TO THE SHRINE	16

Foxy Grandpa—Lulu and Leander—Yanitor Yens Yensen—Little Nemo in Slumberland—Nobody Works Like Father—Snoozer—The Merry Marcelene—Panhandle Pete—Let George Do It—The Newlyweds—The Monkey Shines of Marcelene—Book Taught Bilkins—Your Uncle Feininger

III.	THE OLD MASTERS	25

Mutt and Jeff—Joe and Asbestos—Happy Hooligan—And Her Name was Maud!—Alphonse and Gaston—Nervo the Monk—Hawkshaw the Detective—Main Street—Polly and Her Pals

IV.	MORE OLD MASTERS	43

The Captain and the Kids—The Katzenjammer Kids—Their Only Child—Bringing Up Father—Boob McNutt—Banana Oil—Count Screwloose—That's My Pop—Grossly Exaggerated—Barney Google—Bug House Fables—Barney Google and Snuffy Smith

V.	OF KATS AND ART	57

The Dingbat Family—Krazy Kat

VI.	THE YEARS OF REAL SPORT	63

The Hall Room Boys—Hazel the Heartbreaker—Desperate Desmond—Abie the Agent—Hairbreadth Harry—Let the Wed-

ding Bells Ring Out—Indoor Sports—Penny Ante—For Better or Worse—Briggs—Mr. and Mrs.—The Man in the Brown Derby—Webster—The Timid Soul

VII. **EVERY MAN'S ART** 80
Orphan Annie—Little Joe—Smitty—The Gumps—Moon Mullins—Winnie Winkle—Harold Teen—Tiny Tim—Gasoline Alley

VIII. **FAMILY TREES** 100
Blondie—Clarence—Toots and Casper—The Nebbs—The Bungle Family—Cicero Sap—Homer Hoopee

IX. **THE KIDS** 115
Reg'ler Fellers—Just Kids—Toonerville Trolley—S'Matter Pop—Skippy—Henry—Little Annie Rooney—Patsy—Cap Stubbs and Tippie

X. **THE GIRLIE GIRLIES** 133
Tillie the Toiler—Fritzi Ritz—Nancy—Ella Cinders—Betty Boop—Dixie Dugan—Ollie of the Movies—Modest Maidens—Glamor Girls—Oh, Diana—Gags and Gals—Teena—Penny—Bobby Sox—Etta Kett

XI. **WITH MALICE TOWARD NONE** 151
Terrors of the Tiny Tads—Johnny Quack—Peter Rabbit—Dolly Dimples and Baby Bounce—The Pussycat Princess—Felix the Cat—Napoleon—Mickey Mouse—Donald Duck—José Carioca—Uncle Remus

XII. **A WELL BALANCED PAGE** 167
Out Our Way—Our Boarding House—Boots and Her Buddies—Wash Tubbs—Buz Sawyer—Freckles and His Friends—Benny—Little Mary Mixup—Alley Oop—Curly Kayoe—Joe Jinks—Joe's Car

XIII. **HE-MEN, HAIL** 192
Popeye—Li'l Abner

XIV. **THE THIRD AND FOURTH DIMENSIONS** 208
Minute Movies—Dickie Dare—Dick Tracy—Abbie an' Slats—Barney Baxter

XV. THE STRIPS CALLED STRAIGHT 221
 Tarzan—Tailspin Tommy—Tim Tyler's Luck—Radio Patrol—Red Barry—Ace Drummond—Johnny-Round-the-World—Winslow of the Navy—Mickey Finn—Captain Yank—Smilin' Jack—Way Out West—King of the Royal Mounted—The Lone Ranger—Red Ryder—White Boy—Big Chief Wahoo—Brutus—Little Jimmie—Rocky Mason, Government Agent—Cranberry Boggs—Pete the Tramp—Miss Fury—Prince Valiant—Dick's Adventures in Dreamland

XVI. THE STAR-STARTLED MANNER 247
 Buck Rogers—Flash Gordon—Rip Kirby—Brick Bradford—Superman—Mandrake the Magician—The Phantom—Wonder Woman—Batman and Robin

XVII. TERRY AND THE PALOOKA 264
 Terry and the Pirates—Joe Palooka

XVIII. THE SMART SET 290
 Scorchy Smith—Johnny Hazard—Charlie Chan—Kerry Drake—Secret Agent X-9—Vic Jordan—Claire Voyant—Debbie Dean—Apple Mary—Mary Worth—Bruce Gentry

XIX. WE STILL LAUGH 304
 Barnaby—The Sad Sack—Smokey Stover—Silly Milly—Pop—Silent Sam—The Ambassador—Travelin' Gus—The Little King—Peter Piltdown—Tizzy—Pookie—Oaky Doaks—Tuffy—Patoruzu—Doc—Herkimer Fuddle—Hubert—The Berries—Ozark Ike—Double Trouble—Elmo

XX. COMIC BOOKS 333
 Mutt and Jeff—The Funnies—Famous Funnies—New Fun—Modern comic books

 INDEX 355

INTRODUCTION

I first found Coulton Waugh's book *The Comics* in a remainder bin when I was about fourteen. It had been published a few years earlier in 1947 by Macmillan, and the copy I found was without dustjacket and slightly damaged. Opening its pages was entrance to a wonderland for a young man who loved the comics as much as I did. Somehow I found the dollar necessary to purchase it and carried it home where it would remain one of the most cherished books on my shelf.

What Waugh told me was that the people who produced the magic of the comics were real people, that behind the colorful stories and drawings were people engaged in ordinary life, who experienced failures and successes, and who loved the form enough not to care about the costs. As Popeye once put it, "A comic artist ain't no different than you or me or anybody excep' he knows how to draw pitchers an' is crazy in the head." The book encouraged me to try to become a professional cartoonist for many years until I became wise enough to employ my talents elsewhere.

It was that personal appeal in Waugh's style that made *The Comics* distinctive. He had a way of engaging readers and taking them into the world of the comic strips and along the way explaining where they came from and how they developed. Sometimes he even created dramatic situations with imaginary dialogue, as in the opening of the book when Charles W. Saalburgh and an artist talk about the wisdom of using the color yellow on a street urchin in some cartoons by Richard Felton Outcault, a character who would be known thereafter as the "Yellow Kid." It is a conversation that may have taken place, but Waugh has made up the dialogue.

Waugh was no stranger to dialogue and dramatic situation. When *The Comics* appeared, he was well known in comic art circles as the artist who had taken over Milton Caniff's *Dickie Dare* in 1934, when Caniff moved to the *New York News* to create *Terry and the Pirates*. Since Caniff had worked on *Dickie Dare* only about fifteen months, it was Waugh who developed it into one of the best adventure yarns then on the pages of the funny papers. It was an entertaining strip of fantasy rather than reality, in the tradition of such adventure literature as *Robin Hood* and *Treasure Island,* and it was drawn in a crisp style which probably owed more to illustrators Howard

Pyle and N. C. Wyeth than to Caniff. In 1943 Waugh married his assistant, Mabel Odin Burvik, who took over *Dickie Dare* entirely and kept it in print for over another decade. Waugh, in the meantime, devoted himself to research and writing *The Comics*.

Among other talents and experiences, he brought to bear on the subject his own experiences of a lifetime as a cartoonist and artist, an insider who both practiced and theorized about comic art, as he would display in his later work as a teacher of art and author of textbooks for classroom use. It is because he was an insider that he could gather many stories about the origins of certain strips that an outsider could not have solicited.

Banking on his own contacts was insufficient, however, and research was not easy. The only book on the comics before Waugh's was neither a history nor a critical study. This was Martin Sheridan's *Comics and Their Creators* (1942), a miscellaneous collection of biographical sketches and interviews with over seventy-five artists and writers. Except for information on the working habits of many major cartoonists, the book was of limited use to the historian. So Waugh had to roll up his sleeves and engage in the dirty work of thumbing through thousands of pages of old bound volumes of newspapers at the New York Public Library (microfilm was still in limited use then). It is for this reason that his history is strongly oriented towards New York papers and his dates are not always correct. Many comic strips began their first runs outside New York and moved there only when they became successful. Waugh's beginning dates for certain strips are actually the dates when they began their New York runs.

Faulty dates aside, Waugh nevertheless did a magnificent job of reading the runs of the major strips and charting their progress and development up to the mid-forties. No one else had undertaken such a task to that time, and regretfully few commentators since then have done their homework the way Waugh did. Most tend to bank on vague memories of having read the comics for many years and simply wax nostalgic rather than speak from an immediate reacquaintance with them. Critics who would never attempt to write about a novel by Faulkner or Joyce without rereading it several times have no scruples about discussing the popular arts in a cavalier fashion without the same attention and care.

Waugh's book is not only the first comprehensive history of the comics in America, it is also the first evaluative study of the medium. He originally set down what is commonplace now, that the comics are revealing reflectors of society: "Because people love to laugh at themselves, the strips are little mirrors which reflect their intimate habits and feelings—and so their history constitutes an informal history of the masses of people, of the way they talked and acted at a certain time." Thus Waugh justified the numerous

social scientists who have turned to the comics as a way of understanding society and human behavior. Although much of their work was misguided, they at least made the study of comics legitimate in the eyes of the scholarly establishment. In a sense, Waugh himself produced a sound social history, because he discussed the development of comics in the full context of what was happening in America at the same time, and he showed how culture is often a direct response to a historic event or a social need.

As an artist himself, Waugh did not hesitate to evaluate and appreciate the aesthetics of what we now recognize as the classic comic strips. His analyses of the work of Winsor McCay, George McManus, George Herriman, and Milton Caniff remain some of the most insightful comments yet published on these figures. He was not always on target—one cannot share his unabashed enthusiasm for the *Katzenjammer Kids*—but to a large extent Waugh defined the canon of major American comic art, except for those like Walt Kelly and Charles Schulz who would not come into their own until after the book was published.

He did not allow his enthusiasm, however, to blind him to the weaknesses in many successful strips. The art work of Zack Mosley in *Smilin' Jack* he found "one of the most painful jobs to look at in the business," and Alex Raymond's characters in *Flash Gordon* "have an empty look—one feels that a cross-section would show little inside their hearts and heads." Even of Milton Caniff, the master, he would say that his work suffers from "smart aleck," his figures are "static," and his plots are "artificial" and wearily "snarled," although few now would agree with such criticism.

In reaching his evaluations, Waugh had looked at the comics in the larger context of Western art and culture. His sources of comparison, mentioned in the text, include such artists as Michelangelo, Renoir, Daumier, Monet, and Winslow Homer, and such writers as Izaak Walton, Kipling, Whitman, Melville, Twain, and Gertrude Stein. Waugh was well informed and read in art and literature, but he is not simply showing off his erudition. He quite rightly views the comics as an integral part of the larger culture and demonstrates the falsity of the artificial boundaries between so-called "high culture" and "popular culture" erected by the academy and intellectual elite. Waugh knew that the comics were as legitimate a part of the culture of this country as the poetry, paintings, novels, and plays by Americans that brought the nation the respect of the world in the first half of this century.

Waugh's own prejudices are clear. Comic books he found to be raw and ugly—"there is a soulless emptiness to them, an outrageous vulgarity"— and he did not approve of the movements towards realism and serious subject matter. It is in light-hearted humor and imaginative fantasy that "the

medium is most itself and performs its most native function." But his insights into the reasons for the popularity of comic strips, his comments on the aesthetic principles behind them, and his primary effort to define the medium make Waugh's work of lasting interest.

Though intended as a study of one aspect of American culture, Waugh's book itself has become a part of that culture through its influence on all the commentary that was to come. His was the enviable but difficult task of the pioneer, the first in the field, so he could lay down the guidelines and principles without fear of contradiction. He did it so well that *The Comics* still makes a legitimate claim to our attention and therefore deserves a continued life in print.

<div align="right">

M. Thomas Inge
Randolph-Macon College

</div>

ACKNOWLEDGMENTS

There is as yet a comparatively small amount of reference material about comic strips. This book has been largely put together from study of the actual comics as they have appeared in newspapers—both old and new. However, the author gratefully acknowledges his frequent use of the following volumes: *Comics and Their Creators* by Martin Sheridan, *Cartoon Cavalcade* by Thomas Craven, and *American Journalism* by Frank Luther Mott. He also extends sincere appreciation to the staff of the Newspaper Division of the New York Public Library.

The author would like especially to thank his research assistant, Robert Burwick, whose wide knowledge of the subject and sharp intelligence proved invaluable during the several years of hard work which went into the book. Thanks are also due to the late George Carlin, and to Bradley Kelly, Sylvan Byck, Frank Reilly, Ernest Lynn, Henry Snevily, and James L. Freeman, together with Mildred M. Bellah and Mollie Slott, all of whom gave the author valuable assistance and advice. For help in the field of comic books, the author thanks Harold A. Moore and M. C. Gaines. To Cecil Scott, whose editorial assistance was of the greatest value in every phase of the work, the author owes a debt not easily repaid.

Illustrations are naturally the life of a book about comics. Both the publishers and the author extend their gratitude to the following individuals and syndicates, whose generous permissions to use copyrighted material made the many illustrations possible. The titles in italics represent comics from which illustrations were made, and whose copyrights are owned and controlled by the individuals or syndicates listed immediately before them.

The George Matthew Adams Service. *Cap Stubbs and Tippie.*

Associated Press Newsfeatures. *Homer Hoopee; Scorchy Smith; Oh Diana; Oaky Doaks; Dickie Dare; Modest Maidens.*

George Baker. *The Sad Sack.*

The Bell Syndicate, Inc. *Pop; Don Winslow of the Navy.*

Mrs. Ruth Owen Briggs. Briggs's panel, *That Guiltiest Feeling.*

xv

Milton Caniff. *Male Call.*

The Chicago *Tribune*-New York *News* Syndicate, Inc. *Harold Teen; Orphan Annie; The Gumps; Winnie Winkle; Smitty; Dick Tracy; Gasoline Alley; Terry and the Pirates; Moon Mullins; Smokey Stover.*

John F. Dille Company. *Buck Rogers.*

Walt Disney Productions. All figures of *Mickey Mouse* and *Donald Duck* and the strip in which the latter appears are copyright, 1947, by the Walt Disney Productions and are used by their kind permission.

Famous Funnies, Inc. *Famous Funnies.*

Field Enterprises. *Steve Canyon.*

H. C. Fisher. *Mutt and Jeff.*

Ken Kling and the New York *Mirror. Joe and Asbestos.*

King Features Syndicate, Inc. *Buster Brown; The Yellow Kid; Krazy Kat; Bringing Up Father; Polly and Her Pals; Toots and Casper; Just Kids; Tuffy; Buz Sawyer; Glamor Girls; The Katzenjammer Kids; And Her Name Was Maud!; The Little King; Teena; Brick Bradford; The Pussycat Princess; Popeye; Johnny Hazard; Felix the Cat; Secret Agent X-9; Mandrake the Magician; Blondie; Flash Gordon; Henry; Rip Kirby; Tillie the Toiler; Dick's Adventures in Dreamland; Abie the Agent; Desperate Desmond; Barney Google; Barney Google and Snuffy Smith; Little Jimmy; Happy Hooligan; Prince Valiant.*

LaFave Newspaper Features. *Napoleon.*

The McCay Feature Syndicate and the Richardson Feature Syndicate. *Little Nemo.*

The McNaught Syndicate, Inc. *Mickey Finn; Dixie Dugan; Toonerville Folks; Joe Palooka.*

National Comics Publications, Inc. *Batman and Robin; Superman.*

NEA Service, Inc. *Alley Oop; Wash Tubbs; Out Our Way; Boots and Her Buddies; Freckles and His Friends; Our Boarding House.*

The New York Herald Tribune Syndicate. *Peter Rabbit; The Timid Soul;* Webster's panel; *Mr. and Mrs.*

The New York Post Syndicate. *Debbie Dean; Silly Milly.*

The Newspaper PM: jacket and end-paper cutouts from *Barnaby,* copyright, 1947, by the Newspaper PM, Inc. Complete strips: *Barnaby; Claire Voyant.*

Publishers Syndicate. *Apple Mary; Mary Worth; Kerry Drake.*

The Register and Tribune Syndicate. *Elmo.*

United Feature Syndicate, Inc. *Fritzi Ritz; Nancy; Li'l Abner; Abbie an' Slats; The Captain and the Kids; Joe's Car; Tarzan; Little Mary Mixup.*

The author would like to make clear that in writing this history, because of limitations of space, it was not possible to include every worthwhile

comic strip. No discredit, therefore, is meant to attach to any strip or panel not mentioned or illustrated.

Of course there are a great many people the author would like to thank—the artists and writers who have made of the comics a lively and a happy medium. Since he cannot thank every one individually, he thanks them en masse, and says to them: "I hope you'll like and enjoy what I've written about you, for this is *your* book."

THE COMICS

Chapter I

IN THE BEGINNING

"Yellow? Why yellow? The yellow jumps out at you—jumps right out of the page. I'm an artist, I understand color." The speaker, a lean man with handlebar mustaches and tight trousers checked in green and brown, was bent in a concentrated S over his drawing board, scowling at a proof before him. "Take my advice, Charlie. Color shouldn't startle, it should soothe. Now a soft green . . ."

"You don't understand, Art," Charles W. Saalburgh, leaning over the drawing board, broke in. "This isn't a matter of good or bad color. I want you to color the kid in this drawing yellow because I've got to find a way to prevent that yellow ink from running and sliding around. I've solved the problem with all the other colors. Now I think I've found the answer for the yellow—to apply a drier made with tallow. I want a good test area which will be printed in yellow, so that I can easily check on the results when the color section is printed."

Art picked up a brush. He was whistling softly, "After the Ball Is Over." "O.K., Charlie, I'll make a yellow kid. A yellow kid! One thing—it's going to be something new!"

The only imaginary things in the foregoing conversation are Art the artist, and the dialogue—for some such conversation there must have been. Saalburgh, foreman of the New York *World's* tint-laying Ben Day machines, was a real figure, and his problem with yellow ink was a real problem on that February day of 1896. Yet he could hardly have known that his experiment was to have a large part in starting an entirely new form of entertainment, the comic strip; or that it would directly result in a famous phrase, "yellow journalism."

So on February 16, 1896, when the readers of the New York Sunday *World* settled back in their crimson plush chairs and slacked their suspenders after dinner, they found in the large section devoted to funny drawings a three-quarter page in color entitled "The Great Dog Show in M'Googan's Avenue," and signed, "Outcault." It was a kind of panorama of the city's slum backyards, filled with cats and wash and a lot of tough children in high-society costumes, who were very busy exhibiting their pets.

These kids framed a central figure, a strange creature who, though evidently a boy, appeared to have passed through the major experiences of life in the first six months. Though small, he was important-looking. His head, bald, with flap ears, had a wise, faintly Chinese face, and he looked directly into the reader's eyes with a quizzical, interrogative smile, half timid, half brash, as if he understood perfectly well the portentous event which was happening through him. The kid was dressed in a kind of nightgown on which was a smeary handprint, and this nightgown was colored a pure, light yellow, which made a vivid bull's-eye in the whole big page.

"Hey, look at this!" laughed the papas of New York. "Look at this, Emma, a yellow kid!"

"Oh, George, that's so silly, it's only fit for the children." And Emma carried the funny section into the nursery.

"*Harum-ph-h!*" grunted papa, back of the sporting pages, but he was thinking: A yellow kid! Huh, that *was* funny!

There must have been a lot of people who thought the Yellow Kid funny, for on March 15, 1896, the stunt was repeated, this time with significant additions. The drawing was entitled, "War Scare in Hogan's Alley," and the patriot kids were lined up with posters such as, "Why don't England turn der X-rays onto der Monroe doctoring and dey can see wot's in it?" And in the nearest position was the Yellow Kid dragging a tiny cannon. He had a red cocked hat, more handprints on his dress, and (the significant point) a word written across it, "Artillery." In the succeeding weeks he was there again, always looking toward the reader, interpreting events for him, becoming the reader's man; and the words on his nightgown expanded rapidly into sentences, into a medium of communication.

Exactly when or how the *World* staff realized that they had more in the "Yellow Kid" than a spot to try out tallow drier does not seem to be recorded. But newspaper men keep on their toes; we may assume that they picked up the public reaction almost at once.

As the spring buds of 1896 ripened into leaves, the Yellow Kid caught the fancy of hundreds of thousands of readers. He was on everybody's tongue; he became one of the well known people of New York. New Yorkers themselves were quite unaware that a new form of communication was about to be built on this foundation. They were just amused at their Kid; but actually two of the typical aspects of the comic strip had been thoroughly established by him: a personality striking enough to endear itself to a large number of readers, and the talk in the actual drawing, instead of an outside caption.

In the strict sense, neither of these innovations was new. Back in the

eighteenth century, the English cartoonist Thomas Rowlandson had made a number of drawings of a certain Dr. Syntax, which were examples of a continuing, popular, and funny personality. In America a crude ancestor of the modern comic, "Ferdinand Flipper," ran in a lurid New York weekly called *Brother Jonathan,* the first copy of which was issued July 13, 1839. Illustrated by numerous woodcuts, this was a picture-by-picture account of the then raw, new land of California, that told a definite story. Speech in the drawing itself had occasionally been used, especially in political cartoons, since the days of William Hogarth. The custom was often to enclose it in a pen line, with a point leading toward the speaker's mouth, and this device came to be called a "balloon."

But these early experiments were far from being comics in the modern sense. A much closer ancestor, in the days prior to "The Yellow Kid," was the series, "The Little Bears and Tigers," funny animals which romped week after week in the San Francisco *Examiner,* beginning with the year 1892. There is nothing especially remarkable in the appearance of these little beasts to make them stand out from the many other gay and humorous drawings of the time, which were used in large comic sections as a relief from the somber side of the news. The historic point about "The Little Bears and Tigers" is their regular recurrence, the fact that the readers made friends with them and, above all, that they appeared with the advantage of a large newspaper audience.

The man who drew them, James Swinnerton, will be a mighty name in this history. He may be said to be the first of three founding fathers, who between them gave the comic strip the form in which we know it today; the others being Richard Felton Outcault, of the Yellow Kid, and Rudolph Dirks, whose mighty contribution we shall soon hail. None of these three created the comic form in its entirety, but they all learned from one another, with the result that all three were doing true comics as the twentieth century opened. Dirks and Swinnerton will weave in and out of this book from beginning to end; here we will return to the creator of the Yellow Kid.

This sharp, capable draughtsman was born in Lancaster, Ohio, in 1863. At fifteen Outcault was an art student in Cincinnati. In 1888 someone sent clippings of his drawings to Thomas Edison—the kindly inventor telegraphed him to come to see him at once, and sent him to study in Paris for a year. Back in America, Outcault began to draw humorous pictures for *Judge* and *Life.* By 1895 his specialty of funny stuff about tenement kids had become a settled feature of the New York *World's* Sunday pages. The Outcault humor was very close to the ground and suited exactly the new tendency to appeal to masses of people; the Outcault line was sharp and wiry; his kids had an impudent life to them.

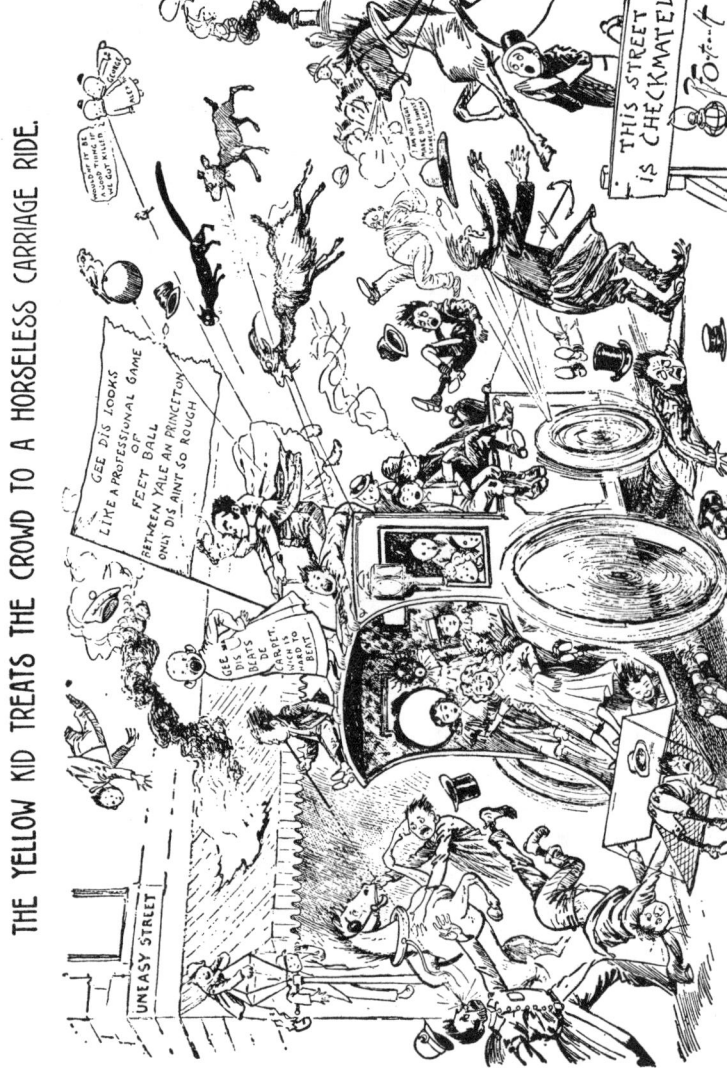

FIGURE 1. The Yellow Kid, shown in a typical early setting. His vigorous personality seems to demand even sharper focus, some medium new as the horseless carriage itself!

FIGURE 2. Appearing only a week after the drawing in Figure 1, this experiment clearly prefigures the new form. We are very close here to the actual birth of the comic strip.

The appearance of "The Yellow Kid" in the *World's* pages, by itself, might not have been enough to have started the comic strips, but we must consider the general setting of the event. This setting was the fuss and furore kicked up by the stormy rivalry between Joseph Pulitzer and William Randolph Hearst, whose newspapers were fiercely competing, in those days, for popular attention. It was because the first comics functioned as highly important weapons in this war that they became imbedded in the American consciousness so deeply that it seems as if no one will ever be able to dig them out.

Comics, therefore, owe their start to a newspaper war; and an understanding of this is important for an understanding of them. Their first purpose was to build circulation, to sell papers; and this situation remains the same today. The comic sells the paper; the paper gives the comic-strip character his chance to invade millions of homes and impress his personality on millions of hearts. This formula, the basic structure of the whole comic business, only became possible in the years we are considering. That is why our history of the comic strips starts in 1896, when newspapers were just beginning to develop huge circulations. It would be possible to dig through history for thousands of years and find many examples of popular funny pictures, yet they would not be "funnies" in the modern sense, for they would not be included in the eruption of the sensational, modern newspaper. The Yellow Kid stood right on the spot when the volcano shot off. And his career in the *World* was not to be his only part in this eruption. See Figure 2.

Many of the characteristic forms of the modern newspaper had been created by Joseph Pulitzer. The New York *World*, by 1886, had become the most profitable and popular paper ever published. It was "affecting the character of the entire daily press of the country," as a contemporary writer notes. Not the least prominent of these innovations were the new color presses; and naturally, in this vintage year, 1896, Pulitzer's sensational colored supplement was a spectacle to set his rival publisher, William Randolph Hearst, into a red, white, and blue frenzy. Hearst was never one to sit and suffer. Result: out burst a new color supplement, this time in the New York *Journal*.

"—eight pages of iridescent polychromous effulgence that makes the rainbow look like a piece of lead pipe." So Hearst described his new comic section, the *American Humorist*. The readers of the *Journal* had been promised, in advance, a choice tidbit from the new color press. When, on October 18, 1896, they opened their copies of the new supplement, there it was, the most iridescent of the effulgences. It was Outcault's now very famous Yellow Kid, nightgown, letters and all.

Hearst had carried out this coup by means of an exceedingly simple and effective technique. He had bought out a big chunk of the *World* staff. Outcault and his Kid had moved to another floor of the World Building, into the Hearst offices. Pulitzer bought his staff back again, but Hearst again outbid him. The situation was grotesque, even in those early wild days. Pulitzer did not try to buy back his staff a second time, but he did not sacrifice his Kid either—there was no legal reason why he shouldn't find another man to go on with it. He found the painter George Luks, whose vigorous oils were, with those of Winslow Homer, George Bellows, and Robert Henri, to lay a foundation for an American pictorial point of view in the fine arts. As a cartoonist, Luks had a short career, but his Yellow Kid was an exceedingly capable imitation of Outcault's mannerisms. Luks, however, never quite arrived at the true, low-down vulgarity of Outcault, who, with all his penetrating humor, certainly, in this period, rarely achieved any sense of refinement.

Typical of this is the rudeness of Outcault's Kid, after he had moved to the *Journal,* towards the old homestead of the *World,* whose readers had been responsible for his rise to fame. In the *Journal* for November 22, 1896, we find printed on the Kid's dress, "De harp wot wunst troo Hogan's Hall de sole of lafter spread—don't live dere any more a tall—because dat joint is dead, but in McFadden's double flat yez kin hear it every day where I am glad dat I lives at ta-ra-rum-boom-de-ay. Keep de change." Downright ungrateful, we call it; besides, Hogan's Alley was very much alive.

Also observable in Outcault's work, as well as in so much other entertainment of the period, was the strong, ugly thread of cruelty. In "The Yellow Kid's Great Fight," December 20, 1896, the Kid knocks down a little colored opponent and dislocates both his jaws. Then a goat butts the Negro and cheerfully pulls the wool out of his unfortunate head.

This was the kind of thing that exasperated a lot of people at the time, and that exasperates a lot of people now. It helped swell the gathering tide of resentment against the turgid, screaming sensationalism of the new journalism. A phrase had been created to express this sensationalism, a phrase directly resulting from the race between the two Yellow Kids— "yellow journalism." Crusades of various types were inaugurated to combat this tendency, most of them unsuccessful—an exception being the founding, in 1908, of the *Christian Science Monitor,* a paper originally planned by Mrs. Eddy to combat yellow journalism by displaying a kindlier, cleaner world before its readers.

But there is an underlying argument in favor of the raw vigor of these old papers. Newspapers had previously been edited from what was termed a "genteel" point of view; they reflected the ideas of the upper-crust readers,

but they certainly *did not* reflect those of our more earthy citizens. And the leveling process of democracy was at work to bring the ideas of the simpler people into the light, to give them their place in the sun. It was an inevitable process. A great flow of simple gaiety and humor roared over the dam from which the flood gates of respectability had suddenly been released.

"Why is de Sunday *Journal's* colored supplement de greatest t'ing on earth? Say!!!" comes from a phonograph in "The Yellow Kid" drawing of October 25, 1896. "Dat's too easy. It's a rainbow of color, a dream of beauty, a wild bust of lafter, and regular hot stuff."

"A wild bust of lafter!" This is the reason, and the only one, why the comics got their start: the people were satiated with seriousness and propriety and wanted to kick over the traces, stick their feet up on the desk, and let themselves go with a deep belly laugh.

The hectic period of the battle of the Yellow Kids lasted only a few years. Perhaps people were beginning to tire of the back-alley flavor. At any rate, George Luks dropped his Yellow Kid to go on with a distinguished career, and Outcault, dropping his Kid likewise, shifted his ground and his paper once more. He had another contribution to comic art to make, which was to be as classic as the Yellow Kid himself.

In 1901 we find him in the New York *Herald,* with a comic called "Lil Mose." By this time the true comic form was well established. The third of the founding fathers, Rudolph Dirks, whose work we will shortly look at, had started operations and made his own contribution to the new form: that of a continuous sequence of pictures separated by frame lines, together with the regular use of text inclosed in "balloons." Both of these conventions were taken over by Outcault in his new work.

"Lil Mose" was not the second of Outcault's two great contributions, however. Mose was an attractive pickaninny who did things like going out hunting with his animal friends and, in deference to their status, shooting at a target instead of living prey. It will be seen that a change had come over Outcault's ideas, a new motive of tenderness. But this kind of thing was a bit of a strain on Outcault, who liked a good hot prank rather than a Sunday school lesson. Mose did not last long. On April 27, 1902, he took a donkey-ride in Central Park, and the donkeys, prophetically, threw him all over the place. We do not find him in the next issue of the *Herald,* his place being taken by a cross, capable-looking little boy dressed in absurd Lord Fauntleroy clothes. The page is entitled "Buster Brown's Bad Bargain."

The most striking feature of Outcault's latest opus is in the change of setting. Buster is, at least in his home surroundings, genteel. This setting gave Outcault an even better chance to play with prankishness than before,

for an overturned paint pot gives far more joy to a child when spilled on a bright, new, suburban, golden-oak floor than on a gritty tenement pavement.

Shortly after his first appearance, Buster comes out in a full page in color, with his famous set of conventions fully established: the day's prank, the resolutions, and Tige, the leathery talking bulldog, who, despite the common notion, was not original with "Buster Brown." He had first appeared in a "Yellow Kid" page in the *Journal* in 1897. A bunch of the kids had fallen into a snow bank and Tige, looking at the customers and gesturing in a sophisticated way, had quietly remarked, "Snowed under." This terse comment on human affairs sets the pace for Tige when he first appears with Buster, in the page mentioned, which is called "Buster Brown's Bath." Tige was a real bulldog, given to Outcault by a friend, John Golden. The artist's two children, Dick and Mary Jane, provided him with models, which he used constantly in his new features. Mrs. Brown's styles were copied from those of Mrs. Outcault.

Two months from the start, Buster suddenly comes into his true self: a guy with a shrewd, regular feller's soul, a hard business sense. He stands out from the other antiquated comics as being American, up to date, and possessed of that special quality of the comics, personality. Buster, like the Yellow Kid, was jammed tight with it. This was the secret of his fame, which spread with the true American enthusiasm of the period, until the whole flavor of a certain age of childhood was dominated by him. The details of Buster's astounding success are familiar to everyone; most of us can remember the thousands of Tiges, and every other kid was called Buster. Even in Caniff's ultramodern "Male Call" will be found this sentence, "Keep away from my block, Buster."

After a few years in the *Herald*, Outcault moved Buster back to the good old New York *American*. Another Buster ran in the *Herald*, and, by 1906, we find both pages competing full blast. By this time the Busters had been so cleaned up that the pages were parlor products. They were clear and pale in color; "nice" children were able to read them without a blush. Before he was finished, Buster Brown was saying "Dee-lighted," in the best Rooseveltian manner.

In 1909 Buster was still appearing before his somewhat jaded public.* The strip had become overfantastic, and one can see at a glance that Outcault was tired of Buster. He was, in fact, tired of comic art and soon founded the Outcault Advertising Agency in Chicago with his son, Richard Felton Outcault, Jr.

We have spoken of the first of our founding fathers, James Swinnerton;

* In other forms, Buster Brown kept appearing until World War I.

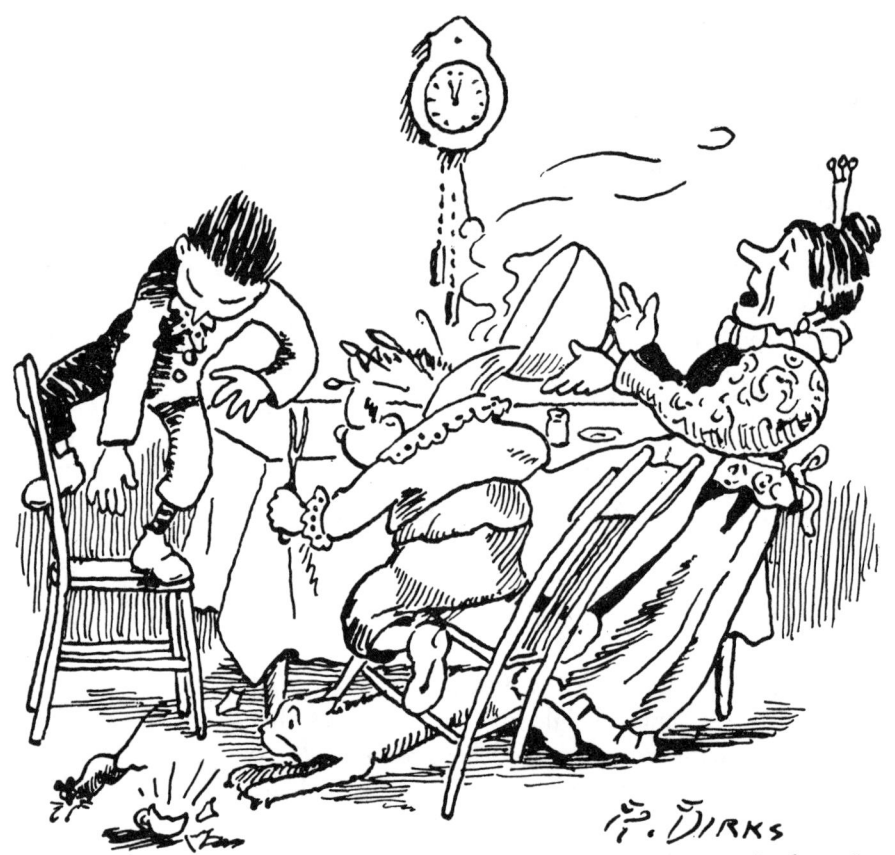

Reproduced by permission of King Features Syndicate, Inc.

FIGURE 3. An episode from the second earliest page of the "Katzenjammer Kids," in the *American Humorist* of December 19, 1897. Made from a tracing kindly supplied by the "Katzies'" originator, Rudolph Dirks.

traced the record of the second, Richard Felton Outcault; and now we come to our final father, Rudolph Dirks. With Dirks's advent came a great explosion of roaring slapstick. A huge rococo cloud, filled with thumps, yells, grunts, and wild laughter, rose up and hung over the comic-reading public and is still there, happily, after fifty years. The date of the first explosion is a significant one in our history: Sunday, December 12, 1897.

On this day appeared in the *American Humorist* a crudely drawn, but engaging half-page in bright color, showing the pranks of three kids. Having been hosed by a mean gardener, the kids find him sleeping in a summer house and, lashing a piece of latticework across the opening, go to it with a hose.

"Ach, Those Katzenjammer Kids Once More! Already Again They

Make Troo-oo-oble!" This is the following Sunday. Now there are only two kids, with the addition of their mama.

There is a fascinating complexity in the events of this particular series of pictures which will be characteristic of the Katzenjammer Kids throughout their enormously long, successful career. Mama is serving a fine bowl of hot soup. A cat chases a mouse under the table. Mrs. K. spills soup down a boy's neck (Hans). Hans jabs with fork at mouse, misses, connects with Fritz's foot. Meanwhile, Mama, sighting mouse, has climbed on top of table. Fritz aims at mouse with broom, but Mama crashes into him and he socks Hans instead, who jabs cat with fork through the tail. This thriller ends with all hands (including Hans) done up in bandages, listening to a severe lecture by Mama, while the mouse thumbs his triumphant nose at the whole group.

How little the nineteenth century readers must have realized the significance of these "Katzenjammer" pages, which first contributed to comics the use of a developing idea, with picture after picture on the same page, and with a permanent cast of characters!

It all happened because a young artist named Rudolph Dirks had decided to come East. In 1897 he joined the staff of the New York *Journal*. It was the very moment for a comic immortal to appear; the *American Humorist* was in full swing, its proud, new color presses ready for any extravagance. Rudolph Block, then comic editor, was the one who suggested that Dirks create a feature based on Max und Moritz, the famous pair of pranksters drawn by the German humorist Wilhelm Busch. Therefore we see that the German artist must be credited with a big part in starting the American "funnies."

The early Katzenjammers appeared with little background, or none, which gave a decorative effect to the page, even if the individual figures were drawn with a crude line. Mama was thin and nervous in those far-off days; she had not arrived at that complacent acceptance of the astonishing evil resident in her sons which allowed her, later, to swell to such widely cheerful proportions.

Nor did the very first pages make use of the convention of text enclosed in "balloon" lines, which we have noticed as being one of the most important contributions of Rudolph Dirks to the comic strip. After starting the Katzenjammers, Dirks experimented with "balloons" and possessing a genius for wild speech, soon found that the laughter quotient of his page had risen 100 per cent. The "balloon" was a permanent addition to almost all comics from that time.

Such was the setting for the first pranks of the frankly demoniac Katzenjammer Kids. The first pranks are, like much of the humor of the day,

pretty dumb. Yet there is enterprise about them, and originality of idea, as well as wild gusto, which is the real reason why they are now the oldest kids in the world.

We must leave them in their antique period. Later, we shall display them in their full fuss and feathers.

Now we must visit our first founding father, James Swinnerton, once more. This big, attractive Westerner had naturally kept his eye on developments within the ball which he himself had helped to start rolling. Since these developments were in the East, Swinnerton somewhat regretfully packed up his gear and headed for New York. He had an idea for a new comic; this was to be one of the best and most likable ever drawn, and one of the most durable in point of time. "Little Jimmy" appeared in the New York *Journal* comic section early in 1905. This, unlike "The Little Bears and Tigers," was a true comic in every way and it showed the features of the new form perfectly. Frame lines enclosed the boxes, which carried forward a story, picture by picture, and the "balloons" and the text were placed with a finality which showed how completely they had become a part of the comic technique. Still more important, "Little Jimmy" was a perfect demonstration of the comic-strip ideal of personality.

Jimmy is extraordinarily himself because of a quality of minuteness. Was it the vast purple distances of the Western desert which had bred in Swinnerton a genius for drawing the very opposite? However it was, Jimmy's sawed-off, pint-size appearance made him a representative of the very young human kind, and to this was added a peculiar and indescribable overtone, which is characteristic of all Swinnerton's work: his characters, rather reserved, give you the sense of knowing a great deal, and you follow them with the hope of uncovering some big secret. The gag you uncover may be simple, but the adventure will have been worth while. At least, millions of Americans have thought so for a long time, in terms of comic-strip history.

Another feature of "Little Jimmy" was the simplicity of drawing, the clarity of line, this being a technical feature which set a precedent. Both "The Yellow Kid" and "The Katzenjammers" lacked this quiet, clear-cut quality which survived the battering of countless printings on the rough, uncertain textures of newspapers. Swinnerton spotted his figures around, used areas of solid black with a sense of art which make these old papers refreshing to look at.

Now that we have seen what the first true comics were and who made them, we can define just what a comic is. Comics, like the radio and movies, provide moments of pleasure for the large mass of people. In doing this, comics sell the medium which has presented them, whether newspaper or

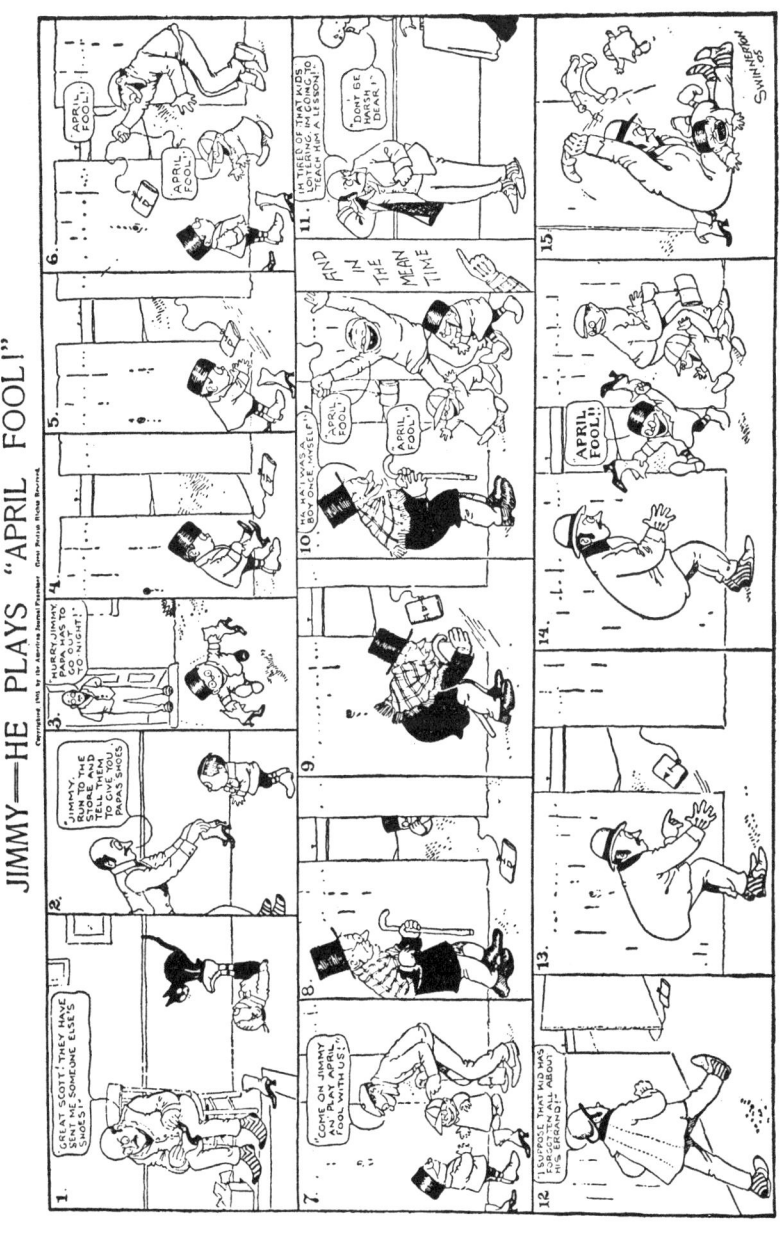

FIGURE 4. A black and white rendition of a color page which appeared in the New York *Journal* March 26, 1905. By this time the characteristic forms of the modern comic strip were well established.

magazine, and so earn their right to live and create laughter. More particularly, comics usually have (1) a continuing character who becomes the reader's dear friend, whom he looks forward to meeting day after day or Sunday after Sunday; (2) a sequence of pictures, which may be funny or thrilling, complete in themselves or part of a longer story; (3) speech in the drawing, usually in blocks of lettering surrounded by "balloon" lines.

Summarizing the history which we have been telling, it may be said: (1) The continuing character was contributed by Swinnerton and Outcault. (2) The sequence of pictures was tried out experimentally by Outcault, used regularly for the first time by Dirks, and refined in technical details by Swinnerton. And (3) speech in the drawing started with Outcault and was developed into true comic form by both Dirks and Swinnerton, as well as by Outcault in his later work.

Comics are a form of cartooning. The special feature of this latter is that it jumps at the reader picture side first—you *see* the situation. In the strips, the writing is a side explanation which the mind picks up, often without being aware of the process. Strips have taken advantage of the ancient fact that a picture carries a thought faster than a group of words, and this is the reason why they have been so enormously successful. Man has always resisted the labor of thought, and the strips take a short cut to the mind of the reader without much effort on his part. Since the cave men drew pictographs on bone and on cave walls, this new language is based on one of the oldest means of communication in the world.

Another point: none of the first comics we have spoken of were, in the true sense, strips. The true meaning of this word is a single series of drawings which runs across, or partly across, a newspaper page. These are in black and white and are generally seen only in daily editions. We shall find the exact moment when such appeared, remembering now that the first comics were in color and appeared in the Sunday sections only. Because of this, it is of course incorrect to speak of the early comics as "strips"—but when the true strips arrived they dominated the scene to an extent that the public, who care little for linguistic refinements, began to speak of all comics as strips.

The word "funnies," so popular today with the majority of people who actually read comics, was originated by the kids in the early 1900's. They referred to the big, gaily colored comic sections, which they looked forward to reading every Sunday, as the "funny papers." Soon the grown-ups were speaking of the "funnies," too. But, even as used today, the word tends to refer more to Sunday than to daily comics. This word "comics" has had a multiplicity of meanings. It meant almost any amusing, humorous drawing in the days before the comic strip; but when the new form, with its immense

popularity, rose over the American horizon it pre-empted this word, and this is the sense in which it will be used in this book—to describe the "funny paper," comic-strip side of cartooning, which has a special definition and a special history.

But any attempt at precise definition must leave out the true meaning of the strips. They exist only because of many people's enjoyment; they are entertainment. Because people love to laugh at themselves, the strips are little mirrors which reflect their intimate habits and feelings—and so their history constitutes an informal history of the masses of people, of the way they talked and acted at a certain time. The beauty of it is, you can't force people to read comics, so that the ones that survive and become popular are the people's choice and mirror their feelings with a simplicity which is perhaps not to be found in any other popular form. They do not sell shaving cream or toilet water; therefore it is not necessary to present the idealistic, unreal world of advertising art. Comics sell newspapers—and they do this most efficiently when they amuse and please people in the most informal manner possible.

The first comics entertained only a few million readers living in and around a few large cities. How did it happen that from this small beginning came a new national reading habit, which shows signs of spreading to every part of the world, a basically democratic habit, using the people's favorite images and expressions, reflecting their littleness and that greatness which works to the top in the end?

That is what we will see.

Chapter II

THE ROAD TO THE SHRINE

AMERICANS have a genius for making up their minds that they like certain things and demanding more. This was the way it was with the early comics. Following the lead of the three Grand Old Men, other comic artists appeared almost at once; other comic personalities blossomed as the twentieth century opened. Some of these have lasted in people's memories down to the present.

There are enough of the ancient strips still continuing after forty or fifty years ("The Katzenjammers," "Little Jimmy," "Polly and Her Pals," "Mutt and Jeff") to prove what a deep, human appeal had been uncovered by these early workers. And now that comic strips have taken over America, an interest in their history has begun to form, and incidentally, an understanding of how good these old jobs were. The way to really understand the old comics is to lug out the musty newspaper volumes and have a look at them, even if you crack a few vertebrae doing it. Coming to the surface after months of such study, the writer recommends it to anyone interested in comics. The student of manners and society will come back with fresh material, the comic artist with inspiration.

In New York, go to the Newspaper Room of the New York Public Library, at 215 West Twenty-fifth Street, after having first secured a study card from the main office of the library, at Forty-second Street.

The comic sections will be found bound together after the year 1924, before which it is necessary to get the full volumes. Many of them, owing to the inferior quality of paper, are tattered and torn, and the researcher works in a dusty storm of yellowing fragments. But it is well worth while. Few books have yet been written on the subject, and these are necessarily brief summaries, so that much interesting matter remains to be uncovered. Who knows what ripe old rarity one may find, some one of the odd combinations, for example, the old-time gag-makers used to delight in? The author made such a discovery when, turning a cracking page, he found the famous Yellow Kid, discontinued since 1902, reappearing in a 1910 page of his usurper, Buster Brown. He and Buster actually exchanged clothes

Plate 1. The last four boxes of "Little Nemo" for March 11, 1906. Nemo (6) meets Flip on a night mare. Flip appeals to the dawn (7) who brings in the day (8) and (9) poor Little Nemo is awake.

© *The McCay Feature Syndicate and the Richardson Feature Syndicate.*

in this historic page, in which two social atmospheres, two decades, met for a hail and farewell.

Why is it that these old color sections seem more amusing, more artistic, than those of the present? Perhaps the slightly yellow paper gives a richness to the color. You will find a better use of black, and a much simpler approach to backgrounds in those happy days. The truth is, these old strips were not illustrations as so many of our current ones are; they made, with few exceptions, no pretense at depth, and therefore exist in a flat, sensible world of their own. At least for their readers, it was a comparatively happy world that they were reflecting, and, for the longer part of this period, a world of prosperity and peace.

Remember "Foxy Grandpa"? This gentle, plush-lined old epic had a saucy sting in it and it also contained one of the first attractive and likable comic personalities. Mischievous boys were the subject matter of all subject matters in which the early strips dealt. Here was a refreshing change, the pranksters pranked upon; for Grandpa was only a silvery-haired boy himself and his wits were usually sufficient completely to turn the trick on the two young gentlemen with whom his comic life was associated.

Charles E. Schultze, who, in a "foxy-grandpopian" sort of way, used the pen-name "Bunny," was the creator of this job. It early appeared in the New York *Herald* where, on January 14, 1900, we find Grandpa and another man standing in what appears to be a combination of den and trophy room. The two boys are in the background, plotting: the plan, it seems, is to develop a wrestling match. Grandpa conveniently moves off to examine some trophies. The conspirators slyly suggest their stratagem to the stranger, who seems perfectly willing. The boys delightedly help Grandpa off with his coat; this is the time, they feel sure, to get even with him. A scene of what was then wild action follows; the men circle around, knocking over a few articles of furniture, including the boys. The battle over, the two boys peer cautiously from behind chairs, surprise on their faces. Grandpa is astride the visitor, and as he makes a remark about rough riding, the modern reader draws up sharply and looks back over the comic. There is something familiar about that stranger. Sure enough, he is old Rough Rider Teddy Roosevelt himself. This habit of hauling famous figures into the informal "funnies" has continued, occasionally, to the present.

From the *Herald*, Gramps soon changed over to the New York *American,* where he enjoyed such popularity that even today oldsters can be heard to remark, when seeing another oldster cut up, "My, isn't he a foxy grandpa though!"

Another ancient page mate of this comic, "Lulu and Leander," was not in the same class of attractiveness or interest. Leander is an oily social

climber with an enormous head, like all the other characters in the comic. His only charm is that he usually gets thrown out on his ear, which relieves his customers, as it will later relieve the followers of Percy and Ferdie in "The Hall Room Boys."

A more attractive personality of these very early days was "Yanitor Yens Yensen," by Taylor, which we find running in the *World* in the century's first decade. Yens had a stringy, Northern appeal. At the same time, he was too remote a character for the great mass of readers to attach themselves to him. The great comic personality of the time was Outcault's Buster Brown, and his emergence points up a fact about comics in this period which deserves mention. The whole atmosphere of the comic sections before 1900 was one of toughness, of the harsh life of bums and thugs—"The Yellow Kid" exactly expressed this preoccupation. But now, with "Buster Brown," with "Foxy Grandpa," gentility, which was once pushed aside in the humorous sections, is flowing back into them. Why was this?

The reason was simply that the comics are mirrors which reflect the habits, tastes, likes, and dislikes of their readers; and the comic readers of the twentieth century's first decade were establishing themselves in a new setting.

America's spiraling business civilization was making of certain cities nations in themselves; hundreds of towns within commuting radius were sprouting crops of ugly but highly efficient houses, planted row by row, as if they were cabbages. On Sundays, millions of children sprawled on the carpets and read the "funnies." They bore no resemblance to Yellow Kids at all.

For, whatever the conditions in the hinterland, business America was becoming prosperous. This was the peculiar and exclusive group of readers for which the comics originated.

When we look at New York's papers in a year representative of this time, say 1906, it is surprising to see how many of them were doing nothing about the comic needs of this vast audience. The "wild bust of lafter" was not fashionable, it had not been allowed to penetrate inside that border line which protected the smart people. Laughter, for example, plays no part in the staid pages of the *Times*, the only big New York paper which has preserved its lifted typographical eyebrows to this day. The *Sun*, with its minute withered headlines, is holding its nose too, in 1906, as will at first its soon-to-be-delivered infant, the *Evening Sun*. The *Tribune*, although pioneering with a small but very modern-looking photographic magazine section, is another total abstainer.

But one of the first papers to use comic strips had also discovered the new thirst for social standing. Looking over the color section of the New

York *Herald* in 1906, we find little that could irritate parents, whose angry protests had already killed "The Yellow Kid," and whose voices, aided by pulpit and the conservative press, were to attempt a vain crusade against comic art in general, about the year 1910. On the last page of the *Herald's* comic section we will find one of the best jobs ever turned out in art for children: "Little Nemo in Slumberland," by Winsor McCay.

There must be millions of Americans who look back to this feature with nostalgic affection. "Little Nemo" was not a comic in the peculiar sense which that word was coming to have; it was not drawn with the special conventions of the slapstick masters. It stemmed from the great tradition of fairy lore and children's illustrated books; but McCay found in

© *The McCay Feature Syndicate and the Richardson Feature Syndicate.*

FIGURE 5. A black and white version of a fragment from a "Little Nemo" color page of March 11, 1906. Here Flip is riding a night mare, with dark designs in mind. For what happened, see color plate 1.

the new technique of sequential pictures, enriched with occasional "balloons," a release for his own very remarkable talents.

McCay was not a great producer of character in the usual human sense. Nemo is a blurred and uncertain figure, although he is at times capable of rising to self-sacrificial heights. But he is the dreamer, and in a dream, is the dreamer himself ever very clear? It is when one turns to the full panoply of the dream itself that McCay makes his lasting impression.

Nemo's companions are more sharply focused than he is, and are gay and amusing. Flip is a squat, earthy clown with green face and aggressive cigar, who supplies a practical viewpoint and tempers the sentimentality of some of the other actors. A cute little brown cannibal reinforces the occasional note of pathos. Those three play against a vast procession of others: a certain Dr. Pill, and queens, princesses, giants, policemen without num-

ber. McCay draws animals with an avid enthusiasm which shows what a wonderful time he is having; and his page overflows with processions, circuses, court scenes, banquets, and festive occasions of every kind, done with bewildering detail.

But even now his unique contribution remains to be stated. It is the sense of size. In wild exaggerations of depth, of the contrast between a pea and a planet, of the enormity of a giant's mouth—in which one pulls a tooth by dynamiting it out—McCay has had no equal, before or since. The solitary master of perspective among the "funny-makers" of his time, McCay dwarfs the efforts of the most recent comic strip artists in this respect.

McCay achieves these results in depth by pure drawing ability. Who could forget a certain page where all the animals put on skates, and Nemo and Flip ride them with exuberant joy? Behind a pink-and-blue-striped elephant, planted far off in full stride, appears a small part of a skating ostrich, so perfectly done that the big bird exists in complete depth to the mind, yet is hardly seen. Here is something worth the attention of all aspirants to comic-strip fame, a comic artist who is also a master draughtsman. How rarely is it realized that even the loosest, most careless result requires good drawing to begin with!

McCay's color is another point worth the attention of any modern stripmaker. He was the first to discover the use of grave, dark tones, setting the full primaries blazing by contrast. A group of figures, or animals in the foreground, might be overprinted with a deep, greenish blue; behind, the focal point of the box would be set flashing with color. McCay used color with great taste. The complementaries, like orange and blue, he would contrast together in large areas; he avoided tones that were too close together, or ran into each other too much—and so his colors were in a series of distinct steps, giving a pleasant pattern to his pages.

Recently this fine old comic has undergone a resurrection. It is good to see Nemo and Flip again, Doctor Pill, the fabulous perspective, the gay processions. This modern Little Nemo is the real thing, for it is made from McCay's original drawings which, though browned with age, still reproduce clearly, revealing a delicacy of touch unmatched in comic history.

A friend of the McCay family, Irving A. Mendelsohn, was responsible for this resurgence, for Winsor McCay died a number of years ago. McCay's pages, although packed with imagination and excitement, never dealt in horror or crime, and it was the rash of comic books of the horror type which prompted Mendelsohn to engineer a revival of the old comic he had loved for many years. With the McCay family he organized the McCay Feature Syndicate to reprint the large supply of original drawings which were still

in excellent condition. The Richardson Feature Syndicate of Indianapolis was chosen to sell and distribute "Little Nemo," and the first page was released March 2, 1947. Modern newspaper proportions are different from the old ones, and so a certain amount of adjustment is necessary—and this brings up the most curious point of the Little Nemo story. For the man who arranges these old pages, mending a tear here and there, whiting out a thumbtack hole, is actually Little Nemo himself. He is Robert Winsor McCay, the cartoonist's son, the inspiration for the first "Little Nemo" pages back in 1905. And big Little Nemo must often wonder, as he bends over his father's pages, whether they were not his own actual dreams, so true are they to the childish and airy wonderland of sleep.

Leaving the *Herald's* gentle comic section of 1906, we shall head directly into the still furious battle of the giants, to assay the sparks as Hearst's steel rings on the Pulitzer shield and buckler. It is obvious by this time that the once mighty *World* is feeling the strain. Again and again the *World* discovered some comic giant, only to have him spirited away by the gorgeous, glittering brilliance of a Hearst future. Looking over a 1906 Sunday *World*, we shall see them nursing a star of the first magnitude, who will later be lost. The first page of "Funny Side," as the 1906 *World* called its comic section, does not feature this oncoming star, however. Top billing is given to "Nobody Works Like Father," by Gene Carr, a comic which was too reminiscent of the ancient days of Dickens and Cruikshank to last long in a modern world.

Turning the *World's* "Funny Side" page, however, we come to three features by the first-rate star mentioned before: "Snoozer," "The Merry Marcelene," and "Panhandle Pete." The star was George McManus, who was destined to take the father idea and bring it up right. McManus had not hit his full stride at this time, but he was stretching his funny wings. Still another feature he tried out was "Let George Do It," and he hit pay dirt in "The Newlyweds." We shall talk of him later, but it is obvious, looking at these early jobs, that the man was one of the top pictorial humorists of all time. A McManus face, any one, is funny. It has the quality of quietly tickling you for a long time. So a character like Snoozer, who is a heavy, overgrown boy with a steady, obstinate love of sleep, need exert himself not at all to rock a nation into laughter. Even McManus's horses, standing in their stalls, cross their legs in a way you can't forget. At this time the perfect McManus technique was fully developed. There was none of the fumbling art work of other early beginnings by famous cartoonists. It was only in ideas that he hesitated and discarded. He was searching for the perfect idea. He was to find it.

In contrast to the *World*, with its lone and soon to be lost star, we find a

pleiad of famous names glittering in the 1906 color section of the New York *American*. Since the Hearst papers are the true parents of comic art as we know it, it may be of benefit to summarize briefly their history and that of their comic sections, which were shuffled around in a sometimes baffling manner.

Hearst's first New York paper was the *Journal*, originally the *Morning Journal*, which Joseph Pulitzer's younger brother Albert had started in 1882. The *Journal*, under Hearst ownership, first appeared on November 7, 1895, added the *Evening Journal* on Monday, September 28, 1896, and brought out its first color comic section on Sunday, October 18, of the same year, under the title, *American Humorist*.

Soon the *Journal* added two more supplements, each partially in color, the *Woman's Home Journal*, and the Sunday *American Magazine*. In 1901, the *Journal* changed its name to *American and Journal*, and then divided these names: the *American*, after this year, referring to the morning, and the *Journal* to the evening edition.

At first the *American* published the colored Sunday sections while the *Journal* specialized in black and white daily, humorous drawings of various kinds. Finally, however, the *Journal* added a color section published on Saturday, and the *American* ("Mutt and Jeff," 1909) began the use of daily comics. The evolution of the two papers was complete, except for the final act: as of today, we see the twins merged into a single *Journal-American*. The *Journal-American* has a tabloid-size, colored comic section on Saturday, and the full-size "Puck, The Comic Weekly," on Sunday.

Returning to our 1906 survey, we find a regal comic supplement in the *American*. Ach, dose Katzenjammer Kids! Hans, Fritz, Mama and the Inspector lead off, and we shall come to them and Rudolph Dirks later. There follow the hilarious, spirited "And Her Name Was Maud!" by Opper, as well as the vigorous doings of "Happy Hooligan," by the same artist. "Lulu and Leander," by H. M. Howarth, as we have mentioned before, is hardly in the great tradition. It is a relief to turn to Swinnerton's "Little Jimmy," a fine job. Also often appearing, by the same artist, is "No Wedding Bells for Him." The genuine, signed, Outcault version of "Buster Brown" winds up the *American's* big show.

Looking at the 1906 daily papers, we make a striking discovery. Although the Sunday color sections were much like those we have today, no true daily strip in the present familiar pattern existed. Cartoons in the dailies were of two main types, sports and editorials; although the budding form of the daily strip can be discovered breaking into both. Cartoonists like Tad, Opper, and T. E. Powers, had been introducing funny figures as a sort of side show. The *American's* single true daily comic was the "Hall Room

Boys," by McGill. This was not a strip however; it was a three-column, upright panel, usually divided into six frames.

The *Herald's* partner, the *Evening Telegram*, was also pregnant with the coming daily comic form: two panels, "The Monkey Shines of Marcelene," by Norman E. Jennet, and "Book Taught Bilkins," by Rigby. Like the "Hall Room Boys," these were usually divided into separate boxes.

The *Telegram's* comics first started in 1904, and could be said to be the origin of the use of the new art in daily papers, even though they appeared only two or three times a week.

Although the strip proper is yet to come (the very next year), all the strip conventions, except the across-page form, have been firmly established. The page-straddling excesses of former days have been channeled off, in most part, to the scream feature sections, the true comics being orderly progressions of action and idea, each neatly enclosed within a box frame. "Balloons" and lettering are of modern appearance, although "balloons" do not cling as tightly to the top frame line as later. It was necessary for the hurried eye of the commuter to scoop up the tiny drama at lightning speed, and it was difficult for him to adjust his eye to the different levels of the old-time "balloons."

We have seen George Luks doing "The Yellow Kid"; now we will note another well known painter who worked in the happy medium, an artist who showed what could be done with real color and design.

Lyonel Feininger is a man with an inspired passion for the arts, who is also a natural caricaturist and cartoonist. He was born in New York City in 1871. Although he lived almost entirely in Germany until 1937, when, hating Fascism, he returned to the land of his birth, the developing American comic strip form did not escape him, and in 1906 he invaded the field himself. The comic supplement of the Chicago *Tribune*, of April 29 of that year, promised entertainment by the famous European artist Lyonel Feininger. Each Sunday a big color page appeared signed, "Your Uncle Feininger," with his vivid little people, some enormously tall, some extremely short, some very round, some very angular, performing all kinds of dreamlike, childish exploits, such as pulling steeples off churches with balloon anchors, or exploring space in marvellously cranky, homemade flying machines. Feininger used the same beauty of line, of form, of color, which had distinguished his European work, and the result is something for us comic artists to study. It is highly likely that the Chicago *Tribune* color pages of 1906 will be more and more thumbed over as the years go by.

The absence of suspense and continuity is striking in 1906. American graphic humor was tending to divide in two directions; steadily appearing comic characters had adopted the boxes and "balloons" and a general news-

paper habitat, while funny cartoons, using different gags each time, flourished in magazines such as *Judge* and *Life*. They too, were developing a special American tang, although they were far more moth-eaten at this time than the true comic. It was not until after World War I that the worn-out pun and stale English aftertaste dropped happily away and the United States cartoonists began to develop something smart and new in magazine humor, the single gag line, which led to brilliant results with the emergence of *The New Yorker*, in the mid-twenties.

Perhaps this very staleness of American magazine humor helped the development of its lively rival, the "funny sheet." Until now we have studied the approaches to the comic holy of holies. But the time has come to unveil the inner shrine itself.

Pow! Bang! Sock! The classic period is upon us.

Chapter III

THE OLD MASTERS

BIG BLACK exclamation mark. Below it, a little whiskered runt. Dotted line from runt's eye over shoulder of a hard-boiled poker player and onto his hand of cards.

Next scene: A billiard table and a tall guy with funny, sad feet and a tough face which is somehow sort of harmless. "Where you been, Jeff?"

The runt: "I was upstairs watching a poker game, Mutt. I saw that Hoboken bootlegger deal himself two aces off the bottom of the deck and I think he ought to be reported."

The tall guy puffs a smoke ring that resembles a greasy doughnut. "Wasn't it *his* deal?"

The runt: "Yes."

"Then what of it?" The tall man, crouching, is squinting along the table, figuring out his next shot. The runt is registering the great comic convention of shock, hat flying high, sweat drops spraying out, hands grabbing at the top of head.

Ladies and gentlemen, Mutt and Jeff talking, Bud Fisher's great comic team. One of the richer plums from one of the riper arts. The first true strip, the one most widely copied, the one most richly gagged. A king among strips.

The yellowing sport pages of the San Francisco *Chronicle* of 1907, rare and difficult of access, enshrine its origin. On November 15 of that year, "Mr. A. Mutt Starts in to Play the Races." There was no Jeff at that time; he was not to appear until some four months later. Mr. A. Mutt, a hungry, worldly character with pathetic feet, sets the pace of his early adventures with his first remark: "I'm a rum for working for $10 a week. I see here where a guy copped a million on the track." The sports afflatus instantly enters; Mr. Mutt is one to whom horse racing will be closer than an old set of false teeth. "Mr. A. Mutt decides to take a short cut to riches and—," say the captions under the first picture of Mutt, "after wising himself on the dope and—," "absorbing a little of the 'inside infor'—," "invests thusly." The last is under a primitive-looking box showing the race recruit plunking down

FIGURE 6. Above: Mr. Augustus Mutt starts his career in the San Francisco *Chronicle* November 15, 1907. Below: a heading from a recent color page. Right: Cicero's cat speaks for herself.

his ten-spot in the bookie's window. "See what Mr. Mutt does for himself in tomorrow's *Chronicle*," winds up the strip.

We say "strip," and that is what this innocent-looking experiment really was, for the pictures followed, one after another, across the page in a strip of drawings, instead of the square or rectangular groupings previously seen. The idea, the most important addition to comics after the birth of the form itself, was established by Bud Fisher, the old master behind Mutt and Jeff. Another contribution was that "Mutt and Jeff" ran on a six-day-a-week basis, almost all earlier dailies, such as those in the New York *Evening Mail*, having appeared sporadically. From this time the modern comic strip was itself in every way, not a single feature missing. In fact, comic artists are still trying to reach the mark Fisher set. Even Fisher's drawing style, when matured, had an original and lasting influence on strip development; some of the best of the latest additions to the strip world can be traced directly to it.

Strictly speaking, "Mutt and Jeff" was not the first comic to use the cross-page form, nor was it the first to feature a character whose life revolved around horse-racing, nor the first to appear regularly every day. "A. Piker Clerk," drawn by Clare Briggs for the Chicago *American* in 1904, is, according to this writer's knowledge, the pioneer in this form and can therefore be called the first true comic "strip."

But this first "strip" did not establish the form, a triumph to be reserved for Bud Fisher. "A. Piker Clerk" was, like the "Yellow Kid," the result of a newspaper race, the contestants in this case being the Chicago *Daily News* and the Chicago *American*. It was the direct brainchild of the *American's* editor, Moses Koenigsberg, a man who had a tremendous influence on the history of newspapers of his time, since in 1913 he founded Newspaper Feature Service, Inc. (the first syndicate to supply a complete budget of features seven days a week), and in 1915 the famous syndicate which bears the name of Koenig shortened to "King." As Koenigsberg tells the story in his book *King News*, his problem was to get a day-by-day grip on his sport page readers, to provide something to excite them into following sport pages continuously. Having decided on a continuing comic, he narrowed the theme to horse-racing, defined the plot wherein an aggressive boaster without backing gets into funny snarls in his efforts to raise bet money, and selected the paper's cartoonist, Clare Briggs, to visualize the idea. He picked out one of Briggs's sketches of a thin-necked, pop-eyed fellow with slack chin and heavy mustache who was dressed in loud, high-society clothes, and christened him "A. Piker Clerk."

With eighteen strips roughed out, publication began. The new strip was making a hit. Koenigsberg and Briggs were slapping each other's backs

when—came the ax. A member of the Hearst organization relayed the boss's reaction. The boss considered the strip vulgar. It was the end. Clerk, that piker, sank out of sight. Briggs went on to other phases of his career, and the true daily "strip" idea lay waiting for the master hand of Bud Fisher.

If this bit of history may disappoint believers in the thesis that Mr. A. Mutt was the first to drag shapeless comic feet across a daily newspaper page, Mutt fans should remember that Fisher is the real Columbus of the story. The fact that the Vikings, possibly others, set foot on our continent before Columbus does not dislodge that hero from eminence. The others experimented. Columbus and Fisher succeeded. They had the whole Western world with them.

Chicago is the city which has the honor to be Harry Conway Fisher's birthplace, the year being 1884. He studied in the Hyde Park High School, and for three months was a college man at the University of Chicago; but the "funny" stuff was in him and he got to Frisco and headed for John P. Young, managing editor of the *Chronicle*. He had ideas about this comic business.

Fisher did not sell his dramatic idea of a group of "funny pictures" that strung across the page to the *Chronicle*—at least, not for a long time. Instead, he signed on as sport cartoonist and acquired the nickname of "Bud." Tough-minded Bud, believing in his idea, kept on rooting for it, and two years after signing on the *Chronicle* he caught the editor in a weak moment with his blue pencil down.

"What's that?" the editor is said to have inquired, referring to a new group of cross-page drawings.

"That's me. A. Mutt."

"It looks funny. We'll publish it."

Mr. Augustus Mutt was the composite result of Fisher's study of racing fans at the Emeryville track, across the bay from San Francisco—particularly of those who, jamming together like homing subwayites, attempted all to be first to wedge through the gate. This student of man noticed the outpoking noses, the long-stretched necks, the receding chins—and so Mr. Mutt was given to a grateful humanity, which has always loved true pictures of itself. Here was the original of a long list of such comic headpieces.

Fisher started his career, as we have said, on the sporting page. The established convention of these racetrack and baseball artists was to spot their sport material around in a free and easy way, and then, for fun, add a few boxes with comic characters. This was the start of many of the famous daily strips; the little, funny characters would catch on, dominate the scene, and the sport cartoonist would find himself a comic artist, with a set of characters, a contented following of fans, and a fat future. Tad, Opper, Powers, all

started as sport cartoonists. "Buck Nix" by Sidney Smith of later "Gumps" fame, as well as "Krazy Kat," evolved from the sports cartoon. There was an easy-going hatonthebackofthehead, footonthedesk feeling about the sports artists, and the language of Mr. Mutt is ripe and low-down, from the start. The first strips abound with such expressions as "fall guy," "tumbling to himself," "good thing," "piker," "got his goat," all quite new in 1907. It was "inside stuff," sophisticated patter such as would later distinguish Caniff's "Terry and the Pirates."

Apart from this, what Mr. Mutt does for himself is the main interest of these early Fisher strips, for Mutt is a thin and unformed character, although he does run engagingly in a pinwheel pattern, which remained one of his permanent trade-marks. It was the enormous fluctuations of Mutt's finances which gripped the early reader, and his hot tips, which later gained him a great reputation among the racing fans.

Shortly after its inception, the strip and its creator moved over to the San Francisco *Examiner* and here, in March, 1908, the gods looked down and smiled.

It is March 29, 1908, in the *Examiner's* pages. Fisher's strip shows Mutt visiting a city institution for the feeble-minded. The inmates are about to put on an imitation of a real trial which was taking place in San Francisco at that time. "This is gonna be a scream," Mutt comments, and so it turns out; for a simple-looking guy who happens to walk into the room is promptly spiked to the wall and has his legs almost pulled off. The little guy calls himself Jeffries, which does not surprise Mr. Mutt, considering the frenzy into which the pugilistic world had been fisticuffing itself. 1908 was the year of the great build-up to the fight between Jim Jeffries and Jack Johnson; the name of Jeffries was on every sporting tongue.

What strange, kindly impulse moved the cold heart of Mr. Mutt at this point? Perhaps the soft spot all hard-boiled people nurse away somewhere; at any rate Mutt rescued the little man and took him over, shortening his name to Jeff. This one, kind act accomplished, the great plot of Mutt and Jeff was off on its long career. Jeff is so grateful for this ancient good deed that he gladly settles down to a lifetime of taking it on every spot of his anatomy, and Mutt, every day, becomes more ingenious in dishing it out. This does not mean that Mutt had lost sight of the prime passion of his early life, horse racing. This grand drive is well illustrated in the first Eastern appearance of the strip, March 22, 1909, in the New York *American* (for cartoonist Fisher, like several other West Coasters, had realized that the big comic fields lay eastward).

Mutt is hiding in an ashcan. (It is one of his appeals that he goes so very humble when he's down.) Hunger forces him out to reconnoiter. "Yon

domicile might be touched for a bean sandwich," says he, back of a tree. He spies pies: "With these pies under my belt, I might be strong enough to find the price of a bet." The family bulldog, however, catches him "in flagrante delicto." Over the fence, bulldog hanging to coat. At this point Mr. Mutt's special abilities become manifest; he heads for a pawnshop: "Hey! Gimme $2 on the dog!" Does he now feed? No. His passion is greater than such gross trifles. "Two dollars on Booger Red!" he cries at the bookie's window, while the word "disguise" points to heavy, extra whiskers. (He's been in very hot water around those parts.)

So it goes. His little protégé, Jeff, is introduced to the ins and outs of the racing racket. They make money, enormous amounts of it, live high. (Mutt enjoys ordering a bootblack to gold-plate his shoes.) A Mrs. Mutt joins the strip at this time, and prepares for a long hard lifetime by honeymooning in the brief financial sunlight of Mutt's fortune. But in the end, the sheer weight of numbers, the number of times he has gone back to that ashcan, tell on the unfortunate Mutt, and he deserts the racing game for the green pastures of the stock market. Thursday, May 5, 1910, Jeff decides to help him.

He suggests Mutt try for some "inside infor" from the financial giants. But Mutt, with a letter to J. Bluepoint Morgan, is kept on ice by the hard-boiled receptionist. Finally he boils over, hard, too.

"I've been waitin' here for two hours like a boob. I'm gonna crush in on that guy right now."

He does, and on the floor is—Jeff! "Come, you seven!" "Ah, roll 'em out, Jeff," says the great man, on the floor himself.

The final scene, the police court:

"Prisoner, the officer charges you with attempting to throw a bomb into the office of Morgan and Co. What have you to say?"

"Guilty," shouts Mutt.

This is one of the grand patterns of the old Muttology, that Jeff, the kicked-at, the despised, turns up in the soft spot in the end. We shall find him climbing to very high soft spots; and it is an interesting feature of this old trail-breaking strip that actual people and actual portraits of them were introduced.

On March 4, 1929, we have a new President entering the White House, and on that inaugural day we find the following: Mutt, dressed in burlesque knickers, is engaged in the "business of raising window-shade" and thinking: "It was a great idea of mine getting the job of head butler in the Hoover household! It will enable me to become chummy with Herbert and ask him to slip me a lucrative appointment! This is the day of the inauguration and the President elect left orders to draw his tub at seven bells!" Mutt has drawn

FIGURE 7. "Mutt and Jeff," from the New York *World* of March 6, 1918. Originally stretching across the page, this and other daily strips are halved in the present book to obtain a readable scale.

the bath, knocks on door. "In a moment I'll see the new President for the first time! I hope I can find my voice when he speaks to me!" A voice says, "Come in." Mutt opens the door and Herbert Hoover says, "Mutt, we're going to have our coffee in bed." Stretching alongside the President in bed, Jeff adds, "And see that it's hot, kid!" The last box shows Mutt leaping from the Washington Monument, saying, "I faw down and go boom!"

Turning to business, Mr. Mutt is hardly more successful than in the stock market. He settles down to a life of just playing one racket after the other, while the tendency to beat up Jeff at the slightest provocation grows on him. Poor Jeff! He is the eternal symbol of the little man, kicked, downtrodden, and yet eternally coming back for more. It would be tragic, if it wasn't so darn funny.

It's funny. That's why, at this point, Mr. A. Mutt's financial whirligigs are no longer needed to maintain reader interest. Fisher had developed into a sublime, a master gagster, and the drawing was as funny as the idea itself, or funnier. The development of Fisher's full style was gradual. Starting with a dry single line, he added rounded richness, and when, reversing earlier defeats, the *World* won Fisher away from Hearst in 1915 (first appearance Monday, August 9), the full baroque of the old master burst upon us. It was a magnificent, eye-catching strip, very large, very grand.

In a recent book on cartooning, Lawrence Lariar has skillfully defined the simple basic shapes many cartoonists use as "doodles," the forms one works out idly while thinking of something else, yet which, if studied, may make the basis of a personal cartoon style. Mutt and Jeff support this true analysis.

Their heads are both "doodles," simple forms happily arrived at without any worry about anatomy, although each character has a separate "doodle" of his own. Fisher's "doodle" for feet, however, extends to all his characters. It is one of the funniest points about his technique; these feet, so unreal, are curiously human. Mr. A. Mutt is a mean man, just what his name implies; but his feet save him for us. They are ironic, and—a supreme quality in cartooning—touching, pathetic. No matter how plainly vicious Mutt can be, he has those feet. He and Jeff used their feet, too, running from one country to the other, for this was the first strip to get itself read all over the world.

In later days a certain respectability descends, like a gentle evening glow, over the hard life of Mr. A. Mutt, the dweller, as of old, in the garbage cans of America. As we find him in recent years, he attains a suburban status; lives a comparatively quiet life. The strip rolls on, on its gags, its grand and still funny drawing.

Mutt: "You're so dumb I'll bet you think a football coach has four wheels!"

Jeff: "Why? How many has it got?"

One of the inspirations of latter-day Mutt and Jeff is the smaller comic which appears below the main feature, labeled: "Cicero's Cat." We are grateful to Mutt for his son, Cicero, and even more grateful to Cicero for this cat, one of the most purely amusing of comic animals.

This is no Krazy Kat, it is a down-to-earth cat, as hard-headed as Mutt himself; a human cat who does such things as pointing with one finger; giving the impression that her cathood is only a disguise, a disguise, however, which never comes off.

"Oh, how can you sit there and eat all that meat? Don't you know there's a meat shortage?" Cicero's cat says accusingly to a caged wildcat who is working on a red, appetizing steak. She slips into the cage. "Don't you know that meat is rationed? Where did you get all that meat without red stamps? Shame on you. How can you be so gluttonous? I'm ashamed that I belong to the cat family with you!" This is taking effect on the poor, simple, wild creature. "You should be so ashamed you should go hide your head in the corner," and of course the poor, spotted one does, and when he dares look around, there outside is Cicero's cat, picking her teeth, with legs luxuriously crossed.

"Mutt and Jeff" has gone on delivering its robust humor to the present. Its slapstick style, encountering resistance at first, forms the pattern of what many people feel to be the best, the gayest, and the most amusing comic work. Bud Fisher early syndicated the strip, and is said to have earned over a million dollars.

"Mutt and Jeff" last appeared in the *World* on February 27, 1931, going to the New York *Daily News*. It ran there until January 27, 1932, and, following a period when it ran only in out-of-town papers, reappeared in New York on March 7, 1942, in the New York *Post*, where it ran until September 18, 1943, when the daily strip was dropped.

An interesting side of Bud Fisher's character was revealed when the *Post* dropped the daily "Mutt and Jeff." From the beginning, he had been an independent character, and he had always taken pride in having his strip displayed in large, impressive form. Paper shortages were pressing in 1943, however, and the *Post* decided to reduce the strip from its five columns. Fisher said no, and both parties remained firm. The result was no daily "Mutt."

But the grand old strip has been staging a comeback recently. Bell Syndicate, which now distributes it, reports that comic-strip polls in all parts of the country still show "Mutt and Jeff" running high among the top favor-

ites. The Chicago *Sun* took it on January 8, 1945, and as of that date there were more than three hundred other subscribing papers, including the Minneapolis *Times*, Boston *Globe*, Philadelphia *Bulletin*, Washington *Star*, Syracuse *Herald* and Newark *Star Ledger*.

Three men on a park bench. Serious expression. Big problems. Listen—they're talking.

"Dis filly should cop de first." This is Asbestos, all black-face, rubber lips, and professional intensity.

A sharp semi-zoot-suiter: "Not wid that bug rider." The third man: "How about playing Atkinson's mount in the third?" This is Joe himself, of "Joe and Asbestos" by Ken Kling, a feature of the *Daily Mirror*.

Joe's life is one perpetual horse-nagging, and he looks ragged and nagged. "Why play jockeys? If the nag tires, Atkinson can't get off and carry him home, can he?" This from him of the ironwork checked suit.

But Asbestos has another suggestion, "Dis plater should win de final trot."

"Never runs two races alike. Belongs to a hot and cold stable."

Now both Joe and Asbestos whip around at the kibitzer: "Well, wise guy—how would you advise us to bet?"

"Sanely; just slip" (the rest printed in tiny type) "$2 on Expression at Jamaica."

This is a sample of the Kling strip technique. The strip itself heads a *Mirror* page devoted to horse racing. To the non-racing fan, the entire page and its strip are written in an exasperating language in which hints of human meaning are buried deep beneath technical jargon. Here is the printed text which headed the strip we have quoted. See what you can do with it.

"Faiseur, $17.10, was our yesterday's Jamaica booklet sleeper 11. The other code horse there, Blenco, was 12 to 1 and ran 2nd in a photo paying $10.90 for place. Booklet sleeper 10 goes at Jamaica today. Nine letter horse promised for today is Bean 7-4-20 at Suffolk. We bet $2 win, $2 third, and $1 on Yam 22-10-22 at Garden State. Both Suffolk bets lost yesterday."

That last sentence at least, is pregnant with meaning.

There is nothing that is unique about the little comic figures that dance across this highly technical page, but there is something very startling about the way they talk; the information they are handing out is real. If we follow the charts listed below our specimen, we'll see that "Expression" is a real horse, that he is picked to place high by all the authorities given, that he is chosen to win in the consensus of opinion. It's difficult even for a non-racing

man to resist that impulse to rush right out and plunk down two dollars on "Expression."

For this unique service to his eager public, Ken Kling is very well rewarded, with a salary that is said to be more than $100,000 a year, even if the syndication of the strip is one of the smallest in the world. This small syndication, by an interesting paradox, is caused by the immense popularity of the strip. Big papers using "Joe and Asbestos" want to serve their tips sizzling-hot, and they therefore demand exclusive rights. Usually comics are restricted to one paper in each city, but here we have a restriction by territories. Among the important papers that do handle "Joe and Asbestos" are the Boston *Record*, Baltimore *News-Post*, Philadelphia *Daily News*, and the New York *Mirror*.

Reproduced by permission of Ken Kling and the New York "Mirror."

FIGURE 8. A recent "Joe and Asbestos" strip, demonstrating that Kling—often called "The cartoonist on horseback"—sometimes drops his preoccupation with racing tips to put over a good old-fashioned gag.

Ken Kling worked as assistant to Bud Fisher for about three years. Mr. A. Mutt, readers will recall, was originally a race shark and smelled of horse ever after; so it was natural that Fisher's assistant should, as the first "Mutt and Jeff" strip had it, "Absorb a little inside infor." Yet, when Bud Fisher invited Kling to the race at Saratoga, Ken tried to beg off, pleading ignorance of racing, which he had heard rumored was a sucker's game. You don't have to know anything, my horse is sure to win, was the gist of Fisher's argument. Result: Kling went, Kling bet, Kling lost, but Kling thought. His thought: Why not a strip wherein the central character would each day bet, each day lose, each day work to obtain money for another bet?

He tried it out on the Baltimore *Sun*, but his character kept picking winners. After a few more tries on Kling's part to have his character lose, the excitement was mounting almost as fast as the *Sun's* circulation. The strip was made; but when the horses Kling picked started to lose, he worried, and even spent thousands of dollars trying to obtain inside information. By

the time his contract expired, he called it quits. After resting for a year, he started a strip called "Windy Riley," but his old race-horse readers refused to believe he wasn't still giving out tips, and insisted on reading meaning into such things as the date in the corner of the strip (4-3, they figured, could mean a horse with four letters in his name, running in the third race).

So the pressure was on again. Kling revived his race strip, "Joe and Asbestos," in the *Mirror*, and it looks as if he would go galloping on into eternity.

One does not rummage far among the papers of the happy years before World War I without running into the name of F. Opper. A cheerful meeting, for here is the noble funny-man in all his fuss and feathers. This comic giant was the creator of those rich, rare old strips, "Happy Hooligan," "And Her Name Was Maud!" and "Alphonse and Gaston." Among the dying puns and stale jokes of the early 1900's, it is refreshing to come across these specimens of the new humor. Take "Alphonse and Gaston." For pure amusement, this writer would stack certain of these pages against anything done since, even entering it into a contest with the best the *New Yorker* can put forward.

Alphonse and Gaston were national figures. They became a symbol for the inefficiency of over-politeness. "Cut out that Alphonse stuff," one would say: "Let's get down to business." Yet there was warmth in them, too: "Why did I ever leave that dear South Norwalk, Conn.?" or "Let me return instantly to that dear Paterson, N. J.," they would wail from some horrible situation into which their excesses of courtesy had led them. Who could resist that?

Opper was one of the very first true comic artists. He had been doing various types of cartooning well before 1900; Happy Hooligan, his greatest comic character, was created in 1899. His work therefore belongs to the old type of Sunday page in color which appeared before the days of Mutt and Jeff. A point to clarify is that Opper, like a number of his comic artist contemporaries, was a staff artist on a newspaper; there were no huge syndicates as we know them in our day. Opper's work appeared in the New York *American and Journal* every Sunday, with sometimes one, sometimes two, or even three, comic pages or half pages; but there was little consistency in the appearance of the various titles he used—indeed, this was not necessary, for it was before the days of a continued story. If Opper got an idea for one of his characters, he drew that for the next Sunday. Thus he juggled Happy Hooligan, Maud, and Alphonse and Gaston, often combining them, and sometimes in playful mood, introducing characters from other staff artists' work.

The writer came across a most amusing example of this mutual character juggling in the New York *American and Journal* of Sunday, May 13, 1906. At first sight it appears to be the Katzenjammer Kids; they are on a ship sighting three castaways.

"It's Alphonse, Gaston and Leon," cry Hans and Fritz.

"You be saved first, my dear Alphonse."

"After you, my dear Gaston," and the Frenchmen are rescued, Mama Katzenjammer kindly providing "some velly fine fish soup," as the Chinese cook puts it.

"I like people vot iss polite," Mama says feelingly, but the realistic Captain comments, "Aw dey aint polite, dere crazy."

Meanwhile Hans and Fritz have cooked up their usual devilish scheme and succeed in spilling the fine soup over the poor, famishing castaways, who, infuriated at such treatment, dive back, unfed, to their raft.

"Iss dere not *one* soft spot in your hearts?" giffs Mama, handing out perhaps the most deserved beating this Katzenjammer student has yet found. The page is signed both by F. Opper and R. Dirks, and, for good cooperative measure, the heading shows a hippopotamus chasing two comic gorillas and remarking with a grin, "After you, my dear Monk!" This was signed by Gus Mager, another *American and Journal* artist, who was doing the Monk comics, "Nervo the Monk," "Henpecko the Monk," etc. The boys must have had quite a day of it.

"Happy Hooligan," Opper's most sustained opus, started, as noted before, 'way back in 1899. Hooligan was a nineteenth century character, a tramp with a little can for a hat, one of a vast number of such tenement and slum heroes. It must have been his simple, blundering good nature that turned him into a national figure. There is a remarkable strain of sadism in the very early strips. It would seem that readers liked to see simple, helpless people beaten, kicked, cuffed around, jammed into sewers. We have seen that the Yellow Kid once smashed a rival Negro kid's jawbone and was very gleeful about it. Happy Hooligan's appeal is that, unlike the arrogant Kid, he does not dish it out, he takes it, and so represents the better and warmer feelings. Of all Opper's strips this was the one most frequently used as a feature, and it held its audience for well over a quarter of a century.

Stylistically, this is a handsome strip. Opper's "doodle" for a head was very special; one can pick it out of the old newspapers at a glance. It served equally for comic characters, man-like animals, political cartoon heads, and anybody and everybody. It is a round head with an enormous upper lip, two lines bounding this from nose to mouth corners. With this convention Opper carved a career. These heads were expressive: a little changing of the two lip lines and one had pathos, anger or joy; and they were funny, always.

Even better, they were unusual, striking, personal. Comic students should study and ponder them well.

But this writer's very personal favorite among Opper's various features is generally identified by the most resounding of its names, "And Her Name Was Maud!" Glamorous Maud with the dynamite in her feet! What a mule! What funny business!

Of course the plot is very simple, very childish, if you insist. You find the innocent mule going about her business in some perfectly normal way, and a stranger, unaware or thoughtless of the devastating potential in her hooves, presuming upon her good-natured appearance. Maud's goggle eyes

Reproduced by permission of King Features Syndicate, Inc.

FIGURE 9. This fragment from a "Happy Hooligan" color page of 1905 seems to present Hooligan as a "desperate wretch" indeed. Actually, poor Hooligan was only trying to find a home for what he thought was a foundling baby.

begin to roll and then look cross-eyed, a sure sign to the initiated of what is to come. But the stranger goes his selfish, stupid way, and Bam! Powie! With front legs well braced apart, Maud lets fly with everything she's got, and that's so much that complete wreckage of her immediate surroundings invariably follows. Of course the reader understands this from the start, and perhaps it is his sense of superiority in knowledge, as opposed to the poor fool of a stranger, that gives such a glow; or the deep, hidden, pie-throwing urge, in which all normal persons share, may have been given a sudden and satisfying release by Maud's flying heels.

Like other Opper strips, Maud had little background, depending upon strong spotting, expressive heads, and wild action for its visual effect, which is highly satisfying, something conceived within the limits of the medium.

FIGURE 10. Two boxes were dropped from the bottom of this fine old page, but it's clear enough what's going to happen. And the reader has been spared a lot of carnage.

Most of the strips of the time were content with this strong, two-dimensional appearance, giving the old color sections a sort of stylized, textile-design effect, quite different from, and in many ways artistically superior to, the suave illustrations of today.

Gus Mager, one of the big names of old-time slap-strip, with Bud Fisher helped to partially check the Hearstward set of the comic stream. Having started in the *Evening Journal*, we find him later on with a big, full-page comic in the *World's* Sunday section, which ran during the early nineteen twenties, and which rolled with blacks and yellows and the title "Hawk-

shaw the Detective." We say "rolled," because it was a souse of a page; at least during the merry period when the focus was old Sir Dryden Tipplewort, whose battle cry, that of the gentleman for his highball, many will remember over the years.

Tipplewort had an apparently endless provider in the person of a certain professor; and the plot usually revolved around the amazing ingenuity of these two in piping the liquid cheer to the Tipplewort stomach. The stuff might be sloshing in the bag of a Scotch bagpipe, and Tipplewort tippling it through the chanter pipes; or it might be deep in the clothes of a Negro maid's wash basket, and the old boozer disguised as the maid.

Hawkshaw's part is to uncover such fiendish plots with the aid of magnifying glass, pipe and Holmesian costume. He was a good, thorough-going burlesque of the great detective and provided rousing entertainment. With all that, there was a certain warmth lacking; and Mager tried another comic page called "Main Street," which displayed a startling change in style, and was a close approximation of "Bringing Up Father." This first appeared in the *World* on November 19, 1922. If it seems like imitation of another man's work, we must remember that this had happened many times before in comic history, indeed in all art history. "Main Street," a very good-looking page, is last seen in the *World* on October 7, 1923.

Gus Mager, during his early period with the *Evening Journal,* developed a highly personal "doodle." It was the lengthening of the lips to an enormous, forward-pointing proboscis, something half duck, half monkey. These creatures, otherwise quite normal human beings, pursued the usual course of comic characters; were occupied with their business relations, loves or hates, jealousies, rivalries. Apart from the startling snouts, the titles stood out as striking and original, the main plot of each being summarized, as "Henpecko the Monk," "Nervo the Monk," or "Colfeeto the Monk." The word "Monk" entered the public consciousness of the time.

A grand old strip that rates top billing in the classic period, and that is still running strongly today, is Cliff Sterrett's "Polly and Her Pals." Funny-Man Cliff Sterrett started out from the Chase School in New York in 1902. There were few heroines in the early strips and Sterrett, sensing a gap to be filled, sold the idea to the New York *Evening Telegram.* American youth was demanding its place in the family sun; the glittering jazz age was approaching; the time to portray a girl conscious of her imposing youth had arrived. His first strip was "For This We Have Daughters," which had only a short career, but after feeling his way for a bit, Sterrett landed safely in the New York *Journal's* arms with "Positive Polly," first appearing in 1912, a title which he changed first to "Polly" and then to "Polly and Her Pals."

There is nothing remarkable in Polly's plot. A tall, good-looking, assertive

blonde, she pushes Maw and Paw around, handles and unhandles her suitors. Polly is historically important because she is the first of a type—the famous comic type based on the French doll: bulging brow, tiny nose and mouth, huge, deep-set eyes. Add long, well displayed legs (known to the trade as "cheesecake,") and you have Polly, a perfect picture of an upstanding, American girl-goddess; stimulating, if more illustrational and realistic than the other characters of the free and rollicking age of the Old Masters.

But Sterrett was an Old Master at heart, one of the best and freest of them. In his portrayal of tiny Maw and Paw, as well as the various relatives, Ashur, Lisha, Gertrude, Carrie and Aunt Maggie, he lets himself go and creates an ultimate in wild stylization. These characters have a head "doodle" that reminds one of a slightly flattened Edam cheese. Their noses are small rolls stuck in front of two circles that touch. These are eyes, the

© *King Features Syndicate, Inc. Reproduced by permission.*

FIGURE 11. Background details are well left out in these three boxes from a "Polly and Her Pals" daily strip of 1916, full of the old-time spotting and punch.

irises of which turn in together in a perpetually wall-eyed state. The heads are squashed down on tiny, neckless bodies whose leg extensions (what else can we call them?) are sliced off to make enormous feet. Sterrett's anatomical phantasies reach their limit with his animals; one, a very fine gray cat that accompanies Paw and registers that tormented one's every mood, is perhaps his noblest achievement. This cat marches with wild leg construction displaying ludicrous, upturned feet. Despite the high slapstick of these figures, the line is careful and exact and the plots are strictly human. This delineates it sharply from other stylized strips such as "Krazy Kat" and "Popeye," where imagination is part of the basic idea and where the characters are symbols. The characters in "Polly" are sharply themselves, and nothing else; this is at once their strength and their limitation.

There is a sense of pattern in Sterrett's work, a very strong feel for spotting and beauty of arrangement. He is one of those who made the old pages fine to look at, a burlesquer working frankly in two dimensions and

having fun. He belongs to the company of men like Swinnerton, Dirks, Opper, Fisher, and later, George Herriman, who made of comic strips a gloriously free and gay creation, something to match and reflect the healthy and hearty laughter of the people. Another very interesting point about his

© *King Features Syndicate, Inc. Reproduced by permission.*

FIGURE 12. This heading from a recent "Polly" Sunday page shows Cliff Sterrett still a master of spotting and arrangement.

work is that it has definite abstract art value, and the value appeared in "Polly" long before modern art was accepted by American art critics. This is one of the conspicuous cases in which the humble little "funny papers" often forecast important later developments.

Chapter IV

MORE OLD MASTERS

IN THE forefront of the "funnies," one strip has been prominent from the beginning. We spoke earlier of a kind of cloud from the explosions of gusto and laughter which hung over this strip; now, in these later days there are two clouds, two sets of explosions. Since 1913, there have been two sets of Katzenjammer Kids, four boys, two Captains, two Inspectors, two Mamas, all functioning at full frenzy. One set, which appeared in the old New York *World*, and now is seen in the New York *Post* and is syndicated by United Features, is signed "R. Dirks," and is entitled "The Captain and the Kids." The other set appeared in the New York *American*, and is now drawn by H. H. Knerr, under the title "The Katzenjammer Kids," appearing in the Sunday *Journal-American*, and being syndicated by King Features. This situation, in the tradition of the two Yellow Kids, is the result of an interesting story.

Earlier, we saw the "Katzies'" beginnings at the penpoint of Rudolph Dirks in the New York *Journal*, Sunday, December 12, 1897. Dirks had carried his opus on very successfully for fifteen years. But in 1912 (ah, dream of all comic artists!) the hard-driven Dirks decided he wanted a full year's vacation. Once before, his strip had lapsed from view while he manned a gun in the Spanish-American War. There was no war handy in 1912, but Dirks wanted to paint and travel. And forget those damned kids.

The *Journal*, however, did not share the artist's rosy dream. At least it said, "Catch up a year ahead on your strips before leaving"—that ironic plan, the only means by which the poor comic artist can restore himself to normal. Dirks did double up on his work, at least for six months, but snags appeared in his relationship to his paper, and one day he simply sailed away for Europe with his wife and his paintbox. Frenzied telegrams followed him and he sent back a certain amount of work. The *Journal*'s old rival, the *World*, sensed a great opportunity and went hammer and tongs after this most famous of strip artists. They got him—under the agreement that the strip should be allowed to lapse until legal complications resulting from his *Journal* connections were ironed out. So came into being a classic lawsuit that hit the front pages, and brought the decision that Dirks had the right

ABOVE: RUDOLPH DIRKS, ONE OF THE FOUNDERS OF THE MODERN COMICS, CONTINUES HIS SPICY OLD EPIC FOR UNITED FEATURE SYNDICATE.

BELOW: THIS LIVELY VERSION OF THE KATZENJAMMERS IS DRAWN BY HAROLD H. KNERR FOR KING FEATURES SYNDICATE.

Above: © United Feature Syndicate, Inc. Below: © King Features Syndicate, Inc.

FIGURE 13. Colored crayons or glue—the two versions of the "Katzies" produce endless and endlessly entertaining trouble.

to draw his characters under a new title, the rights to the old title and to a strip with the same characters remaining with the *Journal*.

Dirks chose the title "The Captain and the Kids," and the new feature appeared in the *World*, looking as lively as ever.

Meanwhile, the *Journal* had, with characteristic energy, discovered exactly the man to carry on.

Harold Knerr had been for twelve years drawing various comic features for the Philadelphia *Inquirer*. Signed on by Hearst, this artist shouldered the difficult assignment of "The Katzenjammer Kids" with brilliant success. A careful comparison of the two "Katzies" will reveal little to choose between them, although this writer prefers Knerr's style, his line having more deci-

sion than Dirks's, who always showed an unpleasant crudity of drawing. On the other hand, Dirks's continuity and wild language seem slightly more amusing.

Not all strip students unite in admiring "The Katzenjammer Kids." Gilbert Seldes has complained of what he calls its sloppy color and weakness of conception and execution. Yet despite this damnation, the Kids have continued to flourish for a period unique in strip history, of forty-seven years, and even to divide in two equal parts, as the cells of the human body propagate themselves. Surely there must be some grand principle of vitality here that Mr. Seldes has overlooked.

It's not difficult to find. Our critic has considered strips as an adult; the "Katzies" are for children. Some of the overtones which induce adults to admit strips into their mental world are missing in this one. The mournful pathos of Mr. A. Mutt's feet, which appear as symbols of humanity in an evil world, is missing. The irony, the delicately beautiful language of "Krazy Kat," its abstract pattern, are missing. But children are not grownups. They are not interested in these rarefied matters. They do not know what the word "picaresque" means; they do understand Hans and Fritz when they are sticking hatpins in the Captain's ample backside.

In defending Hans and Fritz, we'd better admit at once that they have carried their fiendishness to apocalyptic heights. At first they were but bungling amateurs in the art of adult-baiting; a half-dozen jars of cranberry sauce would buy them off any time. But they studied and became experts; they were enjoying hellishness, not for any reward, but for the pure, abstract beauty of the thing itself. Here is the strong inner core of their appeal; for most healthy people have gone through such a stage when they were unthinking children. Hans and Fritz represent the savage; but it is the refined, intelligent, even artistic savage. The Inspector once said it all: "Mit dose kids, society iss nix."

If, in certain pages, the Kids seem unbearably cruel, soulless little brats, let's remember that with a few years of normal growth they would be hard at it, doing a good deed every day. A clipping singularly apropos comes to hand; it is from Leonard Lyon's column in the New York *Post*, published a few years ago:

"'We must distinguish between viciousness and boyish pranks,' said Mayor La Guardia. Then he confessed that when a boy, he and his friends would walk along the streets until they spied a horse hitched to a post. 'We'd unhitch the horse and ride him around the town,' said the Mayor, 'and then we'd return the animal!'

"'Are you telling us that you were once a horse thief?' asked one of the startled listeners.

"'No,' said the Mayor, 'I'm telling you that I once was a boy.'"

There you have it; that's what the Katzenjammers' critics have forgotten.

In the fuss and fury of the boys' pranks, certain human aspects of the plot of "The Katzenjammer Kids" are apt to be overlooked. The relationship of the Captain to Mama, for example. Who was Mr. Katzenjammer? This writer has no information, only knowing that Mama started in alone. Apparently it was Mama's superb cooking that originally induced the Captain, a lover of remote voyaging, to join the family. The Captain is not the boys' father, nor is he married to Mama, yet one suspects delicate, but strong mutual feelings between these two. The Captain, exasperated by the fearful hazards of home life with the team of Hans and Fritz, is always on the point of leaving. Sometimes Mama restrains him with a simple clout on the head, but often she puts the joys of home to him in an irresistible manner:

"Yoo-hoo, Dollink, back to der home sweet home! Giffs flop-chacks for breakfast!" and the Captain is apt to reply:

"Ven all iss done und said, dere ain't no dod-rotted place like home."

This researcher, fresh from a study of the subject, believes that the truth is that Mama Katzenjammer is one of the finest, sweetest, most interesting characters in all the "funnies." Her patience is not inexhaustible, but her heart is entirely genuine, and her love for Hans and Fritz unique in grandeur, considering the circumstances. Then too, she is so romantic; can be so happy; can sing cheerfully: "On der mountain spitz mit lieber Fritz, yo lay, yo lay, de hoo—!" She can give a sweet, though naïve thumbnail sketch of home-happiness. "So long Mama got two nice liddle boys to protection her, it giffs doughnuts und afterwards der moofies!"

It is interesting that these characters have so endeared themselves to Americans that two wars against Germany have not affected their popularity. Perhaps it is the ingenuity of the boys' pranks, but this writer likes to think that it is also because of the warmth and humanity of the Captain and Mama. "Kindness mit kidlets iss der pinochle of life!"

In an earlier chapter we spoke of a great comic star which the unfortunate New York *World* was nursing back in 1906, only to lose him to Hearst, as usual. George McManus was the name. A list of some of his early features includes "Alma and Oliver" (St. Louis *Republic*), "Snoozer," "The Merry Marcelene," "Let George Do It," "Panhandle Pete," and "The Newlyweds," (New York *World*). This big fish landed flopping on the New York *Journal's* desk early in 1912, and began a comic called "Their Only Child."

From the very start, McManus's work was masterly in humor and

decisive in execution. Indeed, it might be said that he holds the all-time record (or possibly shares it with Daddy Dirks and James Swinnerton) for consistent delivery of the best in comics. Technically, his work is the same today as in his early period; the spark is still in it, an unusual achievement for any artist after forty-six years. ("Alma and Oliver" was started back in 1900.) But in the days when he joined the *American*, in 1912, he had still not found the perfect idea. "Their Only Child" was not quite it.

For years he had been haunted by the play, "The Rising Generation," and he now decided on the plot-idea back of this play for still another strip trial. This time he hit it. "Bringing Up Father" appeared first in a tentative way in the *American* on August 3, 1913. It took some time for the new plot —that of the social problems of a working man grown rich overnight—to make itself felt. In 1916 it is still only a daily, "Rosie's Beau," the last of the artist's many idea experiments, occupying the Sunday page. But in the early twenties, "Bringing Up Father" at last dominates the scene in both Sunday and daily, and "Rosie's Beau" takes the part of a subfeature in the Sunday, where it remained until 1945, when it was replaced by "Snookums."

"Bringing Up Father" was, for the comic fans of 1913, a pre-view of the coming flood of man and wife strips; and it had no small part in releasing this flood. But Jiggs and Maggie are not purely typical American husband and wife in the sense of Toots and Casper, Mr. and Mrs., or Blondie and Dagwood. These latter are possessed of modest working incomes; they are little people. The theme of the Jiggs and Maggie saga, as we have just remarked, is that money has flooded a simple Irish workman's life in amounts large enough to satisfy any dream—and while this brings out all the Maggie in Maggie, it also brings out all the Jiggs in Jiggs—this Jiggishness being the really attractive feature of the strip, ameliorating, to some degree, the fights and brawls, the unpleasant picture of marriage which it portrays. As Maggie scrambles furiously for the top rung on the ladder, Jiggs looks wistfully at the bottom and makes pathetic attempts to return to it.

For the great theme of "Bringing Up Father" is, of course, the joys of the simple and homely. What empty social grandeur can compensate to Jiggs for an evening spent at Dinty Moore's, in company with his companions of old days, Casey, Sweeny, or Larry O'Girity? Jiggs labors at his office with secretaries amid respect and formality, yet all the time longing for a chance to take off his coat, and his shoes too, and be simple, natural, himself. He is very attractive; it is all human and understandable, especially when you consider Maggie. Ah, Maggie! Now there is the most sharply drawn female in comicdom. With unfaltering, hideously clear line, McManus rolls all ambitious, driving, aggressive women into one. Maggie

is ugly as sin, although she has a good figure and beautiful legs. But with true feminine optimism, she insists on teen-age clothes, frilly dresses and tip-tilted hats. Does she think she is getting away with it? Yes, she does.

Ah, Maggie! What other woman of the strips could face you in a battle of will power? Mama Katzenjammer (indeed the whole family) would run, screaming "Hurry! So fast as is possible!" Tad's Lil, Briggs's Vi, what could they do? And all the other strip women, Blondie, Bettie, Polly, Boots, Dixie Dugan, all would be perfectly helpless before Maggie. The Men too—even Flash Gordon, even Superman could not budge her. No, there is only one strip character who might impress his own will on this hard female; that's Popeye.

FIGURE 14. The last two boxes of a "Bringing Up Father" daily strip of 1918. To compare with Jiggs and Maggie of our own time, see color plate 4.

There is a peculiar artistry about "Bringing Up Father." It is easy, entertaining to look at. All the characters are quietly funny; they are all truly drawn. The layout, the pattern of the strip is remarkable. It stands sharply out among the confused styles of many modern strips with a refreshing simplicity. Finely arranged blacks, uncluttered backgrounds, which are still full of telling detail; beautiful line, as clean as a telephone wire after a thunderstorm, and always humor—even the ostentatious vases and rugs in Maggie's house are funny.

It is one of the best strips for a beginner to study. Notice especially the expressiveness of each face, every one of which will be found registering some definite, easily understood mood or idea. There are no "dead-pans" here, no half expressed or sloppy characterizations.

Plate 2. This "Krazy Kat" page ran in the Saturday color section of the New York *Journal American*, December 11, 1938.

This, combined with the great humanity of Jiggs himself, is one reason for the world-wide pull of "Bringing Up Father." Published in twelve languages, Europeans, Asiatics and South Americans alike respond to the appeal of the simple little man, lost in the emptiness of wealth.

Back in the old days around 1906, in the pages of a now nearly forgotten daily, the New York *Mail*, we will find something to our comic taste in the sport section. Across the top of the page stretches a line of drawings, half comics, half sports comment. What makes them stand out from the others of the time is their queer, joyous lunacy; the way the law of gravitation is defied; the inventiveness, the crazy backgrounds and contraptions. They have punch, character, originality. They are Rube Goldberg.

This master was another West Coast product gone East to glory. Rube had graduated from the University of California and, like Bud Fisher and Russ Westover, started cartooning on the San Francisco *Chronicle*.

Berthed in the *Evening Mail*, things happened fast. Goldberg is not only a funny man, he is an artist, one of the best in the field of cartooning. He also has a peculiar, restless inventiveness; he is original, a quality much rarer than one is apt to think. One day he drew a cartoon of a man who had just fallen from the Flatiron Building, with a dumb spectator asking, "Are you hurt?" This was the beginning of his famous series of foolish questions.

"Foolish Question No. 1" was answered: "No, I jump off this building every day to limber up for my business." This was funny; his subsequent "Foolish Questions" were funny, and of course the inevitable happened. The story is repetitious, but it must be told: he landed on the *American*.

Here, in 1924, we find him doing a big color page, "Boob McNutt." Its zany humor and strength of drawing make it stand out; but it derives its tone more from wild grotesquerie of background, than from the actual character of Boob. He is a helpless clown, a punkin body, a round, foolish redhead. Once Boob's father said, "I think a brain has started to grow in your head." But no, oh not at all. His only point of interest is his intense love of his mate Pearl, whom he first dumbly pursues, then marries.

It is not a very interesting plot; but the gorgeous incidents, details and backgrounds save it. In the circus where Boob works, acrobats hang from hoops by their noses alone; and riders rest one hand on the circus horses' backs, while holding their bodies diagonally in the air. This is the true Goldberg. Why is it that we feel so happy when our minds are stretched so widely? There seems to be a kind of mental sunshine that floods its way in. People liked the loony catchwords and phrases invented by this master as well as his art work. "Baloney," "I'm the guy," "Mike and Ike, they look alike," are all Goldberg originals.

Another of the old-time slapstickers, like Goldberg, played around the edges of the strip world rather than dwelt in the middle of it. Milt Gross inherited the traditions and has the feeling of the period of the old burlesque stripmasters, and his name is a famous one. The comic form, it seems, was naturally made for Gross, even if only a small per cent of his work has been comic strips. There is something archaic about him; he is the funny man who has had a good time and laughed since man's dawn-days. He might have scratched his pictures on clear pieces of bone by pre-historic fires, or he might have been one of those medieval carvers of saucy grotesques, which brought a popular touch to the great, soaring cathedrals.

Milt Gross came from the Bronx. He is said to have been a schoolmate of "Dutch" Schultz, the gangster, and to have begun drawing with pool-room chalk. When he was twelve, he was off on his famous career. He became office boy for Tad, of the New York *Journal*. He became prominent almost at once. His first strip was "Henry Peck, A Happy Married Man," which he left for animated cartoons. But he was a "stripper" by nature and soon was back on the New York *World*, where he began to hit his natural style, which has a loose, rattling gusto, like a Third Avenue elevated train. His *World* strips were "Banana Oil" and "Count Screwloose." The first World War made an interval in his newspaper life; he came back from it to the *World* again, and this was the time when he tapped his greatest vein of originality. He began in a wild, Bronxian language which, with the publication of *Nize Baby* in book form, made him and his Fertlebaum family familiar to all America. Always restless and experimental, his next phase was Hollywood, working on Chaplin's *The Circus*, and making *Nize Baby* screen plays. Then followed *She Done Him Wrong*, new ground in literature, a book without a word, all pictures. Back again to the comics and King Features Syndicate, where Gross reeled off "Dave's Delicatessen," "That's My Pop"; and "Grossly Exaggerated," which was one of his last comic panel experiments.

One of the greatest strips in this great period, a strip that has carried forward the flavor of these old days into our own, is still famous in spite of the death of its creator and drastic changes in the roster of characters.

Looking in the New York *American* on December 19, 1919, we see a three-quarter-size goof with poached-egg eyes in the classic comic head and with a big, rotten-apple nose, sitting up in bed looking at the sun shining in his window. "I wonder what time it is?" Now he is dressed and talking to the room clerk: "Say, I want my room changed. Every morning the sun wakes me up at seven o'clock."

Apparently hotel rooms were scarce even then, for the clerk very politely shouts, "If you don't like it, *move out!*"

Barney Google is discovered back in his room, muttering to himself, "I'll show that guy—I ain't goin' to get up every morning at seven when I don't have to be down to work till nine. I'll paint the window." And he does, with black paint. He sleeps through one box, and wakes in the next: "Oh, boy, that was some sleep—I feel like goin' to work this morning."

In the last box Barney has just opened the door to his office; the manager shouts, "YOU'RE FIRED FOR NOT SHOWING UP FOR TWO DAYS!"

But true to the tradition of the time, loss of job could happen every day without visually affecting the character. He could be left in the most difficult situation imaginable and still bounce back the next day involved in an entirely new gag. It was a plot "doodle" which, even if carried to extremes, the public had come to accept.

At first Barney Google, the man, was about three-fourths as tall as a normal man, instead of the half he is today. The strip began with straight gags, but after a bit a big, domineering wife was added, and it seemed as if another man and wife had arrived to air their nagging. But the strip's creator, Billy DeBeck, a man of originality, was heading for a different brand of nagging.

On July 17, 1922, we find Google standing on the sidewalk outside of the Pastime Jockey Club. Barney hears an argument going on inside. "I think I'll stick around, sounds like somebody was gonna sail through the air." He was right; in the next box a man does come sailing through the air and lands on top of Barney Google.

The sailing stranger picks himself up and turns to Barney gratefully: "My friend, if it hadn't been for you, I might have broken my back. I own the racetrack here! To show you my appreciation, I'm gonna present to you the finest two-year-old in my stables—Come on!"

In the last box Barney is talking into a pay phone: "All our troubles are over now, sweet woman—I gotta racehorse." In Barney's hand is the rein of the wonder-horse of all time, Spark Plug!

What happened is part of the American legend. At first this horse angle was intended to amuse the racing people, handlers, trainers, and bettors; but much to everyone's surprise, the ordinary public, that didn't know a horse blanket from a dope sheet, took Spark Plug to the private paddocks of their hearts. It wasn't that the public knew or cared anything about horse-racing, but they did know and care about funny strips; they recognized that this crazy horse was one of the most inspired bits of funny business since the strips began.

Spark Plug was a wonderful, gay comic creation, a startling thing of huge, rolling eyes; something generous in fantasy and pure fun from the word "whoa." There were those eyes and that head, and then the mass of the body covered by an enormous blanket which was buttoned down the front. From under it the galloping feet projected like the wheels of a mechanical toy. There was a very special shape to those feet: they were shapeless.

This animal was responsible for a whole generation of city children growing up with the impression that all horses had yellow sides. It was only the more sophisticated kid who recognized in this yellow covering with the big red patch any resemblance to the smart racehorse blankets from which it was taken. Spark Plug, unlike lesser rivals such as Whirlaway and Man o' War, wore his blanket while racing, though it hugged his ankles so tightly, it was difficult to see how he could run.

It is reasonable to assume that the blanket served the secondary purpose of being easy to draw, and after the few occasions the reader was allowed to see Spark Plug disrobed, he was only too glad to allow DeBeck this short cut. Sparky's figure was that of a saw-horse with rounded corners. When stripped, Sparky's eyelids would lower to half mast over the big, expressive eyes stuck in the sausage-shaped head, which drooped at an angle. The effect was one of utter shyness; you couldn't help but neigh with relief when the blanket resumed the place nature had intended for it. Maud, Sparky's rival in the early Sunday pages, was a technically correct mule compared to this wild conception of a horse. Here was a horse stripped to fundamentals, and the fundamentals changed to suit the fancy of Billy DeBeck.

Though Barney and Spark Plug had many trying adventures in the pages to follow, their mutual affection was one of the most touching and enduring relationships in stripdom. Spark Plug, denied the gift of speech, could always show emotion in the "balloons," filled with bursting hearts, which habitually floated above his head. One glance at Barney was sufficient to create this phenomenon. Sometimes, under extreme emotion, the big brown eyes in his sausage head would fill with tears.

Once Spark Plug signs on to the Google family, Barney's personal life changes completely. Like a kid with a new toy, he can't wait; he must race Spark Plug at once.

At once, too, he discovers that it costs money to race a horse—but Google is ingenious; among other devices he pawns Sparky and digs him out at night.

On Thursday, August 17, 1922, Barney gives his horse a last-minute talk: "Sparky, old fellow, in two minutes you'll be at the post—every cent

I could borrow, beg and swipe is on you and you're a hundred-to-one shot —Look at me, Sparky—Promise that you won't f-f-fail me!!"

It was against the traditions of comic strips to let Spark Plug win his first race, but there the genius of DeBeck opened a new thrill to the comic reader. Sparky won. From now on the reader felt it would be possible for the horse to *either* win or lose. DeBeck had found suspense. With both suspense and humor, the strip was the only thing that couldn't lose.

The dénouement of this race brings a second great change in Barney Google's life. He lays aside the derby hat and nondescript clothes of pre-

© King Features Syndicate, Inc. Reproduced by permission.

FIGURE 15. Yes, the graceful object under the blanket is Spark Plug. This half of a "Barney Google" strip printed in 1923 shows that while Spark Plug made peoples' eyes ache, their hearts ached too.

race days, and shows up in the clothing that became so famous, the high silk hat, white gloves and cane.

Barney Google and wealth offer a sad commentary on human behaviour. After winning the race, Barney is seen with his "sweet woman" only once. From then on he was on the trail of the "New Mama," a racy, sleek little number more suitable to a man of his means. What became of the wife, DeBeck never explained, but Barney is involved in a torrid love story.

Apparently Spark Plug had been at first just a device to change Barney from a poor working man to a rich one. But at this point that usually sleeping giant, the public, stirred itself. It liked the goofy plug; loved it, lapped it up, had to have it. Naturally it got it, and the wild galloping nag tramped his shapeless feet all over the strip and America and made history, comic history and American history. Few strips have achieved hit songs all to

themselves—but "Barney Google with His Goo Goo Googly Eyes" swept the nation. In its influence on American slang, this strip probably topped all others. Some of the older gems have sunk in time's stream, but most of us remember "Osky-wow-wow," "okmnx," "So he took the fifty thousand dollars," the "heebie-jeebies"—this last apparently a permanent addition to our tongue. More recent: "taitched in the haid," "shifless skonk," "Why shor," "jug-haid."

Was there ever a comic-strip character who did a syndicated comic feature himself, with his own name as a by-line? There was such a feature; it appeared for a while in the New York *American*: its title was "Bug House Fables," and its author (at least the one whose name appeared as by-line) was Barney Google.

After Spark Plug had been running for many years, a new friend was added to the Google household, a character by the name of Rudy. Rudy was an ostrich. Rudy's main purpose in life was to make trouble for Barney. The only thing that saved the ostrich was its tremendous love for little Barney, for it is pretty hard to do actual, bodily harm to something that loves you with every fiber of its being.

Later Barney became the manager of Sully, the world's champion wrestler. Sully's strength was amazing, but it by-passed his mind; hence the need for a combination nurse-maid, promoter, and manager. Barney and Sully ran into a little trouble and it eventually became necessary to hide out for a spell. They chose the hill country of the South, and that was where they first met Snuffy Smith. What happened since that meeting is comic strip history. Snuffy is a wise-cracking, sawed-off, little half-pint, who looks remarkably like Barney, except that his nose is a little redder—thanks to the jug of corn squeezin's he keeps right handy—and his eyes have a sleepy cast that Barney's lack.

Snuffy, his wife Lowizie, and their nephew Jughaid made a tremendous hit, and eventually the name of the strip was officially changed to "Barney Google and Snuffy Smith." After America entered the war, both boys tried hard to join the armed forces. It was almost impossible, but finally Barney swung the navy and Snuffy the army. Snuffy eventually landed in Japan; he escaped with the talking bird, Hawky Tawky, and was picked up by the United States Navy, where he ran into Barney again.

Billy DeBeck was still at the top of the comic pile when he died in 1943. Fred Lasswell, DeBeck's former assistant, had returned to America the day of DeBeck's funeral. Lasswell had been a radio operator for Pan American, but when the army took over that operation, Fred was released. King Features Syndicate, which controls Barney Google and Snuffy Smith, put him to work immediately, and Lasswell continued the strip even after he entered

© King Features Syndicate, Inc. Reproduced by permission.

FIGURE 16. To the three panels of a recent "Barney Google and Snuffy Smith" strip we have added Snuffy in postwar poses. Here is proof that Lasswell has helped to keep the basic hilarity of the old comics alive.

the Marine Corps, where he was a member of the staff of *Leatherneck,* the Marines' magazine.

As drawn today, the strip still has the old rampant boisterous flavor, one of the very few with this flavor which has survived. Snuffy and Barney translated the war years into their own idiom, and in the great tradition, enriched the popular levels of the language with choice G.I. phrases. Snuffy, especially, had a way of talking which got across to soldiers. Barney called him "Yardbird," and this became orthodox Joe-talk. Recently, another addition to the language seems to be registering with Americans. This is Lowizie's forceful cry, *"Shet yor tater trap!"*

These are comic characters for the people, indeed; they wade in and kick over the formalities. During the war they represented the inborn conviction

of the enlisted man that he is as good as, and a damn sight better than, the officer.

"I swow!" the fine long-beaked comic bird, Hawky Tawky, remarked to Google. "Th' capt'n is in thar bowin' an' scrapin' to Snuffy—he's called th' ship's tailor to outfit him."

"You're tetched, Hawky Tawky!" replies he of the Goo Goo Googly eyes, but looking through a port he sees Snuffy being fitted with a gorgeous uniform.

"Run this sword down to th' machineshop, chubby, an' get my cross mark set on the handle wif p'arls."

"Gladly, sir!" replies the captain.

In a similar spirit, we engrave Barney Google wif p'arls in our story of the comics. Gladly.

Chapter V

OF KATS AND ART

"KRAZY KAT" was not only the maddest, merriest of the "funnies," it was art. That is not only this writer's opinion; it was forcefully expressed by Gilbert Seldes in *The Seven Lively Arts*, published in 1922. By "lively arts" Mr. Seldes meant those direct art forms which depend upon the mass approval of the people: popular music, dancing, movies, vaudeville, comics. Admitting that Krazy belonged to the second order of the world's art, he considered it first rate in its class; even more interesting, he selected Krazy, together with Charlie Chaplin, to represent America's highest achievement in any art, lively or sober.

Consider, if you rebel at the idea of a lowly strip or movie meriting such praise, how original these masterpieces, both produced in America, really are. Fine, moving painting this continent has produced; but set the best of it beside Titian, Rembrandt, El Greco and van Gogh, and it will be seen that the achievement is not unique. Krazy Kat and Charlie, however—they are fresh flowers from Nature's wonderful hotbed, the people. They have no antecedents, they are art originals, and such pure new sources of joy deserve to be respected.

Krazy's origins trace back to this century's first decade. About 1909 we find his creator, George Herriman, doing a daily comic in the New York *Journal*. "Mary's Home from College," runs its caption in September of 1909. "Ay bane hoozled moozled if Ay let anybody make art vorks on my rollings pin and fryings pan," says the cook, for art-conscious Mary has been "slathering" her talents around the household. The important thing, however, is a minute box with a little embarrassed feline looking up from a milk bowl with a deferential "Sir?" to a dog holding his stomach in agony, who says: "Touch it not, Kat, touch it not, somebody's doped it with fresh paint."

Here is not only the archetype of the sweet, gentle Krazy and the man of affairs, Offisa Pupp, but a premonition of Herriman's peculiar literary style; a kind of hypnotic chant that starts echoes ringing, not in the mind, but in the soul. This, of course, is poetry, and Herriman's unique status is

that he is poet as well as artist; combining poetry and art in a form curiously adapted to that purpose.

The poet-artist, however, developed from the usual strip-matrix. George Herriman was one of the *Evening Journal's* gang of cartoon handymen, able to turn his hand to any lively matter, like his hard-working fellow gagsters Tad, Powers, Opper, and Gus Mager. In 1910 we find Mary, referred to above, giving place to "The Dingbat Family," which will become "The Family Upstairs." The little dog and cat, seen in "Mary," persist in a minute, occasional side-play of their own. Herriman, always experimenting, searching for the perfect expression of his unique personality, could not let the talking animals go, and on July 26, 1910, he produced a strip with two striking innovations. One was the use of typewritten capital letters in the "balloons," which he shortly abandoned, the other the development of the Dingbat's "Kat" to a minor but permanent position in that feature. Indeed in this fascinating strip the great plot of "Krazy Kat" appears in archaic form; all the rest will follow as variations and embroideries upon this theme. Below the doings of the Dingbats (who are obsessed by their weird, off-stage torture at the hands of the "Family Upstairs") appear, first a tiny mouse, then a stone, then the Kat, primitive, quietly meditating, innocent. The mouse reaches for the stone, aims, scores a bull's-eye. The little Kat is left alone, paw to head.

Such is the beginning of the fantasy, the creative rearrangement of familiar things, that is "Krazy Kat." The arrogant mouse, naturally defenseless, takes the bold step of stone-slinging his mortal enemy; the striking feature is that the Kat shows no sign of fight, no suggestion of anything but innocence. It is the plot of the little man (mouse) and the big bad man (cat), with the twist that the big bad man is shown to be not bad at all, just another mouse in Kat's clothing. It is true that in the similar tiny episodes that follow, the Kat chases the mouse in an orthodox manner; but his expression is too mild, he is too blundering, too simply handled by the Napoleonic mouse to register as the usual sharp feline. A fantastic relationship is developing between them. What this is, or will be, is first clearly indicated on August 15, 1910, when for the first time the tiny Kat-Mouse drama is separated by a line from the "Dingbat Family" above, and has boxes of its own, the first of which says: "And this another romance tells."

The Kat, sometimes male, this time female, with numerous kittens, is stalking her fixation, the mouse: "Keep your eyes on mother, children. Coward," she says, as the mouse dives down a hole. But the mouse reappears with an enormous progeny of its own, and the Kat family disappears in a shower of stones, bricks and horseshoes. Then the Mouse, sitting content by

his hole with a pillow and a cup of hot coffee, makes an historic comment: "Krazy Kat," he says.

After a period of Kat-baiting in every possible way, the two begin to hold conversation. They are companions, although the mouse retains his dominance at all times. He comes boldly up, takes a bowl of milk away from the Kat. He becomes the Kat's boss; boots, kicks, and manhandles him or her. And the Kat likes it, loves it.

The Kat-Mouse drama begins a separate existence from the Dingbats in 1911, under the heading "Krazy Kat and Ignatz." A uniquely gifted office boy is said to have first recognized and pointed out to his higher-ups the appeal of this mighty side show. Herriman's settled style is emerging. The strip has become a pure fantasy as far as literal detail is concerned, but Krazy is becoming the true Krazy. He is emerging as a symbol of the dreamy freshness and innocence of the human mind; he is the antithesis of the worldly, hard-bitten mouse, and, supreme triumph of the emotions, he has begun to love his little enemy, whose daily occupation and pleasure is to "krease his bean" with a brick.

Krazy thus becomes the personification of the romantic, loving strain in mankind; he is no longer an animal, and yet the animal form, the sadness, the ironic wit, with which he is presented have given his creator a chance to draw a picture of the soul—a thing too delicate and ephemeral to describe, except in symbols and side glances.

John Alden Carpenter, in the program note to his Krazy Kat ballet—an adaptation of the strip which was performed in New York in 1922—has pointed out the similarity between Krazy, Don Quixote, and Parsifal, all optimists. Carpenter considers Krazy the greatest optimist of all, since he maintains an affair with Ignatz Mouse which is complicated by the fact that the gender of each remains a mystery.

This theme of infatuation with the mouse is early developed. "My, but there's nothing to do but get lonesome now-a-hot-days," murmurs Krazy, sitting sadly with crossed eyes in his little strip under the Dingbats on July 25, 1911. "Hello, what's this coming through the air?" Smiling happily, he eyes a high distant dot, meditates wonderingly, "How fast it travels!" and with a *Bam!* is heavily struck on the head by the big brick. "Dear little Ignatz, it's one of his 'Kalling Kards,'" he winds up, examining it hopefully for some inscription, which we feel sure will not be there.

In "The Family Upstairs" Herriman had gradually fallen into a very close stylistic imitation of "Mutt and Jeff"; but with the Kat's emergence as his major effort his own great cartoon style rapidly developed. His sense of spotting and pattern, always beautiful, was nourished by a wild freedom of arrangement. Backgrounds shifted without any reason but that of amuse-

FIGURE 17. This "Krazy" black and white daily strip appeared in the New York *American* in 1939. See also color plate 2.

ment, gaiety, irony; a house could instantly become a tree, a church turn to a mushroom. The luscious Kat language was another of his four freedoms; for in addition to freedom of plot, background and color, freedom of speech was one of his most joyous contributions.

"See the two new hice," says Krazy, July 9, 1914.

"Hice?" questions Ignatz.

"Sure, hice."

"What's hice in American?"

"Listen, Ignatz, one house, but two hice, sees doo?"

"O. I. C. now. You mean two houses," says he who is sometimes referred to as the "mice."

"Idyik," responds Krazy.— "Would you say two mouses, Ignatz?" and the "mice" is too angry even to hurl his usual brick.

This poetic kicking-around of the language has its graphic corollary in

the "art vorks" which Herriman gradually unfolded. A great lover of Arizona and its deserts, he developed ultimately a fantastic stage setting for his Krazy Karackters, based upon the flora and fauna of that strange region. Coconino County is the actual home of that fantastic wonder, the Grand Canyon, and the town of "Coconico" was the ultimate home of Krazy, which became a full strip and soon added a wonderful Sunday color page. Here dwelt in eternal mystery and beauty our Krazy hero; Mr. and Mrs. Ignatz Mice and their children Milton, Marshall, and Irving; Offisa Bull Pupp (himself involved in a romance with Krazy); Kristofer Kamel; Joe Bark; Mock Duck; Don Kiyote; Joe Stork; the brick dealer Kolin Kelly; Walter Cephus Austridge; and the various Kats—Krazy Katbird, Aunt Tabby, Uncle Tom, Osker Wildcat, and plain Alec Kat.

With such a setting and such people Herriman built a bridge over which we crossed from the dull, literal glare of facts to the underlying enormity of the soul.

"The shades of night are falling," says Ignatz in a daily Krazy published a few years ago. "So they is—so they is." The Kat looks up, worried, cries "One side," and pushes Ignatz away. "One side," and he is racing forward. "I got 'em, I got 'em." Yes, they are shades, an armful of real window shades and rollers. By what magic has the artist made this simple pun into an eerie echo of the enormous, offstage mystery of the night? "That's not all you're going to get," ends Ignatz, reaching for his brick—the master's touch, never missing; for thus the Ignatz irony brings down to earth and makes tolerable Krazy's dreamy mysticism.

There are bells that can be struck in the soul, sonorous sounds, deep vibrations; instruments that if reached and sounded, shake men with joy. The privilege of playing on these instruments is denied to the matter of fact, the prosaic, the literal. You can't think your way into this music room; it is wit, imagination, genius, that is the password. They are very few, these useful men, who can reach down and set those bells ringing. Such, in *Moby Dick,* was Herman Melville; such, in "Krazy Kat," was George Herriman.

> O! carve not with thy hours my love's fair brow,
> Nor draw no lines there with thine antique pen,

wrote Shakespeare. And lovers of Krazy are perhaps glad that he was allowed to suffer no decline, that no other pen except that of the master, Herriman, ever was to touch the little potbellied cat.

Herriman died on April 25, 1944, and King Features Syndicate wisely allowed him to take his sweet little cat along to heaven. It was a unique tribute to the individual genius of a master cartoonist that the syndicate

announced no competitions would be held to select a successor. Genius of that type rarely strikes twice.

With this strip, and with the group which we have referred to as "Old Masters," the comics reached a peak of humor and fantasy which, many people feel, better realized the possibilities of this new form than ever before, or since. In a medium which owed its origin to the natural need for fun, freedom and gaiety, the minuteness of Little Jimmy, the rococo sting of the Katzenjammer Kids, the high slapstick of Spark Plug, seem natural, healthy developments in accord with the ancient need of man to find an escape from the literal pressure of facts, to use imagination, his most valuable asset. Comic strips present a perfect medium for this imaginative flight, which is naturally combined in them with humor; Yet, for a variety of reasons which we will shortly study, after this, the gaiety and freedom of the strips began to decline; the literal began to invade this carefree world.

But fashions in strips change. Like the old master painters, whose pictures hang in museums to be avidly studied by the most recent artists, these old master strips still are on view in the newspaper collections. Modern comic artists are increasingly discovering and studying these collections—and it is a wise man, among those planning to enter this business, who makes himself familiar with them, and the fun that is in them. For it may very well be that this type of comic strip is not only of yesterday, but of tomorrow.

Chapter VI

THE YEARS OF REAL SPORT

HERRIMAN's "Krazy Kat" grew out of the genial gaiety of the old color comic sections whose readers, on the whole, were the kids; but it is one of those strips which marked a period of change. For one thing it was a daily, as well as a Sunday comic; for another, "Krazy Kat" became very much appreciated by adult minds—and it is likely to be the one strip the intellectual will admire, along with *P.M.'s* "Barnaby."

Another adult tendency was well on its way by 1910. The parents of the suburban kids had been, ever since the start of the comics, sneaking furtive looks over their children's shoulders as they pawed the funny papers. The grown-ups laughed at what they saw. It was natural that, sooner or later, comics would be made to entertain them as well as the kids. This meant that a new set of strip heroes began to emerge, and these were pictures of the new readers themselves.

What hastened this development was the origin of the daily strip, which, as we saw before, began to appear steadily after 1907. Almost all of the new comics followed Bud Fisher's lead, and the regular pattern became both a Sunday page and a set of dailies, with the dailies slanted directly to interest the commuting heads of suburban families. This group of readers did not have the imaginative needs or interests of their children—what they liked was a good chuckle about characters concerned with matters in their own world of club life, poker games, golf, fishing, and the hazards of marriage.

Of course certain earlier characters, Hooligan, Alphonse and Gaston, Mutt and Jeff, were adults; but these were picturesque, imaginative people, not to be taken as portraits of the adult comic reader. The new characters were portraits. This is something new for us to consider; a pattern which is to dominate a period.

An early example of this tendency is "The Hall Room Boys," by H. A. McGill.

In 1910 we find this comic, usually of two five-column strips, alternating with "Hazel the Heartbreaker" by the same artist, in the daily pages of the New York *Evening Journal*. Social documents, these, concerned with

certain major struggles of the youth of that time: Hazel, to find a financially eligible mate, and Percy and Ferdie, hall room boarders in Mrs. Pruyn's boarding establishment, to lay the cash foundations for careers in the upper brackets.

To say that Percy and Ferdie high-light the drive of the profit motive in American life is to put it very, very lightly. Their goal, absorbing their days and dreams, is social standing. They aspire to mingle with dukes, earls and barons on an equal footing, and to be worshiped by butlers and footmen. The key to this goal, hard cash, is never lost sight of. It comes hard, since they generally toil on obscure jobs at $9.50 a week. Sometimes, though, glittering fate spins the wheel.

For example, Mr. G. Whatawad, a fellow boarder whose specialty is impressing them as they wish to impress others, tosses them a packet of defunct mining stock. Of course a white-whiskered, wide-hatted stranger overhears them talking; identifies himself as chief owner of the mine in which a new vein has been located, and buys the stock outright, for three thousand of the greenest. Then to see the boys bloom into glory! They assume the peculiar pose for which they became famous: feet at an angle of ninety degrees, torso leaning sharply forward, chest blown up like a pouter pigeon, eyebrows lifted, eyelids heavily down, eyes scornful slits, and contemptuous mouth. They are wild caricatures of social snoot, nauseating, exasperating, but telling, nevertheless.

McGill's picture of our social structure is unique in that all the actors in his drama are driven by the same fierce motives, scrambling over each other like soulless puppets, unrelieved by any touch of friendliness, humanity, or even humor. The one redeeming feature of his comic is the punishment continually meted out to the boys. They are caught in the trap of their own soullessness and, their impostures exposed, are mercilessly thrown out, stamped on, and whole-heartedly kicked by a long series of butlers, chauffeurs and doormen. The reader joins in the kicking. Perhaps this is why "The Hall Room Boys," later "Percy and Ferdie," ran for many years and will be remembered as an interesting and satirical comment on the get-rich-quick thread in our national life. But when at last these not-so-social climbers, who had occupied a color page in the New York *Herald*, sank from sight in January, 1923, there could have been few broken hearts among their readers. The boys' last adventure was the same as their first; they went out on their ear. Their thirteen-year struggle had been in vain. There was no heart in them.

"Oy vay is meer no vos izz? Foon Konneh Gobernia."

We turn to another, much more human strip; one using two of the Hall Room Boys' characteristics, money and adult leading characters,

but adding the sparkle of soul and charm to its pattern. This is Harry Hershfield's "Abie the Agent," and the gibberish is from the mouth of Abie's antithetical ancestor, Cannibal Chief Gomgatz.

Gomgatz was a character in Hershfield's original strip, "Desperate Desmond," which we find running in the New York *Journal* in 1910. It was modeled after its predecessor, "Hairbreadth Harry," by Charles W. Kahles, which began publication in 1906 in the Philadelphia *Press*. In "Desperate Desmond," Gomgatz was Desmond's man Friday. Desmond's function is shown in our illustration.

Notice that this burlesque has a genuine suspense ending; it was one of the first true comic strips to introduce this. Like "Hairbreadth Harry," it started as a take-off on melodrama, which had been carried to a lurid

© *King Features Syndicate, Inc. Reproduced by permission.*

FIGURE 18. The three last boxes of a "Desperate Desmond" strip as printed in the New York *Journal* in 1910. Desmond is not only cutting the bull loose but releasing something new into comic strip history: the continued suspense story.

extreme in the early movies. But the suspense was clearly timed, and the readers figeted on the extreme edge of their seats, worrying about Claude and the bull, forgetting that it was all a joke.

Abie's connection with Desmond is that Hershfield introduced some actual Yiddish words into Gomgatz's jargon. The *Journal's* editor, Arthur Brisbane, liking this innovation, suggested the idea of an all-Jewish strip. So was born a new feature, "Abie the Agent," syndicated by King Features.

The depth and imagination of Harry Hershfield's mind were shown in the creation that followed. Desmond had been pure melodrama, an insistence on lurid events, the characters playing set parts according to an undeviating formula: bad man, hero, heroine. Spanning the scale, Hershfield conceived a character based on drama, on the reaction to events of the fluctuating, many-sided human soul. For if one could slice from this soul a visible cross-section, surely one would find a strata of all the qualities

© King Features Syndicate, Inc. Reproduced by permission.

FIGURE 19. "Abie the Agent" for November 27, 1916, the first two boxes of Hershfield's daily strip in the New York *Evening Journal*.

known to man—meanness, warmth, fear, courage—in every individual. These strata are not fixed, and it is in the discovery of unsuspected ones that great dramatists are skilled. It is because Abie Kabibble is a true picture of this real, many-sided man, that he became one of the best-loved comic characters of our time.

Abie is a minute, roly-poly figure with striped "pents" and button eyes who moves through a complex of business and home affairs with a sustained energy all his own. His habitat is convincingly real. The offices, cottages, pavilions and "dence" halls he inhabits are all there today, in every large city; and he is there too. Of course Abie is a sharp realist. Quarreling with a waiter about a ten-cent overcharge, he says, "It ain't the principle, either; it's the ten cents." But he is wonderfully capable of other feelings: the Jewish family devotion, bursts of generosity, gaiety, anger or depression. He has masculine pride and keen interest in the events of the day. In other words he is not a puppet; he is a man.

In addition to "Krazy Kat" and "Abie," the *Journal* was developing adult comic strips in the 1910–1920 period, in still another way. Another pattern was being built, adequate to give the picture of the informal lives

of the men who were riding the dizzy peak of America's upward-zooming business. The mass production giant was on the march; again the comic mirror reflects faithfully a social phenomenon.

The *Evening Journal's* cartoonist referred to was T. E. Powers, a dry and witty worker with a peculiarly terse style. Using a single astringent outline, no embellishment or backgrounds at all, he began, somewhat stiffly at first, to comment on the lives and problems of the adult commuter. Using a panel with six or eight divisions, Powers built a convention to express the American business man and his mate.

What a mate! She was an enormous brute of a wife, modeled like a majestic ninepin. Her man was a tiny runt about three feet tall, bald and feeble, a pathetic flea. In various techniques, in their different manners, other cartoonists were developing the same picture, and soon the proud builders of the New World's civilization were on display as little, pot-bellied, henpecked mice.

Comics, vulgarly frank, generally do reflect some truth about their times. Granted this pair was distorted, it is true that the life of the American business man is not always healthy. Bending continually over his desk, he softens in mid-section; he is nervous, driven by thousands of irritating responsibilities and details. His wife, for all her family and household cares, has periods of rest and refreshing gossip. Her less nervous life seems to build her into a sturdy and lasting mountain, rather than the male, short-lived molehill. It is not an ideal nor, in many cases, truthful picture; and later we shall see a most interesting nation-wide reaction to it.

Powers's early humor was simple. "Let the Wedding Bells Ring Out," as of November 13, 1916, shows the mountain wife picking up her man with one hand and kissing him on top of his tiny head. "Good night. I want you to get up early, you're to beat the rugs."

"Not me! I'm going to sleep late in the morning." But, as he sleeps, a big female hand slips an alarm clock close to his head. So the poor creature, with sour face, ends up beating the rugs. With fifty million variations, here was the master plot of these times, perhaps of all times.

Later Powers's work developed more subtlety, but it retained its grim, ruthless satire, its hard-hitting quality, to the end.

Meanwhile in the same papers, the New York *Journal* and the *American,* another topnotcher was reflecting an even wider slice of America. This was Tad, Thomas Aloysius Dorgan, a great humorist, a name to conjure with. Tad specialized—in the old days before he took up comic art proper—in eye-filling, zany sport shots; huge, kidding or serious sport figures, all scrambled with wisecracks, funny figures, improvisations of all kinds. This man drew with power, something you can't say of many comic

artists. He must have been the editors' dream, for he worked with mastery in any and all mediums, often writing long articles to accompany his drawing.

With the strong stomach of the sport-page worker, Tad looked directly into the dark waters that lie under politeness, and often speared a paradox of American living or politics fair and square upon his 290-pen. He was no stranger to corruption, to the gap between pompous convention and hard reality. One of his comic features was a world of dog-headed men, the hero a little Judge with soft white hair and a down-to-earth soul. How human, how corrupt he is, preaching the law in one box, violating it in the next. While Lincoln Steffens was busy "muckraking" American cities, Tad was also suggesting the process of the humanizing of the law. A car whizzes past a dog-cop as he helplessly says "Phew!" and the passing Judge gives him an angry, questioning look.

"No, I didn't get the number of the car, Judge, it got by me too fast."

"You're not blind, are you?"

"No, sir, I'll say that the Jane driving was some sweet patootie though."

"Wasn't she!" grins the Judge, as he pats the smiling cop on the shoulder.

Tad could pin up a good old gag in his corner.

"I want a dee-vorce," rages a dog-man, as the Judge says from his little box, "Try a nose dive."

"And I want it im-med-iately!"

"Steady," advises his dog honor.

"My wife hasn't spoken to me in a month."

"Clam yourself, clam yourself," smiles the Judge, "I would speak with thee. Listen to me. Don't tell everybody about her; you'll never get a wiff like that again." And the infinite wisdom of this obviously makes an impression on the husband.

From his feature "Indoor Sports," which usually ran side by side with the Judge, Tad was fitting himself into the T. E. Powers pattern, enriching it with his more elaborate and capable drawing. A school of workers in this pattern was emerging and soon it would become difficult to tell them apart. Jean Knott's panel of club life, "Penny Ante," running in the *American,* was another of this type. Tad's top achievement in true comic strips was his fine full page in color in the Sunday *Journal,* "For Better or Worse," which we find in 1923. This has the usual, feeble, moronic husband, but its gratifying feature is that the lady is even dumber and less managerial than Webster, her blundering mate. After the big, driving, aggressive and successful females of the other contemporary strips, this researcher fell around Lil's neck, and Heaven knows, she's no beauty.

Of course we haven't yet mentioned the two great names in this particular field. Everyone knows them, for they rode the crest of the great suburban comic-reading wave we have seen developing; they summed the flavor of a happy, prosperous period, and it gives us a nostalgic twinge as we set down their names: Clare Briggs, H. T. Webster.

In 1885 a ten-year-old boy was delivering papers in the small town of Reedsburg, Wisconsin. Every Saturday night this boy got a "grand and glorious feelin'," because on that night he was paid for his week's work forty cents. "Skin-nay," as his companions called him in the raw, tuneless shout of boyhood, was already a part of the great newspaper world.

In winter "Skinnay" went "belly-whoppers" down perilously steep hills and ran the risk of death by collision with the hooves of the great gray horses who drew the coal truck on the street which crossed the bottom of the hill. In the summer he was a frequenter of the old swimming hole, the soft water his only bathing suit, the mud oozing between his toes when he got out perhaps to find his overalls maliciously hidden. A dog of uncertain pedigree followed wherever his master might lead him.

The summer and vacation ended, the bleak perspective of school lay heavily ahead while the sun was still bright outside the school windows. But "Skinnay" was not the dullest scholar in the class by any means, and he kept his job while others played ball in the lot. He was a newspaper man; these were the "days of real sport."

When he was fourteen he had to begin life all over again, for his father moved to Lincoln, Nebraska. But after all the boy found it was still the same world. There, too, he found "real folks at home." He lived in a slightly more pretentious house now. One bleak November night, when the rain sounded like the contents of a broken bean bag hurled maliciously against a window and the wind made a shrieking noise like a revengeful ghost, "Skinnay" lay in bed, miserable. His mother had made a rule: No dogs in the house. The picture of his faithful pup whining against the fast-closed door, cold and shivering all night in helpless, pathetic neglect, kept him awake. Were he not a man he might have supposed that those were tears which had wet his pillow.

"Ma," he called, breaking the night stillness, "can't I let Spot in—just in the kitchen, Ma?"

"No," came the sharp answer. "Now go right to sleep, Clare."

It was one of those times "when a feller needs a friend."

Later the youth attended the University of Nebraska and was instructed in mathematics by the young West Pointer, John J. Pershing. When he left, it was not too easy to live on the six dollars a week he made typing. This grown boy was always drawing pictures, always playing with

That Guiltiest Feeling - - - - - - - - - - - - - By BRIGGS

GOING TO THE GOLF LINKS - THE NINETEENTH HOLE AND EVERYTHING ON SUNDAY MORNING.

© *Mrs. Ruth Owen Briggs. Reproduced by permission.*

FIGURE 20. On December 14, 1918, this panel appeared in the pages of the New York *Tribune*.

pen and pencil. And then a miracle! A few of these sketches, with good ideas attached, were accepted and *published* by the *Western Penman*. For the first time the young man saw his name in print, "Clare A. Briggs."

It was 1896 and Briggs was twenty-one. Boldly, with next to no cash, he moved to St. Louis. In those days only the biggest New York papers could afford to use half-tone; others used direct line cuts made from pen sketches. It was as a sketch-artist that Clare Briggs sold himself to the St. Louis *Democrat*. He was now, he pinched himself to remember, in a big city and he had a newspaper job! It was once again the "grand and glorious feelin'." Later and for more money, he changed jobs and worked happily on the St. Louis *Cyclone*. But all was not as well as it seemed. The half-tone process was being used now throughout the country, and the sketch-artist was no longer in demand. His job folded. After the small sum of his savings was spent, he knew that "guiltiest feelin'," when he had to satisfy his landlady with subterfuge, not cash.

The young Westerner decided that he might just as well starve in New York as starve in St. Louis. Of course he did not really believe, as the whistle of the fateful eastbound express blew, that he *would* starve in the Big City. But he did, or very nearly.

In such a city, he thought to himself, there must be some kind of job for everybody. Not, of course, a job sketching for a big newspaper, but some sort of job somewhere for a young man who would do anything—a young man who had to eat!

This theory seemed, partially, to work; Briggs found himself employed by a sign-painter. He got out a ruler, began making guide lines for the lettering.

His employer turned an ugly shade of red.

"Why, you so and so," he raged, "you have the face to come and ask me for a job, and you even get me to hire you, and you have no eye for lettering! You have to use guide lines! Guide lines, and I thought you said you was an artist! In my profession we are all artists. No self-respecting sign-painter would be seen shot beside an assistant who had to use guide lines."

"And so on far into the night."

Then another job hardly more durable than the last: this one was with a cataloguing house. The artist was employed to draw endless numbers of men's suits. He lost the job. Another artist had come along, a better artist than Clare Briggs—or so thought the boss—but the deciding factor was not an artistic one. This other artist would do the two weeks' super-exacting work for six dollars!

"Wonder what a fired artist thinks about?"

It turned out that this one was thinking of getting married. Somehow he returned to St. Louis and there he was married to Ruth Owen. "Mr. and Mrs." Briggs returned directly to New York after the ceremony. A handwriting expert, Dr. Kinsley, had faith in Clare Briggs and sent him with a warm letter to the art editor of the New York *Journal*, his personal friend.

Briggs was sent to make courtroom sketches of a big murder case, then the center of public attention. He well realized the vast importance to himself and to Ruth of those moments in the grim courtroom. He must, he knew, do the very best work he could do. Even his best might well not be good enough. That had happened before, too. But he got deeply interested. He forgot all theories, forgot to draw well. He just *drew*, absorbed in what he saw. Before he knew it the time was up, the judge suddenly adjourned the court, and he was left with the sketches he had made. There was no time to improve them, to make others. He was due

back in the *Journal* offices; the minute had almost come when he must show them to that editor.

Slowly the editor's cigar rolled, tilted up. "You're no sketch artist!" The words shattered the young man standing before him. *"You're no sketch artist,"* he repeated. "You're a *cartoonist!"*

And what a moment that was! "Oh, man!"

The sketches were run off big; a half-page was given to them. The career of Clare Briggs had started. He stayed with the New York *Journal* only to leave it for a bigger job on Hearst's Chicago *American and Examiner.*

Clare Briggs spent seven productive and well-paid years in Chicago on the *American and Examiner.* He left the paper to work for the Chicago *Tribune,* and from that paper, in 1917, he came to his final and greatest job on the New York *Tribune.* For sixteen years, until his untimely death in 1929 when he was only fifty-four, he worked for the *Tribune,* happy in his inspiration and in his editorship.

It was the "grand and glorious feelin'" again; even "Skinnay's" daydreams, back in the ol' swimmin' hole days, were barefoot beside it. And in this period of achievement Briggs set a pace and a goal for comic art.

Of course the panel form, used with the very famous titles we have suggested the possible derivation of, is not literally a comic strip—but many of these panels were subdivided into a series of pictures, and it was only a little while later that Briggs invaded the actual strip field with that classic of classic plots, in which a woman misunderstands a man and vice versa, "Mr. and Mrs." We may misunderstand our mates, but we don't misunderstand this strip: it's life—and like life, it's gone on to this day; like life, it will probably keep going on.

Briggs's work was not completely original; indeed it was the Chicago cartoonist John T. McCutcheon who brought the ol'-swimmin'-hole kind of kid into newspaper cartoons, and Briggs gave him credit for much inspiration and advice. But Briggs broke rules and made new ones. He was able to be himself; he was able to uncover and express in words the real secret of success in this field, to tell young cartoonists that they should draw what is in their hearts to draw.

Briggs's drawing was simple, scratchy, and without pretense. He defined its function exactly when he said his drawing made a clear diagram of his idea. It's the idea that gets you: the hominess, the truth of it, the insight, the looking into so many tiny dramas, hopes, and frustrations, which no one else ever bothered with and which are utterly real. In one of his panels we see a whitewing sweeping the streets; there is another whitewing in the distance. The smug first one is thinking that Joe over there isn't so bad at

straight sweeping. Of course, he wouldn't be much good around telephone poles!

Clare Briggs was awfully good around the telephone poles.

The voice of Clare Briggs is still, but his influence lives, as well as the famous comic "Mr. and Mrs.," still flourishing for New Yorkers in the *Tribune*. The daily strip has been carried on by Arthur H. Folwell, author, and artist Ellison Hoover, a very good friend of Briggs. Joe looks as if he had smoked too many cigars, indeed his head somehow reminds one of a stale cigar butt, and the famous marital spats have been lengthened out to a point when one longs for some kind of relief, a baby, a pet monkey, anything—but the job is still based on the eternal rock of human interest, still holds its millions. It looks a little odd, contrasted with the smooth, sleek illustrations

© *The New York "Tribune," Inc. Reproduced by permission.*

FIGURE 21. This is the first picture of a recent Sunday "Mr. and Mrs.—" page. It is typical of many strips based on the give and take of marriage, in which it seems one must take a lot in order to give.

of most of the other strips; out of date—yet homy. It carries you back to those years when the make of your icebox was the most important thing in the world.

"Nay, let me tell you there be many that have forty times our estates, that would give the greatest part of it to be healthful and cheerful like us; who with the expense of a little money, have eat and drink, and laught, and angled, and sung, and laught, and angled again . . ."

This is from the dreamy pages of Izaak Walton's *The Compleat Angler*, and is written of Englishmen, but it closely parallels the ideal of rods, reels, close harmony, golf, good liquor, and plenty of poker held by great masses of American middle-class men as an escape from their business lives. Old Izaak had been a business man too, with an office on the north side of Fleet Street, London. It would not be difficult to translate this quiet figure, angling on some polished water, to that of an American commuter on a happy day

off; and this commuter could easily be "The Man in the Brown Derby," H. T. Webster's old classic of suburban life.

Webster in the *World*, Tad in the *Journal* and the *American*, Clare Briggs in the *Tribune*: these were the big three among the comic portraitists of the New York suburban family during the 1920's.

"Webby" had to struggle in his younger days. He began by working in a brickyard and peddling newspapers. He also drove a grocery wagon, and himself, hard, at his ambition of becoming a cartoonist. As a result, he saved $150 and began art study in Chicago. This young man was impatient for action and he got it.

"I spent twenty days," he wrote this writer, "at Frank Holme's School of Illustration, Chicago (not the Institute), then got a job on the Denver *Republican*, moving a few days later to the *Post* where I was paid for my services. The succeeding hops were to the Chicago *Daily News*, Chicago *Inter-Ocean*, Cincinnati *Post*, New York *Globe*, New York *Tribune*, New York *World*, and finally the *Herald Tribune*."

"The Man in the Brown Derby," Webster's first real comic strip, first appeared in the color pages of the New York *World* on October 14, 1923. Under the derby is Egbert Smear, an attractive little man with a thin neck and white mustache. He is neither gorilla nor mouse. He can play poker or get "tight" on equal terms with any man on earth. Intensely democratic at heart, he can become suffused with ardent ambitions. If these never meet with outstanding reward, neither do those of most of us. Meanwhile, Egbert and his wife squeeze a lot of happiness from their little lives. Their joys, his fishing and poker, her house and family preoccupations, are not to be lightly valued these hard modern days. Further, the relationship between these two is gentler, more understanding than Briggs's rival pair, "Mr. and Mrs." One does not miss that vindictive wrangling.

In a typical page, Egbert, reading a book on will-power in the glow of his warm little home, conceives that all a man has to do is assert himself and the world is his oyster. This is an old story to Mrs. Smear, evidently, but she enjoys it. "Oh, you vicious, bloodthirsty boy! Now run along before you're late for work."

Similar understanding greets Egbert's Napoleonism when he tries it out on the office staff. "You look so f-funny, Egbert; gosh, but you're comical," grins the office-boy.

Secretary: "Egbert, I always said you was a born comedian."

Unappreciated, Egbert crashes the boss's office, puts on a show and actually demands more money. Even the big, fat, formidable boss seems delighted.

"Egbert, did you hear the one about the dwarf who drank a cup of

strong coffee before boarding a train? Haw-haw! It's a pip—lissen—Th' next morning two salesmen were talking an' one of 'em says, 'How'd ja sleep last night?' 'Rotten,' says the other. 'There was a midget pacing up and down over my head all night long!' " And Egbert's afflatus escapes with his forced laughter.

But the man under the derby need not be pitied, he has his very good times. He struggles with and vanquishes the mechanical mysteries of his early radio with the huge horn loud-speaker, only to be ill rewarded with a forty-minute chat on women's fashions. Fishing days dot his life with joyous idleness; he has all the poker and golf he can escape from his wife to play. Since this is never enough, his appetite for such joys is perpetual.

Then there is the straight stuff of behind-scenes marriage, such as:

Wife says going to party, must dress for dinner.

Husband: "Who, me?"

Husband struggles with boiled shirt, cursing it out. "When the ancients wanted to torture a man they put him into a kind of cider press called an iron maiden an' twisted a lot of screws until his bones cracked. They had a little compassion in the good old days."

Husband, however, sees self in mirror, is impressed, frankly delighted.

"Oh, Egbert! Mrs. Chase just phoned and said Joe wasn't going to dress. You'd better put on your navy-blue suit."

Egbert's blossoming ego withers slowly. "I don't think I'll bother to change. It's too much trouble; if th' other boys don't know enough to dress properly that's *their* funeral."

Many people feel that the cream of Webster's work is the long series of panels which ran for many years in the *World*, and later carried on the Briggs tradition in the *Tribune*, where they will be found, still human, funny, and very well drawn, today.

The very titles are part of American living. Who doesn't know "The Thrill That Comes Once in a Lifetime?" A prize "Thrill" is just a picture of a happy boy leaning against a billboard with the caption: "School has closed, the water is warm enough for swimming, the fish are biting, the circus is coming to town, the baseball team has elected him pitcher, and the only girl has written a note baring her very soul." No, that could never happen again!

Other famous titles were: "The Events Leading Up to the Tragedy," "They'll Do It Every Time," "The Boy Who Made Good," and "How to Torture Your Wife."

If you want to know one of Webster's recipes for this last: Box one: "Now, Oswald, for heaven's sake, *please* hang up your clothes when you

© *The New York "Tribune,"* Inc. Reproduced by permission.

FIGURE 22. The terse but telling title of this Webster panel is "Bridge." The panel ran July 27, 1945.

change for dinner tonight. Here are some hangers. Please put your shoes in the closet, too."

Box two: She comes into his empty room to check. He just hasn't done anything about it. Clothes are everywhere, on bedposts and floor. Shoes are lying around.

Simple and effective, isn't it?

Still another famous title of old *World* days was destined to outshine them all, to gain individual status as a great American strip.

This was "The Timid Soul," whose modest star, Caspar Milquetoast,

shrank in the old *World* as he shrinks in the *Tribune* today. He evolved from Egbert Smear, the Man in the Brown Derby, but he is a degenerate descendant of that worthy. Egbert's chin was small, but firm; Milquetoast's has gone with the cringing years. The white mustache remains, but the hard brown derby has been replaced with a silly little bonnet. Caspar is the logical reductio ad absurdum of the whole generation of feeble, wife-bitten, flaccid American strip-husbands. Ironically, he is a howling success.

Why?

Before answering, let's have some Milquetoast.

He-man friend: "An' I says to the wife, list'n! No fash'n'ble resort for *me!* We're goin' where I c'n catch *fish!*"

"I'd rather fish than eat," says the Timid Soul.

Another he-man friend: "Well, my missus says, 'I s'pose it's useless trying to get you to spend your vacation at th' seashore.' An' I says, 'Kid, you're one hundred per cent correct, we're goin' fishing!'"

"Great! I'm a fish-hound myself," says the Timid Soul.

Still another: "My wife used to try to get me to go to some jazzy hotel for our vacation. She knows better now. We go where there's fish or we don't go at all."

"Nothing like a little fishing when you're run down," says the Timid Soul.

Same he-man, suddenly: "By the way, where are *you* going to fish this summer?"

Says the Timid Soul: "We haven't quite made up our mind. You see, I find th' sea air rather beneficial an' I may decide to go to some hotel where there's good bathing and dancing. Th' missus likes to dance an'—well, you know how it is!"

This is an early Timid Soul panel from the *World* of June, 1925. With Caspar's emergence, by himself, in a shuddering *Tribune* color page, a new era in timidity dawns over comic art. Never before or since was such a figure conceived. In the memory of man, who is like him?

He inherits a farm. Arriving there, he finds the gate barred, with an old sign that says, "No trespassing." "Well, I guess there's nothing I can do about it," he whimpers, turning home.

He starts out for a walk, on a fine day. His wife calls him back, makes him put on first an overcoat, then a muffler, then galoshes; then he has to take an umbrella. "It *might* rain," she explains. "Hm! She's right; it *might* rain," poor Caspar realizes helplessly. "And what's the use of walking in the rain?" as he goes back sadly up the stoop.

In a fishing camp, a "dumb" woman named Eleanor borrows Caspar's prized rod. She hooks a vast salmon, but—"She broke the rod! I can't look!"

Eleanor, handing him the remains: "I had such a good catch, and I would have caught a big fish if the pole had been any good."

"Er—uh—yes, I'm sorry. It was just a cheap $75 rod. You broke *both* tips? Oh, well, I was only up here for five more days anyway."

The success of this exasperating mealy-mouth is astonishing. Granted that the strip is cleverly built, that it has a head of humor going; but the character of Caspar Milquetoast is so sickening that many of his fans wonder why they go on reading it. It's funny, of course, but there's another reason, if we are honest with ourselves.

Most of us have a Milquetoast streak. We are too lazy to face difficult, biting issues; we excuse ourselves by thinking we are good-natured. Our soft,

© *The New York "Tribune," Inc. Reproduced by permission.*

FIGURE 23. "The Timid Soul." Two boxes from a Sunday page in the recent life of Caspar Milquetoast. A man was pasting billboards on *his* fence. So he ought to paste the man. But—

well-fed bodies shrink before a zero wind; we retreat to an overstuffed chair and fight the storm via an adventure book. Such weaknesses link us at once to Caspar; through these he catches our attention. Then by a clever convention, he hands us a sudden backhanded compliment.

This convention is simply that he acts with a timidity far in excess of that of the average man. *We* would not be as puling as that, we think, and we are quite right. In this realization, we glow with a happy, suddenly inflated ego. We are quite pleased with ourselves after a Timid Soul reading, and look forward to an equal glow tomorrow and next Sunday.

One wonders, however, whether this process will go on eternally. The world around Caspar Milquetoast has changed so much recently. If he could be said to be, though extreme, an American symbol, he would have sons, also American symbols. These sons would be Milquetoasts in name only. One, perhaps, has seen hard fighting in Germany; he is not going to give up

looking at the news because an advertisement says, "Read every word of this!" Another was at Iwo Jima: you cannot expect him to stand waiting in the rain for two hours for a man who wants to borrow a hundred dollars. Father Milquetoast has pure white hair. Perhaps that too has a symbolic meaning. He was one of a past generation, he does not express the toughened American of this New World.

Looking back, we see that the main period of Briggs's creative work, lying between 1917 and 1930, fell in the cream of the crop years. The First World War was over and the depression was yet to come. This, too, was the time when Webster built his little daily bridge into the American consciousness. These two men expressed and summed up a period of American modes and manners. It was a good period, the years of real sport.

Chapter VII

EVERY MAN'S ART

COINCIDENT with the paradisical period, technical events occurred in the strip-marketing world which suddenly removed the little boxes from the exclusive possession of big-city readers and made them every man's art in a literal, national sense. Syndication arrived.

A feature syndicate is simply a company, or special section of a newspaper or group of newspapers, which undertakes the producing, printing and distributing of a group of features, such as comic strips, sports and editorial cartoons, news photos, and various types of specialized news writing. Syndication made historic changes in the strips. No longer were city matters of importance. A strip artist whose work was appearing simultaneously in, say three hundred papers throughout the country, had to offer matters of national interest, and to avoid racial stands or political matters.

The first big syndicates appeared about the time of the birth of the epochal New York *Daily News*.

Both of these developments are historic, from the comic strip point of view. If syndication gave strips a national character, the *News* offered a medium, a picture-paper, which was precisely made for the new form. This paper contributed greatly to the reading of comic strips because of the extraordinarily successful group of strips which it and the Chicago *Tribune* developed and distributed. We shall devote this chapter to the original group of *News* strips; others, added later, emphasized new tendencies and will be fitted into our historical picture as it develops.

The first experiment in tabloid born in the twentieth century was, surprisingly, not the *News*, but the New York *World*. The Englishman, Alfred Harmsworth, later Lord Northcliffe, had in December, 1900, crossed the ocean with Joseph Pulitzer, the *World's* owner. Pulitzer handed over his paper, for one day, to Harmsworth to publish in any way he chose. So the *World*, of January 1, 1901, appears in a startling format, half the size of the customary page.

"It's a tabloid newspaper," said Harmsworth, "and it will be the newspaper of the twentieth century." These prophetic words were lost, however,

on even as brilliant an innovator as Pulitzer. Back went the *World* to its customary form next day, and the tabloid idea in America lay dormant until the days of World War I.

"Somewhere in France" two cousins, Captain Joseph Medill Patterson and Colonel Robert Rutherford McCormick, who had jointly been publishing the Chicago *Tribune* since 1914, had a historic "powwow" about newspaper ideas. The Captain mentioned that Northcliffe's tabloid *Daily Mirror* in England was selling 1,000,000 copies a day. The cousins shook on it. As soon as peace was declared they would start such a paper in New York.

So originated on June 16, 1919, the *Illustrated Daily News*, a title which, as too English, was almost at once clipped to the *Daily News*. It was a picture paper, and it was a perfect setting for the newly developed art of the comic strip. The first issue shows but a single strip, "The Gumps." It was the almost instant popularity of this famous strip that directly brought national syndication into being. Midwestern and other papers began writing to the Chicago *Tribune*, which also published "The Gumps," requesting to be allowed to use the new comic, and the result was that the heads of the two papers collaborated and founded the Chicago *Tribune–* New York *News* Syndicate, which soon was distributing *Tribune-News* features to every nook and cranny of the country.

Of the two men responsible for these developments, Colonel McCormick and Captain Patterson, it was the Captain who was mainly responsible for the origin and rise to fame of this group of strips. A captain, indeed, of his paper, the *Daily News,* he was also the pilot; he chose artists and developed ideas to please himself. His astuteness and folk-sense were demonstrated in the lasting quality of the strips he chose for his tabloid. In 1924, we will find appearing in the *Daily News*: "The Gumps," "Harold Teen," "Smitty," "Winnie Winkle," "Moon Mullins," and "Orphan Annie"; and all these strips are vitally alive today.

This is a remarkable record. It was possible because Patterson dug down to the simplest, rock-bottom instincts of the masses, and built a strip upon each one. His six basic strips are easy to analyze in this respect: "The Gumps," gossip, realistic family life; "Harold Teen," youth; "Smitty," cute-kid stuff; "Winnie Winkle," girls; "Moon Mullins," burly laughter; and "Orphan Annie," sentiment. Other strips, added later, also represent distinct facets of human interest, as: "Dick Tracy," adventure and the fascination of the morbid and criminal; "Terry," adventure of the most up-to-date, sophisticated type; "Smilin' Jack," flying and sex; "Gasoline Alley," hardly a facet, life itself.

It will be noticed that the element of imagination is small in this roster.

© The Chicago "Tribune"—New York "News" Syndicate, Inc. By permission.

FIGURE 24. Below: Annie as she appeared in the first two boxes of a daily strip of October 1, 1926. Above: Tik Tok, the comic artist, and the last two boxes of the daily strip of April 5, 1947.

True, "Smoky Stover" is as wild a comic as ever tried to burst from its box frames, but it appears only in the Sunday edition, and it relies more heavily on its enormous crop of puns, than on the kind of imaginativeness which we found in the old masters. The truth seems to be that Captain Patterson was most interested in a literal, down-to-facts quality. Here he was quite different from William Randolph Hearst, the other discoverer of top comics, whose tastes include gaiety, the quality of imagination, and lightness of touch.

But Captain Patterson amply proved that he knew people. Take, as an example, that strip so widely read by the home folks, "Orphan Annie." Annie has no home. That's just it. The fans provide a home for her in their

hearts. Indeed, so widely has this little woman been loved that in recent years certain liberties have been taken with the original theme.

Lately the child has assumed a managerial quality. It is difficult to imagine this astute little female in the true orphan role, pressing her nose against the pane as she wistfully ogles the yellow warmth of some happy home, while driving snow piles high on the little black shawl which she draws about her shivering body.

But in the old days it was far different. Then she was a tiny thing with a pathetic, wispy hair-do. A doll named Emily Marie, her dog Sandy, and millions of readers aflame with protective ardor, were her only friends. She was very appealing. Yet even in those days a certain sharp realism of outlook was developing. On January 24, 1925, she confides to her doll Emily Marie: "I'm not even adopted. I'm just borrowed to work here, Emily Marie. And Miss Asthma is getting paid for taking care of me just the same, and keeping the money for herself." Yes, Annie is skillful at it. She gathers the heart strings carefully in both hands, and then *yanks!*

Annie is surrounded by a peculiarly sinister but fascinating world, the threatening tone of which is sustained by a unique technical device invented by her creator, Harold Gray.

This trick consists of drawing the eyes of all the characters as ovals (until the summer of 1947, when a tiny iris was added, perfectly blank). Result: the reader, taking his cue from the plot, the character's gesture, or the expression of the mouth, supplies the eye-meaning for himself, and this meaning is clearer and more forceful than if the eye details were completely drawn. It is the method of the French cartoonist, Honoré Daumier, who often drew a face in a white blur, but with such skillful accents and surroundings that the meaning is marvelously clear. One recalls too, what a powerful feeling is created in Herriman's "Family Upstairs," because this family never appears, is only known by its eerie manifestations, and has, because of this very off-stage existence, a gripping reality. Here is something for students of the strips to study carefully. Restraint, suggestion: these are particular tools of the comic cartoonist, the essence of whose job is to do much with little.

Annie lives, as a rule, in a world of men, a clever device, focusing attention on her femininity. The enormous height of these friends or foes is another device. It makes Annie petite; it means that however capable she may have become, the world is against her physically.

There is very little action. The figures stand portentously tall, occasionally lifting a big heavy hand. Here again, there is restraint. Perhaps it is because these big fellows rarely go into action that the reader believes the more in their ability to do so. There is an overtone, an atmosphere about the strip. Despite lack of action, it is one of the most gripping of them all.

Annie, aided by her huge wonderful dog Sandy, is a bubbling well of courage, determination, and common sense. A hard life has given her a great soul, and she is one of the most effective of strip characters. Recently she has been forced to play a new role which poses new questions as to the position of the strip in society.

Annie's early friend and protector was named, with the harsh frankness of the strips, "Daddy Warbucks," which meant that a war profiteer was elevated to a hero's role. There had been a certain preoccupation with money and business in the strip, but readers did not particularly notice it until recently, when it became evident that Annie's creator, Republican and conservative to his toenails, was, through the medium of the strip, after that man that lived in the White House, and his measures. It's not difficult to understand the feeling of a politically biased strip artist. Here he is with a huge daily audience (Gray's was about 16,000,000). He's burning with a desire to "plug" his side to this audience. Yet the not-so-unwritten law of the syndicates is (since their features appear in papers of different political complexions) to keep off politics entirely. The unfortunate, politically minded strip artist finds that he is a big fierce lion without any teeth.

Harold Gray broke the pattern. When he took the bit in his teeth and began to dig at gas rationing, he was setting a precedent. But there were sharp, immediate repercussions. An important paper, looking at advance continuity, dropped "Orphan Annie"; Gray's syndicate immediately "killed" the offending strips, and Gray went back to his knitting again.

But Gray's Republicanism, if subdued, has reappeared from time to time. Annie is a great and warm strip character. As colonel of her Junior Commandos she plugged the war, hard, in her capable way; political sniping was a disappointment to at least some of her followers. Of course it's a free country and Harold Gray is entitled to his own views. What concerns us here is the interesting possibility of a new trend in comic strips. The Liberals have their "Joe Palooka," and the Communists their "Lefty Louie" in the *Daily Worker*. Others with definite political slants may appear and a relaxation of the most classic of strip taboos is possible.

There have been many strips on the West, but few which to the Easterner conveyed the sense of a totally different and romantic country, a country where the ground, the rocks, the plants have a fascinating newness. Such a strip was Swinnerton's "Little Jimmy" and "Rocky Mason," and such a strip is "Little Joe," by Leffingwell, a Sunday opus which is seen, in the East, sporadically in the *News*. Westerners, too, seem to agree to the veracity of this overtone. Stylistically, "Little Joe" is a close approximation of Gray's "Orphan Annie," and we will find more than a superficial resemblance when we examine them closely.

Little Joe is a small attractive redhead, whose huge ten-gallon hat shadows an appealing and normal personality. A page from the very early days in March, 1934, shows Joe walking on the roof tree of his ranch house home, while his mother worries at his danger. She suggests a ride down the canyon to pick up the mail, an occupation in which there could hardly be any risk. But Joe thinks that there is no reason why he shouldn't ride for the mail by way of Break Neck Gulch. He succeeds in finding such hair-raising entertainment on the narrow pass, with its straight drop of thousands of feet, that the reader completely forgets that this is only a little pen-and-ink figure. Little Joe is last seen hanging far out over the chasm, while he calmly cinches up his saddle. At the same time his mother is happily congratulating herself that her son, at least for the moment, can have invented no new ways of risking his neck.

Another fascinating character in "Little Joe" is that of the old-time sheriff, Utah; he and Joe go through many a desperate gun-fight side by side. In later years the strip exhibits a strong preoccupation with fights and blood, with violent and sudden death. The Liberals regret "Little Joe's" tendency to follow "Orphan Annie" by entering the political field on the side of the right. Sometimes this takes the form of wild pokes at the old New Deal, but on May 20, 1945, an example appears in the *News*, the following fragment of which seems aimed at the left generally. "Don't Picket Up" is the subtitle of this little piece, which shows a city boy, named Hoiman, visiting Joe on his ranch. "Hey, what's this thing?" says Hoiman in one part of the page. "A big woim that makes a funny noise."

"That's a *rattlesnake*," cries Little Joe. "Look out, it'll *strike!*"

Hoiman: "Chee, have they got a union too, way out here?"

One forgets controversial considerations when one turns to Berndt's cheerful "Smitty," also appearing in the New York *Daily News*. It's a chipper job, brisk, and gaily drawn. "Thmitty," as his little brother Herby calls him, is an active, energetic, likable, American office boy whose business entanglements, contrasted with his boy's nature and home life, make a good theme. Some "Smitty" fans feel that Little Herby steals the show. He is one of the most telling of strip characters. Not only is Herby all that is implied in the nickel word "cute"; the way he stands, with his minute coat blowing out in front of him, and the profound, practical wisdom he is capable of giving, as well as the warmth of his heart make him irresistible.

Smitty's creator is a big jolly man, precisely the fellow one would imagine drawing a comic strip. He's sharp and easy-going at once, and fond of funny stories. He shatters the popular idea that the professional funny-man is necessarily sour and monosyllabic, except when on the job. If Berndt hears

© *The Chicago "Tribune"—New York "News" Syndicate, Inc. By permission.*

FIGURE 25. This is Herby, in Walter Berndt's daily strip "Smitty," as of April 2, 1947. A strip that has unusual gaiety, "Smitty" can be human and poignant as well.

something that tickles him, he slaps you on the back and shouts cheerfully, "It's a gag!" Not that he needs to go around listening to them; the man has a natural well of them bubbling up somewhere inside, fifty gags to the minute. Happy Berndt!

Family life in a different strain comes into view when we take up the famous "Gumps." Perhaps there is no family better known in all America. Millions of people will be able to tell you every in-law of Andy Gump, just what happened to Uncle Bim and the widow, where Chester is this minute, and almost what Min is planning to serve for supper. There are some

12,000,000 such readers. The Gumps appear in almost every city of any pretensions in the United States.

All this despite the fact that for harsh, raw characterization of human beings, the Gumps, in their main period, have had no equal in the strip world or out of it. Min Gump is not so bad to look at, she even has a certain sweetness, although very plain; but if a man from Mars could compare the average man with Andy Gump, he would not believe that such a monstrosity could have become a great, national, picture hero. A man with no jaw at all and his mouth an obscure black hole in his neck—to look at Andy gives the reader with an eye for human form a sharp shiver. Other characters, such as the old maid Tilda, are drawn with the same remorseless sarcasm.

The drives that animate Andy and Min are equally harsh. One of the Gumps once defined the Gump creed: "Take the proud old name of Gump and nail it to the topmost rung of the social ladder with spikes of gold. Make the smart set sit up and smart. Remember you're a Gump and keep your head up like a farmer looking for rain!"

And for sharpness, sharp as Andy Gump's nose, consider this: The rich widow (out after Uncle Bim) is dandling the infant Chester and gushing to Min: "There's something in the touch of infant hands (blah blah). All the money in the world cannot buy the happiness to compare with one smile from an innocent child, etc. etc." But a box later, in a taxi, the widow soliloquizes: "That little brat, he wiped his feet all over my skirt—could have choked him—wish I had him for a few weeks—what he needs is a good spanking before and after each meal—"

"Well, what's the matter with that?" you ask. "Bet those were the widow's thoughts exactly!" Reader dear, you took the words out of our mouth. For we were just about to explain that there must be, there is, a strong reason for the popularity of this family. People are that way, and if it isn't a pretty spectacle, it's a true one. Perhaps realism like the Gumps's is particularly refreshing to Americans after the saccharine bath of sweetness and light they have to endure in advertisements and illustrations. There all young men are clean-jawed and intelligent-browed, with perfect waist line and faultless clothes. All young women are too distracting: long, willowy legs, no bosom-pads, and such eyes—! All mothers have peaceful light falling on silvery hair; all children apple-cheeks, all dads—but dad is perhaps the one exception to this rule. He can have a pot-belly and can be shown with stooped shoulders, but then he is always cheerful, he always has a paper, and he always wears slippers. No wonder a hard-pressed people, searching for something that really resembles themselves, take to the comic

strips. Nowhere else, in all the big forms of mass reading and looking and hearing matter, will this sharp reality unreel before them. Imagine, for example, the before-mentioned soliloquy appearing in one of the radio soap operas.

In the end, our criticism of the Gumps has turned into praise. Also it must be said, in fairness, that there is more to the Gumps than harshness. Chester has exciting adventures; there is occasional warmth, and the humor and dialogue are excellent.

The Gumps' papa, Sidney Smith, was an old comic hand before he made his famous creation. His first job was on the Bloomington *Sun Eye*, in 1895. Then followed a long procession of staff jobs on various papers. Smith developed into a sport cartoonist, but he had keen humor, and enjoyed embellishing his cartoons with comic figures in the new style. Landing on the Chicago *Tribune*, he became a comic artist with the feature "Old Doc Yak." Animal-men seemed to fascinate him, and in 1909 he started "Buck Nix" for the *Evening Journal,* this being one of the early daily comics. The characters are human-bodied goats with horned heads and possess a mysterious fascination; they seem alive.

The strip was doing well when along came Captain Patterson, who was brewing his *Daily News*. It was Smith's big opportunity; he grabbed it and the *Tribune–News* people had their man back again. It had cost them money, but rarely was money invested like this. Captain Patterson roughed out and even named the feature this new man was to create. This was "The Gumps."

A fortune came to Sidney Smith as the Gumps became popular, for the *News* was, and is, generous to its artists. His famous million-dollar contract, $100,000 a year for ten years, was signed in 1922, and in 1935 he signed a new five-year contract for an even higher figure, $150,000 a year. Then, to this darling of Fortune, came strange, obliterating tragedy. Driving home after signing his new contract, he was killed in a smash-up.

The Gumps, however, lived on. Publisher Patterson held a contest of artists to decide Smith's successor, and the hard-working, intelligent *News* sport cartoonist, Gus Edson, came off with the plum. Edson started with a close imitation of "Gumping"; recently, however, the famous style has received a strong infusion of the current "Smart Set" approach, and we find "gammy" gals and buxom blondes rubbing their soft selves against the harsh realities of the old technique. It would be a shame, many of us feel, if one of our last standbys of reality were to go soft on us.

So the Gumps' verisimilitude cancels their ugliness, but this is not the reason why another strip in the *News* roster, "Moon Mullins," gets along so nicely. "Moon" is a gritty-looking strip in which most of the characters

© *The Chicago "Tribune"—New York "News" Syndicate, Inc. By permission.*

FIGURE 26. Above: a fragment from a "Gumps" daily strip, May 23, 1922, as drawn by Sidney Smith. Below: the first two boxes of Gus Edson's continuation of the "Gumps," from his daily strip of April 5, 1947.

seem to need either a shave or a kick in the pants. The theme, being high-life tumbled down into very low-life, seems to leave out the average reader; but perhaps this is really the basic strength of the strip, for the readers feel superior in some way to every one of the actors in the little tenement drama, and this gives the readers a glow. "Moon" is exceedingly well drawn, with a burly simplicity and a forceful spotting which recall the work of the older strip masters. Like the earlier strips it exists for the most vital of reasons: the gag.

89

FIGURE 27. Willard's specialty, in "Moon Mullins," is a gag complete in itself. This daily strip ran on March 31, 1947.

Cartoonist Willard is a true gagster, a craftsman of the humor business. Take the way he handled the dizzy first days of spring in 1947. Half of first box: two little love birds, heads together, a single heart dancing above. Next half: rear view of Kayo, hand in hand with an ounce-sized lady love, two little hearts dancing above them. Second box: gooey-eyed Moon with gooey-eyed girl—big, almost bursting hearts this time. Third box: the fat little man with the checked pants is sprawled in snoring sleep over the sunny back yard, the rough and angry head of his woman peering down from above. Last box: same little man, inside, sweat drops spraying out as he grinds a washing machine, a balloon filled with fury symbols above. To

one side, his rough but no longer angry wife, big legs comfortably crossed, is reading a magazine entitled *Spring Styles*. And no words are needed. There are so many of us that have to grind and drive ourselves while the birds go twit, twit.

Or take this tête-à-tête between Lord and Lady Plushbottom.

She: "Just think, Plushie, that plastic surgeon said that after he got through lifting my face I'd look like a schoolgirl—but the operation would cost $5,000."

He: "What? Why, that's robbery!"

She: "Yes, that's what I thought. Oh, dear—if there was only something less expensive I could try."

He (with that classic comic convention of walking out of the box): "You might try wearing a veil!"

The early days of the *News* were those of "The Lost Generation." It seemed that the cement which had held young people in place was cracking, the ancient taboos were gone, lost in the maelstrom of war and a disillusioning peace. Old concepts, old people, had failed; let the young take over, viva the young! So the young took over. They are well represented in Captain Patterson's strip nursery.

That all these sheiks and shebas were not irresponsible, is proved by Martin Branner's "Winnie Winkle," a capable lassie with a determination to go places, despite her very plebeian family. Although started in the early months of 1920 when flaming youth was the word, Winnie had little time for collegiate eccentricities. She had a career to carve, a mate to find, and a family to bring up. Winnie struggles for gentility, and manages to uncover a lot of humor and humanity in doing so, for "Winnie" is an engaging strip, whose characters are plain, real, and close to American life. It makes no pretensions at smartness of style, using good, old, slightly musty conventions and cross-hatchings, but it can be studied to advantage. See how the center of interest is clearly focused; how every line tells, how definite the expression of every face is. There is something homy and attractive about the way it is done.

Mike (Martin Michael) Branner, "fawthaw" of the strip, is a swell fellow, and his story is unusual and romantic.

Mike began as a "hoofer" in a vaudeville circuit. Teaming up with a Miss Fabrini, Mike fell madly in love with his partner. Almost at once eighteen-year-old Mike had a fifteen-year-old wife. The families objected; but this was a real marriage, the honest stuff for better or worse, and it was worse almost at once. The kids worked out their own act only to have the theater burn down, together with their personal possessions, costumes, clothing, and money as well.

Tough; but youth and love can lightly jump over rough spots. Living in a tiny hall bedroom, cooking on a one-lung gas ring, playing twenty shows a day in a store theater, and painting scenery, the indomitable Branner kids punched back at fate. From the not-so-distant days of high school, Mike had had cartoon ambitions. The young "hoofer" managed to squeeze in a little drawing, selling ads to *Variety*. It looked, however, as if Fate was tapping on the door with dancing shoes, for the kids made a success of their act. They were making four hundred dollars a week and were billed for a European trip, when that continent went up in smoke. "Martin and Fabrini" broke up, as Mike enlisted. After the armistice the hoofing lovers reor-

© The Chicago "Tribune"—New York "News" Syndicate, Inc. By permission.

FIGURE 28. "Winnie Winkle" is a cozy strip, but it also has punch. This represents half of the daily strip of March 31, 1947.

ganized their act, but Branner's cartooning ambitions were fermenting and in 1919 Bell Syndicate, impressed with his energy and ideas, signed him for his first strip, "Louie the Lawyer." After a short run of another strip, "Pete and Pinto," in the New York *Sun* and the New York *Herald*, Arthur Crawford, manager of the Chicago *Tribune*–New York *News* Syndicate, picked him for the New York *News* early in 1920 and his fortune was made.

And there, reader, is a perfect new theme for a unique strip: Married lovers with the dew still in their hair, tap-dancing with fate!

"Quiet, pliz!" "Le-s go, panty-waist—"
Nothing startlingly original in this, just teen-talk from "Harold Teen" which, by the time this sees print, will probably sound hopelessly musty. It's a desperate business, keeping up with the latest thing in drugstore pat-

ter, and most of us post-collegiates don't, and should never, try. Harold's creator, Carl Ed, does a remarkably able job of it, but then he is a professional, a sharp craftsman in his own line of business. It is a good business, too, because children are constantly turning teensters, and so an eternal public waits to lap up its chocolate sundaes and its "Harold Teen."

Carl Ed never misses his stride as he marches from generation to generation. He was, of course, a high school student himself. Born in 1890 in Moline, Illinois, he graduated from the same state's Augustana College, in

© *The Chicago "Tribune"—New York "News" Syndicate, Inc. By permission.*

FIGURE 29. If this talk seems a little blaah now, remember it once was th' berries. The first half of a "Harold Teen" strip of May 24, 1922.

Rock Island. He had been playing with art, and early landed on the World Color Syndicate, in St. Louis. He began a baseball strip, "Big Ben," but soon, feeling a yearning for his college town, he went back to Rock Island and got a job as reporter on the Rock Island *Argus*. Perhaps here, this Ponce de Leon found his bubbling fountain of perpetual youth in the local collegiate drugstores. Perhaps he was laying the basis, here, for "Harold Teen."

Ed, being very intelligent, soon rose, via sports editor, to city editor, satisfying his teen-age art drive by drawing another baseball strip, "Luke McGluke," in his spare time. Young comic aspirants might well notice the kind of abdominal stuffing it takes to be a success at this business. A city editor is normally an exceptionally busy man; yet here he draws a syndi-

cated comic strip as well. It is this shove and enthusiasm that gets you there.

Carl Ed was not satisfied with the "sticks." Off to Chicago he went, to become cartoonist for the Chicago *American*. Still restless, he tried the Chicago *Tribune*. Here things happened fast, for these were the early days of Captain Patterson and his New York *News*. Ed, still faithful to the youth motive, submitted a strip to be called "Seventeen." Patterson renamed it "Harold Teen" and it made its debut in February, 1919, in the *Daily News*.

Harold is an unremarkable character to look at, his chief interest being the changing picture of youth, with its clothes and evanescent shimmer of young talk.

For the record, here are some Harold teen-age dippings from other years:

1919. They're all "sheiks" bringing "peachy" boxes of chocolates to their "shebas." "Zat so, you little squirt!" "Don't rush me!" "For cryin' out loud—" Harold has narrow trousers and enormous, triangular eyes. His girl "Lillums" experiments with "Knicks." Harold specializes in a "slick pomp."

1925. Now Harold has changed to button eyes, wide trousers. "Shux!" "Hot pups!" Young men are still "sheiks," but the craze is on the way out.

1935. "Yeh, Man, he's the nertz." And this period was the "nertz," linguistically. "Shebas" are now "honey buns," "Ersters is out a sisson," and "These twits ain't gonna get my goatee, nozzir!" A "twit" is also a "twerp," or is he? There may be a fine distinction here that escapes this writer. It was a great period for Harold, "Yowsah!" His little side-kick Alec "Shadow" Smart had appeared, a toothy chipmunk with a passion for double choc'lit splits, with pecans, and go heavy on the whipped cream, pliz.

1943. *Oh*—oh, what a change! The girls' torsos, especially, have bloomed out with unexpected resources. As for the "drips" (the "sheiks" and "twirps" of yesteryear), the unfortunate drips are a greatly sobered lot, busy with the sudden enormity of their world importance. Gone is the gay glitter, for the "drip" is suddenly about to become a man.

The technique of "Harold Teen" is without grace, the drawing raw and ugly, and the plot slight. Yet the strip has drugstore truth, and fulfills a function which perhaps cannot be exactly assayed by a non-teenster.

"I was born (in the usual way) September 26, 1899, in Chicago," writes Stanley Link, who does cute, folksy "Tiny Tim," also for the New York *Daily News*. Tim is a towheaded, active, appealing kid who possesses a magic amulet by means of which he can exist in one of two standard sizes, minute and normal. Tim responds to a natural dream of boyhood, a dream in which the child sees himself scurrying into rat holes, or discovering microscopic races of people behind the sofa. Big or small, Tim gives an

impression of normalcy, which is the same impression given by Stanley Link, and no doubt is the reason that both have been successful.

Link further summarizes his life story: "Student, Chicago Academy of Fine Arts, 1914-1916; animated cartoons, 1917-1921; free-lance artist and cartoonist, Chicago, Ill., *Daily News,* 1922-1924; assistant to the late Sidney Smith, 1926-1936; originator Tiny Tim Sunday comic feature, Ching Chow, daily feature for the above syndicate. Served U. S. Navy, First War. Married; two boys, thirteen years and sixteen years, my two most ardent critics. Reside Long Beach, Indiana, where I do my work; don't play golf or any sports—just plain lazy."

Characteristically, when asked the secret of success for aspiring, young cartoonists, this "lazy" worker advises: "Draw, draw, and draw some more. This cartoon racket isn't any different from any other. Stick to it. It's the old story. Practice and hard work. Read a lot too, I may add. Simplicity, and the way you handle and present your story is the key to appeal in a strip. Personally, I like the free-and-easy style of drawing, careful–careless, if you know what I mean; although, it seems to me, the trend seems to lead toward a more mechanical style. But one shouldn't worry about the style of drawing or technique when first starting out. You'll gradually develop into a style of your own as you go on."

Now we arrive at the cream of all the *Daily News*–Patterson strips, "Gasoline Alley."

This is a quiet, faithful, tender picture of suburban America. No bluster, no lurid fuss. It has a calm pace which irritated the intense activity of Gilbert Seldes's mind, who remarked that he could never understand what the residents of Gasoline Alley were doing; he suspected them of doing nothing.

This suspicion was unfounded. Walt Wallet, Skeezix and Little Judy were growing up in the strip, an innovation in comics. They were, also, giving America, through the mirror of the comics, one of the most faithful and cheering pictures of the ordinary business family we have to show. "Gasoline Alley," because it's a strip, is free from the sickening "pollyanna" of the illustrators and advertisers; it's equally free from the cheap sensationalism of many of its fellow comics. This allows its suburbians to look through at you, without distortion for once, and it makes one feel that Abraham Lincoln was right.

Frank King, as one would expect, was born in the middle of America, in Castleton, Wisconsin. From this little town in the Kickapoo Hills, the family moved to Tomah, Wisconsin, where Frank quietly grew up, drawing naturally from the age of three. He carried this ability through grade and high school and marketed it for the first time at the annual county fair. A

sign King drew for a bootblack in the local hotel earned him an interview with a newspaper editor in Minneapolis and he was off on his career.

A few years later the pull of Chicago became irresistible. Jobs on the *American* and *Examiner* were topped by a better offer from the *Tribune,* and soon the now well broken-in King was drawing all kinds of art work, including a number of comic strips. His big job was the "Rectangle," a Sunday page of current humanisms, with subtitles such as "Pet Peeves." In 1919 we will find a little square down in one corner of this page, highlighting male chatter about the big interest of the time, automobiles. It was called "Gasoline Alley," and dealt with Walt Wallet, Doc, Avery and Bill. The story is similar to a number of other strip beginnings; the side-feature grew and stole the show.

When "Gasoline Alley" was first published in the *News* it was still a square, and appeared spasmodically, but after June 21, 1920, it became a regular cross-page strip.

The simple plot of "Gasoline Alley" is the growth of its characters. At the time of its origin it was the only strip to admit the passing of time. Walt Wallet, the original hero, was a big roly-poly bachelor, who finds on February 14, 1921, a newly-born baby left on his doorstep. Baby Skeezix grows, takes the center of the stage, passes quietly and charmingly through youth's phases, meets a girl named Nina Clock, graduates in 1939 with her from high school, engages her to become engaged (engaging idea), and one day in August, 1942, finds himself in front of a window with a sign which says: "Recruiting Office." Perhaps the text of this strip will convey the inner charm of "Gasoline Alley" as well as any other.

There's no time like the present, thinks Skeezix.

The sergeant: "Yes, you may enlist although you are already a selectee and subject to call."

Skeezix: "I would want to get into some branch where I would get special training."

"Your experience along almost any line may be valuable in the army, and special training is available if you qualify."

"My job has been along the line of mechanical research; I'd like to get into something technical where I could keep on learning."

It would hardly be possible to find a truer picture of young 1942 America, grave, sober, adjusting itself to the furies of the year with the steadiness to be proved at Salerno and Tarawa.

Millions of us, seeing our Skeezix in North Africa, with a dome helmet over his young friendly head, knew we were truly at war, and felt him a symbol of something keen, clean, and quietly determined. Earlier in this book we said that strips reflected a suburban point of view. It is interesting

FIGURE 30. This daily strip which ran April 1, 1947, illustrates the central family theme of "Gasoline Alley." To the right we have added Wallet and Bobble, and Bix; to the left, the Sarge, Chipper, Skeezix and Avery.

to notice how Skeezix passed from this narrowness. He was America itself; it didn't matter if he came from Montclair or Tucson or Yonkers. His class origins, too, ceased to matter. In a time of great crisis unity arises through the body politic. It is a wonderful thing to see. Skeezix is an American—long may he wave; he is one who makes us believe in ourselves.

Meanwhile Walt Wallet carried on for the home-folks. Happily, he fell off his bachelor perch years ago and married kindly, plump Phyllis Blossom.

The family relationships of "Gasoline Alley" have become a matter of public concern. To keep the public aware of the status quo, Frank King occasionally puts out a "key" strip, such as the following, which appeared on February 27, 1945. Uncle Walt and Aunt Phyllis are sitting before the fireplace. King's art work, never sophisticated, is still curiously capable of rendering the coziness of home life, as in this strip, in which shadows from the warm firelight focus on Walt and Phyllis as they relax in mutual content.

Walt: "Ed List at the office is thinking of adopting a child. Of course I told him to go ahead by all means."

Phyllis: "With two adopted and one of our own, we should know, Walt."

"People ask me which of our children are adopted. Even our friends forget sometimes, Phyllis. Skeezix, who was left on our doorstep twenty-four years ago, seems as much our son as Corky, who is our own flesh and blood. And Judy, who was left in our car and was known as the 'running board baby,' has been a joy ever since."

Phyllis: "It's remarkable. They all know the facts, still they feel no difference in their relationship to us, or to each other."

It's remarkable, but the public feels no difference in their relationship either. Judy romps before us in the true, unconscious charm of childhood. She is a perfectly realized figure, unaffected and sincere, with a special, joyous grace all her own. Corky, the only true Wallet, displays the same charm and simplicity as his brother and sister.

As for Skeezix, he rose in army rank in true, unspectacular manner. As staff-sergeant, he returned not so long ago from overseas duty for a stay at a Southern army base. Nearby lives his wife Nina, and we see them one cozy evening, Skeezix settled in a happy, bouncing comfort in a big chair, while Nina cuddles their baby, Chipper.

"Are you happy, Skeezix?"

Skeezix replies for millions of G.I.'s as well as himself. "I'll say! This is exactly what I've dreamed about, Nina. I'm just afraid somebody will wake me up."

With the war's end, the quiet, faithful picture goes on. Wallet and

Bobble are an unspectacular firm, but few business institutions have such a grip on the American heart.

Sound stuff, this; straight stuff, warm feelings gotten across without sobs and sugar. And the interesting part is the way the public laps it up. "Gasoline Alley," with a number of others, confirms something this writer has suspected for quite a while. Popular stuff *can* be good, if the people who do it take pains.

America need not be ashamed of its "Gasoline Alley."

Chapter VIII

FAMILY TREES

The number-one United States strip is distributed by Hearst's King Features Syndicate. We have observed before that Hearst, who, like Patterson, listens with his ear close to the ground, hears a somewhat different tune from the one the *News* publisher picked up. It is less matter-of-fact, more imaginative; Hearst again and again has discovered and encouraged the great masters of humor, lightness, gaiety. Strip number one also reveals his touch, for "Blondie," while down-to-earth and funny enough to appeal to everyone, has warmth.

"Blondie" has more, and more ardent, fans than any other strip at this writing. "Blondie" is the champion.

Murat Young, "Blondie's" boss, comes of an art-conscious family. His mother is an artist, his sister teaches art, and his brother Lyman Young is known to most of us as the creator of "Tim Tyler's Luck." In high school, Murat Young acquired a new and more usable first name. "Chic," although late in absorbing the family passion, plunged in when his friend, Edgar Martin of "Boots and Her Buddies," suggested that girls were the coming thing in the comic world. My meat, thought Chic, and landed a job with N.E.A. Service in Cleveland at $22 a week. Here, while working with a group of practical jokers in the syndicate department, Chic had a hair-raising brush with Fate. A voice from New York, over the telephone, proposed a job, at $10,000 a year, working in New York at King Features Syndicate.

Twenty-two-dollar Chic thought it was a gag typical of his fellow workers, and calmly turned it down. He liked his present job, he explained. But the memory of the call must have rankled, for a little while later he went to his boss and asked for more money with the result that he went out on his ear.

Still thinking of that gag-call, Chic hopped a train for New York. And then in the King Features office, the comic department head asked him a startling question. Why, when he had been called to King Features a few months ago, had he turned it down?

So Chic married King Features and drew happily ever after. His first ink

© *King Features Syndicate, Inc. Reproduced by permission.*

FIGURE 31. Presenting the Blondie of yesteryear. A daily strip of September 19, 1930. Dagwood was the heir to billions in those premarital days.

baby was "Beautiful Babs," followed by "Dumb Dora." Chic's keen observation, however, noticed something happening to the young She. Dora had been a true flapper, but now a new type was emerging. It was a mysterious change; suddenly, out of the hard sexless chrysalis of the "flapper," a soft, full-bodied, lovely something emerged. With a flutter of ribbons and a snapping of bursting buttons, the girls let their curves go, and all over America men grinned with relief.

As for Chic Young, he grabbed his pen and began "Blondie," from the start, the prettiest girl in the "funnies."

The Bumstead Bible's first date is September 15, 1930. On that historic day the New York *American* displays the new strip for the first time, and very engaging and capable it is. Blondie is all dewy and fresh; cute as the

devil with nice calves, nice everything, bouncing into the heart of America with long, lovely legs and as bold as brass.

Not all Blondie fans, who are used to the modest Bumsteads of today, remember that the strip took off in the atmosphere of great wealth. Strip No. 1 begins with Dagwood's father, an exceedingly sour, lozenge-eyed billionaire, sitting in a tall chair carved with a newly-won crest. "But, son, I'm awfully busy—I'm working out the plans for this new merger."

"But Pop—I want you to meet Blondie, we're engaged, you know." Dagwood is a more assured male than he is today. The famous hair antennae are not yet there, and he has more on top of the head.

He is dragging lovely, apparently unwilling Blondie in with both hands: "This is Blondie, Dad—She's awfully bashful and shy—you'll love her."

"Oh tee-hee," cries Blondie instantly. "I always feel so boo-boop-a-doop when I meet my boy friends' papas—" and springing forward with modest feminine enthusiasm: "But I usually like them better than the sons— Can I call you 'Pop,' Mr. Bumstead? Tee-hee."

Dagwood is delighted. "Come, Blondie, we must go—Dad is awfully busy—he's working out plans for his new merger."

"Oh, Pop," cries Blondie gaily, pushing that one back on his heels, "if you aren't the terror! What are you going to do with your old wife?"

"Isn't she cute, Dad?" drips Dagwood, but the question was really addressed to America. And the answer was "Yes!"

Blondie makes a furious frontal attack on the old man.

"Are you sure the reason you want to marry my son isn't that you heard I own a lot of railroads?"

"Oh, Mr. Bumstead—then I'd be a gold-digger. Really, I'm the home-girl type—I'd love Dagwood if you only owned *one* railroad."

Blondie doesn't improve her position a day later.

"I wish you could think of the college you attended so I could get it into the engagement notice for the papers," the old man growls, for he is being beaten down.

"Oh, dear, what was it? Name some colleges—is there a Yale? Yes, I do believe it was Yale!" Blondie gets out of this dangerous impasse by acting dumb (Imagine!). "Now I remember, I didn't go to college at all—I just sent for an application blank."

The plight of this modern Cinderella pulls at the heartstrings as the girl herself tugs at the eyes.

"The idea! Our son, heir to the Bumstead billions, wanting to marry this Blondie person, uh!" Thus Mama Bumstead.

Dagwood: "I wish we were just plain, poor people so I could marry the girl I love."

Pa Bumstead: "You talk like a piece of cheese."

Events pile up in a really hair-raising way about these lovers. Despite her thousand-candlewatt charm, Blondie cannot persuade the Bumsteads to give her Dagwood's hand. Billionaire Bumstead calls a meeting of the entire Bumstead clan.

"Members of the Bumstead family, the important question before us is whether we'll allow this girl to marry into our illustrious family."

And the five members of B.'s personal legal staff render a decision: "It is the opinion of the legal staff, after considering every angle of the matter, that this marriage shall NOT take place."

It is a little disappointing to find that Dagwood fails to rise to this supreme opportunity of his life. "To hell with you," he could and should have said. Perhaps he might have said it, but before he could open his mouth, Blondie, the capable one, sprang to the wheel.

"But folks, you're too late! Dagwood and I have been secretly married for six months." The entire Bumstead family, legal staff and all, collapse in a stylized faint.

Dagwood, always the stupid man: "Blondie, you know that's not true. We're not married. Why did you tell them we were?"

"I just wanted to see what they would do."

The Bumstead family spine is now cracked. "Oh well, go ahead and marry her," gives up Mrs. B.

"But you'll never get another penny from me," cuts off Mr. B., and so the track is clear for the marriage, which is recounted in retrospect in the Sunday page of February 12, 1933. Blondie looked very sweet, and Dagwood, though penniless, very happy.

The rest of the story is simple, attractive and well known. Dagwood fits naturally into an office job, Blondie into an unpretentious house. They have a thousand quarrels and triumphs along strictly normal lines. The big ripple on their married pond is the appearance of Baby Dumpling on April 15, 1934. "Chic" Young very sensibly let the baby grow up in normal fashion.

As Baby Dumpling grew, the naturalness of the strip grew also, and the reading public followed. Letters began to pour in to Chic Young telling him that Baby Dumpling was oh so cute and exactly like their own baby and could they have a signed picture. Blondie's tide was rising; Columbia Pictures signed her for the movies, the family went on the air. War, with its dislocations, proved a stimulus to the readers of "Blondie": people worshiped home life more passionately than before. "Blondie" books glutted the Five and Tens. Men craved her and women looked in their mirrors and found that they resembled her exactly.

FIGURE 32. This little tragedy, which took place April 4, 1947, clearly shows why "Blondie" holds first place in the great U. S. heart.

"Blondie's" eminence over other plot Number One strips is probably due to a few very simple factors:

1. She is prettier and cuter than other strip heroines, yet she's no sloe-eyed vixen. With all her sex, she's "good," and so are the gags.

2. Dagwood is young, which makes the whole marriage more romantic. He may be dumb, but he's a "good skate." The fact that he isn't too strong or clever makes us feel better about ourselves. If a Blondie goes for Dagwood, just think what we rate. If he were Tarzan, we'd be left out.

3. There's romance in the house. Compared with the back-biting Gumps, or eternally nagging squabbles of Mr. and Mrs. Cute, homy things happen, such as the making of enormous "icebox sandwiches," following some midnight bout with a teething baby. (They are becoming embedded in the language as "Dagwoods.")

4. The truth and brightness of the small Bumstead clan also helps, for Baby Dumpling was followed by Cookie, an equally famous toddler, and there is a hilarious dog Daisy, and a raft of hilarious pups.

5. When the boys came home and married, there were millions more Blondies and Dagwoods to experiment with the fascinations and frustrations of life in a cottage built for two or more. These are days when the young husband is apt to roll up his sleeves and help with the dishes, which is exactly what Dagwood would do, or at least what Blondie would expect him to do. This pair reflect the lives of a large group of people at the present time, which is proved by the fact that when newsprint paper was made available after the war, and new comics came into existence, it was "Blondie" which most of the newcomers tried to imitate.

Yes, it's not a bad strip to have on display as the favorite. It shows that in their hearts people enshrine sweet and normal things: youth, romance, home, and babies yelling for milk.

Fat Men, Attention! You too can be attractive. "That nice, well drawn fat man!" That's the way many people, some of them very sweet and feminine, react to the hero of "Clarence," the round, cozy epic of America's well clipped lawns and well scrubbed suburban kitchens.

Travel through the outskirts of any big city by bus and you will see little, square, well painted houses, with little round shrubs and humorously tame-looking trees. Almost all have plush green lawns. There will be boxy little garages in the back, there'll be fat little perambulators in the front. Nowadays you'll find well cared for vegetable gardens making a new pattern of the backyard. These aren't estates, but the people who own, care for, and love them are kings in their own way, and very much better off than any king ever was at any time in history. One of these cozy, comfortable kings is Clarence.

Here is plot Number One, or marriage problems, with a new twist. A married pair that never seems to bicker. A married couple who never disagree.

Prosperous and plump Clarence is watching his pert and pretty wife, Mary, packing her suitcase.

"So you're really going?"

"I must, it's been perfect ages since I've seen the folks."

"How long do you expect to be gone?"

"Oh—not more than two or three weeks."

"Gosh, I'm certainly going to miss you, Mary."

"*Nonsense!* Why, you'll have the time of your life while I'm away, I know you men."

Clarence is walking about the house disconsolately.

"Nope—It'll be mighty lonesome around here without you! The old place won't be the same. Listen, Mary, I know this may sound kind of silly to you—but, before you go, would you mind giving me a lock of your hair?"

"Why, Clarence, you sentimental old darling—I had no idea—I can snip some off where it won't show."

"Thanks a lot."

"Hadn't I better tie it up with a little ribbon?"

"What for?"

"Well, I thought perhaps you might want to carry it next to your heart—"

"Oh, no,—I just want to put a few hairs in the washbowl each morning to make me feel that you're still here."

There is something reminiscent of "Gasoline Alley" in "Clarence." After all, Uncle Walt is an attractive fat man, too. These two tummy-toters are the best advertisements for avoirdupois since Santa Claus. If it is true that laughter is fat-producing, Clarence has helped a lot of people to join him since April 6, 1924, when he started in the *Herald Tribune*. But such a long run doesn't seem to have done anything for his own waistline.

Burrowing back to December 17, 1918, we shall find in the New York *American* the beginning of two, or rather three, more famous symbols of suburbia who have had a famous career under the direction of King Features Syndicate. There is a tiny man with an egg-head and frankfurter-nose, and a young wife who closely resembles a French doll of the period. These are "Toots and Casper" of pre-Buttercup days; they seem strangely archaic, compared with our present-day couple. Casper's head has completely changed, a transformation not unusual in the strips, for a comic artist needs to try his characters out a bit before settling them down to a quarter-century run. Now Casper's brow bulges forward; then it retreated sharply; now his nose has a characteristic shape, wide at the end; then, it was a long, straight sausage. Cartoonist Murphy probably had to work out a unique shape to identify his hero, for the first Casper resembled other comic personalities.

The first doings of this pair were concerned with the usual married spats and jealousies, but the strip stood out from other married life cartoons, such as T. E. Powers's "Let the Wedding Bells Ring Out" and McManus's "Bringing Up Father," for several important reasons.

First: Toots was good to look at, the first, really attractive strip-wife. Second: this pair had fun together and enjoyed their home lives—another great relief, for comic readers were beginning to wonder whether marriage made any sense at all.

With their dog "Snookums," the pair gadded about until the significant date, April 2, 1920. After this they retired from the pages of the *American* for a discreet season. Could it be . . . It could. They are back again on December 12, 1920, with a big, fat, bouncing baby, and they are desperately hunting for a name.

Time: December 22, 1920. Scene: a golf course.

"Toots!! What are we goin' to name baby?" They are airing Baby.

"Dear me, Casper, I don't know!"

"Look, Toots! There's Mr. Mortimer Kale, the great Banker!"

"Oh, Casper, let's name baby 'Mortimer' after him! He's such an upright and honest man—he gives so much to charity, too."

Casper: "As soon as he makes his drive we'll tell him we've named the baby after him."

Banker: "I topped it!!" (String of unprintable symbols meaning unprintable things.)

Toots is stopping her ears. "Come, Casper! And to think we nearly named our child after that horrid man!"

It goes this way for months. They settle on "Harold," but an efficiency expert named "Harold" fires Casper from his office. "Percy" turns out to be the name of an old flame of Toots's, and similar objections dispose of "Horatio," "Eddie," and "Matthew." After they adopt the somewhat desperate expedient of calling their baby "Buttercup," things go better.

The simple humor of early Toots shines in our illustration of September 19, 1930.

Apart from the baby, the great date in Toots's diary was the famous occasion when she "went feminine," for she had started in as a "flapper," and sported an extreme shingled bob at one time. Toots and Casper were out for a walk on May 30, 1923, when something luscious strolled in front of them. Although still in the sexless, tube dress, this "lovely" had a headful of curls. Casper, wistfully: "Look, Toots, isn't that girl's hair stunning? I like fluffy hair—"

Now they're home. Casper has evidently "taken a beating" on that last remark. He is looking gloomily out of the window: "Well, I just meant her hair was pretty, tha's all."

Toots, angrily toying with Buttercup: "Flapper! She has such convenient hair, too; If she wants to get it washed, and it's raining too hard to go out, she can send it to the hair-dresser by messenger!" And she goes on: "Maybe if I spent some of the time fixing my hair I waste cooking your meals and darning your socks my hair would look **better too**! Ain't that right, Buttercup?"

"Da."

© *King Features Syndicate, Inc. Reproduced by permission.*

FIGURE 33. "Toots and Casper" on September 19, 1930, one half of a daily strip.

The excellent finale of this interesting scene shows Toots at the hairdresser's. Proprietor: "You want your hair dressed fluffy?"

"Yes, and stick on gobs and gobs of curls!"

She got her gobs, and America got its Toots in the final form. Toots is a dresser. Poor Casper works very hard to pay for those clothes, and he is a little gray and tired-looking now, but we feel his life is worthwhile. He lives in a nice house with a swell-looking wife and a healthy baby and has happy times. Like Blondie, Toots is a picture of contentment, and if all homes were like these, the American Dream would be nearly realized.

"In presenting the Nebb family, I will try to portray from day to day, in a humorous, human way, the things that happen in everyday life. The Nebbs are just a little family like thousands of other families. While they have their differences, they are good wholesome people and I hope you like them much." This is Sol Hess, introducing his strip for the first time, in the New York *American*, May 22, 1923. The characters are itemized: "Rudolph Nebb—husband and father—one of those humans who looks in the mirror and wonders why Providence wasn't so kind to everybody, and if he did the job himself he wouldn't change it a bit. His wife—good, sweet, chubby Fanny, with a disposition as perfect as Rudolph will let it be. Betsy Nebb, just an up-to-date high-school girl. Junior Nebb, future President of the United States—if you don't believe it, ask his parents."

From this comic prospectus it will be seen that Hess has reversed the

ancient man-and-wife pattern. Here, it is Rudolph who is the boss; who nags, bullies, browbeats; the wife takes it. This is unusual, but so is Sol Hess and his career. Both have touched and influenced comic-art history in a special way.

Hess began as an amateur, without pay, just for the fun of it—a situation, among cartoonists, of auk's-egg rarity. He was a jewelry and watch salesman who had become a member of Rettig, Hess & Madsen, wholesalers, with an office in Chicago, just across the street from the old haunts of the Chicago *Tribune*. During his travels, Hess had collected much data on the habits of Homo sapiens; being a wit, he had fun retailing his knowledge to the *Tribune* artists, whom he soon knew intimately. Among these were some of the big names in the old cartoon world: Clare Briggs, Frank King, Sidney Smith. With the latter Hess became friendly, and Smith, recognizing a unique continuity talent, began to use Hess's ideas and dialogue in "The Gumps," which he had recently started. This was in 1919.

The fabulous returns which came pouring in from "The Gumps," quite naturally put a bee in Hess's amateur bonnet. With the clever artist, W. A. Carlson (Hess had never done any of the art work), the Gumps' helper leaped into the professional arena on May 22, 1923, his new strip being handled by the Bell Syndicate.

It will not be difficult to recognize the peculiar, soliloquizing style, which had become so famous in "The Gumps," in this early specimen from "The Nebbs":

Scene: Artist W. A. Carlson's very convincing kitchen. Fanny: "We had a wonderful time last night, didn't we Rudolph? I enjoyed every minute of it."

Rudolph, drawing a glass of water, taking his time to do as thorough a job of debunking as possible: "A wonderful time! One of those disjointed musical comedies with a chorus that, when they were dressed up, it wouldn't cost over eighteen cents to parcel-post their entire wardrobe—and the tickets cost $4.40—four dollars for the show and forty cents for the world's democracy." Warming to it: "And then the restaurant—I had to hand the head waiter a dollar to get out of the check room and another dollar apiece cover charge when we got to the table—and for what? A half-dozen crazy guys jumping around playing jazz music to about three hundred people dancing in a space where three expert dancers couldn't miss each other."

Rudy Nebb is usually found running a combination hotel-health resort. This furnishes the perfect strip setting, for within the boundaries of the hotel, movies have been made, the health-giving qualities of the

local water discovered, and many budding romances nipped or nurtured, according to the master plan of Sol Hess.

Max Guggenheim, the only character in the strip drawn from real life, is a sour, dour little old man, but behind his prodigious proboscis he hides a heart of—if we were still on that standard—gold. Max supplies that which is necessary to keep Rudy down to size. It is Max who is seldom wrong, and whose advice Rudy loudly disclaims, but secretly follows. Max is the man behind the drone.

Another unusual family tree was that of "The Bungle Family," now discontinued.

This strip originally appeared, in 1918, in the New York *Evening Mail*, and will be found, in color, in the New York *World* on December 28, 1930. In 1935 it is in the New York *American*, but as of July 6, 1937, it moved to the New York *Post*, where it remained until a few years ago.

In the early years of "The Bungle Family," cartoonist H. J. Tuthill was doing a job in the usual manner. The Bungles were the customary, nagging married pair whose world seemed defined and bounded by little squabbles. More, the drawing itself was exceptionally raw and scratchy, even for a comic strip, and both Bungles were as ugly as sin. But after a few years had bungled by, something happened which bounced the strip far upward in reader interest.

It was becoming evident that Tuthill was a man with a singular perception of the subtleties which underlie the innocent appearance of events, a man acquainted with irony and with fantasy. He was using the simplicities of George Bungle, the butter-fingered and butter-minded sub-suburbanite, whose adventures generally ended in additional damage to a battered face, to further the sense of that mystery which surrounds us all; and in the face of that mystery to laugh. Here is something rare in strips, the *double entendre*, the sentence with two meanings; something especially rare and interesting in married life strips, the only mystery of which usually is, how did Joe escape from his house to play poker. In a light-hearted vein, perhaps we can compare "The Bungles" with Herriman's "Family Upstairs," those eerie people who were never seen.

The art work of "The Bungles" carried on the double nature of the strip, for looking at it was like brushing your teeth with a lawnmower—such was the ungraceful arrangement of people and "balloons" and noses on the people; especially the noses, for the nose was the symbol Tuthill had chosen to express the pathetic humanity of his actors. In spite of all the ugliness, there was a suppressed excitement which the ugliness seemed to

heighten, and you read on. It was like eating ice cream with a sore throat, you soon forgot the sore throat.

In addition to its more innocent readers, "The Bungles" gratified a sophisticated audience, including many people who believe that fantasy has a most natural outlet in comics, and who get bored with straight stuff, or the "leaping corn" of melodrama.

Harry Tuthill, boss of "The Bungles," describes his climb to fame with gusto. His story shows not only that rich association with experience, which backs up so many comic first-raters, but a ripe twist of ideas, gift of the born "funny man."

"My start in cartooning came when, while working in a local dairy as an engineer, I persuaded a local editor to brighten up his paper with some of my seriously drawn topical cartoons. Over several years my admirers constantly urged me that my most serious stuff proved I might be very hot at comics. And hot or not here I am.

"I did not spend too many of my early years in education. Instead I devoted them patiently trying to remain for a full **week** with Chicago employers who advertised for 'a strong, bright boy, not afraid of hard work.' Some of these employers with bad eyesight, or bad memories, hired me twice. Then I started out through the country selling from door to door such household necessities as patented egg beaters, baking powder, and enlarged pictures.

"From these I graduated into fragile connections with street carnivals, circuses, and medicine shows, and not in star parts. While at liberty I did other things, such as working one summer as clinical assistant to an itinerant corn doctor who, when partly sober, kept his pledge not to draw blood. By clinical assistant I mean I combed the town for men who limped and, after leading them to the doctor's hotel laboratory, held them while he removed their corns and as much money as possible.

"It may sound only like a poor gag, but an especially diverting aspect of my work with the doctor was, that frequently his own corns so troubled him, that his extra-curricular reliance on massive doses of alcohol, as a cure for this disorder, kept our one-room clinic closed.

"He and many other employers predicted a bad end for me, but so far, if drawing a strip be excepted, they have been, I feel, wrong."

One of the first comic artists to use the suburban-pair idea was Fred Locher, and his good old page "Cicero Sap," described one of America's best known comic families. Cicero's lineal descendant we still have with us in the Associated Press comic, "Homer Hoopee." Locher, a man of spark, originated both of these strips.

"Cicero Sap," which ran in the New York *American* in the 1930's, had the theme, later overworked, of the business husband, the home wife. But Cicero, as well as present-day Homer, had a special slant that kept the feature original. Both men engage in a constant battle with their wives, but the balance of power is interestingly different from that of other married strips. In "Bringing Up Father" and most others, the wife rules; if you doubt it, you will have the umbrella stand thrown at your head, and it will hurt. In "The Nebbs," the man is boss. But in Locher's strips, the contest is a draw, each side triumphing in his or her season, and this change-around gives grateful relief.

© *AP Newsfeatures. Reproduced by permission.*

FIGURE 34. Strip artists learn to say much with little. Notice how much trouble is packed into these two boxes of a "Homer Hoopee" daily strip, which ran December 30, 1945.

When Fred Locher concluded "Cicero Sap" and started "Homer Hoopee" for the Associated Press, his work took on added vitality. His style had always been interesting, although it had the defect of pictorial monotony; one strip or page of Cicero or Homer looking like every other strip or page. Despite this, Locher's work had character. He made no attempt at realism or anatomically correct drawing; the energy thus saved went into amusing and gay facial expressions and ideas. Homer is more completely realized than Cicero; above all, Locher's strips were packed with witty gags and good dialogue. A specimen sequence will show his neat idea cabinetwork: Homer's wife, Helen, now has a job in his own office. The big, aggressive mother-in-law, who plagues him, calls for the first time at his place of business.

Homer: "Hey, just a minute there! Where do you think you're going? Is the whole family trying to get into this office?"

"I've got a lemon chiffon pie for the boss—I baked it myself!"

"Pie or no pie, you can't barge into the private office! Leave it with me—I'll see that he gets it!" Homer with arms extended is guarding the sanctum. In the next box, mother-in-law is winding up with the pie in her right hand.

"Leave it with you, huh? All right, brother—You *asked* for it!" *Whoosh*, the pie flies, but Homer ducks adroitly. Result: *Flop*, the pie "bull's-eyes" on the face of the boss, who has opened the door to see what the shouting was about.

Other strip-makers might be content with this as a single gag; Locher develops it cleverly. Homer, it seems, ducked so successfully because he began his career evading baseballs in a circus. He confides this to his little cain-raising nephew, Hector, who persuades him to rig up a screen and demonstrate this deep-rooted instinct in the rumpus room. Of course Helen discovers it all.

Helen: "Have you taken leave of your senses?"

Homer's head spotted in the screen: "Aw, I just did it to amuse Hector! It was all his idea! He heard me telling how I used to stick my head through a canvas at the fair and defy people to hit me with baseballs—and nothing would do but he had to try it! You know how kids are!"

Helen: "Why can't you be dignified? By the time he tells that around the neighborhood, it's not going to improve our social status!"

"*What* social status?" cracks Homer.

Here is a pattern of idea development worth study, for a new threat, lack of prestige, looms over the Hoopee family, and several weeks of good strips can be built around that.

Locher's conscientious, hard-working career came to an end in February, 1943, when he was suddenly stricken with pneumonia. He had stayed at his drawing board overlong. The Associated Press appears to be unusually fortunate in his successor, somber, lank Rand Taylor from West Virginia. This young man, fresh from his home-town paper, surprised AP editors by his intimate knowledge of their strips, and when Locher's illness was reported, did such remarkable samples of "Homer" that the job was turned over to him. The quality he puts into his work is enthusiasm, which, if added to ability, makes a winning combination.

People often wonder what happens to a comic strip when the original artist passes on. Few seem to realize that the name, the characters, the main idea of a strip do not belong to the artist. These are owned (with very rare exceptions) by the syndicates. Naturally, a syndicate is not going

to drop a strip which has a following of millions of people, because the creator is no more. A new artist will be found, and often the public is quite unaware of the transition. But the syndicates realize that it is difficult for an artist to do his best work while being forced to plant his feet exactly in the footsteps of some predecessor. An editor's advice, therefore, to his new artist is apt to be something like this:

"We want you to follow the early style just as close as you possibly can—at first. You'll find ways, probably, of making changes and improvements as you go along. We don't want you to be a rubber stamp. Find out how *you* want to do this strip, and then gradually change over. Just watch it for the first six months to be sure there are no abrupt changes—we don't want readers writing in that their favorite funny strip is going to pieces."

There are many such cases of successful transition in strip-history, beginning with George Luks's "Yellow Kid." A particularly brilliant job was that of H. H. Knerr, with his handling of "The Katzenjammers," which is true to the spirit of the original, and yet, stylistically, his own. Such examples should be studied by young workers in the comics, for this is one of the channels by which they may break into the big time. There is a life in comic strips often more lasting than that of the men who make them.

Chapter IX

THE KIDS

THE COMIC ball started to roll because certain boys kicked it from behind. The Yellow Kid, Hans and Fritz Katzenjammer, Buster Brown: these were their names. A boy and a comic strip go together. A boy is packed with steaming life; so is a good strip. A boy laughs much of the time; so do the best strips. A boy has room for imagination, for dreaming, for the little, useless things which make life worth the living. So do the strips.

For these good reasons we will find, ducking in and out of the history of the comics, all kinds of boys and girls. In this chapter we are going to get on shouting terms with some of the most remarkable—for we must confess at once that there are too many comic kids to do equal justice to every one. And before we get to the great, single personalities, it will be necessary to clear a number of important gangs out of the way,—for boy-gangs have furnished one of the greatest themes since Huck Finn and Tom Sawyer began fishing for mudcats.

We will go back to the days of the old masters and take up a comic which was purposely left out of those chapters. The boys, we said, were the rocks upon which the whole pink, red, and green comic structure has been built. But there was something a bit off in those first youngsters. Did any of them adequately represent the real inner essence of American boy? Hardly. The Yellow Kid? Certainly not. The Katzies? They are in too early a stage of development; they lack the gallantry, the soul, which anyone who associates much with boys will know to be a true feature of boyhood. On the other hand, the boys in "Foxy Grandpa," as well as "Little Nemo," lacked the vigorous punch of true young America. Swinnerton's "Jimmy" was a great strip, but the kid was taciturn, cold. There remained, therefore, a fine opportunity for a comic which would reflect the truth about this important group of little Americans. Gene Byrnes waded in and did it.

With a cracking of baseball bats and a clashing of wooden swords, "Reg'ler Fellers," a gang of them, swung into action first as a side filler for Byrnes's famous "It's a Great Life If You Don't Weaken" in the days of World War I, then as a separate comic in the *Herald Tribune;* later, released by the Bell Syndicate, the gang swarmed all over the United States

lot. They will be remembered for their long run in the New York *Sun*. Nowadays they slide and shout, very much alive, in many newspapers—among these the Philadelphia *Bulletin*, Chicago *News*, Washington *Star* and Houston *Chronicle*. The first thing that impresses you as you look over these old boy pages is energy, bubbling enthusiasm. The plots, about the small matters that really do concern our back-lot heroes, are not of great interest. Nor are the characters themselves remarkable for any overtone or symbolism which might throw a light into man's major problems. But what of it? These are true boys we are looking at: inventive, furiously alive, clean, technically minded. Puddin'Head and Pinhead race through their young lives, blowing off a healthy and heartening steam; they have an endearing habit of exchanging wisecracks with their pals while hurtling down steep slopes on sleds or roller coasters, vaulting over high fences or, lacking equipment, simply standing on their heads.

There is an artistic quality about this strip also, especially in the big color Sunday pages of the old days. Gene Byrnes knew how to spot lively and decorative blacks through his page, and he took full advantage of the set of comic conventions which had been established. So we will find a fine assortment of comic stars and whirligigs, plenty of *Pows* and *Bams*.

It is a tribute to Byrnes that his readers' interest is sustained without the lurid accouterments employed by the average comic artist. No high-breasted, deadly-eyed females here; no spine-chilling suspense endings, no bat-winged men or fluttering of interplanetary cloaks. And we don't miss them. Restricted as "Reg'ler Fellers" is—for these kids are just below the age at which one might conceivably introduce them into the world of adult adventures—the strip possesses a high-pressure quality which fills its frames to abundance. We salute it as a good job.

Another old-time kid strip, begun in 1921, whose wit still is alive in the *Journal-American* today, is "Just Kids" by A. Carter, syndicated by King Features.

Carter's art style is the real low-down, high-up strip stuff. One of its best features may be expressed in two words; it's fast. By that we mean the lines seem to have been slapped on with vigorous, quick feeling, and carry a charge like a hot electric wire. It looks easy to do this sharp, fast style; actually it's one of the most difficult things in strip-making. It implies a perfect knowledge and perfect coordination of eye and hand. There's a comfortable, free and easy air about a fast style, which makes you feel your collar is unbuttoned, that you're having a holiday, and this is one of the things people pay for in comic strips.

There is more to Carter's stuff than speed, however; there is humanity. An example is the little mother who paddles around the boxes of "Just Kids"

FIGURE 35. A little strip, but a big feeling. "Just Kids" for April 14, 1947.

with her unique hair-do over a face untouched by meanness. A sweet and vital being, like the other people of "Just Kids," she has a quality that is true of comics as a whole: she is little and big at once.

Many another "reg'ler feller" has appeared as a strip hero. The son of Posen's "Sweeny and Son," in the Sunday edition of the New York *Daily News,* and Doc Winner's "Elmer," in the *Journal-American* on Sunday, another King Features strip, are examples. And of course the famous kids who appeared shooting marbles, or leaning against fences in the daily cartoons of Clare Briggs and Webster, were the most "reg'ler" of all.

Speaking of boys and boy-gangs appearing in the daily papers brings us to a point of historical interest. We should remember that the boys who started the strips were in color sections only. It was the very un-boylike Mutt who was the original daily strip figure. Who, then, started boy stuff in the dailies?

With the appearance of the first truly drawn kids regularly to appear in the daily press, we come to a name of thunderous importance in our history: John T. McCutcheon, one of the most widely followed and widely discussed political cartoonists of all time. In 1903 he had joined the staff of the Chicago *Tribune,* and there he remained, doing his humorous or fiercely lashing front page cartoons. These cartoons, of course, are outside our subject, but for a long period McCutcheon did another kind of drawing for the *Tribune,* which is germane to it. These were the jolly, spontaneous and deeply truthful panels of country kids in which the artist shook off the bitterness of politics and had a wonderful time.

A raft of little kids, the leading one carrying a raft of little dogs, walk barefoot along railroad tracks towards the old swimming hole. "Gee! I don't see how anybody can be sad in summer-time, 'specially if he's a boy an' likes to go swimmin'!"

This is a very familiar kind of thing to us now, but we should remember that the ordinary occupations of ordinary people were once looked upon by the upper classes, and hence by the writers and artists, as vulgar, smelly subjects, not to be compared with romance motives, such as castles and elegant, dreamy maidens. It required the sturdy writing in *Huckleberry Finn,* the magnificent, earth-stained English of Walt Whitman, the powerfully direct vision of the painter Winslow Homer, gradually to show Americans that the best and most moving subjects for art and entertainment lay in front of their noses. In cartooning McCutcheon was the one who first found out the deep appeal of the healthy American kid. Of course there were Yellow Kids and Buster Browns first; but these were specialized

and local, peculiar to city and suburb. McCutcheon's was the far more numerous country product, the very essence of real boy.

McCutcheon was not a strip artist in the literal sense, but his importance for us is in the enormous influence he had on so many men who were stars in the new profession.

Clare Briggs credited much inspiration not only directly to McCutcheon's work, but liked to tell of the personal help he had received, a story one will hear from famous cartoonists again and again.

Fontaine Fox credited his start to a letter of approval written by McCutcheon, and Frank King, of "Gasoline Alley," wrote: "McCutcheon's encouragement had from time to time meant a great deal to me, and I know that his kind words have done much for other struggling cartoonists." Still later, it was McCutcheon who introduced Milton Caniff to Arthur Crawford and Miss Slot of the *Tribune-News* Syndicate; the result was "Terry and the Pirates."

With all his importance, McCutcheon is off the main stream of early comic strip developments, because his kids were country kids, and comics, as we have well seen, were a suburban product. It was not until a good deal later that the hillbilly idea brought the man with the hoe into the strips. McCutcheon, however, had successfully run the kid idea in daily papers. Who was to take them into the prosperous fringes of the big cities?

The real originator of the suburban daily kid idea was Fontaine Fox, who successfully challenged McCutcheon in his own home town.

When we were young, didn't we all love to get down on our knees and build up some minute world below us—either of lead soldiers deploying in tiny holding attacks and flanking movements, or perhaps charmingly colored animals arranged in forest and farm scenes, or parading in twos towards a painted Noah's ark?

We lose none of the satisfaction of climbing out of our little skins as we grow up, but we want the lead soldiers and painted animals to be turned into real people. See Figure 36.

The Toonerville world has been arranged for us by a master cartoonist, Fontaine Fox. For more than a quarter-century America has been gazing at it with fascination. The Skipper of the Toonerville Trolley (which meets all the trains) is nearly as well known as was F. D. R., and as President Truman and Tom Dewey are. Aunt Eppie Hogg (the fattest woman in three counties), the powerful Katrinka, the Terrible-Tempered Mr. Bang, Suitcase Simpson, Tomboy Taylor, Handlebar Hank, Spunky Edwards, "Wilbert!!" and Mickey (himself) McGuire, are names more familiar to millions of Americans than those of their own congressmen. It is not only

the humanity, wild liveliness, and pure humor of these little people which have endeared them to us; it is, above all, the thing we mentioned at first, the perspective on a whole community. With the exception of Dudley Fisher's "Right Around Home," Fox's perspective, looking *down* on the lives of tiny actors below, is unique in the strips and goes to prove how well originality pays in this business.

Fox was born in Louisville, Kentucky, in 1884, and did his first cartooning there, on the Louisville *Herald*. His subjects were local, and this phase of his career laid all the foundations for his cartoon greatness—he never lost that local flavor. Yet Toonerville is not particularly Kentucky, and there you have a great strip success recipe: something local, that can be true *everywhere*. In Fox's case, this broader viewpoint was stimulated because the *Herald* called for cartoons of general interest as well, and when Fox met McCutcheon the old master urged him to try for a job on the Chicago *Evening Post*. Since McCutcheon's own work was also appearing in Chicago it took a bit of doing on Fox's part to persuade the *Evening Post* to bring out more kids in the McCutcheon territory. But as Fox made clear, his were to be kids, not from the farms, but living in that shifting, eternally expanding fringe where rural and urban people mix and contrast, the outer commuting circle, to which an occasional rambling train or trolley makes a creaking visit. This selection of locale was made in 1908 and has been good to the present day, and probably will remain so ad infinitum, for the big cities' fringes are still growing, still contrasting the two fundamentally different ways of living.

In 1913 Fox signed with the Wheeler Syndicate and came East, and as of May 11, 1924, his Toonerville folks came into wide prominence with a full-color page in the New York *Tribune*. By 1928 we find the familiar, square black and white panel, as we see it today, appearing in the New York *Sun*. At one time the panel was distributed by Bell Syndicate; now it is under the McNaught Syndicate banner.

The origin of the very famous, rocking, swaying little Toonerville trolley that is so dear to the Skipper's and America's heart and that jumps the tracks on so light a provocation is compounded of two periods in Fox's life. Back in Louisville in the days when he was cartooning on the *Herald*, Fox had swayed to work on such a prehistoric contraption, and had made sarcastic drawings which appeared in the local sheet. It did not occur to him to make a regular cartoon feature of a trolley until years later. Fox was in Pelham, New York, on that historic day, attempting to pay a visit to Charles A. Voight, the cartoonist of "Betty." He did not know just where Voight lived, and he was amused when he was referred to the motorman of an old, rickety trolley, which reminded him of earlier days in Louisville. It seemed

FIGURE 36. Here is true cartooning, sharp, vital, telling. A busy corner in Fontaine Fox's "Toonerville" world, which is seen from above as if one looked down on a tiny stage.

that the Skipper knew every little fold in the countryside and so it proved, the old fellow taking the trouble to get out of his trolley, climb a point of vantage and point out Voight's house. That very minute the Toonerville trolley was born and a classic symbol of the old leisurely life was added to America.

Fox's work has three striking technical points which are worth every comic art student's attention.

First is the vitality and freshness of the drawing. Fox believes in retaining the snap of the very first impression, and has made a study of how to preserve it. He makes a quick vigorous sketch on scratch paper. If he has the action and life here, he sees no reason why he should laboriously redraw it; he recognizes the danger of losing the sense of life. So he rubs a little pencil on the reverse side of his scratch paper and traces the drawing down. He believes that the first impression one gets of some situation or funny character is apt to be the best, and makes it his business to catch it while it's fresh.

The second point is the use of the unique, looking-down perspective we have mentioned. It is a semi-bird's-eye view, the equivalent of examining the surrounding terrain from a three-story window. Notice that in Fox's work the eye-level is placed well up on the paper, usually two thirds up the drawing or more. Since one is looking down, the figures are small and a number of them can be used—we're back to the fascinations of the lead soldiers and little painted animals.

Point three is the wonderful simplicity of the work, the way the backgrounds are kept from sticking to the figures, the use of blank space. The amazing vitality which is packed into one of these tiny figures is enough to give the onlooker an eyeful and our artist wisely lets very well enough alone. This is true classic cartooning. Taken together, these approaches add up to a personal style which is one of the peaks in our comic history.

Another early worker in daily kids was C. M. Payne, whose "S'Matter Pop?" was one of the brightest, most distinctive of the old-timers. This was running as a Sunday page in the New York *World* in the 1920's, but is well remembered for its long run, as a daily, in the New York *Sun*, although its career ended about ten years ago. It was at one time controlled by the Bell Syndicate.

Like Fox's work, Payne's stemmed from the loose-pen tradition of Charles Dana Gibson and James Montgomery Flagg.

"S'Matter Pop?" however, had little of the illustrative about it. Though the line was free, vigorous, and crisp, the whole approach was decorative. Payne had a way of whacking in simple, stylized black shadows, but he did not descend to the vulgarity of shading, which, in newspaper work, had best be omitted. Pop was a tall, huge-footed young dad with the "goof" face and simple mind which American men of the time were supposed to have, according to the "funnies." His own kids were manageable enough, but he was tormented by the visits of a neighboring fiend in infant form, "Desper't Ambrose." A page in the *World*, September 19, 1926, will convey the type plot, as well as give an idea of the originality of Payne's tot-talk.

This time, Ambrose's papa is visiting, as well. "I like to build radios. I've

got a weakness to build things," Pop remarks, for those were the days of home-brewed static.

Ambrose, behind Pop's big legs: "Good morning. 'Tis I, desper't Ambrose. Psst! 'Tis I, desper't Ambrose, tha deteckativ," growls that one again angrily, for Pop, not noting him, is dandling his baby close to the radio.

"Yas sir, I like to put them together," Pop smiles.

His neighbor observes reverently: "They sure are a mass of wires an' screws an' coils, an' glass doohickeys, ain't they!"

"Yas indeed, I like to put them together," dreams Pop, not observing his baby who has been sucking a large monkey wrench and is now looking into the radio, meditating, "S'K'boock?"

Sock! the baby smashes wrench to radio.

"Awk!" Pop collapses, sitting down on Ambrose, *Scrunch.*

Neighbor, vindictively: "Bigosh, this ought to tickle you! You'll have to put it together again."

"For the luvva cream," Pop agonizes, again not noticing Desper't Ambrose, who is brewing one of his famous fury-fits.

Ambrose, back home: "That was a insult! It's a insult to sit down on company—I'm gettin' mad! I'll go back an' make trouble!" Once started, this redoubtable infant cannot control himself. "Hiss! Now I'm walkin' my desperate walk. His whole fambly had better watch out! Hiss!" In Pop's house again, he comes across the baby, alone, who coos, "Squaa-aa-nig?" Ambrose sits with violence on the baby. *Scrunch!*

Pop is seen running towards a howl. "It's old timer, he's in trouble." Ambrose has gone.

"Skpmnk Squaamf!" screams old-timer, while Ma rushes in.

"S' matter, Pop?"

"Yas, he's got a big complaint about something, I can't make it out."

Last box, Ambrose stamping home: "Tha's the kind of a desperate guy I am! A tooth for a tooth! A sit for a sit!"

Amusing as this was, there was something lacking in Payne's kids: reality of characterization, the focussing of one's attention on a personality, which as we have repeatedly seen is one of the surest ways of holding comic readers over long stretches of time. The boy-gangs we have looked at, such as appear in "Toonerville Trolley" and "Reg'ler Fellers," have enough life and punch to stand on their own sneakers; yet they, too, do not fill the opening we speak of: the kind of thing that Buster Brown did in the old color sections. It was logical that some smart comic artist would find this hole in the daily papers and plug it—ensuring himself a famous career. Percy Crosby did it: the kid's name was Skippy.

With this new strip we arrive at one of the high spots of our story. This was no routine, ordinarily good job. In a recent book on Chinese painting, George Rowley has distinguished four grades of greatness which the Chinese use in estimating the quality of their art. The first is *chiao* (clever); the second, *miao* (wonderful); the third, *shen* (divine). But the fourth and highest grade is *I* (effortlessness). At this height the artist has attained freedom; the freshness and bigness of universal things show through his work, without distortion by the attenuating processes of strain and labor. Usually genius is the only means of producing such work, for the man of genius possesses an inborn clairvoyance which enables him to short-cut the struggles of the rest of us. There is more than a trace of such quality in the work of Percy Crosby, who created, wrote, and drew the comic strip "Skippy."

Skippy was only a little kid dressed in a quaint costume all his own—an indescribable checked hat, huge white collar, flowing tie, and dragging socks. He and his equally tiny friends sat around on curbs or swung baseball bats or acted in other ways like boys. But two aspects of this little world stood out and carried "Skippy" to the top of the comic-strip pile. The first was a rare quality of humor, expressed sometimes by words, sometimes in pantomime.

On May 24, 1931, he was sitting quietly on a rock with a bored expression. There was a pile of stones—evidently imported, for an empty wheelbarrow was close by. The only other objects were an enormous greenhouse in the background and a little kid who, with one of the stones, was winding up for a throw at it. Next box, the shot was wide and short. Skippy hadn't bothered to look. This was repeated for four more boxes; the pile of stones was diminishing. Then the little kid, sweating and desperate, heaved the last stone. Skippy yawned and the last box found him in the original position, with the same bored expression. He spoke for the first time. He explained that the kid's inability to hit the greenhouse showed why he wasn't allowed to play on the team.

The second top quality in this strip was the strain of searching philosophy which poured out of Skippy, who combined knowledge of the world with the vernal freshness of a child. Percy Crosby made his Skippy comment on the complex problems which surround and often bewilder adults, and out of the mouth of his strip babe often came new light. One day, for instance, various little kids defined their religions, and in each case, it turned out, each kid liked his own. Whereupon Skippy remarked that they had nothing to sell to one another.

Skippy represents the extreme development of that quality which we found starting the comics on their way in the old days of the Yellow Kid:

personality. He was a microcosm of a man of a certain breed, American to his minute sturdy backbone, an inheritor of a driving business civilization. Skippy, in his tiny way, was a boss-man, who made decisions of his own, and dominated the other characters in his world which lay under the dining-room table or very close to the sidewalk. He was at ease. His tot size and his small-kid clothes only emphasized, by contrast, that cocky sense of belonging, of holding his place.

Apart from its quality as one of the greatest of the strips, "Skippy" illustrates some important points in strip technique. This strip was loosely, even roughly executed. It was pen impressionism: details blurred, few blacks, frequent hazy drawing. Yet the very looseness and absence of background detail focused attention the more sharply on the main thing that mattered: Skippy himself. The kid was drawn with such mastery and force that one was hardly aware of the rest.

Loose, disconnected lines such as were used in "Skippy" have a wonderful power of conveying action, because objects in action actually blur in the eye. But a loosely drawn figure will fall to pieces if the cartoonist surrounds it with a sharply focused, carefully drawn background. Therefore, the man who wants the easy swing of disconnected lines will let the background details go. Many cartoonists, however, are fascinated with exactness of detail; they like the last leaf on their palm trees and the last shiny highlight on their machine guns. These men almost always find that they have to connect up the outlines of their figures and use plenty of black. It is really a choice between two general approaches—a choice illustrated on one hand by such strips as "Skippy" and "Cap Stubbs," and on the other by "Terry," "Mary Worth," and the flood of modern illustrative strips.

Through most of its famous career, "Skippy" was released by King Features Syndicate and appeared in the New York *American*, where it remained until only a few years ago. At one time the *American* paid this strip the high honor of running it on the front page, which meant tops in popularity.

Skippy stood out as the big thing in his strip, yet he was essentially a reg'ler feller. Perhaps the strongest boy personality left to dominate the scene is an irreg'ler feller indeed; an odd, misshapen child with high, bald skull, long pipestem neck, potbelly and dumpy, sturdy legs. In him the boy has not yet shaken off the chrysalis of the infant; this is an enormous, inflated infant—and at the same time very capable in a hardheaded way. Such a special appearance and character is a thing of great value in comic strips. Even more striking is the fact that Henry doesn't speak.

Henry's face, too, is entirely expressionless. He starts in a page or strip apparently the pawn of Fate—his silence prevents him from crying out.

At the end of the page, however, Henry will be found to have solved his problem in some new, unexpected way, and it will be funny.

"Henry" began in 1932 as occasional cartoons in the *Saturday Evening Post*. He grew to be a regular feature of that magazine, and it is said that it was a German reprint of some of these, captioned "Henry, der Amerikanischer Lausbub," which first, in 1935, drew Hearst's attention, for the publisher was then touring Germany. The keen eye of the master strip-picker had not lost its sharpness with the years, and following a wire to King Features in New York, Anderson and his "Lausbub" were soon safely in the great Hearst collection, running in the New York *Mirror*. Anderson found himself famous.

An interesting feature of Henry's creator is his comparatively advanced age, for most strips are begun by young men. Anderson was born in Madison, Wisconsin, in 1865. He had a woodworking tradition in his family, his father being a carpenter, and even today he plays with tools as a hobby.

There can be no question that part of Henry's success is his pantomime. Even adults will often tell you, "I like Henry because I don't have to read it," and the non-literate kids gobble it up. Reading text means an effort of the mind, an exercise which the average person is often delighted to forego if he can have a thought passed to him directly, through such a medium as a series of pictures.

There has been no lack of little girl personalities in the last twenty years. "Orphan Annie" and "Mary Mixup" belong in other chapters; here we have two girls who deserve mention.

Signed "Batsford," "Little Annie Rooney" appears in the New York *Journal* on February 24, 1930, syndicated by King Features.

In these early episodes the strip was sketchier than at present. Zero, the dog, was larger and shaggier, and Little Annie's facial features hadn't settled into their very definite outline. Darrell McClure took over the strip on October 6, 1930, and he changed the art approach to the same style the strip has today. McClure has drawn the strip since that time and a little later Brandon Walsh's name appeared on the by-line as author.

Before doing "Annie," McClure had had a strip of his own running in the *Journal* called "Vanilla and the Villains." This was in the style of "Desperate Desmond" and "Hairbreadth Harry." The art work used on this strip didn't forecast the style he displayed with "Annie."

Darrell McClure is an expert yachtsman. He has done a lot of work for *Yachting Magazine*, and is very well thought of by the sailing fraternity, being that rarest of cartoonists, one who knows the difference between a

FIGURE 37. "Henry" for March 18, 1947. Since Henry makes no comments, why should we?

topping lift and a martingale. McClure's sea fever once burst out into a very capable strip called "Donnie," concerned with the adventures of a boy, his dad, and a catboat, and seagoing readers were for once delighted with pictures of boats really well drawn. Now that McClure is doing "Annie," it is interesting to note that very often we still have occasion to see an old sea captain, a barge, or even a sailing ship.

In practice this strip illustrates the validity of the Golden Rule. Annie is continually cheerful. Once in a great while circumstances crowd her to the rail, but they never last long with this stout-hearted child. After a period of abject poverty, Annie usually joins some character who has too much money; then comes a wild time of swimming pools, chauffeur-driven cars, footmen, gold bath-tubs and so forth.

Unlike her little counterpart, Orphan Annie, Miss Rooney loves everybody. As she is lying in the gutter, where she has been kicked by some evil person, Annie is apt to look up with a dreamy expression and mutter through battered lips, "People are awful swell, honest they are."

Our other little girl is "Patsy," syndicated by the Associated Press. "Patsy" began in 1934, with a gentle Alice in Wonderland theme. But the dear, gentle days of the Mad Hatter and the Mock Turtle are not our days, and quite soon Patsy's creator, Mel Graff, began to cast about for a more modern theme. When he came to Hollywood he found it; the child star was a hot subject in those days, with all the excitement about Shirley Temple, and Patsy became securely established in a smart setting of cameras, swimming pools and the glitter and glare of the flickers, which Graff did exceedingly well. J. P. Panburg of Paragon Pictures is her boss, and dispenses contracts, quaint English, the typical nervous chewing of cigars and the pacing and restlessness which the typical movie magnate is supposed to indulge in. It makes a good, lively, if not especially remarkable plot. The chief impression one gets from studying old "Patsy" is the high type of art work. Mel Graff uses multitoned Ben Day with exceptional skill, and in this respect has few rivals, with the exception of Roy Crane, who did such artistic work on "Wash Tubbs" in the *World-Telegram*. Graff has a sense of design and knows perspective; his detail is authoritative. In May, 1939, Mel went the way of many bright strip artists, landing in Hearst's comic heaven, the New York *American*, with the job of drawing "Secret Agent X-9."

The strip called the "Adventures of Patsy" then began a series of adventures in style and appearance. A number of artists have taken their hand, and several plot approaches have been tried out.

In 1942 Charles Raab carried on the strip, a capable workman of the smart, modern school, with a looser touch than Mel Graff. The plot at this

time is still Hollywood stuff and more or less on the original model. With Raab's induction into the army a very striking change in both art work and story took place. Signed "Storm," the strip went back to the original Alice in Wonderland, fairy-tale feeling and was filled with talking Piggie-banks, witches, Reynard Foxes, and so on.

Still later, as of 1945, "Patsy" reverted to a middle ground in appearance; it had neither the smart, modern appearance of Mel Graff days, or the Disney-like extravagance of Storm's handling. Done by Richard Hall, it dealt with the stage and screen again, but in an open, simple manner.

On April 8, 1946, one of the best "Patsy" daily versions appeared, drawn by Bill Dyer, just out of the navy. Before his enlistment he had drawn the Sunday version of "Oaky Doaks" for two years. Dyer is head artist for the Knoxville *News-Sentinel*. He began work with that paper in 1935, but even before that he had been drawing sport cartoons carried regionally by the Associated Press. His "Patsy" has a dash of the old slapstrip, yet he gets in a streamlined touch, too. Best of all, it has that hearty, intimate, informal spirit which is in the best tradition of the comic strips.

One of the greatest boys in comics is, nevertheless, drawn by a woman. "Cap Stubbs" is as true to the boy theme as were Briggs's boys; he has a personality, yet he's a "reg'ler feller," too—one can't pigeonhole this strip exactly, but it has made new precedents, and all very healthy and heartening ones. One of these is that Cap Stubbs gladly shares his eminent position with two very different characters, who hold as powerful a grip on our affections.

"My land, Mary, I wish you'd make him stop playing in that old shack they built, it isn't safe—but of course no one ever listens to me. Goo'ness! I wish school would start so a body'd know where that boy is—part of the time anyway! Cap Stubbs! Don't you dare go down there! What if a tramp came along? He might kill you."

This is fussy little Grandma Bailey, fussing, eternally fussing—with only an occasional break for gumdrops—over that apple of her eye, Cap Stubbs.

Grandma is one of the very greatest of all the people of the strips. She scolds, admonishes, and completely wins our hearts, moving with an old-fashioned, feminine energy through her son-in-law's comfortable little home. An enormous spotted apron is tucked high over her dumpy figure, her glasses slip down over her nose and her mouth is usually wide open in an extraordinary expression of vitality. She does more than scold her grandson: "My land, Mary! There's not many children who'd be so unselfish." And this combination of realism and tenderness is characteristic of "Cap Stubbs and Tippie," one of the most vital strips in our history.

As one looks through the New York *Post*, where "Cap Stubbs and Tippie," by Edwina, syndicated by the George Matthew Adams service, will be found appearing since 1934, an important fact about strips becomes clear. Here is a story that has hardly any plot—at times we find nothing but kids running out and walking along the edge of a roof tree—one that appears side by side with the most impacted thrillers that the lurid, modern mind can provide; yet this simple strip goes on appearing year after year, while some of these lurid thrillers gasp out their last strangled climaxes and sink without a gurgle.

What sells the strip? The characters are so presented that you think of them as real, and when you do, they're so likable that they become part of your life. Many strips are only a parade of events involving people we don't know. Very often the mechanics of melodrama impose a rigid, metallic screen between us and the characters and, as a rule, the creators of such strips don't bother about characters much. Melodrama is simply the impinging of events on people's lives. It is not until we deal with the people themselves that we come to true drama.

Cap Stubbs, of course, is just as fascinating as his fussy old grandma. He has the same remarkable way of saying things in a wide-mouthed shout and the full gamut of emotions registers on that tiny inked-in face.

"Hi, fellas!" Cap Stubbs, in an old daily strip, rushes out all life and joy, followed by his frisking dog, Tippie. In the middle box is shown a football scramble of four or five boys; and in the last: "Hi, gran'ma!" As poor grandma appears on the porch in her full, open-mouthed horror, Cap Stubbs is limping home with hair a snarl, clothes torn, banged knee, and other injuries without number. Behind, Tippie is sorrowfully carrying his cap.

And this brings us to the third great character of the strip, Tippie, the most vital dog of the comics, who could stand by himself, and does in the little daily vignettes called, "Alec the Great." This is a top job of animal drawing. Tippie can express the zest of a summer day or the quality of wonder; he can be infinitely pleading, he can be scornful, baby-like, sophisticated, or plain dog hungry. Every pen stroke seems to chisel out a necessary part of his anatomy.

Tippie is the foundation stone of this strip edifice. Everything was built around and for him. His origins go back to an actual incident in Edwina Dumm's life. The usual simple story of the father who finds the little dog and brings it home to charm the family for the rest of its life. In this case, however, there was an artist in the family who found in the character of the little white dog an inspiration which determined the events of her own life.

© *The George Matthew Adams Service. Reproduced by permission.*

FIGURE 38. "Cap Stubbs and Tippie" on March 18, 1942. Just a boy and a dog and a grandma and a swell strip.

Edwina was born in the old Indian village of Upper Sandusky, Ohio, of a newspaper family. Therefore it was not unnatural for her to conceive of a career of cartooning. She took a correspondence course and became a political cartoonist in Columbus, Ohio, having successfully fought the taboo against girl newspaper artists. Edwina drew with such remarkable vitality that George Matthew Adams, of the George Matthew Adams Service, noticed her work and invited her to visit him in New York. Her dog drawings, stemming from that original family pup, were what he particularly liked. But a dog must have a boy, hence Cap Stubbs. Soon after came illustrations for Alexander Woollcott's "Two Gentlemen and a Lady," which led to the well known "Sinbad" pages in the old *Life* magazine. By 1929 the comic strip "Cap Stubbs," was in full swing, and has been gathering affection and readers ever since.

131

Edwina has had three dogs in addition to the original orphan. Dog number two was named Lily Jane Sinbad II. The name Sinbad was chosen through a contest held by *Life*. The purpose was to select a name for the dog character which was appearing weekly in the magazine. The chief characteristic of the dog was getting into trouble, "in bad." Thus Sinbad won.

The present incumbent is a woolly, waggly "pooch" named Tippie, which Edwina has had for nearly two years, having found her at the Bide-a-Wee Home when the dog was two years old. Tippie preserves her biological status with Edwina's cat, Jasper. Each of them ignores the other.

When you meet Edwina, you realize why she creates attractive people. She's direct and simple. In a certain sense, she never grew up. She's preserved her feeling for fun and play. She doesn't like lurid or complex stories and thinks some comic books may have a poor influence on kids. She's completely integrated with her work; Edwina and her strip are one.

Recently, collaborating with the singer and composer, Helen Thompson, she broke new ground by combining comics with music in two little books called, *Tippie's Tunes* and *Tippie and the Circus*. The one faintly sad thing about Edwina is that she can never quite catch up with her work. She has tried assistants, but, well—they just don't draw the way she does, and she is a perfectionist. Edwina wastes no time with modern movie-strip techniques. Not for her are enormous close-ups, breath-taking overhead shots. She doesn't even use the convention of the thought "balloon," but then, she doesn't need these trimmings. Her means of expression is adequate, and it's a happy moment in any art when the thing to be expressed and the means fuse into one. "Cap Stubbs and Tippie" answers conclusively the criticisms driven against comic strips by purists and educators. No meanness or horror here. Not even criminals are needed.

Edwina's work succeeds through a delicate balance of factors; she stops at that point in human interest and warmth before sentiment begins to rot the idea. She draws straight, natural people doing natural things. It sounds very simple and it's actually very difficult. However, success will always be waiting for comic strip artists who can achieve it.

Chapter X

THE GIRLIE GIRLIES

Polly, she of the Pals, was the first true girlie girlie in strip history. She was a reaction from the first raw females the unflattering comics had produced—those great, grim creatures with chins like flatirons, with noses like rolling pins. Polly was a French doll; strong men ate her up, even the women, envious, were interested. The discovery that she was liked brought editors to the natural conclusion—give the public what it wants. So a change came to the strip world of women.

We will chronicle a number of such changes in this chapter, but first we must look at the other French dolls, for this was a type which made a peculiar appeal to strip readers: the bulging brow, high forehead, short, up-tilted nose, and enormous eyes, produced in the male the illusion that these were just helpless babies to be rescued from the hard practical world about them. And the writer of the strip could always count on a laugh by exposing how realistic and capable his dolls were—these being about the hardest-headed group of citizens in the world.

Toots, of "Toots and Casper," was the next "lovely" of this type to be offered to the comic reading world. Toots, the first really pretty strip wife appeared in 1918; in 1921 we were presented with another French doll, equally famous today.

Russell Channing Westover, with a new idea for a girl strip, had approached King Features Syndicate in 1920. On January 14, 1921, "Tillie the Toiler" made her first appearance in the New York *American*.

While it is true that strips have tended to follow cycles, it is well to remember that each strip has some special slant that makes a separate appeal. Tillie's slant was her habitat, the world of offices and typewriters. After the First World War, women were working in offices in larger numbers than ever before, but it was not until the strips acknowledged this fact, that people were really convinced that we had a new way of life on the American scene.

Tillie, from the very first, has worked to popularize and dignify the American white collar girl. When Heaven got tired of protecting the poor "woiking goil," Westover threw his pen and heart into the breach.

FIGURE 39. Two generations of young things overlap as Tillie the Toiler, first seen in 1921, prepares to crash the bobby soxers of 1947.

It may seem strange that the strip that has continually poked fun at office girls should still have proved helpful to these same girls. Tillie had accepted her position with no sense of "See how daring I am." While she got into trouble, it was never because of fighting off the evil attentions of her employer. These object lessons helped to make it difficult for the mothers of would-be Tillies to complain that a business career was immoral.

The only things about Tillie which haven't changed with time are her French doll appearance and her approach to work, and of course the fact that instinctively, almost unconsciously, she attempts to land the male in her toils.

This pattern has become very familiar to millions of us since. There is subtlety in it. Although Tillie is a man's-eye girl, she also appeals to women for certain reasons. Tillie manages to have a lot of dates, get by with very little work, keep herself clothed in the very latest fashions, and enjoy life. The women admire that, by various tricks and subterfuges, it is often poor hard-working Mac who does the bulk of the work—and the men like this, too. They are pleased that the brains in back of business still turn inside masculine skulls.

Russell Channing Westover, Tillie's creator, has an interesting story to tell. He is another comic artist whose rich experience has been gathered from both coasts of America and the interior as well.

"I was born in Los Angeles but never worked in my home town. No one would hire me up to the time I left, which was when I was seven years old.

"My first newspaper job was with the San Francisco *Bulletin,* where I worked six months drawing sport cartoons. Then I went over to the Oakland *Herald.*

"I lost the Oakland job because of a cartoon I drew about an unprecedented plague of mosquitoes which struck the town. It was of a man in bed, assailed by swarms of huge mosquitoes, some of which were tearing holes in the wire netting. The caption was, 'Come on in, boys, the meat's fine!' Numbers of the paper's readers were indignant, some, perhaps, because publicity on the subject was giving the town a black eye. The reason most of them gave, however, was that the man wasn't sufficiently covered.

"In the next few years I worked for three San Francisco papers, the *Globe,* the *Chronicle,* and the *Post,* where I did sport cartoons and caricatures. I went to Reno for the Jeffries-Johnson fight and sent back pictures of that. It was on the *Post,* too, that I did my first comic strip, a baseball feature called 'Daffy Dan.'

"When the *Post* was merged with the *Call* in 1913, I left for New York and soon found myself doing a Sunday page named 'Betty,' and a daily

strip, 'Fat Chance,' for Julian Harris on the *Herald*. But with the merging of the *Herald* and the *Tribune*, I was out of a job again and took up free lancing.

"It was in 1920 that I approached King Features Syndicate with an idea for a pretty girl strip and in January, 1921, 'Tillie' first appeared. It was the postwar period of short skirts and 'flappers,' and women were working in offices in greater numbers than ever before. The other characters I developed more or less from life, although some are composites. The character of Mac is based on a friend I knew in California, though the resemblance is in personality and not all in physical appearance. Simpkins is a combination of several executives I have known.

"In most of the twenty-four years of his existence, Mr. Simpkins has been engaged in running a fashion salon with Tillie as his assistant, secretary, stenographer, and girl of all work. And one of the chief characteristics in the strip has been that Tillie keeps up with the styles. There was, however, one interlude. Since the strip, partly because its concern with fashion made it require timeliness in other matters, had always dealt with the topics of the day, Tillie couldn't be otherwise than deeply affected by the coming of World War II. Her boy friends entered the army or the navy. Tillie at first took the place of a garage man who had been drafted. Later she had a war garden. But in 1942, as soon as the WAC was organized, she joined up. Now, after more than two years in uniform, she is back in civil life again, and looking forward to the postwar world."

"Winnie Winkle," mentioned elsewhere, is another French doll engaged in the world of business primarily. With these two strips established, the average man became accustomed to the fact that girls had as many money problems as everyone else. But on the old *Evening World* there was a man who had a different idea of a French doll's place in life.

Larry Whitington's "Fritzi Ritz" makes her entrance in the grand manner, and in the "manor" she remains. The year 1922 was at the beginning of the "Big Money" period, and on October 9, 1922, we see a new strip in the *Evening World*.

Fritzi is a somewhat modified doll, but the dollishness is there all right. She's a big, calm, handsome, squeezable creature. A groom is helping her to dismount from a beautiful horse. In the background we see the pillars of a lavish resort hotel. A languid Fritzi is in her room, one of her dainty feet resting on a silken pillow, the other is having its riding boot removed by a maid. Miss Ritz speaks to still another maid, "Marie, see who's at the door."

"Yes'm—your bath is ready now, ma'am."

[Comic panel with speech bubble: "I DON'T KNOW WHAT STRIKES YOU SO FUNNY?" Signed NOV-16, ERNIE BUSHMILLER]

© *United Feature Syndicate, Inc. Reproduced by permission.*

FIGURE 40. This box from a "Fritzi Ritz" strip of 1932 shows that Fritzi was not the only one of her set to put on the dog.

A girl is at the door; she rushes into the room: "Hello, Fritzi, old dear, what are you doing up here in the mountains?"

Fritzi replies, "Oh, just roughing it for a while."

The mood is established. The strip uses many of the established, young girl gags, but the worry over a $10 loan, or how to get money for a new hat, are not of the troubles that bother Fritzi. Larry Whitington soon moved her to Hollywood, where she helped perpetuate the idea of directors always wearing their caps with visor to the rear, and having their valuable calves shod in leather puttees.

While Fritzi was enjoying her adventures in Hollywood, a young man had been promoted to sweeper in the art department of the *World*. It is well to point out at this time that in order to be a sweeper in the art department, you had to have considerable talent as an artist. The theory, which seems to have worked out very well, was that by being around the other artists and seeing their work, your own work would gradually acquire polish and finish. The young man who was promoted was Ernie Bushmiller. The theory worked so well that when Whitington dropped Fritzi, Bushmiller caught her, and held her elegant form high up before the customers as usual.

Bushmiller is a very talented cartoonist, with a dry, economical style, an uncluttered art sense refreshing to see; there are no scratchy pen thistles to hurt your eyes in his work. It is also comic work, pure but by no

© United Feature Syndicate, Inc. Reproduced by permission.

FIGURE 41. A "Nancy" daily strip of 1947. Here is a perfect comic strip style, uncluttered, forceful.

means simple; and after a while Bushmiller began to tire of the limited plots possible with Fritzi alone. So arrived Fritzi's little-tot niece, an engaging chunk of little girl, with contented eyes and a very personal and neat black sponge of hair with a minute, white hair ribbon snugged on top. Perhaps Nancy was originated as a gag device, but today it is Nancy who keeps the pat of butter on Bushmiller's generous slice of bread, for she has captured the public heart; indeed, the strip itself is now called by her name. There is a primitive simplicity about "Nancy" and the kids in it that moves more than the great dreaming public to praise.

Manny Farber, in the *New Republic* of September 4, 1944, writes: "It is possible that 'Nancy' is the best comic today, principally because

it combines a very strong, independent imagination with a simplification of the best tradition of comic drawing. 'Nancy' is daily concerned with making a pictorial gag either about or on the affairs of a group of bright, unsentimental children who have identical fire-plug shapes, two-foot heights, inch-long names (Sluggo, Winky, Tilly, Nancy) and genial, self-possessed temperaments. This comic has a remarkable, brave, vital energy that its artist, Ernie Bushmiller, gets partly from seeing landscape in large clear forms and then walking his kids, whom he sees in the same way, with great strength and wellbeing through them."

When you get that kind of review from the intelligentsia, you're either very good, or very bad. "Nancy" is very good.

The humor is bright, fresh, and contemporary now that Nancy has the center of the stage. Shortly after rationing: "Oh, Nancy, will you bring me a stamp, please?" We don't see Nancy, but Fritzi says: "What kind? Don't ask silly questions, bring me a *stamp!*"

In the last box Nancy is surrounded by stamps and says, with some trace of pique, "Postage, defense, sugar, gasoline, coffee, or shoe?"

As we have seen, "Fritzi Ritz" originated on the old *Evening World*. When the *World* was sold and became the *World-Telegram*, most of the *Telegram* strips remained, while most of the *World* strips were dropped. Therefore "Fritzi Ritz" was homeless until the rapidly growing New York *Mirror* offered her living space and a clean window on January 10, 1932. She was happy for quite a while in her new home; but "Fritzi," now called "Nancy," made a last move to the New York *Post*, being syndicated by United Features.

Strips tend to run in cycles, but there are always a few that don't follow that cycle.

"Betty," by C. A. Voight, was such a one. Instead of receiving its impetus from the French doll school, its lifeblood came from illustration. While done in a scratchy and what seems to us now an old-fashioned approach, at the time of its inception it was one of the most daring strips, perhaps the first to exploit the pure pictorial value of a pretty girl. Betty, at the seashore, clad in one of those floppy old black bathing suits with a discreet, black, bulging hat will not race the pulse of anyone today, but then it must have seemed like a breath of heaven, when compared with the Maggies of the comic strip world.

"Betty" was a strange mixture of straight humor, plausible situations, and now and then a dash of pure fantasy. After a long run, the page was finally replaced in the *Herald Tribune* on June 20, 1943, by the antics of a teen-age girl called Penny.

In June of 1925, two men gave the French-doll type of comic character

an entirely new conception. These fellows were Charlie Plumb and Bill Conselman; their new conception, "Ella Cinders." Ella has all the characters of the French doll type, yet the sum of all the parts does not equal cuteness. It is just possible that the authors thought it was time to prove that people would read a strip about a girl with character.

As the name implies, the story of "Ella Cinders" is that of a Cinderella in modern dress. A sound idea, but one does get a bit of a shock to read in the official promotional material, released by United Feature Syndicate, that Ma Cinders treats Ella "with all the harshness their relationship entitles her to."

Are all relations between them so bitter and mean? Of course there are two sides, even to Ella, and United Features thus explains the positive side: "She's spunky. And while she has many a setback in her career, she has—for everyone—a wisecrack to meet it with. . . . It is this courage of Ella's, this matching of every trial with a smile, that has won her, as a star of comics, such a countless following of fans."

The cast includes Ella; her stepmother, Ma Cinders; and Ma's two daughters, large and buxom Lotta Pill, and small and sour Prissie Pill. The characters arrayed on Ella's side are her father, Pa Cinders; Blackie, Ella's brother; and her husband, Patches. These three can hold their own against the in-law coalition, but for the sake of plot, they very seldom are all together at one time; therefore you usually have one against three. The code of the strip demands that Ella can "lick" her two stepsisters, but she can't "lick" her stepmother. When Ella is battling alone, she is reduced to a state of peonage.

At one time Ella says to her father, "Oh, daddy, why did you ever marry that woman?"

Daddy answers, "So you've begun to wonder too! Ella, the only reason I married her was because when we first met she seemed to take a dislike to me and I wanted to show her she was mistaken!"

Another human ambition doomed to failure!

Charlie Plumb does the drawing of the strip. He likes to travel, and for a while did the strip from a South Sea island. Plumb, like those other lazybones of the comic-strip world, Milton Caniff and Mel Graff, does his best to perpetuate the idea that he is the laziest man in the business. This must be a fixation on the part of comic strip artists; possibly it is a ruse to prevent people from realizing how hard they do work. But the argument grows a bit thin when you once know how much work goes into a weekly set.

Bill Conselman lived in Hollywood and did his writing from there. When Conselman died, Fred Fox, assistant to both the artist and the author, was given the chance to write it. After three years he convinced the

Syndicate that he could handle the job, and was given a by-line. And so, with the rolling pin of the stepmother softly waving in the evening breeze, we bid adieu to "Ella Cinders," the plain French doll.

While we are riding on the French-doll cycle, it is well to point out that it could go only so far before it reached its absolute peak. This peak was "Betty Boop," a creation of the Max Fleischer Studios, who *was* a French doll. She was the ultimate of the type, a reductio ad absurdum, a thing of enormous head, huge doll eyes and tiny twinkling body—reminiscent of those first comic dolls of early days, Lulu and Leander. "Betty Boop" was introduced in the animated field and found her way into the strips, had a fairly short run and "booped" off into oblivion.

After Betty it was impossible for strip girls to become more "Frenchy," they could only travel away from that influence. The influence was still strong, but other features started to appear. Lillums, Harold Teen's girl friend, was still from the same source, as was Dumb Dora, but a new and delicious curve is now about to start in the graph of strip girls; we have arrived at a point where a blending of influences takes place. Take the basic fascination of the French doll and modify it so that the girl is less of a caricature; add personal warmth, humanity and a dash of adventure—enough to be assured of a very feminine reaction—above all, keep to a picture of what a nice, good girl is really like, and you will have the delicate balance which is presented in the strips by two such: Boots and Dixie Dugan.

We would like to write about beautiful Boots now, but we have a special niche for her, and pass on to consider the dark-haired rival, who could give her a close run in a charm contest.

Smooth, that's Dixie Dugan. Yet too sexy, too attractive to need to wrap herself up in the spinach of smartness, even if she could afford it. A normal, balanced kind of girl, a very sweet, dark-haired flower blooming on the comic bushes of the American middle class. Her neat piquancy is difficult to analyze, being a quiet blend of lipstick and heart, but one thing can be said of her which makes her leap out of the page towards you, and which gives her a stellar place among comic women: she is herself. Not a type, Dixie is one, particular girl. Her heart-shaped face, with its high cheek bones and the dash of Creole in her dark, tilted eyes and straight expressive eyebrows, is all her own and breaks sharply with the doll tradition. La Vie Parisienne was all very well, but it is refreshing to have the company of a heroine who, for once, displays a trace of reticence and refinement. The great success of Dixie seems to show that these latter qualities are not unappreciated by Americans.

There are two episodes in the story of the creation of this strip which

FIGURE 42. The great thing in "Dixie Dugan" is the personality and charm of Dixie herself, here clearly presented on April 25, 1947.

will be news to most Dixie fans. First, their home girl was originally conceived as a high-stepping basker in the lurid light which bathes, but does not necessarily wash, the vaudeville chorus; second, she owes her very existence to a curious bit of assistance given her by the big-hearted Joe Palooka, Ham Fisher's famous fighter on all the fronts. To understand these items of Duganiana, we must know something of the girl's team of creators.

J. P. McEvoy, writer, and John H. Strieble, artist, met during a mutual working phase of boyhood. Strieble, fourteen, and a Notre Dame freshman, had landed a job doing current event cartoons on the South Bend *Daily News*. Another freshman from the college of fighting Irish had become an office boy on the same paper. McEvoy was fifteen and the two struck up a

rare and happy partnership which has lasted throughout their busy lives. Both graduated, both became individually successful: Strieble in advertising, fashion, and commercial art, McEvoy in newspaper work and movie plotting. The old days at South Bend held them together, and when McEvoy got his big break—a chance to do a new Sunday feature for the Chicago *Tribune*—he brought his pal to that paper to illustrate his opus, which was called "The Potters." Later on Strieble began a strip of his own, "Pantomime," which had a life of six years; but when McEvoy landed an important serial story in *Liberty Magazine* Strieble was his illustrator once more. This story, "Show Girl," found its way into the movies and made a hit; it was natural that when the McNaught Syndicate suggested a strip based on it, Strieble should have been the man back of the pen.

"Show Girl" began during October, 1929, but here the team struck a not-so-comic snag. Despite the fact that, following editorial advice, the new strip soon dropped the chorus-girl angle and the name was changed to "Dixie Dugan," sales to the papers languished. Some of the very best strips have had starting-trouble. Despite all charts, studies, and popularity surveys, the public remains inscrutable when it comes to new reading and looking matter. It may be captivated by that delicate, misty thing called personality and led around by its big nose for many years, but no one can tell in advance precisely what will bring this happy result about. Dixie needed a friend. Luckily for her the cartoonist, Ham Fisher, was in town.

Ham Fisher was bursting with ideas about his new fight strip, "Joe Palooka," and he had a job with Dixie's syndicate, McNaught, a move in the game of putting "Palooka" over—for the syndicate was cold to "Joe." Fisher believed passionately that "Joe" would sell, and had determined to prove it by selling it himself. First, however, he had to convince McNaught that he was a salesman. They gave him the languishing "Dixie," which at that time had only two papers on its list. Fisher, his own career hanging by a pen line, was back in New York in forty days and "Dixie" was established in forty papers. Almost at once the public growled quietly: "Swell. More." "Dixie" was made and has stayed so ever since.

The art work on "Dixie" is adequate, but unremarkable except for Dixie and her girl friends. Perhaps the unstylized backgrounds and extra characters help to throw the spotlight on Dixie, who is drawn with real feeling, and whose face expresses delicate waves of emotion, or the control of it; something most unusual in the simple medium of comic strips.

Another strip girl who appeared constantly before us apparently owed her popularity to the intense interest in the subject with which she was associated.

"Gentlemen, it will cost millions of dollars! Well, anyhow $250,000!"

A. G. talking, in the glittering celluloid comic strip, "Olly of the Movies," by Julian Ollendorff. Whether this strip truly represented the movies will be a matter of controversy. Those who feel superior to the movies were given a chance to indulge their feelings with Olly, for this strip didn't apologize; it showed the wooden framework behind the sparkling false front, and dripped with glamour. The most ordinary objects were drawn with a phony liquid shine not caused by the real light of the sun, but by the highly artificial brilliance of an elaborate set of spot-lamps. Even the men, with their sticky eyelashes, seemed always in makeup, and it made no difference what their occupation—sailors or cops, their hair was always shining with "stickum," and you could smell their manly perfume ten feet from the local paper.

Olly was the conventional figure who had throbbed her way through many a tense mile of flickering film: the good girl, the honest heart beating bravely amid Broadway's cruel, tinsel setting. In spite of this plot cliché, many people did like that girl; they felt there was something nice about her, and that was that. Perhaps they admired the fact that Olly could remain, year after year, surrounded with such luridity and still be a really nice girl. The truth was that Olly had a strong zest for life and a strong stomach, although very little of it showed in her figure.

She and Hollywood had a long run in the New York *Sun*, retiring from the papers in 1946. Ollendorff is creating a new strip.

The girls we have been talking about were especially designed for the strips, but coincidently there was another strata of printed "lovelies" developing, whose special habitat was the magazines and the newspaper magazine sections. Since several of these spilled over into the strips we will look at them—noticing that to look at them defines their purpose exactly; to attract such looks is what they are supposed to do in life. These are not Dixies or Bootses; the element of personality is missing. These are decorative objects, decorative, indeed.

The creation of the lithe, full-breasted, long-legged American girl-goddess, who inhabits so much of our printed looking-matter, owes much to the famous illustrator Russell Patterson. Patterson has been in the field a long time and is a smart, able draughtsman with one of the liveliest and most artistic styles in black and white that America has seen. The Patterson girl has been everywhere; in the newspapers she was especially prominent, romping in color in the *American Weekly*. Patterson has been an inspiration to many commercial artists, and we would speak of him more fully if his work were strictly within our field. We do have, however, a comic artist who invaded the girl field, and whose work adds something even to the Patterson style and snap: Don Flowers.

Flowers has about the finest line ever to be bequeathed to a cartoonist. It dances; it snaps gracefully back and forth; the touches relate. A great many of us cartoonists envy this ability and try to imitate it sometimes. Usually in vain. Back to our plodding outlines we go, humbler for the attempt. Trying to discover from Flowers the origin of this beautiful line revealed something the writer long suspected; it was born in the guy. He writes about his early days with an attractive modesty:

"I attended Harry Woods' pantograph School of Art, otherwise known as the Kansas City *Star*, for five years. A few other graduates of the joint

"He is inclined to be a bit fickle!"
© King Features Syndicate.

"I left the room—they said they were going to kid the pants off George."
© AP Newsfeatures.

FIGURE 43. Don Flowers originated "Modest Maidens" for the AP, now draws "Glamor Girls." Jay Alan has done a brilliant job of carrying on the original feature.

are J. Machamer, R. L. Lambdin, R. Van Buren and the late Ralph Barton.

"My formal 'art' education consisted of six or eight sessions at Ken Chamberlin's weekly class in the Village (New York), a few years back. The boys would all chip in on the model, see, and the models were invariably not worth it. They were unsylphlike.

"Any claim to fame I might have I owe to diligent swiping right and left and staying sober at the drawing board. That I'm an ardent admirer of Gilbert Wilkinson, R. Patterson, and Garret Price is no doubt apparent in my own efforts. (Confession is good for the soul.)"

Maybe—but we can't see that Don swiped that line from any one— except perhaps the ancient Chinese.

Flowers's big chance came with the Associated Press. For years he turned out two of its features, the panel, "Modest Maidens," and the comic strip, "Oh, Diana." When the Associated Press brought out a full-sized color section, something had to give way in the Flowers schedule, and it turned out to be "Oh, Diana." Several artists have handled the latter strip since, among whom are Bill Champs and, lately, Virginia Clark, who has proved that a woman cartoonist can turn in an excellent job. Her style is different from that of Flowers, relying less on pure line, but it has its own vivacity.

The Flowers girl is a long-legged creation. There is a rough rule of proportion that is very useful for gals of this type, and that will instantly produce the long-legged effect. Top of head to waist, equals waist to knee-

© *AP Newsfeatures. Reproduced by permission.*

FIGURE 44. Virginia Clark's style has snap and vivacity, as shown by these three boxes from a 1947 daily strip of her feature, "Oh Diana."

cap or kneecap to floor. One, two, three, and you've got 'em. But of course you haven't got Don Flowers. The Flowers girls have a real rhythm running through them; they are, in this respect, somewhat more relaxed and graceful than the Patterson product, although the Pattersonites can claim a vitality and sparkle on their side.

In the fall of 1945, as the leaves turned bright colors, Don Flowers with his looping line and long-legged lassies moved over to the New York *Journal-American,* appearing in the Saturday color section under the title of "Glamor Girls." But the line still loops in the Associated Press color sections too, and the "Modest Maidens" are just as modest. This new version is one of the closest jobs of imitating an original style which comic history has to show. Jay Alan had understudied the "Maidens" before Flowers left; he had drawn animated cartoons for the movies and much staff art work for the AP. Even at that, it's a remarkable job he's been doing; he doesn't have to be modest about his maidens.

Both these girl-types we have been talking about possess a certain refinement. Sexy they are, and yet, despite every display, somehow they always do remain modest maidens. There is another important girl-artist whose work has invaded the comic-strip field, who also draws sexy girls. These last, of the same general proportions and type, seem to sweat with almost savage ardor. Their great turned-down mouths and intense eyes leap out of the page at you, and you can feel your hair sticking down on your forehead with the heat.

"Gags and Gals," by Jefferson Machamer, began in the New York *Journal and American* on February 14, 1937. Machamer, making his first newspaper bow with an entire page of dazzling, droopy-lipped "sexies," was no stranger to the American public. It was his art approach that kept the old *College Humor* magazine alive. Machamer's work was undoubtedly influenced by Russell Patterson to an extent. As far back as 1922 Machamer's stuff could be found in papers like the *Herald Tribune*. At that time his work was humorous, but it did not depend on pretty girls quite so heavily.

It could be said truthfully of the strips at one time that they were comparatively free from an insistence on sex. This can no longer be said. Strips, like other popular expressions, responded to the general loosening of the strict, old moral codes, and one can trace a warming-up process from quite a way back. In addition to Machamer's tremendously hot, sweating women, there was another group of ardent females who carried this warmth into the heart of stripdom, and these stemmed from the movies, from the appearance of a group of heroines of a certain type, high cheekboned and sophisticated, such as Greta Garbo, Jean Harlow, and Marlene Dietrich. It was inevitable that a wave of pulchritude of such popularity should move into the strips, and it was the smart Milton Caniff who led in the new type. The Dragon Lady and Burma were frankly adventurous women, out for what they could get; but they fitted in with the spirit of the time, with a certain desperate gaiety of our age. These were not family women, but there was more than a hint of intense warmth concealed under the surface, ready to leap out for the right man.

This type of girlie was at her peak during World War II. She rose from the boxes of "Terry and the Pirates" to settle with a flick of cigarette ashes in many another strip, and in a number of new strips which reflected the popular sophistication of that time. She was also the perfect heroine, or vixen, to translate the radio soap operas, which were sliding all over the place in those days, into picture form. A later chapter, "The Smart Set," will look at these hollow-cheeked smoothies.

Some people got a little tired of strip women during the last war.

Except for the normal old favorites, we seemed to be inundated with the smart set type; those jawbones, that smooth black hair was everywhere, and there seemed little relief in sight. Yet at that very time, an entirely new group of strip lassies was getting ready to invade the "funnies."

These women were right under our noses and we didn't know it. They were sitting in our parlors, strolling past our windows headed for the drugstore. Not only were they, as a group, about to crash the "funny" papers, they were to invent a new art pattern, throw musty traditions out of the window, and furnish a new twist in this story of styles in women, which is one of the heartening notes in the history of strips as a whole.

"Good news, ladies! My cousin Kate went home this morning."

© *King Features Syndicate, Inc. Reproduced by permission.*

FIGURE 45. Typical of the bouncing, dreaming, swooning bobby sox comics is this but awfully romantic fragment from a 1947 "Teena" page, drawn by Hilda Terry.

The ladies: "Wow! Let's go find the fellows, quick! Maybe we can catch some on the rebound!" The agitated conference of the ladies displays the fascinating stage of ladyhood at which they have arrived; they are hard buds. The pink, lovely petals are there all right, but all wrapped tight together, as the story goes on to show.

"Where'll we go?"

"My house, natch, as long as they don't know she's gone, they'll all be coming there looking for her!"

The boys (or rather men—how else describe these snappy teensters?) arrive, a solid block of them, and the girls, having trapped them with the suggestion that they wait for Cousin Kate in the parlor, decide to wait before tackling them—"until we have six, one for each of us."

Rrinnnng!

"That's six, now!" Four hours later. You see the row of the boys feet in the distant parlor, the hands of one holding a book, another looking at a

record. Outside in the hall the wilted group of little girls look pathetically young, their arrogance and assurance gone. "But *someone's* just *got* to go in there and start talking to them! We can't leave them alone *forever!*"

This Sunday page from Hilda Terry's "Teena" is a type plot of a block of new teen-age comics, which arrived en masse, like the boys, and are being royally welcomed in our contemporary "funny" prints. The whole thing started, of course, quite a way back, as the age of swing pulsed rhythmically over America, and the voice of the Crooner was heard in the land. A wild laugh strip of a highly specialized character, "Silly Milly," was perhaps the first to capitalize entirely on the bobby sox era; but this, while strictly solid, was a burlesque, and left an opening for a realistic picture of the new race which was upon us. For millions of Americans discovered that they were growing older when they first realized that, although their children's mouths were moving, they couldn't understand a word the kids were saying.

"Teena," like "Henry," originated in a panel that ran in the *Saturday Evening Post,* and now is a King Features feature, a star of the Saturday color section of the New York *Journal-American.* Hilda Terry is like her strip. She is cute and young-looking; she knows young girls at first hand and her drawings of them have an uncanned, juicy quality, like asparagus tips fresh from the garden. Her New York career began, when she was seventeen, with two years as a waitress at Schrafft's. Then came fashion illustrating at the Art Students' League, which was dull to her humorous pen. The next was marriage to a cartoonist, Gregory d'Alessio. One day a fourteen-year-old cousin came for a visit—and the idea of "Teena" came with her.

Harry Haenigsen had a big part in starting bobby sox comics. He began "Our Bill" in the *Tribune* on March 6, 1939, a date which is simply remote, if you know what we mean. Then, when the paper decided to drop "Betty," Haenigsen was asked to develop a new strip with a girl character and we got charming, lively "Penny," one of the newer and brighter spots in the comic picture. There is real action and joy in "Penny." Some critical young people suspect that the main purpose of such strips is to educate oldsters; they doubt whether they are amusing to the teen-agers themselves, except to illustrate how far out of touch with the teen-agers the writers themselves are. Not all of them, however, seem so hyper-critical. Haenigsen keeps his ear open to young drugstore talk, which he picks up, interestingly enough, not in a big city, but in the small towns of New Hope, Pennsylvania, and Lambertville, New Jersey, close to the farm which he operates and on which he draws his strip, at night.

For the teensters who are almost out of it, the *Journal-American* and

King Features offer "Etta Kett," by Paul Robinson. Etta is a fine, gangling girl, really good-looking, whose specialty is to be shown in floppy, running poses.

Marty Links's lively "Bobby Sox," which is released by the Consolidated News Features and appears as a panel in the New York *Sun*, has also become an effective color comic in the Sunday edition of the New York *Mirror*, and appears in many other papers, including the Boston *Globe*, Detroit *News*, Washington *Star* and Philadelphia *Bulletin*.

Taken as a whole, this group of strips has created a very special comic style, and this is one of the best our history has to show. Realism is there, but it is more in the bright freshness of the subject than in dull literal details. Perspective is there, but again, subordinate; for the chief thing in these strips is humor, fun, the sense of life and excitement—something very close to the main object and purpose of comic strips. It seems that this group of artists has arrived at a set of conclusions about certain points of style which are appropriate to the strips, with their special need for reproduction on rough newsprint paper: a clear line, simple spots of telling black, and an uncluttered layout with plenty of open spaces to rest the reader's eye.

Of course one criticism is often made; they all look alike. Haenigsen, as creator of this style, must be credited with originality; the others have shown little, although the girls in "Bobby Sox" do have an unusual way of dropping their mouths wide open. In fact this particular strip is more interesting in visual humor than the others.

However, a successful strip almost always leaves a certain opportunity for duplication in the other papers, until the saturation point is reached, which might arrive almost any day in the world of bobby soxers.

One thing, however, we are not likely to become saturated with. This is the normality, the freshness, the health of this latest group of strip girlie girlies. If these buds are about to become women, and with extreme rapidity, we feel confident that they will not become dangerous or vicious ones; they are more likely to grow up to resemble Blondie, or Boots, or Dixie Dugan.

The various critics of the strips might well look at them. And come to the conclusion that the comic girlies have turned out very well indeed.

Chapter XI

WITH MALICE TOWARD NONE

Now we have the happy task of tracing what is probably the most important thread in comic-strip history; for if this thread began with an appearance of innocence and simplicity, it has ended by tying in cartooning to the whole pattern of modern man's life and education. Furthermore, in this romantic story strips will be shown to have contributed to the development of a new language which may unite the world, and which had its origin in the little animalistic laugh-stories we will consider. We humans have been indebted to animals in very many ways since we first started our climb to civilization. It is curious that through them we may be, in this, their latest service, better able to live together as human beings.

In addition, we are indebted to animal comics because of their principal purpose of giving our children healthy entertainment; and we shall see how well this job has been performed and to what extent these gay little animals are embedded in the kids' hearts. We can reveal some recent facts here which may help to illumine the future, and we will find some interesting parallelisms as the comic years roll by with their recurring cycles: old strips which relate to the new, and things said in animal strips which echo, or anticipate, conclusions in other fields.

Animals are as natural to a child's world as humans, who often seem to them to be remote and to behave foolishly. From the first we have funny animals in comic strip history, because children use their bright, new imaginations on animals as soon as they discover the wonderful trick of superimposing one mental image on another. As it was in the beginning, it is now and ever shall be.

Swinnerton's "Little Bears and Tigers" was an early example of this; the color Sunday sections, which were the comic strip matrix, swarmed with both straight and fancy beasts. Children are modern artists with a taste for surrealism, and so we find, back in the first decade of the twentieth century, truly fantastic goings-on, long before the American adult world had awakened to the fun of kicking literal things around. Verbeck's "Terrors of the Tiny Tads," for instance, which was running at this time in the New York *Herald*, has its spotlight on the crazy animals which inhabit the

Tads' world, and which are obviously ancestors of the later comic zoo, as well as good prehistoric Dali. This is one of the most interesting of our parallels, or rather prognostications. Modern art was practically unknown in America in that time, and only partially developed abroad. Imaginativeness, combining things into new patterns, was to become one of the central interests of surrealism later, yet in these old comics we have an abundance of it, wild enough to satisfy anyone.

Examples are the Emunicorn, an ostrich with a foolish mule's face and the horn of a unicorn, and the Hippopotamosquito, a flying hippo complete with mosquito wings, feet, and stinger. Verbeck did more than combine animalisms; he fused the animate with the inanimate, with results such as a rhinoceros which is also a rustic seat and can carry a load of Tiny Tads very comfortably at full gallop.

"The Naps of Polly Sleepyhead" offered talking frogs, and of course there was Tige, the great and famous talking dog in "Buster Brown," who is the legitimate ancestor of Gorgon, the talking dog of "Barnaby." Perhaps few people will remember that there was another heroic duck who, anticipating the famous Donald Duck, assumed the mantle of man's joys and sorrows. This was "Johnny Quack," also a New York *Herald* Sunday page, to be seen about 1910 and drawn by C. Twelvetrees, a well known cover artist of the time. Quite a Disney-like duck was Johnny Quack, with many different facial expressions, abbreviated clothing, such as a Scotch bonnet, white collar and flowing tie, and a way of using his wings like arms, folding them across his breast as he looks out of the corners of his languishing eyes.

The *Herald* had started its color comic section with a galaxy of humorous animal features of the type we have mentioned, but by about 1915 the *Herald's* comic emphasis passed to the new theme of family life with such comics as Russ Westover's "Snapshot Bill," although tots and fairies hung on with "Pinheads" by A. E. Hayward, and "Mr. Tweedeedle" by John Gruelle, a nice little half-page with a kid called Dickie and intriguing fairies.

To follow the animal theme we must move over to the New York *Tribune,* where one of the oldest and most famous of all comic animalisms, "Peter Rabbit," by Harrison Cady was flourishing. This is such an innocent, simple-looking comic that we wonder at its immense longevity, for of all the strips that were in the first issue of the *Herald Tribune,* only "Mr. and Mrs." and "Peter Rabbit" are left today.

Of course one explanation of this is the advancing army of very small citizens who perpetually surge forward looking for "funny" pictures or to have their mummies read to them, and if there are perpetual gaps being left

by graduates who find "Peter Rabbit" but awfully dated, there are perpetual replacements who toddle forward to fill these gaps.

Another explanation, perhaps, throws light on why the parents themselves are entertained as they read, and brings up an interesting historical point about this page. Peter himself may be a rabbit, but more precisely, he is one of the earliest American comic business fathers, worried sick by the stresses and strains of his life; he is an exceedingly Republican rabbit, forced to make out needless reports on his business. (One feels that at a certain period there was a Great White Rabbit in the White House.)

The interesting parallel drawn by this strip is with other comics which have human beings for actors, for "Peter Rabbit" early exploited the famous comic man-and-wife situation with which we were all to become so familiar;

© The New York "Tribune," Inc. Reproduced by permission.

FIGURE 46. This "Peter Rabbit" fragment is from a Sunday page which appeared February 10, 1946.

indeed, this page, despite its outward difference, has a deep generic resemblance to its newspaper mate, "Mr. and Mrs."

One day, dancing down the little road away from his house, Peter was laughing, full of health and spirits. Had he gotten a refund on his income tax? Not a bit of it. His wife had wanted him to take care of the babies while she visited one of her charities, but he had pleaded a high fever—he looked awful—pointed out that he must have air—and here he was, his escape made good. Of course, in the great tradition, his grim wife catches him at last.

On March 8, 1931, another very innocent-looking page appears in the New York *American* which was to initiate another very successful animal comic. "Dolly Dimples and Baby Bounce" was by Grace G. Drayton and was also addressed to the more roly-poly among us, but the characters, at first, were children. It was Cumfy, a round-headed, very soft and really

cute, white pussy cat who stole the page, however. Cumfy was everything the very small child longs for and wishes to sink its tiny fingers into.

The next year "Dolly Dimples" dropped out of the *American's* color pages, but as of May 12, 1935, the Cumfy motive reappears in a page devoted entirely to little round, squeezy animals and called "The Pussycat Princess," a page that is still with us, distributed by King Features Syndicate. Although still drawn by Grace G. Drayton, it was now written by Edward Anthony. Ruth Carroll later became the artist, but the character of the page remained much the same, a dreamy tale of little animals who are half fairies. In the central Princess theme, one can recognize the old fairy-

© *King Features Syndicate, Inc. Reproduced by permission.*

FIGURE 47. This cuddly lead-off box is from a cuddly Sunday page of March 30, 1947.

tale heritage, but in such conceptions as a Chimpanzebra who, being fed up with the jungle, decides to let the Princess and her retainers capture him if they will build a modern zoo, we remember the composite imaginations of the "Terrors of the Tiny Tads." There is another, still more definite influence at work, too. A really fine-looking page shows the winged horse Pegasus teaching her little one to fly—and this suggests Walt Disney—but before we come to his animals we have several others to look at.

There is a fabulously famous group of animals which have come to mean America to millions all over the world, and the majority of these are cats and mice.

There was Krazy Kat, Herriman's dreaming incarnation of the innocent, loving spirit, with his or her opposite, hard, practical Ignatz Mouse. There is Cicero's cat, a striped skin drawn over a funny personality, which plays

lower page to "Mutt and Jeff." There is Mickey, the gay, cheerful mouse, and one more of the same tribe. This last is a Mickey-like personality, or at least he is Mickey-like in appearance; he is "Felix the Cat," a King Features comic.

"I am the cat who walks by himself, and all places are alike to me." This immortal description of felinity, from Kipling's story, "The Cat Who Walked," shows why Krazy Kat was so Krazy, for poor Krazy didn't want to walk by himself at all. By this standard, Felix is a more catlike cat, and conforms to Kipling's general picture of an essentially wild being, who is yet smart and practical enough to appreciate the superior comforts of

© *King Features Syndicate, Inc. Reproduced by permission.*

FIGURE 48. The question posed in these three boxes of a 1947 "Felix the Cat" strip is answered in the fourth. "This," cries Felix, jamming the empty cone on the mouse's head.

human living arrangements. The first Felix page that appears in the *American* on March 8, 1931, gives a clue to Felix's practical abilities and a hint of the gay humor with which it has consistently entertained its readers.

Poor Felix spends much time looking longingly for a home. In one of the best of his imaginative schemes, he connives to have a farmer break a window by driving a golf ball; Felix then glues the remainder of the golf balls together, forming a pole, which he climbs, and goes contentedly to bed, with the very fine detail that he detaches his tail and hangs it neatly on a nail in the wall. The bed has four shoes on its feet.

Felix (again following the cat in Kipling's story), takes good care of the babies when he is at last admitted to a respectable household, but his treatment of humans reveals a certain calculating quality.

There have been some great comic dogs: Orphan Annie's big Sandy, all of Edwina's (hers the most truthful); Pluto; Gorgon, Barnaby's talking

"pooch" who tells Shaggy Dog Stories—and many more. Above the "yips" and "yipes" and "arfs" of the comic kennels, however, one deep, great voice lets out an occasional authoritative roar; one huge head towers up, mounted on a long, scraggy neck. True, this giant "pooch" is not widely syndicated, compared with certain of the others, but the deep devotion of his fan-millions compensate and proclaim him the king of comic canines. He is Napoleon.

Nappy's secret of success was well exposed in the December 4, 1944, issue of the magazine *Life*. It seems that it is cartoonist Clifford McBride's fascinating custom to pose himself for Napoleon. One look at the flexible McBride face, as shown in these pictures, and Napoleon's grip on your emotions is clear as a well chewed bone. Emotion displayed by others produces emotion in ourselves. Of course dogs are very expert in displaying emotion so as to produce certain desirable results upon their masters; but we, being humans, are more sensitive to human expression than to dog expression. Put a human range of expressions into a dog's head, therefore, and you've got something. And with 250 pounds of dog (Napoleon is an Irish wolfhound) the entire effect is magnified to the point where one is swept away. McBride arranges his whole strip around this winning gnaw at the heart.

We sympathize with the underdog because of a hard position in life which is not his fault; in Napoleon's case we are sympathizing with an upper-dog for the same reason. His enormous size and naturally limited dog understanding get in the way of his attempts to carry out the Golden Rule, which is the purpose back of his lanky, well meant life. He is no pacifist about it; he conceives of himself as a Heaven-sent instrument of justice and applies his terrific force where he considers necessary. This usually results in his master Uncle Elby having to pacify his neighbors or pay whacking fines, and means that cartoonist McBride very often has to screw his face before the mirror into a new expression of doleful and frustrated embarrassment.

"By golly, a good Camembert cheese is hard to find these days. Old Bill Ortman sent that beauty over, Napoleon, and I can't wait to try it with some Russian rye and green onions." Uncle Elby is probing into his kitchen closet while Napoleon is taking a sniff at the cheese in question as it lies on the kitchen table. His face expresses horror that such an offending object should be allowed to smell up his master's clean kitchen. Box two of this tragedy shows enormously portly Uncle Elby, having put his rye and green onions out on the table, suddenly getting the full impact of the fact that his dear cheese is gone. Through the window, far away, we see Napoleon burying that foul object as fast as he can.

© *LaFave Newspaper Features. Reproduced by permission.*

FIGURE 49. This is a book illustration rather than a strip, but it shows why Uncle Elby, his dog, and creator McBride's humor are so popular when combined in the comic strip "Napoleon."

This is revealing of Uncle Elby as well as of Napoleon. Elby is the coziest thing in comicdom. He is all the fussy, slipper-loving, golf-playing, puttering, bumbling old bachelors rolled together into one enormous ball. He is neat, likes to do his own work; he likes especially to put on his chef's costume and dispense culinary largesse with an accent on the large. The one thing Uncle Elby cannot tolerate is interruption of his sacred routine. As a result, he has 250 pounds of leaping, drooling, wagging interruption every day in the week, for creator McBride understands plotting exceedingly well. You set up some aim for your hero and then prevent him from reaching it. For example, Uncle Elby is varnishing his floor and smugly congratulating himself that this time he has figured it out so that he won't varnish himself into a corner. Just then a closet door swings open in a highly sticky corner of the room, with Napoleon's huge, lugubrious head showing inside. He's been tied up so that for once he couldn't get in the way.

This is one of those sturdy old strips which have been extant for quite a while and have hardly changed in appearance. Clifford McBride, Minneapolis-born, was reared on the West Coast, in Pasadena, where he still works. He had useful experience on the Chicago *Tribune* and Los Angeles *Times*, and also worked with McNaught's Syndicate and King Features. "Napoleon" first appeared in June, 1932, with a small list of papers, but grew rapidly in public esteem and in 1934 became a part of the enlarged comic page of the New York *Sun*, where it has since remained. In 1941 the strip wagged its way into Hollywood, and a good movie job was made of it, adding the final proof of the basic soundness of its appeal. It is distributed by La Fave Newspaper Features.

The art work of Napoleon has a distinctly dated quality; the sharp, rapid, crisp penwork and the clever mannerism are echoes of the Flagg-Gibson period. But this is hardly a criticism. Uncle Elby is of that period, something very comfortable and conservative, the way most comic-strip readers were in those far-off nostalgic days. Millions of people, for a long time to come, will enjoy dreaming over the unrationed rotundities of the past.

Is there a real Napoleon, a real Uncle Elby? Yes. One inspiration originally came from McBride's uncle, Henry Elba Eastman, a Wisconsin lumberman. Mr. Eastman enjoys the part, although he has lost eighty pounds since the old days, and doesn't look like the prototype of Elby any more. There have been two actual dogs named Napoleon in the McBride household, although McBride is said to be more a student of mankind than of dogs. Perhaps it is true. For this is another parallel between animals and men: McBride's strip-Napoleon is really a version of the Don Quixote theme, a blundering spirit in search of the heroic and

good, who usually only succeeds in upsetting all the neighbors' paint pots.

We will find, in trying to determine who started what in the comic world, an interweaving of influences which makes it very difficult to ascribe pure originality to anyone. But fortunately, in the case we are coming to, there is an almost universal recognition of the lengths to which cartooning has been stretched by Walt Disney. If he used techniques and ideas some of which, as we have seen, were established, he has proved his originality by doing things with them which were never done in any medium in the history of the world. Walt is a genius. If he has faults, so had Shakespeare. Although comic strips are the minor side of his activity, it makes a cartoonist-historian proud to be legitimately able to include his story, for he is one of the very few living men whose names may be familiar a thousand years hence. Walt Disney is the man who transformed the simple story of comic animals into what seems to be a world language, and if cartooning does conceal such a happy possibility, we can thank Walt Disney for having discovered it and put it to work.

Americans are fearful perfectionists. We want everything, and when some driving Yankee gets a new vision he'll worry the Fates until they give in. That is the way we developed a country and a national idea, and all the cars and Mickey Mouse. Mickey isn't only an American who has scampered over the whole world; he's Ford and Bill Kaiser and all the rest; he arrived in the classic way—empty-handed, only the big American shove making him go. Mickey is a comic-strip character and yet he isn't; he originated from the strips and yet he didn't. Paradox or not, his story is tightly woven in with their story.

Walt Disney was born in Chicago, December 5, 1901, of true American blood—Irish, Canadian, German and American, all mixed. He didn't like school, it seems; didn't finish high school. No "art" for him: he naturally thought of drawing as cartooning. He arrived home from World War I with his future undecided. However, he decided to decide it, chose cartooning and worked at night in the Chicago Academy of Art.

Then came the well known tap of fate. Disney answered an ad by a company that made slides, was accepted and thus worked his way into the animated moving-picture industry, which was already well established. Once involved with cartoon animation, Walt was settled in his career; he seemed to see it ahead of him.

Laugh o' Grams, his first film, was ordinary, but at least it was his own, and Walt Disney took himself seriously. Content only with being his own boss, he burned his bridges and went to Hollywood where, in August, 1923, he had a tremendous break—his brother Roy signed on as business partner.

Roy was extremely talented in his own useful way, and Walt was able to spend all his time swinging at the creative part. An epic of business! The Disney Studio started with a capital of $280, of which $40 was Walt's and $240 Roy's.

The title of the first picture Walt produced on his own was *Alice in Cartoonland*. It was a crude job, with a real actress as Alice superimposed on the cartoons, and it caused the onlookers difficulty in adjusting their eyes to the film. Still, there was Disney in it. The mission, the purpose of his work was clear: he was to dispense the innocence of childhood to mankind. In this first picture, too, there was a hint of the style, peculiar to him, of using tried appeal in imaginative new forms, as well as a decided hint of the artistic dilution that the old classic masterpieces of childhood would have to bear in the process.

Alice made a hit. The tiny studio almost burst with its contract for sixty pictures, to be released one a week. But Alice didn't content Walt; she wasn't his own character. Funny animals had been very successful in the strips, and that was what Walt was after, a personal, funny animal. He concocted a fairly good one: Oswald the Rabbit. Like his Alice, Oswald caught on, and Walt's mind billowed out with a cumulus cloud of schemes for the development of his rabbit and his studio.

Here he ran headfirst into a situation that pleased his independent nature not at all. In those days the central production agencies in New York ran the animated cartoon business. You worked through them, or you didn't work. Walt had come to New York to renew Oswald's contract; he wanted financial help to develop the new techniques with which his fingers were itching. Not only did the New York people turn him down, they refused to renew his contract. Disney had butted his head hard against a system that was not devised to stimulate creative effort. He had, it seemed, lost more than his contract. He had lost his rabbit. For Oswald did not belong to his producer at all. Someone else would go on turning out Oswald. Here was a stew for Walt Disney with not even a rabbit in it.

The classic American touch in this story is this: Walt just wasn't made to be stepped upon. On the train going back to Hollywood he decided to buck that system—with a new character of course. It wasn't all inspiration; it was partly the memory of certain old days when a tiny, squeaking somebody ran along his drawing board in a charming, friendly way, and it was partly elimination; but somewhere on that ride, the legend goes, a little black and white party with big round ears popped out of Walt's head, ran down his arm and waved a cute little white-gloved hand. It was Mickey Mouse.

Like Beethoven with his Fifth Symphony, Walt knew he had some-

thing. He and Mickey and Roy would punch holes in the animated cartoon game and a blast of revivifying air would surge through the holes and rejoice the public. It didn't work out so simply as that, however. Everybody seemed to like the looks of the first two Mickey "shorts," *Plane Crazy*, based on Lindbergh's flight, and *Gallopin' Gaucho,* in which Pete, the atavism, the "animalization" of evil, first appeared. Everybody liked them except those New York people, whose help was still necessary in distribution. The system didn't like this man who was trying to scramble up its rigid iron face, on his own. It was out to squash him.

© 1947 *Walt Disney Productions. Reproduced by permission.*

FIGURE 50. These figures were clipped from "Mickey Mouse" Sunday pages of 1947. They show the range of expression which has endeared this little character to millions of hearts.

Just then, however, as in a movie, fate reached over and pulled a trigger that exploded the whole "flicker" industry in a shower of frantic producers, heartbroken stars, and clamoring audiences. It was sound.

Al Jolson was rocking America with the miracle of his voice, cheerfully singing out of the gray quiet of those old-fashioned pictures. *The Jazz Singer* was the turning point in movie history. Again Disney was in New York, this time trying to peddle his Mouse to the system. As he listened to Jolson's voice he was struck with an idea. He proposed incorporation of sound in the third Mickey "short" he was then working on, *Steamboat Willie,* and the system, cracked wide open by the obsolescence of all its properties, suddenly gave in and grinned with a weary iron grin. Maybe this young man would rescue animated pictures after all. Back to Hollywood sped

Walt, this time with the cash in his pocket, and *Steamboat Willie* was introduced to America on September 19, 1928. It was a wild, rollicking success. Within a week it was showing at Roxy's in New York and Mickey Mouse belonged to America. This was the picture in which Mickey performed his famous improvisations on "Turkey in the Straw." Remember?

It isn't this book's task to trace the astonishing growth of Walt Disney's shiny new art form, but we must notice certain technical points, because they were what made Mickey take to the strips and because they have conditioned Disney's other strips, "Donald Duck," "José Carioca," and "Uncle Remus."

Before we mention these, let's give a whoop and hurrah for the big point that Mickey's creator has lived the kind of career that we Americans are most proud of: he has given us a new medium in which the possibilities are limited only by the blue horizon. Catching up with blue horizons is our specialty. This new medium is in the tune of an age and yet is devoted to an exposition of the ageless. For Walt Disney brought his subject into thousands of movie theatres, newspapers and toy shops throughout America, and it contrasts remarkably with the dirt, the hopelessness, violence and horror, which so many popular entertainers seem to think the people want. Walt's central subject is innocence. It is the preservation of the fresh, the youthful and the untainted, and if there is a better service an artist can render than to stamp such an ideal on growing children's minds, millions of us can't think of what it might be.

Returning to the story of Mickey and the strips, the important technical point is the new creative condition which Disney found necessary in order to carry out his work. This new art work broke sharply with that of the immediate past, where a single artist labored, and lo! there was a single drawing. All of this became obsolete in the Disney Studio where five, then ten, fifty, two hundred men and girls labored over Mickey, producing thousands, millions of Mickeys, all alike as peas. It was mass craftsmanship, partly similar to the work of the ancient artists and artisans on their cathedrals, who gave us the greatest mass art ever created by man. Then as now, this pyramiding of workers was enormously expensive.

Of course Walt could have rested at some point of his upward climb, but that wouldn't have been Walt. He was dreaming a fabulous dream. The Mickey "shorts" were preludes to the wonderful *Silly Symphonies* which, in turn, were preludes to feature-length animation. Walt gambled everything he had and more on *Snow White,* and won, hands up—and those hands were full of cash, too. But along this route was the continual driving need for money, more money. Walt needed every million of nickels he could rake in. This was why his practical little partner, Mickey Mouse,

took to the strips at first. He was and is out to help finance his boss's dreams. Mickey, of course, does more than earn pin money for his boss Walt. In his comic form, as originating with the Walt Disney Productions and distributed by King Features Syndicate, Mickey entertains millions of newspaper readers.

Some day there may be a pure white Mickey Mouse monument in Washington. If so, it will be because Mickey, a Columbus to Charlie Chaplin's Magellan, was the greatest pioneer in the new international language of the picture-thought, something that skips over every artificial boundary on earth and searches every heart, black, brown, pink or yellow. Where this new means of communication may lead it is not possible to say, but one may point out that it has been recognized by the United States Government in a number of ways and has helped to carry the message of Democracy to otherwise unreachable millions. The American people have now clearly indicated that they are prepared to take a part in world affairs. Little Mickey, sitting on Walt's shoulder, must chuckle sometimes, "It's old stuff to me!"

Donald Duck was one of the gang built around Mickey, and he had an edible-looking body and a crusading soul. You distinctly wanted to eat Donald; then you felt this great spirit in him and decided that you would rather watch him than eat him. The result was that Donald followed Mickey into the strips and chose New York to paddle around in, beginning in the New York *American* in 1938.

In his strip, it is Donald we look for; but the gags are often good, too. For example: Donald, with a ten-dollar bill, seeks change. The wind blows the bill down a sewer grating. Donald jabs dispiritedly with a stick. Then with a big grin, he brings up two fives! Beside such somewhat standard humor every now and then we come across those characteristic Disney flashes, the kind of imaginative thing that makes one sit up sharply with a newly washed soul.

Donald is drawn with the competent location of form in space which is to be found in all Disney art works. Having been done millions of times, every line has been divested of hesitation; it's all mechanical, precise, exact. Good action, remarkable expressiveness is there, and a simple decorative quality.

It's a very fine thing to stimulate good relations among continental neighbors, and from that point of view Disney's color page "José Carioca," which appeared in the New York *Evening Journal* in 1943, had much to recommend it. José was a parrot with an enormous bill-nose or nose-bill, who lived a comic opera existence among other bird people and doll-like women who were too stylized to be attractive.

© 1947 *Walt Disney Productions. Reproduced by permission.*

FIGURE 51. Here is a "Donald Duck" strip characteristic of much of Walt Disney's work in its gaiety and innocence.

José spent an enormous amount of time posturing and the page had a somewhat confused and indigestible appearance. Later, José was starred in the picture *The Three Caballeros* which, despite the dubious use of both real and cartoon actors, had moments of that strange and eerie beauty which has earned Walt Disney the right to be considered one of the

important artists of the time, perhaps the most so. Up to the present this quality of beauty has been characteristic of the Disney film rather than of the Disney strips; but with such an explorative genius you can't tell what might happen.

That moment in *The Three Caballeros* when, in front of the wild, blood-red landscape of Bahia, a dead-white parrot sails soundlessly out and circles around, who can forget it? Who can forget the fearful convulsion of earth-making forces in *Fantasia,* such a picture of boiling rock and metal as never man saw; something no literal report could give an inkling of. Could something of this sort invade the comic strip? It is quite possible. Of one thing we can feel sure in Disney's work: he will use symbols which we all understand. Perhaps in these last words is the secret of his importance. Many creative artists care little for the idea of communication with masses of people; Disney builds everything around this core of communication, and so earns the right to be called a people's artist.

It was shown that Disney had substituted entertainment with the subject matter of innocence, for entertainment with the subject matter of degradation and horror. The second point is that he is using this technique for man's benefit. It was World War II that made this clear. Before our entrance into battle, however, Disney was at work for America, and his activities have grown in importance, day by day. In April, 1941, Disney made a training film for Lockheed Aircraft called *Four Methods of Flush Riveting,* and the idea of teaching useful techniques through an entertainment medium registered at once on the New World as it prepared for war. Canada asked him for a teaching film on antitank guns, and *Stop That Tank* was the result. The United States Treasury called for help as it increased the tax load Americans had to carry; Disney used Donald Duck in *The New Spirit* to show 60,000,000 Americans why this was necessary. Other pictures followed in a stream. Many uses were being found for the new technique and no one can say where it will end.

Let's hope that Walt Disney will have a private studio very close to the core of the United Nations—they need him.

There are certain criticisms, from the purely aesthetic side, that can be made of Disney's work, especially of the early stuff: too much air brush, too much sentimentality, and not enough of the lasting structures of good design and good color. Yet the critics must remember that Disney is not working simply for them; the great mass of people like this dash of tripe. The wonder is that, despite popular demand, Disney has been able to create such stirring work.

In the beginning of this chapter we promised some facts about animal comics which might throw a light on the future, and here they are. In the

course of writing the history of the comic magazines, those fabulous little books that pass through the hands and heads of almost all of our young people, this writer questioned an authority on them about the new trends which might be expected. Almost all of the adverse criticism of comics can be traced to the comic book, and almost all of such criticism is of the lurid, morbid horrors certain of these specialize in. According to this authority, such criticism, from preachers, parents, and educators, was beginning to tell. Fewer horror books would be published in the future, he believed.

"And what," asked the writer, "do you think will replace them? Is there any type of subject which makes an appeal to everyone, to teachers, parents, children?"

"There is such a type. It is one, according to our recent sales figures, which is rising in popularity all the time, and which we depend upon for the future. It is the Disney-type comic book, funny, gay animals. Who could possibly object to that?"

Who indeed? Who could fail to see that children's minds need stretching as a young bird needs to stretch its wings; that Donald and Felix and Mickey and the rest are the ones to do it, or that funny animals are with us to stay, as long as a kid can laugh at a kitten in a pair of doll's pants?

Chapter XII

A WELL BALANCED PAGE

ONE of the nail-biting problems the comic editor of a big paper has to face is that of feeding a balanced ration to his readers. The public, lined up like so many seals in a zoo, weave their heads and wait eagerly for the strip-fish that are about to be fed to them. Each reader must be tossed his own special tidbit, for people are extraordinarily choosy about strips, which is another sign of the intimacy of the medium. Each has his own favorite and clings to it as women cling to their own type and color of clothes.

Of course one escape for harassed editors is to buy a group of strips, en bloc, from some syndicate. This means that it is the syndicate editor's job also, to worry about what constitutes a well balanced comic page. He is also one of those men who are apt to walk a little bent to one side from a habit of keeping one ear open to what the public, and especially the kids, are saying about comic strips.

A great many people, when asked about their strip preferences, will growl, "Comic strips—those awful things? Never read 'em. Well—of course I follow 'Boots' (or 'Li'l Abner' or 'Barnaby'); that's *different!*"

The editor's job is to see that every one of his paper's readers has his special strip appearing year after year, for that one strip is all that is needed to build a comic page that spans a wide variety of interests. Some of these groupings are so successful that the same page-mates appear year after year together. There is the group appearing in the New York *Sun*, dearly beloved by the conservative commuter; the *Mirror* group, the *Journal* group, and so on. One such stable of winners is so widely known, and has hung together for such a term of years, that we shall let them go on elbowing each other in the present chapter, though they belong in separate categories. This is the group of strips appearing on the same page in the New York *World-Telegram* and syndicated, with the exception of "Mary Mixup," by the NEA Service—a very good example of the balanced comic page with something for everyone.

The present chapter, therefore, will be a kind of editor's-eye study, considering newspaper and syndicate editors, for this purpose, as the same.

For dignity of appearance and general richness of content, it is doubtful

if any paper topped the daily morning issues of Joseph Pulitzer's grand old New York *World*. Studying it from the pictorial point of view, in the 1920's one is struck by the fact that, though so few, its five features were all masterpieces of the newspaper art business. How different from the jammed-together, war-shrunk art jobs of recent years were these huge drawings, each presented in full spotlight, each dominating its pages!

There was "Metropolitan Movies" by Dennis Wortman, of all newspaper drawing perhaps the most artistic; the political cartoons by Rollin Kirby, powerful and telling with daring use of white space and rich, loosely drawn figures; the gay, lively doings of Johnstone's panel; the human penetration of Webster, and—for we have saved it for the last, the grand and glittering "Mutt and Jeff," spread full across the page, gurgling with its low-down, supreme humor.

Some fragment from this last is sure to stop you as you speed through the old papers. Mr. Mutt at this time is a beauty specialist with an anxious, aging lady client:

"What am I going to do about those lines?"

Mutt: "Those are not lines, those are accordion pleats."

"Oh, Mr. Mutt, I'm so anxious to be beautiful. What do you advise me to do?"

"Change the subject."

Simple, but so satisfying!

Despite these fine features and the brilliant writing of such men as Heywood Broun and Franklin P. Adams, the *World*, in 1930, was losing money at an alarming rate. The young Pulitzers had made the mistake of raising the price of their paper in 1925 to three cents, in spite of the fact that the *Times* and the *Herald Tribune* were selling at two cents. The *World* of 1930 was a balanced paper, not conservative, not sensational; and it appeared that the public wanted its newspaper either one way or the other, a commentary on the problems of the liberal, who is usually kicked at by both extreme parties.

The Pulitzers were forced to sell out to the Scripps-Howard organization, owners of the New York *Telegram*, and the last copy of the morning edition rolled off the *World* presses on February 26, 1931. Many wept at the passing of this gallant paper, including the writer, who had had the privilege of being on its art staff, and who remembers with nostalgia those good old days, the tap-dancing of a certain red-headed office boy, the cowboy songs of the clever artist, Herb Roth; even the large, art-staff cockroach, whom we decorated with his name, "archie" (after Don Marquis), done in Chinese White on his back, and who, at his death, was solemnly buried in a little grave chiseled out of the plaster of the art-room wall.

The morning *World* was no more, but the evening edition was combined with the *Telegram*, the new paper, the *World-Telegram*, starting publication on February 27, 1931.

Three of the *World's* morning art features, "Metropolitan Movies," Johnstone's panel, and Rollin Kirby's cartoon, were taken by the new paper. Both the strips belonging to the *Telegram* and those of the evening *World* appeared, at first, in the *World-Telegram*, but this made a bulging comic section and it became obvious that quite a few artists would have to hunt for new strip-windows in Manhattan. It was at this point that the remarkable cohesiveness of one of these comic groups manifested itself; it was as if these five features had locked boxes together, determined to march through the years in each other's company. These strips and panels were the issue of the *Telegram* side of the combination, and comprised "Out Our Way," "Our Boarding House," "Boots and Her Buddies," "Wash Tubbs" and "Freckles and His Friends." Another *Telegram* strip, "Salesman Sam," which had replaced "The Bungle Family" in November of the preceding year, made a bid for survival in the new paper. It was a pointless, nervous, self-conscious burlesque, and soon was replaced in this paper by the much wittier and more attractive "Benny," by J. Carver Pusey. "Benny" had come from the *Evening World*, and was the only strip from that paper to attach itself to the *World-Telegram*, with the exception of "Little Mary Mixup" and "Joe's Car," which later, with the title changed to "Joe Jinks," now "Curly Kayoe," ran in a page by itself, where it is still to be found today. The other *Telegram* strips were all whirled off and either sank of their own weight or were taken by other papers. These included Haenigson's current-event opus, and "S'Matter Pop," "Bobby Thatcher," "In Animal Land," "The Puzzlers," "Little Napoleon," "Can You Beat It," "Cicero Sap" and "Looey Dot Dope."

The five *Telegram* strips, with the addition of "Little Mary Mixup" and "Benny," were the ones that made such a readable and various bill of fare, and when "Alley Oop" joined a few years later, the roster was nearly as it is today, the only change being the lamented loss of queer, shuffling Benny and the later addition of the rather ordinary-looking western, "Red Ryder."

As we study these eight starry strips in detail, we will draw eight morals from them. These will not be social but professional morals—the causes that have made them a success.

J. R. Williams's panel "Out Our Way" deserves the careful study of anyone interested in the strips. This queer, homy-looking little job has a gigantic syndicated circulation. Many of the faces look more like chipmunks than human beings, and the figures are drawn with a clumsiness

FIGURE 52. "Out Our Way" for January 1, 1947. This is typical of Williams's X-ray pen, which shows up with startling reality the structure of the American middle-class home.

that would be repellent if it were not so real. It is the realism that gets you in "Out Our Way," and the tenderness. One of the strongest points about this comic is that the tenderness never becomes mush. The delicate balance has the effect of stirring readers, after a hard day of work in the factory or on the farm, to carefully clip the little panels out and paste them away in bulging scrapbooks, as if they were family treasures.

Sentimentalism is given a hard tumble in this panel; for better or worse one is forced to look directly at some of the cold motives which underlie many actions of men. Yet there is a positive side to Williams's irony. If he shows you real people and their real problems, he also shows their real heroism, which is not less heroic because the object of his praise is apt to be the over-worked, weary mother holding her heart high among

such domestic problems as are suggested by one of his titles, "Why Mothers Get Gray."

"The Worry Wart," an engaging child with perpetually baggy shirts and pants, jam-smeared face, and tie at half-mast, would be another reason for mother's getting gray if Williams permitted it, but he chiefly bothers his older brother.

Williams also draws a Sunday page for NEA called "Out Our Way," which has to do with the life of the Willett family. The mother, father, brother and sister are all attractive but not pretty people. The sister is not a glamour-girl, but she has no dearth of dates. The brother is not intentionally mean, but his animal spirits keep things from becoming dull. It shows family life as it is, and it is not an unattractive picture.

Williams at seventeen entered an art school; but, thinking that he should get closer to life, he became a railroad fireman. He had a desire for real adventure, trekked West and soon was riding herd as a cowhand. The next step was the United States Cavalry; then the first World War came and he was really busy. After that, he was about to become a Canadian Mountie when a swish of skirts changed his career. Usually life makes you work for your love, and Williams found himself in a machine shop. The old drawing urge impelled him to make sketches of the humanities of the machine shops, and he finally submitted some of these to the NEA Service in Cleveland. Almost at once he was off on his greatest adventure, and "Out Our Way" began its twenty-two-year run in 1922. The moral: the life you have seen, touched, and know to be true, if drawn with humor, sympathy and understanding, will make the subject for a great feature.

Williams may draw with studied stiffness, but "Out Our Way" is pure Michelangelo compared to its panel-partner, "Our Boarding House." The creator of this famous feature, Eugene L. Ahearn, seemed to take a savage delight in fat awkwardness; it is the very repulsiveness of these boarding house creatures that makes us laugh at them and gives them their queer fascination. Unlike Williams, Ahearn had no adventurous background to draw upon. However, he had at one time been a model for men's fashions, and perhaps it was there that he got the inspiration for drawings based on the exposure of pretense, for the model must look like Park Avenue though he may eat *à la* East Fourteenth Street. Ahearn is a natural funny-man and gravitated easily from a job as sport cartoonist into that of comic artist. At one time Ahearn lived in the classic boarding house he has created and its details have permeated his life; he gives us, it seems, its very smell, compounded of warmed-over food and cheap brown varnish touched with a dash of sofa dust.

FIGURE 53. How stuffed this shirt has become is shown by contrast. The large panel of "Our Boarding House" appeared in 1946.

Major Hoople's special and privileged position in the boarding house is because he is the husband of the brains of the establishment, Martha. This gives him the right to boss grandly the seedy colored boy who, with his white coat, gives a faint air of aristocracy to the proceedings.

To some people this feature seems devoid of any suggestion of tenderness, hope, beauty or affection; to others Major Hoople is a rather lovable old character who merely exaggerates the sham that most of us have in a lesser degree. There is a weakness that makes the Major more closely akin than we like to admit, say these enthusiasts. In any event it is curious that such dinginess should interest millions of people and hold their atten-

172

tion day after day and year after year. The explanation seems to be that there are Major Hooples everywhere; people who try to impress their friends by their connection with that distant world of wealth and culture, pride and arrogance, which glitters before their eyes as the real goal of life.

A few years ago Ahearn's panel was absorbed by Hearst. "Our Boarding House" became "Room and Board"; Major Hoople, egad, divided like a life-cell into two, his double becoming Judge Puffle. The Owls' Club turned into the Bat Roost and a new managerial female presided over the new boarding house. The faint smell of warmed-over food, the odor of dust and stale bread crumbs, moved into the New York *American* and millions of new readers found their day made more bearable by the little glow of satisfaction which accompanied the daily downfall of one of the two most stuffed shirts of all time, for the original Major Hoople still carries on, drawn very well indeed, in the *World-Telegram*.

Our second professional moral: find a type of being everybody hates and expose a sample of the type every day.

The appeal of our next page-mate, "Boots and Her Buddies," by Edgar (Abe) Martin, presents no problem to comic analysts. As we labor in our white coats and pince-nez, taking apart the comics so that posterity may disagree with us, we find the solid reason for the wide appeal of this strip curvetting directly before our microscopes. It is Boots. The Buddies are, well, buddies.

Ah, Boots! Sexy Boots! Curvaceous plump one . . . when she stretches out a long rounded leg with those very small feet, we . . . we had better put on our pince-nez again. How can that girl be both thin and plump at once? It is a problem which has long pleasantly agitated, probably will long pleasantly agitate, the American male.

The appeal of this strip is by no means confined to the men. Boots has her—ah—dash of sex, but she has more than that. Sex is one element in a singularly attractive character. Ask Boots's fans why they like her and they will sum up with one of two definitions: "She's sweet!" or "She's cute!" They mean that she is pretty, warm, human, friendly, and dresses well; that she has a determined will, and that she is a good girl. It gives her millions a glow to realize that their Boots, in any contest for the male, can both hold her own and win against women of lesser virtue.

Then too, Boots seems pleasantly helpless. She will do her best to rise to difficult occasions, but she needs some strong fellow to take care of her.

An example of Boots's delightful helplessness appeared in 1931, when she decided to enter the business world. Her plump, kindly, businesslike brother Bill had loaned her $5,000. Money, she had observed, was to be made in many different ways, but the stock market seemed so much the

quickest and neatest. For a while she dabbled quietly—and broke even. This was no fun. With a sudden, very feminine impulse, she threw her whole capital on a single issue. Was she buying on margin? the broker inquired politely. What was "margin"? And after it was explained—why, certainly she was buying on margin.

Boots lost $2,000 in one wild, heartbreaking day.

But the lovely Boots's spine was not broken. A young man, certainly not too attractive, showed her an enormously long, wonderful sport coupé. Oh-h-h, you know, the convertible type. Only five hundred dollars, and she had a thousand-dollar bill in her bag. Why, with a touch here and

© *NEA Service, Inc. Reproduced by permission.*

FIGURE 54. Left, the first appearance of "Boots." This illustration, put together from clippings, shows that "Boots" only gets lovelier as the years go by.

there, she could sell it for . . . The young man was really very nice about it. Gave her five new hundred-dollar bills in change.

Boots drove away so exhilarated that she hit ninety on the straightaway, and was promptly hauled in by a cop. It seemed that the car had been stolen! After her little story had been told and the fatherly judge let her off from the speeding charge, she found herself walking home with only twenty-five hundred of her capital intact. But her chin was still up. She stopped to change one of her hundred-dollar bills at the bank. . . . Yes, those bills were all counterfeit. Two thousand still remained. Cartoonist Martin took that two thousand away in one final stick-up.

Boots is a triumph of that basic comic-strip type, the doll-baby. When she curved softly into the spotlight in 1924, she followed this popular and successful pattern which had been established by "Polly and Her Pals" in 1912, and added to it a human heart.

Stephen Tutt, the kindly, skeptical, fussy professor and his prim wife, Cora, were chosen by Edgar Martin as the velvet-lined case, the home, which before her marriage was to protect Boots from the harshness of the outer world.

At one time her language was severely that of the people, and even now there is a soft laziness in it, a slur, as in "H'lo." Seldom has this slurred girl-talk been better done than in "Boots," with its patter of young women fencing for their men, fencing and spitting with soft voices and meanings curved like their pretty bodies.

"But—after all, gee . . . what of it? You don't s'pose for a minute that I *care*, do ya?"

"Ohhh nooo."

"Saaay, what'e ya tryin' t'do, kid me?"

The vernacular reappears as the girls warm up.

"I was jus' gonna ask you th' same question."

"'Cause if ya *are*, ya aren't gettin' away with it."

This is the fencing that to a man's ear sounds inconclusive and illogical, but to a woman's leads to delicate shades of triumph or defeat.

The moral to be drawn from "Boots" is that, while a straight line may be the shortest distance between two points, a curved line may be the fastest route to success; that a nice girl can be attractive too, and that the public has a heart, as well as an eye, for the girls.

However, a good comic page needs the spice of danger and the fresh smell of gunpowder to keep it alive.

Look! In that strip in the *World-Telegram* for April 21, 1932—something's stirring!

"*Blister Me!*" Two simply drawn, funny-looking figures are opening their eyes. One of them sits up. He is very small. It's hard to tell whether he is boy or man. Thick through the mid-section, he has narrow shoulders and enormous circles around the dots of his eyes; after long study these are seen as spectacles. He is a direct little being, and a wide gamut of emotions registers, each with a pop, on his eager face as we watch him race through his strip. He is Wash Tubbs. Wash realizes that a familiar voice is speaking to him. The voice belongs to one Rip O'Day, who is Irish of the Irish of the Irish.

A little later Rip rips around to face the "Asiatic Monster," a powerful-looking fellow with a mop of black hair and a mask. A classic fray develops as the strips go by. The figures are very simply drawn, outlines decoratively filled with posterlike patterns of black and handsome grays, but the action is glorious and wild, like that of a boy's treasure of firecrackers all going off at once.

"There ain't a man alive tha's even with me, 'cause I'm big 'n' bad 'n' the fightin'est fool afoot."

"Sure, I've heard what a bully you are. But, fella, you can't hit."

"That's a lie! I kin knock over a horse."

"You're too fat, too slow. I had no idea you were such a softie."

"I'll show you! I'll— Oof! Ow!"

In the end Rip finds himself dazed and down, and Wash is shouting excitedly: "'At guy's no more a Chinaman than I am. There never was but one fella could fight like him—an' 'at's old Easy."

Old Easy it turns out to be, as the "Asiatic Monster" takes off his mask and reveals the expressive, Roman-nosed, iron-jawed face of Tubbs's strip partner.

"Blazes, but I'm glad to see you, laddie. I've been looking all over the world for you." He turns to the human wreck that was Rip. "And so you're Rip O'Day? Blazes, fella, I sure hope there's no hard feelings over our little scrap."

The wreck: "Aw, tha's fun. I likes fighting. 'N' maybe, after I rests a bit, we kin have another one, hey?"

Rip was, happily, given a rest, but Wash Tubbs's creator, Roy Crane, who likes nothing better than to draw a good scrap, did have another and another and another, in the boxes of his strip. And, like our example, the fights that thump and bang through "Wash Tubbs" are without malice; they seem to be exuberant expressions of the joy of living, like the martial instincts of a big, husky puppy, who chews your arm half off to show you that he loves you.

In the old days tubby Tubbs and lanky Easy were loose-footed soldiers of fortune, a big and a little stone rolling through the romantic places of the earth, usually broke, sometimes fabulously wealthy, but always ready for fight, frolic, or feed. The special quality that set off the strip was that it had the appeal of a child's box of fascinating toy soldiers, painted in bright red and green, and marching to battle, all gay and flashing, to the inspiriting rattle of tiny drums. Even Western sequences preserved the quaint, toylike flavor. That husky, she-minion of the law for instance, Lulu Belle, a shootin' fool and a romantic pursuer of poor little Tubbs, is a figure one expects to find offstage, standing on a pedestal in the toy cabinet and shining with fresh paint and newly varnished sheriff's star.

The first hint of change in this apparently endless pattern occurred only a few years ago. Little Wash Tubbs, after years of shouting adventure in all sorts of far-away places, got a job. This was in 1941. The world had become serious; the chasing of moustached bandits down semitropical alleys was out of date, and Easy had become a G-man, wrestling with the

FIGURE 55. Bop! Bang! Pow! Sometimes the figures in "Wash Tubs," as in these freely arranged samples, threaten to leap out of the page. An outstanding comic strip style.

grim problem of sabotage. As in "Terry," as in "Joe Palooka," the hard edge of events was crowding the old melodrama. For the first time in his life, Wash found himself chained to a desk, looking unfamiliar and funny with an oversize eyeshade, and busy as a cricket.

We now hopelessly attempt to describe Carol McKee, the plumpest and juiciest of Crane's tender creations. Carol is a blonde, tall and extremely calm with great eyes that look at you exactly as a baited fish-hook looks at a fish. Yes, she and Wash Tubbs had met. By one of those quaint coincidences, she was the boss's only child, heiress to the McKee fortune.

They were married, and as the text of the subsequent strip announced optimistically: "The Tubbs fortune, consisting of three suits, an extra pair of shoes and an overcoat . . . has been united with the McKee millions." Soon a proud display of twins, named Thomas and Jefferson, greeted the visiting Easy. At last Wash had caught up with his name. His spectacled eyes popping with enthusiasm, he is seen scrubbing away at the babies' diapers.

As for Easy, big events were shaping for him, too. Roy Cane had set his shoulder to the American war effort. No more do we hear the rattle of childish drums; the new sounds are the whir of factory wheels or the reverberations of the greatest battle of all time. And we are happy to notice the sense of all races working together which appeared in the strips of this time; it was a reflection of the tendency of America to take its magnificent responsibility seriously.

Easy's big moment came in August, 1942. Called before an officer of the air forces, he was given the rank of captain in Air Intelligence. "You'll be given only the toughest and most dangerous jobs. You'll work through the air forces General Staff in Washington and may be sent to any part of the world at a moment's notice." Blazes! Right up old Easy's alley!

So Easy joined Uncle Sam's other fighting funny characters and deserved a medal for especially distinguished service.

About the time of the "Tubbs" beginnings, the illustrative tendency was poking its way through the strip world, but for a long time Roy Crane was only slightly influenced by the new manner. He has an eye for the quaint, for humor, liveliness, and design, and he combined these aspects of the rollicking old days with illustration, creating a very personal and happy style. Simplicity was the cornerstone; he drew with as few lines as possible, but these were beautiful lines, filled with fun, force, and the delineation of character. His superior sense of taste served him when, in the 1930's, strip artists began experimenting with the mechanical gray tone called Ben Day. Something new came out in newsprint when Crane used it.

"Wash Tubbs" fans discovered that the settings for Easy's modern ad-

FIGURE 56. This 1947 "Buz Sawyer" strip demonstrates Roy Crane's remarkable pictorial sense. Underneath Buz, with smirk and bow tie, is Sweeny, who dominates the Sunday page.

ventures were becoming little pictures. Crane used a faint gray for distant screens of trees or the boil of water under a steamer's stern, and against this airy delicacy he drew rich dark grays or blacks. Some of these drawings gave you a distinct impression of beauty—a sure sign that a real artist has been at work. Comic students should look for Easy's adventures for the year 1943, in the New York Public Library's newspaper room.

In addition to all of us, an eye sensitive to comic-strip values was watching the course of Crane's development. This was William Randolph Hearst.

Hearst and Crane eloped to the pages of the New York *Journal* with a new strip entitled "Buz Sawyer.' Buz is a busy pilot and a handsome young man, although he seems to lack the angular quality which made Easy prominent. A true Crane inspiration, however, is the fightin' fool of a sailor, Roscoe Sweeny. The strip remains to be developed by time, but it will be interesting as long as Roy Crane is doing it. King Features, who syndicate Buz Sawyer, perhaps have in Roscoe Sweeny a true star, one of the big ones of coming comic strip history. Certainly Roy Crane is a master at the business, and can be trusted to keep his grip on the fans.

Crane has left the *World-Telegram,* but his work seems to go on in it. The man who accomplishes this smart and difficult job is Leslie Turner, needless to say, another very talented man. Turner shows a grasp of the old-time flavor of the strip, but he has turned it somewhat in the direction of the prevailing illustrative tendency. In January of 1944, Turner had a chance to make comic-strip history. He had noticed a new fighter plane flying over his Orlando, Florida, home and, needing a dramatic ship for the strip, he borrowed it intact. Thus he unwittingly caught the War Department with its plans down, for their plane, the P-61, the "Black Widow," a night fighter, appeared in "Wash Tubbs" two days before the Army had officially announced it. Turner was sure that the announcement would be made by the time the plane appeared in the strip.

There are two professional morals to be derived from Wash's story. First: the triangulation of the appeals, sex, adventure, and humor, a solid rock for a permanent reader interest. Second: if you have a yearning for the fine arts, why not put some of it in cartooning?

Every well balanced comic page needs a daily shot of youth and humor for vitality. "Freckles and His Friends," by Merrill Blosser, is a picture of a bright, honest boy. This is no work of art. Intellectuals who every now and then make an expedition among the comics and think to dispose of them forever with a neat, thousand-word article, rarely mention Freckles, but then they've usually lost connection with the good, raw stuff of boyhood. The plain style repels them, but the masses of people see the boy. It is not quite true to say that they are not affected by style, but if the characters are vital enough and alive enough, the art work can go hang. Freckles is a character that is alive.

When one realizes that "Freckles" was first syndicated by NEA service in 1915, it becomes clear that he must have traits which endear him to Americans. These are not difficult to find. They are enthusiasm and persistence. He is strong minded. Speaks right up on his own.

In the last issue of the New York *Telegram,* in February, 1931,

Freckles is an innocent, appealing-looking little kid of about ten years, with a clearly defined character.

"Hey-y-y, Freckles!" His tiny "side-kick" Tagalong is calling. The scene is in deep snow. Their pony has fallen, Tag has gone for help and returned with a motorcycle cop.

Freckles to cop: "Gee, this is luck! Something's happened to Lindy. Come and see if you can help us out!!" Lindy is Freck's proud possession, a tiny pony.

"You say he was fine before the snowslide struck him? H'mm . . . Looks like he's sitting down now!!"

Freck: ". . . and he won't get up, as hard as we try to help him. What do you suppose is the matter with him?"

"Looks to me like a broken leg . . . and if it is . . ."

"Yeah . . . an' if it is, *what*?"

The cop: "Well, I hate to say it, Freckles, honest I do!!"

Here is where Freckles's stubborn quality becomes clear. For the cop, convinced that Lindy's leg is broken, gets out his gun to give the little pony a merciful end. Freckles will *not* give up hope; he insists that Lindy be examined by a veterinarian. The cop points out that there is no way to get the pony home. Freck meets this by rigging a little box stall on a sled. And in the end the pony lives; his leg has been sprained, rather than broken.

As Freckles leaves the last traces of tothood behind him, the back-lot setting becomes exchanged for the north woods or the prairie. Then a time comes when he discovers that the next block holds a more thrilling interest than Labrador or Sarawak.

Going to bed one night, his mother remarks to her husband: "Well, it's just as I always suspected. Freckles is crazy about babies!"

"Sure he is!" says knowing Pa. "Especially the ones that were born about sixteen years ago!" (This is the exact age of the sister of a certain infant in whom Freckles has been displaying a most unboylike interest.)

He goes to high school, falls in love several times and has a "gang."

On January 16, 1941, Freckles woke his parents from a sound sleep to make an important announcement. He was going to join the Air Corps. We see him walking blithely down to the recruiting office. A plane drums in the sky overhead and Freckles looks at it in a proud, new, intimate way. Be right with you up there. . . . In the recruiting office he stands very straight and makes the most of his strong boy's body. There is nothing wrong physically with him. But when it comes to birth date he's licked.

At about this time Freck's Dad asks him an interesting question, the reply to which should go on record to show the cooperation of the strips

in a total war. His Dad wants to know, Just what is his gang doing in the war effort?

"June and Hilda are rolling bandages for the Red Cross; Nutty is an assistant block warden; Tag is buying defense stamps; I've sold $1,200 worth of defense bonds, and Sue is assisting at a canteen for soldiers."

"What is Lard doing?" (Lard is the plump, ugly boy with the scratchy, spongelike hair.)

"He's borrowing my car and going around on two wheels to save tires!"

Blosser's strip is packed with good little cracks like this.

© *NEA Service, Inc. Reproduced by permission.*

FIGURE 57. "Freckles and His . . ." Friends? Well, this half of a strip appeared in 1946. The women just don't realize how strong they have been getting.

"If Hilda ever found that I wrote to Jean, I'd walk into the lake and pull the water over my head." "She keeps a secret the way a screen holds back the rain." These are typical Blosserisms. They spice the strip pleasantly, but it has a larger meaning as we have seen.

Freckles, for all his lightheartedness and gaiety, is a boy of determination and integrity. His fans know that whatever he may meet, he will uphold the tradition of American youth.

Spring is an eternal theme for men to write about and paint about, because it graciously comes every year to revive our moldy winter spirits, an endless pulsation of hope, a proof that the worst did not happen, that life is going on. Boyhood is the same. Just when we're ready to concede

that man is in reverse, we run across a boy like Freckles—and have to take it all back. That's the moral.

Remember "Benny," who shuffled onto the comic stage, a figure of mystery, with the first issue of the New York *World-Telegram* on February 21, 1931?

Who was Benny? Nobody ever seemed to know, neither the *World-Telegram* nor the readers.

Benny was a dragging, sagging little figure in a long, loose black overcoat that trailed along the ground. Under a bowler hat was a scraggy mass of blond hair, big pop-eyes and a long reaching nose with nothing below, the nothing going right down to his neck. He was an overtone, a pathetic question mark. He never spoke and his age was indeterminate. This researcher thinks of him as a sort of boy, between the ages of six and twenty-one. If this is baffling, so was Benny; it was his business to baffle. The very name of his creator has a mysterious fascination: J. Carver Pusey. Who ever heard of a name like that? No wonder he could create a figure to interest a nation.

For "Benny," mystery and all, was a big success and ran for a long span of years. There were two excellent reasons for this. He was really funny and he was human.

The rare scenes that show Benny in his own home display it as a pathetic, little packing-box shack, so we assume that Benny is down and out; that he needs a job, food, and human sympathy. Usually he just shuffles along without background, with no companion but a scratchy ink shadow, and this is the way we always think of him. He is alone—and so becomes a symbol of loneliness.

As of March 4, 1931, Benny has a job minding a baby. The baby yells: "Wow!" Benny wipes its nose with a big handkerchief. The baby cries harder: *"Wow!"* In the last box Benny is coming along with a mop.

The next day it is worse. *"Waah!"* the baby screams. Benny is pictured with his hands over his ears. A "vision-box" is shown over his head and in it a pair of earmuffs, so labeled. Box 2: Benny and a sign that says "Men's Furnishings." Box 3: Benny shuffles home with earmuffs. Box 4: Benny is peacefully reading in a big chair by the cozy light of a bridge lamp. It is the baby on the floor that is wearing the earmuffs, but they are placed on his head so that one of the muffs covers his mouth.

When the Dionne quintuplets arrived in this world, a geyser of pure sentiment erupted over the nation. This gave J. Carver Pusey the inspiration of a lifetime. What are these five similar little creatures who march onto his lonely comic stage? Five kittens, *Cat-uplets!* He did a million funny things with them.

Benny, in the infinite simplicity of his mind, did things that, while amusing, were also tragic. When he finds a nickel, the reader is aware of how much it means to him, of how hungry he is. Then Benny sees a sign, "Hamburger Sandwiches, 10 cents." He looks at his nickel, he shuffles off, tossing the coin over his shoulder in a spirally dotted line to the sidewalk.

He was the one figure who has paralleled, if only in a small sense, the creations of the master, Charlie Chaplin. Now Benny is no longer with us, but we miss him. This kind of comic drawing, although it looks so simple, is extremely difficult to succeed with. One must have rare and positive inspiration; there are no set rules to guide the worker in human overtones.

Just the same, the Benny kind of thing supplies a definite human need and someone will come along to supply it. Some day we will have another little figure that will make us laugh, that will cut through the cold outer shell of social and business adjustments to uncover the striving and lonely human spirit.

Moral: It is better to have laughed and lost than never to have seen "Benny" at all.

To help round out our page of comics, let's add an old-fashioned touch, and anyone who doesn't like cosy things had better pass "Little Mary Mixup." Cartoonist Brinkerhoff writes and draws with a fluttering, crinkling quality that reminds one of a crimped-edged, deep-dish apple pie. He clings obstinately to the old approaches, and does very well for his strip and himself.

For streamlined city-dwellers and smooth suburbanites are very apt to mistake their surroundings for Average America. They are not. There are little Mary Mixups everywhere in the small towns and on the farms.

If the old-fashioned flavor of this strip suggests a comparison with apple pie, we should remember that good apple pie has a dash of tartness. There is this in Mary; she makes saucy little remarks like: "We had a swell summer. Hardly any relatives came to visit—only friends." This, the "Mixup" side of her nature, was especially evident in her very early days; she was a little pest. Before she entered the *World-Telegram* by way of the Scripps-Howard purchase of 1931, Mary tormented her elders in the pages of the *Evening World*. In the *World-Telegram*, where she appears syndicated by United Features, a quieter phase begins.

At first the plots are excessively simple. She has a horse named Vanilla. "Vanilla is too fat," explains Brinkerhoff on March 2, 1931. "Mary and Bunny are riding her to school in the hope of reducing her."

"Maybe Vanilla will get all cold and everything waiting till school is out," worries Mary. They tie her to a tree.

"She'll be all right here."

Bunny: "But she should ought to have something to cover her up with."

Mary: "There, that should keep her warm." Mary's hat is on Vanilla's head, the two tiny coats look very small stretched over the horse's big shoulders. That's all, but it's cute: it's what you'd like to have your own kid do, and it's plenty to keep a strip going on.

If Mary's growth kept pace with the strip, she would now be a bustling young woman in her twenties; but she does grow, though lagging behind the actual passage of time. Several striking developments have taken place in her character since the old tam-o'-shanter days. The drive and energy once

© *United Feature Syndicate, Inc. Reproduced by permission.*

FIGURE 58. "Little Mary Mixup" way back in March, 1918. The old comic tradition of flat, well arranged pictures is very evident. Nothing mixed up about that.

expended upon mischief she began to use to help her friends and family, and convert into executive ability. She early became aware of boys, and simultaneously, of clothes. Her tartness, never absent, enabled her, if she wished —and she often did—to be haughty as the very devil.

By 1940 she is in that fearfully grown-up stage that grips little girls; she is busy learning shorthand out of school hours in order to insinuate herself into the office in which her flame, Elmer, is working.

As America went to war, Mary's executive abilities and basic goodheartedness became evident on the home front, as when she assumed the management of a hot-dog stand during her vacation so that the poor mother of the owner, Eddie, could have the profits, he being in the army. In another continuity, she turns in a good haul of Nazi spies. Later, out West, there is

an echo of the very early days: she has a new Vanilla, this time a tiny burro, and it seems very familiar to see little Vanilla putting his head through the window as Mary says, "Vanilla, have some cream on your cereal."

Little Mary in her modern clothes looks up-to-date in an old-fashioned way. Even today, the strip, although lively and vigorous, is drawn in the sketchy pen manner of an earlier period; she is an oldster's youngster, the ideal of the dear sentimental days projected into the present. With many a "Tsk, tsk," at her saucy doings, the kindly people of a quieter age watch this little figure from their own period flouncing through the merry matters they would have been engaged in, if they had been children at this time.

The curious thing is that one does not feel that Mary has any idea that the flavor of a past time clings about her. Hard driving and ambitious, we feel she is reaching for a big career. This writer has a personal theory as to the tenor of her dreams. He feels that she intends to become the youngest fashion editor on *Vogue*. And knowing the power of her personality, he feels that she might very well make it.

The moral here is that though there has been a swing towards "cheese cake," there are still many who will settle for a substantial slab of apple pie.

Now let us throw in a dash of fantasy with the rest of our page mates, combining it with humor. Such a strip, properly managed, might even be able to make history interesting.

Remember Cleopatra? She was sitting on her throne one day, her appearance justifying the title "Miss History" which the verdict of the ages seems to have bestowed on her, and interviewing a visiting magician by the name of J. Oscar Boom. He was a sharp, smart-looking man with a round, bustling black beard, under which a scheming nature appeared to be, and was, concealed.

He was trying to get from Cleo a certain magic belt which had been given her by a friend named Alley Oop—an individual who did not seem to fit into the Egyptian period, for although correctly dressed Oop had an ape-man's face and a Brooklyn accent. Boom posed as a magician, but Cleo was rather bored until he had produced a tiny, flat metal box. That was nothing to get excited about, but Boom, holding it impressively high, caressed its top with his thumb. The box burst into flame and burnt steadily.

Cleo was so delighted that she suggested a trick herself; she wanted Boom to pull a rabbit out of his hat. This request floored him. Working a cigarette lighter was simple enough, but the rabbit trick . . . He shifted his ground quickly and pointed out that he had demonstrated his ability. Now, was he going to get that belt? The answer shows how Cleopatra has left an impression of character as well as beauty. It was "No!"

Boom knew he had to do something quickly. Taking another object out

of his pocket, he explained that it was going to throw devastating thunder. He pointed it at a gigantic vase that ornamented the throne room. *Crash!* A spurt of flame leaped from the tube and the vase tumbled to pieces. Cleopatra had risen in anger, but it was not the thunder-miracle she was angry at. An embarrassed warrior was sitting in the ruins of the vase and on his lap a dark-haired palace cutie.

"Holy Isis!" Cleopatra screamed. "Marc Antony!" Before that royal blow up, Antony took off at full gallop, Boom at his heels, his fire tube forgotten. . . .

It was a gorgeous situation. If you can use more like that, follow "Alley Oop."

V. T. Hamlin, Oop's creator, is a man who, with an airy skip of the imagination, landed in that heavenly combined work room, studio and office where, following blueprints from the board of some unimaginable architect, history is put together. Hamlin seems to have found a switchboard through which the architect converses with different periods of time: "Cretaceous," Roman, the Middle Ages . . . Hamlin has slipped up quietly and, taking the cord marked "Twentieth Century," plugged it into those past periods, one after the other. The game has pleased its twentieth century newspaper readers.

This wild scrambling of time is only dimly foreshadowed when "Alley Oop" first took its place, in 1934, among the New York *World-Telegram's* group of comic strips. The first scene was the far-off, steaming, prehistoric jungles of the land of Moo, where dwell a tribe of cavemen more, or often less, under the authority of King Guzzle, proprietor of the Royal Palace, which is a smelly cave. King Guz is a hard-looking monarch, but beautiful compared to his daughter, Princess Wootitoot, whose upswept and unswept hair-do is topped by an unattractive royal bone. The Princess Wootie has set her cap, bone and all, for a certain young man-about-jungle, a perfect specimen of the prehistoric caveman, as conceived in the Hamlin manner. This is our hero, Alley Oop.

Alley is mostly torso, drawn with clean lines in a stylized, early Greek manner, topped with a gorilla's hairy head. Around his loins are what appear to be a modest growth of leaves. His arms and legs are conceived in the curious comic manner, originated by Segar, to express the phenomenal muscular power of Popeye: pipe-stem upper arms and legs and gigantic forearms and forelegs. Why this should mean strength is difficult to say, but we seem to have accepted the convention. Alley, therefore, is incarnate brute power. However, the germ of evolution is working in Alley. Not for him the atavistic Wootitoot; he has an eye for beauty—he is in love with the Princess Oola, a little Atlantic City bathing beauty, who somehow or other

FIGURE 59. Just a jungle built for two—by V. T. Hamlin in August, 1946. Between Alley Oop and his pet dinosaur it had obviously been love at first bite.

appears in Moo. Her hair is tangled and her skirt is torn, but she's heaven to Alley Oop. Wootie's plots lead to war between Guz and Alley, and the strip rocks and roars with wild, satisfying action from the start.

All this was fun, but as the years went by Oop's prehistoric adventures began to grow stale. They all looked alike. Hamlin decided on a bold step, which blew new imaginative breath into his strip.

April 4,'1939, finds Oop very low. He is separated from his pet dinosaur, Dinny, and surrounded and threatened with extermination by King Guz's

minions. The only bright spot is Oola, who sticks by him loyally, although he urges her to escape. Suddenly, by their camp fire, there is a queer buzzing sound. Something has materialized which looks like a modern camera on a tripod. A moment later, it has faded away. The next day, talking this strange event over, they are surprised by the Guz gang.

"Hah, so you thought you could escape the long arm of the law, eh? Heh! Heh!"

But that buzzing sound again! Oola: "Oo-oo! I feel—so—queer."

"*Look!* They're dissolvin' right in front of our eyes," gasps the King, and a final box reads: "Dear Reader: You must now say goodbye to Moo, if you are to follow Alley Oop in this strangest of many strange adventures. V. T. Hamlin."

The fans sat up. The following day the scene changed to a modern laboratory, hidden away in a spruce woods. A breath-taking experiment is under way. Man is trying to bridge the gap of time.

"Hey, Doc!" calls an assistant. "At last I think we got something with that movie camera we sent through the time machine!"

Bald-headed Dr. Wonmug, buried in a spongelike mass of white whiskers: "Well, get out the projector. . . . Just in case we did, I'll leave the machine warming up for another experiment. . . ."

On their screen flashes a picture of Oola and Oop.

"Good heavens! Prehistoric man!!"

The scientists are absorbed in their find. "Supposing that big ape had reached the camera just as we pulled it back . . . Why, we might have brought him right back into 1939!!"

"My stars, the time machine—I left it turned on!" And they turn around to face it. The time machine has an elevatorlike platform, and standing on it, stone clubs, matted hair, and all, their eyes goggling, are Oola and Oop. All over America people thought gratefully, Boy! This is going to be *good!* It was. Cartoonist Hamlin had hit one of the best and funniest ideas ever to dawn in a comic-strip artist's brain. He was going to have a wonderful time, and so were his readers.

So we find Oop's ape-head scowling from under Roman helmet and Norman casque. J. Oscar Boom, the brilliant but dark-natured scientist, has learned the time machine's secret, and shuttles in and out of the ages supplying the threatening note. The up-to-date is woven in too: Oop is called before the local draft board, but they discharge him because of his enormous age; and the scientists work back through the past looking for a source of rubber. Scenes from history with historic characters emerge, like that of Archimedes at the siege of Syracuse, burning the Roman fleet with huge lenses which concentrate the sun's rays on the attacker's sails. With

scenes such as these, one detects a certain embarrassment in Oop's artist-author. Comic times had changed. A demand for consistency and historical veracity was stirring.

Even in the days before his time machine Hamlin had struggled with this problem. The combination of Oop and Dinny was difficult to reconcile with the modern tendency. Hamlin, in his color pages, worked out at least one solution. He had a corner section entitled "Dinny's Family Album," where he drew faithful pictures and gave real data about dinosaurs and other prehistoric animals. But this was impossible in the strip itself.

Wisely, he let the paradox come to light in the strip—and laughed. When the scientists learn that Oop has a pet dinosaur, the assistant gasps:

"But good heavens, Doc, dinosaurs became extinct in the Cretaceous!"

Wonmug: "That means that instead of just one million years, our time machine must have gone back *fifty million!*"

"But, Doc, at that time man was unheard of!"

Confronted with this logical impasse, Wonmug rubbed his chin and took the only possible way out.

"Well, behold the unheard-of!"

Moral: Present the unheard-of. It pays.

But in planning our well balanced page we must not forget that most men like sports. Well, on second thought, let's have our sports strip, on the sports page, by itself and near to the race results. That's where we find it in the pages of the New York *World-Telegram*, a United Features strip entitled "Curly Kayoe," drawn by Sam Leff. This is really a continuation of the famous old strip, "Joe Jinks," which goes well back in strip history. Curly is a hefty young blond fighter who first appeared in "Joe Jinks" in September of 1944. He connected with the public midsection and gradually stole the show. The switch in names occurred on December 31, 1945, but Joe as a character hung around quite a while. He disappeared from the strip with the first days of 1947, but perhaps he is just off on a vacation. He continues in the strip of his own name, also distributed by United Features, on Sundays, and both "Joe Jinks" and "Curly Kayoe" are well known by their wide national syndication.

He that hath cauliflower ears to hear, let him hear—but others should listen too, for all kinds of people follow fight strips, since the appeal of scraps and scrapping is almost universal.

Joe was not always a fight manager. In the old days the strip was entitled "Joe's Car," and dealt with steering-wheel adventures in the stirring days when every little outing was a desperate struggle with spark levers and magnetos; when all your passengers got out going uphill and coasted down in exciting glory on the other side. As cars became commonplace, Joe took to

the air. But it was not until he merged with the fight racket that nervous little Joe became himself.

Joe occupies a special place in strip history; he reflects a specific yearning in the souls of millions of men who resemble him closely. He is the same figure that dominated the comic pages in the great suburban era we have spoken of: the nervous, exasperated little business husband. Physically stunted, with tiny chest and shoulders and sagging stomach, he has the usual out-reaching comic nose, scratchy mustache and pop eyes. His hair is falling out, and even when asleep, there is an exasperated set to the lines about his

© *United Feature Syndicate, Inc. Reproduced by permission.*

FIGURE 60. This is part of the strip "Joe's Car," which ran December 11, 1918, in the New York *World*. Here is the furiously clamped little jaw and smelly cigar later prominent in "Joe Jinks."

mouth and forehead which reflects the exhaustion brought on by the complex problem of earning money.

"That's the trouble with women—they never realize that we men have to work for their living," as Joe himself once put it; and only the furious clamping of his tiny iron jaw on the cigar which sticks out like a smelly figurehead seems to carry his little, frayed body through the hard day. That, and one other thing, his connection with the exciting world of sport.

Sport is his joy. He and his fans live for these ardent moments when they lose the consciousness of their own narrow chests and soft stomachs and identify themselves with some sweating, spotlighted pug. Joe occupies a privileged position in this romantic world. The beauty of it is, he makes money that way, too.

Moral: There's always a job for a good sport.

Chapter XIII

HE-MEN, HAIL

The remarkable thing about Caspar Milquetoast is that he sums up an era in strip satire. Men, the old comics seemed to insist, were not so much mice, as soft-bellied baby rabbits. Their brains were feeble, their will power drained to zero. Determination, decision, and physical power were reserved for the terrible wives of these pitiful American husbands.

But all business men are not potbellied, and many who are, are not baby rabbits. Also, all Americans are not business men. This last surprising fact began to dawn on us as the strips, carried by syndication, began to penetrate small rural towns and communities. Many of the new readers bore little resemblance to blenching Caspar. They tended to large square shoulders and the big hands that are the result of farm labor. Their faces were the color of a winter sunset; they made their own decisions with the unconscious weight and dignity of men who own land. Or perhaps these new readers were railroad men, steel workers, or fishermen; all hickory-handed fellows whom it would be unwise to slap. These hardy men had been there all the time, bringing in the wood, doing long and heavy work, and bossing their women. There are millions such all around us. No wonder that, with the increase of their readers, the strips found new heroes in old boxes.

(Note here that early folk heroes, like Paul Bunyan, were no sissies.)

Who was it that gave back to the American man his ancient dignity? There were several. We will begin with the one to whom we men are the most indebted—Popeye.

Elzie Crisler Segar didn't design his socking sailor for the specific purpose of saving American manhood from its fate worse than death; Segar designed a new character in the ordinary routine of his carefully planned career. The story lies in what happened when the public discovered that character.

Shortly after happy Armistice Day of the first World War, a Western comic artist came to New York and sold a strip to King Features. Segar's background had been typically American; he was a roving youth who worked in movie theatres, painted houses, hung wallpaper, and worked off excess energy on the snare drums of local orchestras. And then—somehow he

heard about cartooning, and about the huge salaries it brought. In a very orderly way he set out after one of these. According to the rules of drama, he shouldn't have succeeded in this frontal attack. Perhaps his persistence and enthusiasm did it.

"Please publish this on account of how 'my uncle works in the press room," he wrote in a note attached to his first cartoon, which he submitted to the St. Louis *Post-Dispatch*. While this showed a certain admirable realism of mind, he had underestimated the critical qualities of editors, as he realized when the drawing bounced back to him. After trying six more on *Life* with the same result, his common sense told him he didn't know the business. But a little detail like that wasn't going to stop him. He shifted his attack and took an eighteen months' correspondence course in cartooning.

This turned the trick. Where was usually ironic fate that day? Diploma in hand, career-man Segar marched to Chicago, interviewed old master Richard F. Outcault, who was still turning out "Buster Brown." Outcault, a friendly fellow, got him a job on the Chicago *Evening Post*, and there he was, already a success, drawing "Charlie Chaplin's Comic Capers" seven days a week. Marriage was the next step. There was a slight bump in the upward swing when his paper was sold after two years, but he landed on the Chicago *American*. Two years more and he was ready for the "big time." He conceived the "Thimble Theatre," took it to New York, and sold it to King Features.

The syndicate was by no means enthusiastic. There was little continuity or suspense in the "Thimble Theatre." Each day in its boxes little figures acted out a very small play. What sold it and kept it going, were the gags, and an indescribable humor about the figures. The truth was, Segar had comic genius. The "Thimble Theatre" appeared in upright form at the upper left of the daily comic page of the New York *Evening Journal*. Hearst did not think it remarkable, for when the *Journal* sold extra department store advertising the little Theatre was omitted, and it was regularly left out on Fridays.

Among the very small actors on this tiny stage were Ham Gravy and his girl Olive Oyl. Olive was only one step removed from the basic old-maid convention used by children to deface their school books. A single twist of the pen made the knot of hair which finished the dotted hook of her head. Ham Gravy was the usual comic scribble used for a man. These two acted out worn little jokes, which somehow they continued to make somewhat funny.

More substantial fare arrived in the person of Castor Oyl, Olive's brother. He was as mean and unpleasant as his name, and at the same time exceptionally dumb. In Segar's words: "Just this dumb—when Olive's pet duck fell into a deep hole and no one could extract it, Castor came by with

a water hose and floated the duck to the top." Dumb like a great railroad magnate, in other words.

The "Thimble Theatre" was always a pleasant and mildly amusing spot on the *Journal's* comic page, always worth a glance or two. Yet the gold leaf was beginning to peel off the ancient gags. One wondered sometimes if the manager of the "Thimble Theatre" did not wonder himself where the next gag was coming from. Perhaps he said to himself, "No gags, no Thimble Theatre." But these fears, if they existed, were, as we know now, groundless.

Quite naturally, almost as if no one had planned it, Castor Oyl was becoming a person. He was no longer the Mr. Bones, whose dialogue furthered the dingy mechanism of a joke, but a figure full of life who could, and did, get into his own hot water. Because of this, something else happened back of the feeble footlights which illumined the Thimble Theatre. *Castor began to act in a continued story.* He got himself into situations; Manager Segar had only to get him out of them.

At this time Segar must have begun to suspect that he was master of a rare talent, the ability to write absorbing continuity. Segar could tell a story about anybody, even the featureless Castor Oyl, and make you eager to know how it was going to end.

Castor, never ridden by a New England conscience, decided to go crooked. The trouble was, he didn't get any money. Going to rob a bank, he found the door locked! A few more such setbacks and Castor began to realize that he hadn't the iron in him needed for a big-time crook. He wanted money, yes, but without too great effort. So he wooed and won a rich wife, but on the wedding day the bride's father forbade her to give one cent to Castor. Castor faded out, still faced with that problem of the daily caviar. He became, among other things, "a man among men, the editor of a newspaper," dressed like a senator in large black hat and slouchy clothes. Just before the "crash" in 1929, Castor was running a radio store. But he was tired of small potatoes; he was dreaming of folding money, imperishable success.

At this time the Whiffle Hen shuffled onto the tiny stage. She was the property of the handsome, but rheumatic gambler, Fadewell; yet she insisted on following Castor about wherever he went. Because of this fatal attachment, Castor became Fadewell's prisoner, closely guarded by the monster-man, Skum. Crouching behind Fadewell's voluminous armchair, Castor hears all. The Whiffle Hen is a magic bird. You rub the three hairs on her head and she grants you your wish. Further, Fadewell owns Dice Island, a gambling hell off the African coast. Now, with the Whiffle Hen's help, he will trim all the millionaires who infest it.

Castor had learned something from his association with crooks, however

brief and unprofessional that association had been. He sees plainly and at once what he must do: escape with the Whiffle Hen. He loses no time in rubbing her head, wishing for $10,000, and escaping with the bird. The Whiffle Hen, by the way, is just a motherly little chicken of average intelligence; she merely wants to be near Castor, perching on the back of his chair or sitting on his lap.

Castor knows exactly how he is going to invest his $10,000: buy a ship and sail to Dice Island with the Whiffle Hen. Once there, Castor, not Fadewell, will clean up the millionaires. It sounds both feasible and simple. The vessel is found. "A bargain," says her salty owner, "at $6,000; a good ship to handle if you know how, with not a hole in her, except a few in the bottom where they don't show."

Ham Gravy and Castor Oyl spend their days in happy if hectic preparation for their great adventure. The Whiffle Hen lives placidly in the living room, asking no more than to be near Castor. Only one thing annoys them, the absurd insistence of Olive that she is going too. Even when the supreme moment arrives and, with suitcases packed, Ham and Castor are about to board their vessel, they look over their shoulders to see Olive running toward them. The men whisper. Then:

"O.K., Olive," says Castor, "if you must come; but just go to the drugstore and get ten cents' worth of longitude first. It is very important." Then they are worried about something else. Neither gentleman has ever been to sea, and though they possess a vessel it now occurs to them that they have no crew.

The date is Thursday, January 17, 1929; the place, the New York *Evening Journal*, not too far away from the depressing, close-packed type of the financial page. The curtain of the Thimble Theatre is up, and the footlights show the signing on of a one-eyed sailor with a corn-cob pipe. In this strip Popeye says his first word.

Popeye wastes no time in manifesting the qualities that have made him immortal. Segar was simply doing a picture of a hard-boiled sailor; he was quite unaware, at first, that his man Popeye was to quench the national thirst for a comic hero who could stand up, take it, and dish it right back again.

The day following, Castor explains his mean little plan to Popeye: "Sure, you're the whole crew, it's a privilege—twelve men."

Popeye: "*All right.* Then I want the pay of twelve men."

At last. It's happened. Sorry, Mr. Milquetoast, we won't be needing you all the time now. Stick around for old times' sake; glad to read you, of course. . . .

A few days later another telling incident delineates the new character.

FIGURE 61. Proving that Popeye, in his job of bringing back manhood into comic strip pictures of American men, shows them using their wits as well. A 1947 daily strip.

Cap'n Oyl: "I'm worried about you, Popeye—yeh, worried, something awful."

"Worryin' about ol' Popeye. Well, blow me down, Cap'n, you've touched me soft spot. You got a heart Cap'n Oyl, I can see that."

We realize that while Popeye is a salt of the sea, he is also the salt of the earth. He'll stand up for his rights, but he's got, like Minnie the Moocher, a heart as big as a whale. His judgment of Cap'n Oyl, however, was a shade rosy-colored.

"I'm worried about your slumber, Popeye. You've got to look after things while I rest up. And you've got to take the wheel all night while I get some sleep. If I wasn't so kind-hearted I wouldn't be worryin' like this."

A third great facet in this rapidly unfolding character, love, is soon revealed. Popeye has found a stowaway in the hold. The captain sternly orders the stowaway aft. It is Olive! "Bun voyage," she remarks calmly.

There is Romeo and Juliet, and there is Popeye and Olive Oyl. It is hard to say when the divine afflatus seized this latter twain. Having studied their natures, this researcher submits the following incident which filled the Thimble Theatre on February 6, 1929. Let a candid world decide whether this is not the very moment:

Olive: "I never took a look at your face before. Gee, what happened to it, Popeye?"

Popeye: "What's the matter with it?"

Olive: "Why, it looks like a shipwreck."

Now Olive, alone, soliloquizes: "I get a big kick out of kiddin' ol' Popeye. Ha! Ha! I'd hate to go through life with a thing like that on my neck."

But Popeye is silently approaching. Is he going to take it? No, a million times no. We see him bending over, closely examining Olive's feet.

"Blow me down! Canal boats fer feet on a lady!"

Olive, face black with fury, to Captain Oyl: "Throw 'im to the Anchovies! You hear me!"

It was on this voyage to Dice Island that Popeye revealed the great quality which endeared him to Thimble Theatre readers. His mean employers had been depriving him of his slender wages through the use of the Whiffle Hen. Discovering the trick, Popeye very justly got to the Whiffle Hen first. Result: two "broke" employers. Cap'n Oyl ordered Ham Gravy to thrash the offending one-man crew. Ham Gravy sought a solo audience:

"I'm gonna wipe up the deck with you and step in your face. I'm like that!"

Crack!

But it wasn't Ham Gravy's fist that set off the explosion, it was Popeye's.

Ham Gravy, angrily, with black eyes: "You're just what I thought you was—a low-down roughneck. I *won't* fight with you."

The readers liked this. Here was someone who did what, ideally, they would have done. Letters began to pour in to Segar, praising the new character. Segar took the hint. If they wanted fight, they'd have it!

After cleaning up the gamblers of Dice Island, the ship sails for home. But aboard is the gambling house manager, Snork, who has fooled Cap'n Oyl with a sob story. In reality, he is about to poison or shoot them all.

However, hardly is Snork aboard when Popeye marches up and slams him flat with a right upper cut.

"Why did you sock him?" Oyl angrily inquires.

"I don't like his looks." And the sailor goes on: "There's a yacht followin' us. Things don't smell good to me. I got instinct—I knows what I knows."

As the two begin an epic conflict, it is obvious that Segar has something quite new in the strips: suspense. For a week Snork trails Popeye, planning to shoot him but lacking the nerve. It is curious how interested one gets in this story, how impossible it is to stop reading it. When the two finally tangle in hand-to-hand battle, two weeks go by before the reader can wipe his forehead with relief. Another point worth noting is that this battle is offstage. The size and fury of it are defined by their effects on Olive, Castor Oyl, and Ham Gravy, who cower and shudder for days as shots, smashes, and wild sounds of all kinds resound from the unseen battleground. When Popeye is seen, all appears over. After all, Snork had the gun. Popeye is down; he is riddled with bullet holes; his body resembles a tea strainer. Nevertheless he gets to his feet.

"Why, Popeye," Olive cries, "I thought you were shot!!"

The sailor points to his punctured torso: "Well, watcher think these is, buttonholes?"

This is the first hint that Popeye has entered the company of Paul Bunyan and other folk heroes invested with supernaturalism. One might think that such dehumanizing would spoil his appeal, but it doesn't. He is so human in every other way. He engages in ordinary enterprises and meets everybody on equal terms. The warmth of his heart equals the fight in it.

"I comes when I likes, and I goes when I pleases, and I don't take nothin' from nobody," is one side of this great man.

The other: after he has literally given the clothes off his back to a poor woman, she wonders: "I'm not accustomed to such kindness. I can't understand all this unless you're crazy."

Popeye replies: "When people think that a kind-hearted person is crazy, it ain't sayin' much for a world which is supposed to be civilized."

This is wonderfully true, but one might suspect the character to be climbing to an unattainable moral plane. Segar handled this situation with rare skill, showing such faults in Popeye that he settles back to earth and even gives us a sense of superiority, in some respects at least. Here follows perhaps the greatest example of his lovely human sins.

It is August 1, 1931, in the *Journal's* color pages. As the result of such battling in the prize ring as man never saw or imagined, Popeye has $5,000. He proposes to Olive and is accepted on the condition that he will invest it at once in a home. Joyful, he stops to break the news to his hash-house asso-

ciates. Well—there is a crap game. While poor Olive waits for three hours in the park, Popeye loses that five grand. That's not the worst. It turns out, to our horror, that Popeye was using loaded dice. However, Bill Squid's dice were loaded too, only a bit better. Popeye, with his big heart, forgives Bill. . . . But Olive—he had forgotten all about her!

"Why, you rat! You're lower than sea level! Dog! Brute! Nincompoop!"

It is here that Popeye makes his immortal statement of being, which at once links him to every other struggling and floundering human on the planet.

"No matter what you says I yam—*I yam what I yam an' tha's all I yam!*"

Here he emerges in full splendor. One "I yam" and he would have been esoteric; two "I yams" would have made him a fascist, caring nothing for other men's fate; three "I yams" define him as a democrat, and an inheritor of common weaknesses, whose fruition must be found in union and understanding with others.

As Popeye's character fully emerged, a huge response swelled from his fans. The sailor fulfilled a national ideal of manhood, long lost. Syndication rose enormously, increasing by more than 600 papers. Popeye was heard on the radio and seen in movies, by public demand. He appeared in dolls and cutouts; he endorsed countless products. And Segar, who had started as a mail-order cartoon student, now was earning over $2,000 a week. America was happy to pay for an ideal figure.

Popeye's democratic sense is one quality that makes him so American, but there are others. In full development he epitomizes a certain national approach to problems of living. He reflects this quality as a popular Chinese proverb is said to reflect a great quality of that nation: "One should see the flower's shadow in the water, the bamboo's shadow under the full moon, and the beauty's shadow behind a door screen." This leisurely savouring of life is, perhaps unfortunately, not for us. Action is what we crave, whether to serve good or evil purposes, and Popeye is action incarnate. He wastes energy; his temperament is ardent; even his good deeds are done with intensity, with fierce face and furious tempo. He recognizes his mistakes and is fiercely humble about them. He proceeds always under full steam, with fluttering flags and bands playing. God bless him, he is America.

Popeye's hash-house environs became fixed in 1931. An egotistical little referee had mismanaged the great Tinearo-Popeye prize fight of May 9, 1931. This was Wimpy, who is almost as great a character as Popeye; whose self-riveted gaze builds up for himself a pathetic balloon of importance, only coming down to earth to grab a hamburger. It hardly seems possible that a few pen lines could define a nature so fully. Wimpy is a triumph of comic art.

The first appearance of the famous "Café de Rough-House" this researcher can find is June 20, 1931, when Popeye takes Olive there to dine, and she is greatly disillusioned by the "low-lifers" who infest it. Specialties of the house are "Liver worse, clamless chowder, P. Zupe, and rusbif." The Wimpy-hamburger classic begins with the next page. As Popeye enters, Wimpy is vainly suggesting a hamburger on credit. Someone starts throwing "cuspidoons" at Popeye, who had trounced all the "low-lifers" the page before. After he does so again—"All what's innercent I begs yer pardon"—he returns to the counter. "Hey! who hooked me hamburger sanrich?"

Wimpy, wiping mouth, to owner Rough-House: "Cook up a hamburger for the gentleman, and charge it to me."

Popeye's connection with spinach is so well known as hardly to deserve comment. It is not the only source of his strength, for he ate six hamburger "sanriches" just before the Tinearo-Popeye fight, but his use of it has actually resulted in increased sales of this wonderful vegetable. The author is no Popeye, but he maintains that spinach is swell, notwithstanding all *New Yorker* cartoons to the contrary. In Crystal City, heart of the Texas spinach-raising country, there is a Popeye monument.

Segar took a loving interest in his great creation. He believed that sadness and tragedy were the backgrounds against which humor should be built. Popeye, he claimed, had had a sad past. Perhaps this accounts for some of the vital stuff in our sailor.

Tom Sims and Bela Zaboly are now doing excellent work on Popeye, who is still popular, for Elzie Crisler Segar is no more. But this artist left behind him a workmanlike job. It is not a little thing to have made a figure that marches to the step of America.

America is a country of legends, with a full share of fabled heroes, men close to earth, like Mike Fink, Davy Crockett, or the steel-drivin' fool, Ralph Stackpole. These old heroes were exceedingly tough men, no Milquetoasts they. So it is quite understandable that as comics emerged from their first, artificial, suburban stage they should inherit and carry forward the long established hero-worshiping traditions of the countryside. Thus "Li'l Abner," a modern strip, is so popular that it is crowding "Blondie" for first place in American hearts. For at heart we all love superhuman strength.

This carrying on of a long tradition is, however, only one reason for "Li'l Abner's" searching appeal. If his roots reach far back, yet he is himself a young thing, all huge feet and shy soul. Add to that a genuine and original humor.

One time Li'l Abner vanished from his family's ken, and they began to worry something "pow'ful." Fortunately Mammy Yokum, his great little

© United Feature Syndicate, Inc. Reproduced by permission.

FIGURE 62. A very early "Li'l Abner" strip of 1936. The firm outlines of Capp's style have not yet developed: Ma Yokum has yet to shrink in size. But, sho' nuff, the plot is there, and it's a daisy.

pipe-smoking mama, has a gift she calls "vision conjurin'." She cuts her finger, marks an X on her brow with blood, twirls around three times, and goes into a trance in which she sees what her coltlike son is doing at that moment. In this instance he is washing dishes in a restaurant in New York. Because he likes the big city? No. He is trapped in that restaurant; has been so trapped for two weeks, and will go on there until the end of time.

The trap has a wild logic of its own. It seems that Li'l Abner, being "pow'ful" hungry, entered the restaurant with fourteen cents in his pocket. He ate a roast duck. It went to the spot, and he had another, and many other fine things, piling up a check of $8. So there was nothing for it but to wash dishes to square the account. But it took a long time to wash $8 worth of

dishes, and by that time he was "pow'ful" hungry again. That meant more dishes, more hunger. Like a squirrel treading a revolving cage, he was caught forever in this hideous mill. Save for his mammy's "vision conjurin'" and her immediate action, poor Li'l Abner was lost.

The basic reason for Li'l Abner's appeal has, however, yet to be touched on. It is a reason adding a peculiar sophistication to this hillbilly epic; it is a slant catching young people of all classes, and based on reality which society had before hardly admitted to itself, yet which is universally understood.

Everyone knows that girls flower first. Suddenly these delicious creatures are all in bloom, and they expect something to be done about it. The blundering male of corresponding age is irritatingly slow and bashful. There he is, the big lump, with his fine shoulders, blushing and stammering and wasting precious time. Girls seem to know exactly what to do about it. Ideally, you kick and prod the young man from the rear, show him how to fall, and fix it so he thinks it's all his doing. Of course, if he won't fall you get desperate. You grab him any old way.

Here is the basic "Li'l Abner" plot. Luscious Daisy Mae is as sweet as an ear of corn right from the plant, and any gardener knows you shouldn't wait with fresh corn. But Li'l Abner teeters perpetually on the brink; he sums up male adolescence. He loves Daisy Mae, but the fool doesn't know it; he even has a stubborn pride in not admitting it. Once, in the daily strip, he sang a snatch of song that will show what poor, blooming Daisy Mae is up against:

> Oh—Ah'm glad ah is a Bacheluh!
> Ah'm young 'n spry 'n free!
> Haint nevah gettin' married!
> No gal kin bother me!

The proud boast of the last line is hardly justified by the facts. Daisy Mae *had* started bothering him. In the daily strip in the New York *Mirror* of January 1, 1937, Al Capp permits a single flash-back into Li'l Abner's boyhood, and sho' nuff, there is the basic pattern in its sexy richness.

"The clock turns back to a New Year's Day, long ago when Abner was very li'l." Mammy Yokum is showing the tiny boy out of the house. "'Now that yo' has et yo' fill, li'l Abner—run out on th' mounting an' play.' 'Yas'm. Shecks! Thar's no chillun on this mounting t' play wiff!'"

Box 2. Lonely Abner: "Ah is *pow'ful* lonesome fo' someone t' play wif —even ef it were only a gal!"

There is a little vision peeping around a tree. "Mah name is Daisy Mae. Mah folks jes' moved hyar t' Dogpatch. Ah will gladly play wiff yo!"

"*Sho' nuff?* Shall we play Revenooers an' Moonshiners—tha's whar we chases each other an' throws rocks; or Feudin'—tha's whar we stan's still an' throws rocks?"

"No, le's play Courtin'—tha's whar we sets still an' holds hands!"

The last box shows a very tender scene with a huge moon and the two tiny figures seated, heads together, on a big rock. But underneath this highly promising picture is a mournful, frustrated bit of text. "But this was long ago! Times has changed."

Shecks! It almost makes one discount human progress.

The story of Al Capp, however, is a faith-reviving epic. True, he was not a country boy who made good, but he is an art student who made good, something even more startling. He was born in New Haven and studied in the Boston Museum School and at the Philadelphia Academy of Fine Arts. He was going to knock Goya and Turner for a loop.

One summer, with a friend, he bummed his way around southern Kentucky, struggling with the hideous problem of the fine arts. He was doing a landscape when a hillbilly boy came along.

"Whatch-a a-doin'?"

"Embalming this landscape for posterity."

"That don't make sense."

Capp wondered, really, if it did. At any rate he made a sketch of the country kid. Despite the boy's haunting remark, Capp clung grimly to his purpose and entered the Pennsylvania School of the Fine Arts in Philadelphia.

A quote from a promotion article on Capp by his syndicate, United Features, shows, behind its facetiousness, the gratefulness of the big syndicate at the happy turn of events:

"It was at this institution that the great temptation of his life beset him. For a while his closeness to classical art almost drove him to become serious. But that wave of madness eventually passed, and Capp was saved for the funny papers."

The hillbilly's remark had finally gotten the art student down.

He was going to take a crack at cartooning. He landed in New York with just $6, but he didn't have to wash dishes like Li'l Abner; he landed an obscure job with the Associated Press.

Here he had a fine break, a chance to do "Mr. Gilfeather," a nationally syndicated feature. He worked like the devil on it, but a newspaper editor wrote in that the new version of "Mr. Gilfeather" was "by far the worst cartoon in the country." Did our hero simply stiffen his spine when such reactions beset him? No. He threw up the job. There is an honesty about Capp. He felt he wasn't good enough and should learn more, but he did not

abandon cartooning; he went back to studying at the School of the Museum of Fine Arts in Boston.

He sold some cartoons, enough to get married on, but not enough to keep his own Daisy Mae in po'k chops. Once again he made a beachhead landing in New York City, a friendly old landlady in Greenwich Village staking him to a room, carfare, coffee and cakes. Perhaps the sweet old soul had a bit of "vision-conjurin'" of her own. Odd things began to happen. New York is a wonderful city. Perhaps only in grand old Manhattan could the following almost unbelievable incident take place.

Capp was pounding the sidewalks, under his arm a package—a bunch of cartoons, freshly rejected by a syndicate. A man stopped him.

"I'd like to make a bet with you. I'll bet that what you've got under your arm is rejected cartoons."

"I'm not fixed to pay bets," said Capp, a shade miffed, "so I'm not making any. But if it makes you feel any better, you're right." And he walked on.

"Don't get sore," the man called.

Then he offered the hungry Capp $10. He was no wandering philanthropist, far from it. He was Ham Fisher, one of the big, coming strip artists, and the ten-spot was to pay for finishing a comic page. So Capp got the job, and became his assistant. The assistant's job is one of the two classic ways for a newcomer to break into the game, the other being the staff artist's job, an opening Capp had had his chance at, and failed. Surely this time he would worm his way in. But Capp was too original to be willing to bat in another man's shoes. He threw the job up again. He was determined to possess a feature of his own.

The trouble was that he couldn't find the right idea. In the isolation of his garret in the Village, he made his mind a receptive blank. Nothing came. Below in the courtyard, a radio spat static and a harsh voice ground out: "I love mountain music, good old mountain music, played by a real hillbilly band."

He loves hillbilly music, huh? Maybe loves hillbillies, too. Maybe lots of Americans love hillbillies—he was on his feet, burrowing through piles of cartoons, old sketches. He found it, the sketch of the kibitzing mountaineer boy whose remark, "That don't make sense," perhaps did make sense. He sat down and began to work on Li'l Abner. He remembered the setting, the other people he had seen and talked to. The Yokum family came tumbling into being. Out came Daisy Mae all in blossom and set to go for her one man. And that was that. United Features had the wit to see the idea at once, for which they were amply repaid. Speak to a "United" man about Li'l Abner, and watch him sit back and relax.

Once set with his strip, Capp's inherent drive, initiative and ability

FIGURE 63. The lower half of a Li'l Abner Sunday page, December 1, 1946. A clue as to the Englishmen: the first is a vegetarian, the second sets fashions.

pushed the thing rapidly to fame. He worked, and still works. The strip began on August 12, 1935, in the New York *Mirror*. The characters and style were somewhat tentative, Ma Yokum, for instance, being much larger than at present; but by the beginning of 1936, everything was in order. The heavy, clear-cut outlines, which give the art work its force and character, were there. Capp's years as an art student contributed to his drawing, yet he retained a gay, decorative approach that saved the strip from the feeling of a pulp illustration and related it more to the mad, merry masters of the past, to George McManus and Opper. The particular triumph of the strip, which made it popular with every group of young people in the country was, however, yet to come. It was a triumph based on the remote past.

In 1288 a law was passed in Scotland that each leap year all maiden ladies of the realm should have the right boldly to approach, woo and attempt to make off with any man who was not married or betrothed. This first law in recognition of the plain gal's rights was passed under a queen who was probably as ugly as sin. A loophole was provided for the besieged males, allowing them to buy their way out for a pound or so, according to their circumstances. The law must have been effective, for a similar one was later passed in France, and by the fifteenth century the custom was legal in Genoa and Naples. The authorities were probably thriving on the fines milked from wealthy, harassed bachelors. Even as recently as a hundred years ago, if a man refused a proposal during leap year, an unwritten law required that he give a silk dress to the rejected lady.

Similarly, we find the mayor of Dogpatch issuing a proclamation, dated the sixteenth day of October, 1939, to the effect: "Whereas, there be inside our town limits a passel of gals what ain't married but craves something awful to be . . . we hereby proclaims and decrees . . . Saturday, November 4th, *Sadie Hawkins Day,* whereon a foot race will be held, the unmarried gals to chase the unmarried men and if they ketch them, the men by law must marry the gals and no two ways about it . . ." The proclamation was signed, "Prometheus J. Gurgle."

The history of Sadie Hawkins is given in a "Li'l Abner" strip, portions of which we quote:

"Sadie Hawkins was the daughter of one of the earliest settlers of Dogpatch, Hekzebiah Hawkins. She was the homeliest gal in all them hills."

"Pappy," she is seen complaining, "Ah is twenty y'ars ole today! Ev'ry other gal in Dogpatch mah age is married up, how come Ah haint?"

"Have patience, dotter! Yo'll prob'ly be gittin' a offer any day now."

Fifteen years later the situation is unchanged, but "Ah'll git yo' a husband t'morry!" her pappy determines, and next day calls together the eligible bachelors of Dogpatch.

"*Boys!* Since none of yo' has been man enough t' marry mah dotter—ah gotta take firm measures!!"

And as they look at homely Sadie, *Gulp, gulp, gulp,* comes from the unfortunate bachelors.

So pappy proclaimed the day "Sadie Hawkins Day" and laid down the racing rules. "Sadie did catch one of the boys. The other spinsters of Dogpatch reckoned it were such a good idea that 'Sadie Hawkins Day' was made an annual affair."

The young people of America also "reckoned it were a good idea," and they too, have made "Sadie Hawkins Day" an annual affair, having a hilarious time as thousands of sweating Daisy Maes take the field after thousands of apparently horrified, secretly delighted Li'l Abners. It has been one of the most successful stunts in comic history.

Another good stunt of Capp's is to model characters after people in the public eye; sometimes the public doesn't quite recognize the resemblance but does know that that face looks awfully familiar. Li'l Abner has certain trademarks, his mop of hair, his bashful smile, taken from Henry Wallace; Daisy Mae is said to be based on Veronica Lake, and Marryin' Sam has some of the features of Fiorello La Guardia. Others are Adam Lazonga, from Bernard Shaw; Adorable Jones (whom no girl can resist), from Winston Churchill; and Silent Yokum, from William Smith of the cough-drop brothers. Maybe that's why Silent Yokum hasn't dropped a word in nearly forty years.

Popeye and Li'l Abner: the Paul Bunyan and Ralph Stackpole of today; simple guys, heroes of the people. It seems that in choosing two such hefties for its highest honors, the ideal of strength is still with America, and stronger than ever.

Chapter XIV

THE THIRD AND FOURTH DIMENSIONS

THE HISTORY OF COMICS is a sad study for purists who insist that even minor arts should remain within neat pigeonholes. Pigeonholing seems to be a major activity, probably because it is so easy to follow and study something laid out in an understood, orderly pattern, and it is natural to regard the fellows who come along with new patterns as irritating disturbers of the peace, as enemies of society.

Change, disturbance, and growth must, however, go on. Often the pattern-makers are responding to some pushing, human need. The old leaf withers; the new bud crowds its way into the light. It is so with human beings, and with strips.

Comics, in what many regard as their golden age, were once simply riotous entertainment. But they had bored into the mass reader's soul to a unique depth. The mass reader had taken the tiny comic strip circus right in between his eyes, to that illusive intimate place where dwelt his living spirit. At the same time, there existed other popular approaches to the reader. What more natural than that the workers in these other approaches should look with envy on the close connection established between the comics and the cash customers or that bright ones among them should decide to pull up stakes and move over into the new gold fields? It was a process that changed the whole aspect of the strips, and is still at work changing that aspect.

The substitution of a chest for a potbelly in the comic hero was one change. Now we come to another, and here, without question, is the point where we depart from the classic period.

Suspense was not new. It was dripping out from between the covers of the dime novels of yesteryear, so beloved by butlers and coachmen and so surreptitiously and widely read by everybody else.

"Spare my child," she gasped weakly, her violet eyes dewy with fresh tears, as with trembling hands she thrust little Rosie behind her, exposing her frail form to the oncoming menace. A low, scornful laugh gritted out from between Buck Baleford's teeth. His jet-black eyebrows drew together as, with one heavy hand raised, he—

This, children, is suspense. We will find it at the crest in the old motion pictures. A rattling piano, pounded by a gum-chewing, used-up spinster is mounting to a harsh forte. Spots of jagged black flicker and flutter over the screen, but the audience pays no attention to these annoyances. The people are leaning forward on their seats with fixed, intent eyes. They are watching a twitching female figure bound hand and foot across a railroad tie. From around the bend ahead a fearful object is thundering into view at the unbelievable speed of sixty-two miles an hour. It has been painstakingly demonstrated that curly-headed Broncho Jack is exactly one and three-fifths miles away at this second, even if his mount is mouthing spume at full gallop. Jack has simply missed the boat, and the audience knows it. Since the scene is laid in the open country, with no other cover but low clumps of sagebrush, no human help can possibly save Tess from that train. Now it is fifty feet away, now—

This again, is suspense. This is the ancient formula that was waiting to take over the innocent, bouncing comic strip, which in its early years had no other object than to give you a good laugh within its immediate dimension, whether of daily strip or Sunday page, and to call it quits for that day. The suspense writers, noticing that the strip artists were now in the big money, came to the conclusion they could use some big money, too. They knew that their formula, however battered by use, couldn't possibly fail.

The business of suspense is almost unbelievably simple in structure; it has scarcely any anatomy. Take any strong object of interest to the millions. Work out the most violent threat to this interest which is imaginable, and spare not the typewriter here. That object of interest must be about to lose his or her life, honor, love, or money. At the exact point at which this dreadful threat piles up to a certainty in the reader's mind, rule the last box-line vertically across the end of your strip or page. You may add in little letters, "To be continued." Then go and have a cocktail. Everything is going to be all right. Your readers, although convinced in their simple way that the very worst is about to happen, have yet a faint, wild, lingering hope. In any event, they simply must see—and they can't see, until they buy tomorrow's, or next week's paper. And that is what you are in business for, to sell papers.

It will be seen from this that timing is all-important in suspense. If the reader is permitted to guess or even smell the solution, his interest sags instantly to zero. Why should he waste a nickel to see what he already knows? You and your strip can go to the devil. The successful suspense strip artist or writer works hardest on that one point: to end his job on a sufficiently hair-raising and baffling note. The writer worked out a standard of such measurement for himself when he was doing "Dickie Dare." The ideal

ending was one to which he, with his years of experience, had no immediate answer.

Obviously, from the reader's point of view, a slight job remains to the suspense artist when he has fulfilled his first function of chilling the reader's spine. He must have a solution and, especially in these days, it must be logical. If the strip is one with a tradition of plausibility, the author is going to work hard; for the audience, especially the technical-minded kids, are going to be very critical. Pots of coffee may be needed here. If the suspense formula is simple, to conclude it is often complicated. The writer may have to make many attempts before his critical sense is satisfied.

Not too much, however, was asked by the earlier audiences. In the first of our two hoary examples, Buck Baleford has pulled out his long cruel knife, ready to do in trembling little Rosie (end of chapter). But a shot rings out. (Why do shots always ring?) The knife clatters harmlessly to the floor and the man whips around to face Daring Dave, who is climbing in through the window. However Buck was not scratched—that would not have been cricket—and the very next copyrighted instant they are locked in mortal struggle. Which of the two is now on top? Our hero? Alas no, reader. It is none other than Buck Baleford, whose horny hands are closing around the throat of the man on the floor. The young widow's screams come faintly to Dave's mind as blackness floods over—well, here we are again, boys. Let's have a beer.

Example number two is a shade more ingenious in solution. Not twelve feet from struggling, gold-haired Tess, the towering mechanical monster switches sharply to one side, and as sweat pours off the customers in buckets, it thunders harmlessly by. There *was* something hidden by that low-lying sagebrush—a switch in the tracks.

"Why, I never thought of *that*," the customer admires, and is still further pleased when it turns out that Broncho Bill has telegraphed ahead to the switchman's shack. This is good, because that young man certainly looked to be slipping. It appears that his wild ride was for his reward, which he certainly earned, and the customers are in no hurry to see that long kiss end, especially after the lovers have been left thoughtfully alone by the train crew and passengers. But to the onlooker's horror, a long, snaky hand creeps out of the sagebrush. It is holding a peculiarly sinister six-shooter, and it is taking its time with the job of aiming. Now a deformed thumb pulls the old-fashioned hammer back . . . "Hey, Bronc, Bronc, look behind you," a customer is whispering, but no words come out of his dry throat. Meanwhile the lovers kiss on. . . .

We have deliberately chosen examples of suspense from the "corniest" of the old schools, because they emphasize a striking point with reference

to strips and suspense. The story may be obvious bunk, the characters wooden puppets, the drawing hideous—nothing matters, if the suspense is there. If you can give the masses plenty of well timed suspense, they'll pay you a prince's salary and forget your other failings.

An understanding of this explains much about the entrance of the suspense motive into comic history. We have been laughing at the old, worn clichés of early movie dramas, and this is what most of the suspense pioneers in the strips were doing. These first strips were burlesques and satires, but they were good satires, faithful to the originals. And here we perceive a curious turn in comic-strip history; one which changed the character of strips by at least half. The underlying principle of suspense, which we have just examined, was present in the parody as much as in the original, and this principle began to work on the readers of the parody. Strip artists and editors are keen to detect new trends in popular interest, and after a while, suspense stories of many types began to appear in the comic strip medium. The new strips were no longer parodies. It was found highly profitable to feed the public the original "corn." From this point on, laughs were less a factor.

Another explanation, perhaps, for this last phenomenon is that, from the writer's point of view, a suspense strip is much easier to keep going than a gag strip. A good idea may last you over a month and a half, if you spin it out and do your chopping at the right point—and this soon becomes second nature; but to have to think of a new gag every day. . . .

The burlesque entrance we mentioned before was that used by Charles A. Kahles in "Hairbreadth Harry," and by Harry Hershfield in "Desperate Desmond." See Figure 18.

"Desperate Desmond" was going as early as 1910, and was one of the first users of the continued story form. Another pioneer, of the burlesque order, was Segar, whose "Thimble Theatre" carried the interest over from day to day, and whose "Popeye," in the famous fight we reported, built up suspense to a peak of epochal grandeur.

There was, however, another very early strip which, no doubt, will be regarded by the modern story-strip workers as a more dignified and legitimate ancestor than the playboys we have mentioned.

This was "Minute Movies," begun by Ed Wheelan in 1922. Like Hershfield, Wheelan based his strip on the highly developed suspense form of the movies; but his work was what is known as "straight," no attempt being made at humor or satire. At this early day there existed no comic conventions upon which to base continued stories, and Wheelan applied the movie form as closely to the comic strip as he could. "Ed Wheelan presents—" he would start off. Then would unreel an adventure story, often

his version of famous books such as *Treasure Island* or *Ivanhoe*. "On this screen tomorrow—" the last box would start off.

The drawing, while not illustrational in the sense of using depth and shadow, broke with the "slap-happy" style of the current strips and laid the foundations for later developments. There was an interesting tendency in Wheelan's work, which was soon buried as his straight drawing and movie suspense ideas were taken over and exploited. This tendency is working its way through strips now. We shall look at it later, but as we pass, we must note Wheelan as one of the men who have deflected the comic stream.

Suspense and the continued story moved into the comic medium at the same time, for they are parts of the same thing. Without suspense, a continued story falls flat; suspense means that the story must be continued. But the man behind the typewriter, who is responsible for these matters, is obviously only one of a team of producers in a picture form like the comics. The artist is frequently, and usually, another side of the writer, but there are many teams, and the question naturally arises, what was the art work of the suspense form like? Was there something new here also? There was, and its entrance had to do with this duality on the part of the comic producer, or producers.

Depth is the third dimension; time, they say, is the fourth. The strip world was about to blossom out in these two new dimensions; for as we have seen, suspense is simply good timing, and the third dimension of depth was tagging along with it.

What had happened was simply that the cheap, illustrated magazine story was being absorbed into the strip, lock, stock, and barrel. The illustrators of these stories had developed a special approach during the early 1900's, a technique highly applicable to the printing demands of pulp magazines; they slashed in solid black shadows in free, loose brush, knowing that only strong effects would survive the coarseness of the paper. They had also become experts in wild action, and almost all carried on the intensely realistic approach of the Western artist, Frederic Remington. While Alphonse and Gaston bowed and scraped in their gay two dimensions; while stylized Mr. A. Mutt "pasted" stylized Jeff to our delirious joy, these fellows were suggesting depth by the use of clever perspective, working out techniques to convey the realistic sense of sagebrush or steel or leather. There was a time lag before the illustrational world awoke to what was happening, but soon the magazine partners moved over, and the hospitable comic strip opened its boxes and let them in.

The famous strip "Tarzan," originally drawn by Harold Foster and which first appeared in 1929, was the pioneer of this new tendency. We shall look at Foster's work in Chapter XV, noting here only that he had

been a highly successful illustrator before moving into the comics, and that his work was so adaptable to the medium that it formed a new pattern and had much to do with releasing the flood of illustration that later poured forth.

As we have said, there was an interval before this happened, and some suspense strips, like "Popeye," went ahead with the earlier art work. Others absorbed some aspects of illustration and retained some of the earlier cartoon approaches. Studying some of these, we will understand the loopings of the river of comic history.

© *AP Newsfeatures. Reproduced by permission.*

FIGURE 64. Left: from a "Dickie Dare" page of 1943 by the author; right: a box from a 1945 daily strip done by the present artist, whose name in precomic strip days was Mabel Odin Burvik.

"Dickie Dare," syndicated by the Associated Press, and which this writer wrote and drew for nearly nine years, is one of these—part cartoon, part illustration. It was originally created by Milton Caniff, who later became famous as the author of "Terry and the Pirates." Caniff had conceived Dickie's face in the true comic manner. Two dots made the eyes. A half-circle on top, and Dickie was wide-eyed with astonishment. A pin-wheel line spiraling to the right or left of the central dot, and Dickie's eyes rolled with the excitement which is his birthright. The author did not at once realize the enormously expressive possibilities of such conventions.

One day he had brought in a group of six strips about whose quality he wasn't too sure. Something was lacking; the hardest kind of work had gone into them, but still . . . The editor, a brilliant, but very blunt-speaking man, looked silently at them, his face purpling with distaste. The strips jumped as he suddenly banged his fist on the desk. "Look!" he bellowed,

pointing with scornful finger at face after face after face. *"Dead pan! Dead pan! Dead pan! Dead pan!"*

The author was angered, but nevertheless he did look, carefully. Yes, that was it: the faces lacked expression; or, worse, all expressed the same thing. He grabbed the strips and raced back to the studio. Whatever might happen, whether the schedule fell and he lost the job, or whether the walls caved in, he was going to learn to put expression in faces. He did. He analyzed the old comic style and found it more expressive than the illustrational. He made a set of conventions to convey any shade of meaning. And very soon the lively spark of Dickie's face was the best thing in the whole strip, for that editor had stubbed the author's toe on a big secret, which is the reason for telling this story here. The life in faces is what leaps out and arrests the reader's attention.

When the writer decided to turn finally to other matters, he had as assistant a determined young woman with an interesting Norwegian name, Odin Burvik. She could herring-bone up a hill on skiis as fast as he could roll down them, and she had one burning, devastatingly difficult ambition: to become a comic artist.

Knowing the stress and strain of strip-producing, the author decided to try her determination and gave her the most difficult assignments he could. "You can't be sick; no holidays," he said. She wonders now how she ever survived; but she learned so much in a single year as assistant, that when the big chance came in the spring of 1944, the Associated Press agreed to try her out. She won, and soon she was in full charge of "Dickie," matching his bubbling energy with the sense of life which gives her style its own special distinction.

Meanwhile, the author, having given up "Dickie," had embarked on something new, a strip in which a soldier, losing a leg overseas, came home determined to find out why it had been necessary and to prevent his son from having to make such a sacrifice. The result, "Hank," started April 30, 1945, in the New York paper *PM*. Novel art approaches were tried out; for a while about half the balloons were black with white lettering. This was to be a deliberate attempt to work in the field of social usefulness. Eyestrain forced the author to discontinue "Hank" on December 31, 1945. However, indications of this trend are noted in various other strips.

Crime, they say, doesn't pay. Telling all its little details, however, does; as witness the great strip "Dick Tracy," which belongs among those leaders which can be counted on the fingers of one hand. It is another of the half-and-halfs; it is based on continued story, but the art work belongs to the earlier cartoon tradition, with a very particular, tight, defined style of its own. Chester Gould does, it is true, use perspective; but he makes no attempt to

indicate the play of light and shadow that dances in nature. He takes each form as it comes before him, reduces it to an effective essential, and draws it with a hard, wooden outline. The process does not sound attractive; actually, however, it is extraordinarily effective; it allows Gould to dwell with a kind of passionate insistence on the procession of criminals who knife their way through the strip, and on the minute details connected with their crimes—both of which are presented there with more tang and force than in any other picturing of crime we have before us.

There is a kind of extra dimension about "Dick Tracy." It isn't so much the detective story that fascinates people—the endings often have little suspense—it's this extra dimension that is a dark red, the color of blood; that has a queer smell, such as radiates for many feet on every side of B. O. Plenty; that has the deadly taste of cyanide in water. No one has ever lived to report what this taste is like, but somehow we do taste it when Nilon Hoze, that tall, hideously beautiful, blonde chunk of horror drops some cyanide from her cigarette case into the water glass of a minor criminal in the next cell, who is screaming, "I want my dough!" He raises the glass. "Water! I never did like it. It's terrible. What I need is a real drink—UGH—"

Nilon, with folded arms, is smirking in the adjoining cell, looking edgewise at the gagging mobster from her eyes of an experienced rattlesnake, a cigarette in her wide, black, heartless-shaped mouth: "Cyanide and water! It's your *last highball*, Merle!"

And then all the corpses, dissections, and subterranean sewers, down which float bound and gagged figures.

"You see, this long plank will never be able to make that turn at Wells Street, *it'll stick there*. B. O. will *never pass that point,* the sewer is thirty-five feet below the surface there—and no manhole."

"Itchy, you're a genius!"

B. O., however, survived; the author doesn't remember just how, but probably someone smelt him, even if he was in a sewer. After all, he was only thirty-five feet down.

This delineation of the horrible depicts certain habits, such as that of Itchy, who continually pulls at his collar to reach in a scratching hand. The details of the shootings—a mother shooting her daughter or a more commonplace killing, are given distinction; at one time by the bullet making a neat bull's-eye in the open target of the victim's mouth and whanging out through the back of his head. There is a gruesome intimacy here which is perhaps only possible in such a frank medium as these innocent-looking little funny sheets.

All details, however, lead to the great pictorial feature of the strip, the

FIGURE 65. "Dick Tracy," April 2, 1947. The public loves realism, detail; one reason why this strip, in spite of grim subject matter, is close to the top in reader interest.

heads of the criminals; for the strip's tight style reveals them to the reader with all their dagger souls unsheathed. Perhaps never have more horrible faces been conceived; compounded of folds and sinister deformities, they are diagrams, severe lines drawn around a black mouth or pouched eye slits. This master physiognomist is at his keenest when faced with such a problem as that of a man, with his jaws locked tight, who had previously been in freckled, rubicund health; whose very name of Laffy, points up the terror of the change. Once Laffy had fat jowls, which swayed with his mirth, but these are replaced by long, parched, drawn lines, and his eyes are dead, staring buttons filled with death.

The detailed picture of crime given in this strip was tried out on the public at first tentatively, but it was soon found that people liked it. The protests were drowned out by a roar of approval. The deep, human preoccupation with the morbid, with death, with diseased minds and bodies; the strange instinct that gathers men in a circle to gaze with fascination at the shattered suicide, had found an outlet.

The grim horrors of crime are only one side of "Dick Tracy." The defense of their presentation before the public is that such crime does exist, and that in the strip it is always broken by the iron will and searching intelligence of the master detective, a symbol of the forces of law and order. Thus, the argument runs, the general impression is given that *crime does not pay*. Critics counter this by pointing out that the impression given of police intelligence, as contrasted with the intelligence of the master sleuth, is not of too high a caliber. These master sleuths, a potential criminal reader might then reason, exist only in fiction. I can handle the dumb cops easy, he says to himself. The reader will make his own choice between these two arguments. In fairness to Tracy, let us remember that he is not a private detective like Holmes; he is a cop. Of course these arguments refer to the effect of the strips on the readers. This is a highly legitimate study, but one must remember that strips have not been created, until very recently, with that idea in mind. There is no question but that "Dick Tracy" is what huge blocks of readers want and demand.

Tracy is an attractive character. Although his razor jaw is always set at a jutting angle, a perpetual grin softens his austere face. He is a modern version of Sherlock Holmes; a drugless, pipeless Holmes, healthier and cleaner living. He has a satellite in Junior, to whom he gives his first affection; but in and out of the strip weaves his Tess Trueheart, who, readers hope, gets more of his time offstage than she does in the strip. His assistant, Pat Patton, is the heart-of-gold, dumb cop of fiction, always there to yank out the master or snap on the handcuffs. Chief Brandon, his boss, hands out the praise in the end.

Chester Gould, like Popeye's creator Segar, can credit a correspondence school in cartooning for his start. With this background he started professional work on the Tulsa *Democrat* and did sport cartoons for the Oklahoma City *Daily Oklahoman*. Then came the Chicago *American*. This was in the far-off days in 1931; the time and the place were ripe for the beginning of a great crime strip: Al Capone was about to be sent to Alcatraz, and the public mind was stored with gangster lore. Gould says, with perfect truth, that there was a public demand for less red tape and more action in dealing with criminals. "Dick Tracy" was the result. It is a tribute to the amazing reality of the comic character, and a reflection on

© United Feature Syndicate, Inc. Reproduced by permission.

FIGURE 66. This is Slats, from an "Abbie an' Slats" daily strip as seen March 5, 1947, in the New York *Post*—among many other papers. Noted for absorbing realism in the dailies, the Sunday version has mysterious overtones and subtle humor.

the equally amazing naïveté of man, to say that Dick filled this public need perfectly. We forget that he is only a pen and ink detective.

Gould's first samples were submitted to Captain Patterson of the Chicago *Tribune*–New York *News* Syndicate in the summer of 1931, under the title "Plain Clothes Tracy." The *News* publisher, with his characteristic touch, changed this to "Dick Tracy," and the strip began its enormously successful career.

218

"Barney Baxter," syndicated by King Features, is a strip that, although preserving some of the ancient, comic, look-and-laugh art, leans heavily on the newer interest, suspense, to which it adds a very competent technical performance in depicting the flyer's world. It was an air strip from the start.

On January 24, 1937, in the New York *Mirror,* we find the youthful Barney, a junior air pilot, experimenting with model airplanes, in company with "Spud" Vines and "Blackie" Barnes, two farm kids who want to learn to fly. The story, starting in the Sunday, continues in the daily, the boys being rapidly swept into an adventure in a "war to end wars," thus initiating one of the chief motives of the strip; for Barney is always roaring off to the attack in some remote part of the world, and is often mixed up in the affairs of European royalty, as in March, 1937, at the crowning of Crown Prince Emmanuel, later Emmanuel Don Pedro, King of Brazona. Having neatly made possible this coronation, Barney is honored by Emmanuel in the following words, sad indeed to be reading from today's perspective:

"He [Barney] has brought happiness and security to all ze people on this earth! And he will always stand as the grand champion of eternal peace!"

But Barney Baxter was not to spend his life as a symbol of remote hope. The story of his absorption into the storm of war is one of the most dramatic in the strips. Barney made the plunge before most strip characters did.

In September, 1941, we find the flyer and his odd little pal, Gus, crashing two of their planes, and short of funds to repair them with. They accept a job to pilot a seaplane to Bermuda for a wealthy sportsman. But they are met by a man who is waiting for someone else. They don't think too much about it when the man tells them the plane is already in Bermuda, and he gives them two tickets on the clipper to send them there. At long last, when they are taken to the R.A.F. headquarters, they discover the mistake. The commander says there has been an error, and that he will send them back to the States, unless they want to join the R.A.F. The next day's strip, dated September 23, 1941, reads:

"Listen, Gus, we've been given our choice of returning home or joining the R.A.F."

"Yup."

"We've trained ourselves to perfection in military flying and we've got what it takes to knock the stuffing out of the Nazi Luftwaffe! Right?"

"Right!"

"We've yelled our heads off for a chance to get into action and do our bit to preserve decency for the world."

"*Right.*"

"We'd be fools to let this opportunity slide by us!"

"*Right!*"

So, by the time of Pearl Harbor, Barney and Gus were hard at it in the Sunday page, looking for secret Nazi supply bases in Alaska.

Soon a Naval Patrol bomber finds them and they learn officially that the United States is at war. The bomber has sealed orders for Barney Baxter and he is off to bomb every enemy invasion base in the Pacific, and another Sunday comic strip is converted to a full wartime basis without a hitch.

In the dailies, Pearl Harbor found Barney heading a fighter group called the Sky Demons, and since he was already fighting Hitler, Frank Miller naturally kept him going. On his last adventure before Pearl Harbor Barney flew King Jan of Slavania, a little boy, out of the hands of the Nazis, who were going to shoot him. On February 25, 1942, the daily strip reads, "News of the safe delivery of little King Jan into Allied hands electrifies the world," and a picture of the front page of a newspaper shows a headline, "Famous Sky Demon Saves King from Nazis!"

In a certain hospital somewhere in England, Gopher Gus lets his emotions get out of control. And Gus kisses his nurse.

In America, Barney's girl friend, Susan Jones, is proudly reading the paper to her parents. Her father speaks:

"But, daughter, he should return now to help us lick the Japs!"

Susan: "No, Paw, he can serve our cause best by staying where he is! We mustn't lose sight of the fact that Hitler is the number-one murderer to be crushed at all costs!"

Bob Naylor, as artist of "Barney Baxter," makes the strip prominent on the comic pages, for it has a special quality not duplicated among them. The figures are adequately drawn, although Gopher Gus seems a bit repellent in his wild stylization, especially when contrasted with very proper Barney; but it is not the figures that give this strip its distinction. It is the fine drawing of the airplanes and their arrangement in the high world of the upper air as they wheel and dive against dramatic clouds. Here is a sense of size that recalls some of the achievements of Winsor McCay in "Little Nemo," and Naylor has a measure of McCay's decorative sense and feeling for good layout. An exceedingly effective trick is the use of even, well balanced cross-hatchings for shadows under plane wings and for the darker sections of the sky—something that sounds easy, but is difficult to do without appearing dated. As Naylor uses these shadows, they give a silvery glow that is an unusual touch of beauty in the comics.

Chapter XV

THE STRIPS CALLED STRAIGHT

Our story has now arrived at the point where the literal illustrator took over and, for clarity of understanding, we had better define illustration and find out how it differs from cartooning.

An illustration is a fragment. It refers you to its story; its purpose is to interest you in its story; therefore it is not complete in itself.

A cartoon is final and complete, standing on its own penwork. Text and picture are used together to boil down an idea to a simple, forceful statement that can embed itself in the reader in two seconds. The newspaper form developed cartooning because of its need for a medium that would catch the attention of the hurried reader. A dollar sign, for example, conveys the concept of green cash faster than any laborious drawing of an actual bill.

We have previously explained suspense, and shown how it will fascinate people, no matter how presented, if the timing is right. Illustration partly displaced the fun-form because it referred to and pointed up suspense in a more vivid manner than the old gag-art. A realistic tiger about to spring on a realistic girl (with the correct curvature), is more spine-chilling than a comic art tiger, with his slapstick, feminine tidbit, and it has been discovered that chilling the spine is what pays.

The first of a series of disasters overtaking our apparently secure, two-bathtubs-in-every-house civilization struck in 1929, and this was the year of the appearance of the first great illustrational strip, "Tarzan." Coincidence, of course, but dramatic and symbolical; for the lengthening shadow of depression and war that crept over us, partly clouded our sense of gaiety, and led to a grave-eyed, new generation, who demanded more literal and somber reading matter. The strips never escape history. Again, they mirror a national mood.

The roots of the "Tarzan" saga lie still further back in the days of the First World War. Edgar Rice Burroughs, Inc., is a fabulous business. He, or it, is something out of the American legend; a Paul Bunyan of the pulps, an enterprise in seven-league boots, one of which is planted on windy prairies, the other on the firm linoleum of modern business offices. His

ape-men, lariats, six-shooters, and galloping Arabs function to the sharp, clicking tune of thousands of typewriters. A Western town, Tarzana, puts him literally on the map. He, or it, is something done in the American way, brash, uninhibited.

The big pulp man knows his stuff. He was a cavalryman, panned gold, and rode herd in the West. His talent for earthy fiction led him to conceive of a character who, while a scion of English nobility, was reared among apes—in somewhat the same manner as Kipling's Mowgli became part of the wolf world. Perhaps Burroughs figured that, by having his character span society from the very top to the very bottom of the social scale, he would hit the bull's-eye of the cash customers in between. Deliberate or not, that was what happened. The book *Tarzan of the Apes*, published in 1914, competed in interest in the mass-reader mind with the World War.

George A. Carlin, late general manager of United Feature Syndicate, had an interesting story to tell of the adaptation of *Tarzan of the Apes* to the strip world. His note on this subject gives such an intimate picture of the building of a top comic that we quote from it:

"As I have the story, the inspiration came from Mr. Joseph H. Neebe, who is now a vice president of the Campbell-Ewald advertising agency in Detroit.

"Sometime in 1928, Mr. Neebe was in Los Angeles and he met Edgar Rice Burroughs. Neebe had read all of the Tarzan stories and was very enthusiastic about them; he took the first of the Tarzan series, *Tarzan of the Apes,* and had it rewritten in condensed form and illustrated by one of the best of the advertising artists of the time, Harold Foster. The illustrations in general had about five panels to each strip and the text matter was printed under the panels, running about one hundred words to each panel.

"Neebe prepared very elaborate promotion and hired a staff of advertising salesmen who toured the country trying to sell the feature to newspapers. Apparently the approach of high-powered advertising salesmen was precisely what was not needed, because at the end of the campaign no newspapers had bought the feature. Neebe concluded that if selling were to be done, he had better get an experienced syndicate to handle it. He, therefore, came to New York and saw Maximilian Elser, Jr., the president and owner of Metropolitan Newspaper Service. Mr. Elser took over the feature, entering into a contract with Famous Books and Plays and Edgar Rice Burroughs, Inc.

"The first of the Tarzan series, 'Tarzan of the Apes,' ran for ten weeks. Mr. Elser sold the feature to a small but important list of newspapers, with

© *United Feature Syndicate, Inc. Reproduced by permission.*

FIGURE 67. Here, in a 1947 version drawn by Rex Maxon, is the sharp illustrational style of "Tarzan." In 1929, Harold Foster turned comics upside down with this strip.

the understanding that it would run for ten weeks and that then they would query their readers as to whether they wanted the feature to go on.

"When the readers were asked, 'Do you want more Tarzan?' the affirmative response was truly sensational. The result was that Mr. Elser, armed with this sales ammunition, was able to sell the 'Tarzan' strip pretty solidly throughout the country. He discovered he had on his hands a smash hit, tested by the best test of all—reader interest.

"I was the editor of Metropolitan Newspaper Service at the time and handled the 'Tarzan' feature and the promoting of it from the beginning. The first release was on January 7, 1929.

"In 1930, Mr. Elser sold Metropolitan Newspaper Service to United Feature Syndicate, the principal properties being 'Tarzan' and 'Ella Cinders.' The success of the 'Tarzan' strip had been so great that there was an insistent demand on the part of papers for a color page. We, at United, produced the color page. The first release was March 15, 1931.

"At that time Harold Foster had returned to advertising work and the whole feature, daily and Sunday, was done by Rex Maxon. Maxon eventually found this work too much of a chore and Harold Foster returned to draw the Sunday page, while Maxon continued, and still continues, to do the daily strip.

"Some years ago when Foster went to King Features to do 'Prince Valiant,' we obtained the services of that excellent artist, Burne Hogarth, to do the Sunday page. The feature, now in its sixteenth year, continues to be one of our tops."

The references in this quote to the artist Harold Foster point to the new tendency which, we have said, appeared in 1929 and revolutionized the appearance of comics. Foster is referred to as an illustrator, and his work on "Tarzan" was not comic art at all; it was illustration. The cherished speech balloon had been discarded; "Tarzan" was an illustrated story, chopped up into strip form, with text below the pictures.

The story of Tarzan is highly imaginative. Burroughs juxtaposes his people and periods in odd and fascinating combinations; the ape-man, with his bare hands, will be given the assignment of doing in a modern gang armed with machine guns. Still, there is a certain, skillfully arranged sense of probability to the strip. The illustrating adds greatly to this feeling; it almost forces one to believe in the wild story.

The appearance of Harold Foster's work, while it started a new period in strips, almost finished it; the man was so good at his particular job that there remained little for subsequent workers to improve on, and very few have had the ability to come anywhere near him. For the first time, Foster brought to the strips a complete mastery of figure drawing. Tarzan, in spite of his giant chest and arms, was lithe, loose, and moved freely in space. Foster possesses also the true illustrator's passion for periods and authentic detail. He is a remarkable figure among comic artists and his place in strip history is unique. Having ushered in one period, he is now busy with another. Later, we shall find his "Prince Valiant" occupying a prominent place in our story.

Another epochal strip that appeared in 1929 was "Buck Rogers." This

strip, making a break with the present, opened a huge field. Its followers adopted the realism of the "Tarzan" work, and there developed a very special fantasy-illustration school to which we shall devote an entire wild chapter. Our business at present is to see what was happening among the illustrational strips which had some respect for the decent laws of gravity; the strips which can be called "straight."

A strange contrast to Foster's skill is the art work of "Tailspin Tommy," one of the first realistic air strips, which teamed with "Tarzan" in the New York *Mirror* during the early 1930's. This was a hair-raising thing to look at. The suspense was there, though, and this strip shows the truth of what we said before: get your suspense right and you can get by with art "murder." "Tailspin Tommy" specialized in up-to-the-minute air-chatter, such as, "three-point landings," "I'd like to get my hooks onto that tommy gun," "do a one-eighty," "slick job," "let's wash him out," "I'll cut the gun and we'll dead-stick down"—phrases which seem dusty enough now, but which shone with new paint in the young thirties.

Although the *Mirror* was pioneering with "Tarzan" and "Tommy," the *Journal* and the *American* experimented cautiously at first with the new literal tendency. Neither paper had true illustration in 1929 or 1930 in its comic section, although the *Journal's* "Ella Cinders" contained a hint of it and the comic advertisements were rapidly heading that way. In 1932 we find the boys' adventure strip "Tim Tyler's Luck" syndicated by King Features and running in the *American*. This was to be a leader in the new manner.

"Tim" is drawn by Lyman Young, whose brother Chic is the author of the top strip "Blondie." Lyman Young is gifted with an imaginative, adventurous streak. When his brother suggested a comic strip in place of his advertising work, Lyman remembered his boyhood day-dreaming and put it down on paper, very successfully. The result is an honest, clean, forthright job. Tim and his friend Spud are good kids, the kind we'd all like to have around the place.

Young's imagination, however, runs in a conscientious, literal groove. He likes actuality, and started his kids out with an airplane setting; later he moved them to sea adventure. Perhaps it was this literal eye that caused him suddenly to make a change in his art style. At first the strip had been done in outline; but after December 25, 1932, the outlines give way to sharp, shadow treatment, the style of which had been developed by the magazine illustrators. At first it was the single example of this technique in the *American's* color pages.

Contrast this with the situation three years later. Late in 1935 we find the following old-style comic pages still hanging on in the *American*:

"Tillie the Toiler," "The Little King," "Blondie," "Toots and Casper," "Barney Google," "The Bungle Family," "Bringing Up Father" and "Elmer." A sturdy roster, it is true; but the illustrators have exactly the same number ranged on their side, and all this in three short years. We find "Little Annie Rooney," "Ace Drummond," "Johnny-Round-The-World," "Radio Patrol," "Red Barry," "The Hall of Fame of the Air," "Tim Tyler's Luck" and "King of the Royal Mounted."

"Radio Patrol," later "Sergeant Pat of Radio Patrol," by Eddie Sullivan and Charlie Schmidt, is a fast, clean, very modern and very illustrative detective strip, with a boyish slant; for the red-headed cop, Pat, has a pal and unofficial co-worker in Pinky, a black-haired lad. A good feature of the strip is Pinky's gracefully drawn red setter, Irish, who leaps around to many a crook's discomfort.

Another detective strip in this group is "Red Barry," which although generally illustrational, retained enough of the old comic conventions to have a special "zip" of its own, and stood out decidedly in appearance.

Captain Eddie Rickenbacker's "Ace Drummond," drawn by Clayton Knight, was just what one would expect from the great flyer: a fast-moving thriller. Knight had a loose, capable wrist and injected plenty of style into his realism, so that this was good-looking work. Its defect, possibly, was that it fitted so definitely into a certain pattern, that one knew more or less what to expect, and this is fatal to long-time interest, especially in a straight adventure strip.

"Johnny-Round-The-World," if it had a realistic style, was also pioneering and interesting, taking the bold stand that real countries and real animals would be just as interesting as fictitious ones. The action was laid in the South American jungles and the zoological detail was entirely accurate, the feature being by William La Varre, Fellow of the Royal Geographical Society. One misses Johnny and his "zoom camera" in the comics of today. It seems strange that the public is so exceedingly scared of anything that might add to its knowledge or stretch its mind a notch. One hint of the ideas "study," "school," "student," "thinking," and the public lifts its huge head and begins to roll its eyeballs. Then it will bolt like a startled dinosaur and leave you on your back, with the knowledge you wished to feed it spilled over your shirt. The public will be soothing its ruffled feelings by reading "Superman." And the most curious thing is that the public, which should have, and does have, the say in the long run, is actually more sensible than any of its critics. That's democracy, gentlemen. The moral: If you must feed that dinosaur cod-liver oil for its own good, disguise it.

A strip which has dosed the public with needed national vitamins is

"Winslow of the Navy." This is authentic Navy, and naturally the prestige of this magnificent service helps the public to swallow the strip's informative values; but there's another good reason for its popularity—it's a thriller of the old school, with excellent suspense and ingenious, spine-joggling situations. The author, Lieutenant Commander Frank V. Martinek, is unique in experience among strip writers. His personal history is a strip in itself.

Martinek started in as reporter on the Chicago *Record Herald* back in the old crime-laden days. When World War I broke, he joined the Navy, and—the point which is so interesting to us now—became Don Winslow himself. For this man, trained in crime detection, was Fleet Intelligence Officer attached to the Asiatic Fleet, and he organized, for the Bureau of Naval Intelligence, the Physical, Chemical, and Photographic Laboratory. Soon he was appointed liaison officer between the United States Army and the Czechoslovak, which was operating in Siberia. Commander Martinek covered the whole eastern Asiatic coast, a fertile ground for the operation of international spies.

After the war he carried on in America as a G-man, a special agent. Four years of this and he was, understandably enough, ready for a change. He took charge of personnel for the Standard Oil Company of Indiana. At heart, however, Frank Martinek was still the Navy man, devoted to its traditions, its ideals of courage and service. One day the Commandant of the Great Lakes Naval Training Station, Admiral Wat T. Cluverius, mentioned the difficulty of obtaining recruits in the great central portions of America, where seafaring was unknown and tradition and interest were centered in the land. All the navy man in Martinek suddenly erupted at the challenge. He had been writing books, his hero a young officer named Don Winslow. Books were all right, but how to reach a vaster audience, how to present Navy tradition and the story of Navy courage so that every kid in America would realize its fascination and its importance?

As the Lieutenant Commander posed the question to himself, he answered it in the same way that many another who wished to reach that enormous public had answered it; as many educators and certain reformers wish to answer it—with the comic strip. All he needed was an artist. Here he had a stroke of luck.

"One day two artists came into my office," he writes. "Leon A. Beroth and Carl E. Hammond. Why they came, I cannot explain, but it seemed that Providence was getting us together. I asked them if they would be interested and they said, 'Yes.' We organized. I became the creator and producer, Leon Beroth the art director, and Carl Hammond the layout and research man."

FIGURE 68. "Don Winslow of the Navy," as of August 5, 1944.

Colonel Frank Knox, who was shortly to become Secretary of the Navy, became interested and helped to sell the idea to the Bell Syndicate.

"Commander Winslow, of the United States Naval Intelligence, takes the trail after the Scorpion" (announces the new strip in its initial blurb in the New York *Sun* on March 5, 1934) "who is the leader of an international band of plotters. . . . The story moves swiftly over land and sea to all parts of the world. The action is based largely on actual happenings in the military secret service, the working of spies and the methods used to combat them."

"Three years ago," Commander Martinek wrote in 1945, "Carl Hammond, our layout and research man, went into war work, being single and within the draft age. Leon Beroth and I have carried on ever since.

"Mr. Beroth at one time did a strip called 'Tom, Dick and Harry.' He attended the Art Institute of Chicago, where later he was a commercial artist and illustrator. Now he lives in Thompson Falls, Montana.

"Every Saturday I write the week's daily strips and Sunday page, and each week I send the typewritten continuity to Mr. Beroth, and he interprets it pictorially and returns the art work for approval. It works very satisfactorily—somewhat by remote control."

While Don Winslow was advertising the Navy, Frank E. Leonard was wondering if some other public servants couldn't stand some sympathetic treatment.

"Mickey Finn," drawn by Frank E. (Lank) Leonard, is a story about a young, big, lovable, wholesome cop. Mickey is not the usual slapstick police figure; the strip is designed to make the troubles, ambitions, and inspirations of a policeman into something that every family can understand.

The story of Lank Leonard belongs in a comic strip continuity. Lank was a sporting-goods salesman, covering most of the United States. He was making a good living and had apparently no reason to be dissatisfied with his career or his future. But he ran into the late Clare Briggs on a train between Sioux City and Omaha one day and showed him some spare-time cartooning. "Pretty crude," said Briggs, "but there's no doubt that you have talent." Carey Orr, political cartoonist on the Chicago *Tribune*, told him practically the same thing. A correspondence course for Lank followed, and then night-school sessions at the Chicago Academy of Fine Arts. From there he went to the Art Students' League of New York. During this time, Leonard would make progress checks with Carey Orr every time he was in Chicago. Finally, in 1925, Orr felt that Leonard was ready.

And so Leonard, after having made a success of the sporting-goods business, and after having attained the ripe old age of twenty-nine, quietly announced his intention to quit and become a sports cartoonist. He started

FIGURE 69. A "Mickey Finn" daily strip, April 12, 1947. Mickey is the young husky knotting his tie.

modestly as an inker at the Bray studios where an animated strip, "Dinkey Doodle," was being produced. He retained his eleven-dollar-a-week job until he got a chance to do a sports cartoon for the George Matthew Adams Service, keeping on with this until he started "Mickey Finn" for the McNaught Syndicate in 1936.

Leonard's strip hero was based on an actual cop in Port Chester, a burly young fellow whom he watched one day directing kids at a street crossing. He got a hunch, watching that cop, that a strip dealing with police from the warm, human side would ring the bell, and he was quite right.

We must give "Mickey Finn" a pat on the back. In this strip we will not find pools of blood or the garden shears imbedded in the back of the still warm corpse. Mickey has had his share of criminals, but often the young cop's action ends in rehabilitation of the criminal for a useful civilian life.

One of the straightest of straight strips first appears in the color pages of the New York *Herald Tribune* on June 7, 1942, and is called "Captain Yank," a sharply drawn, illustrative job by Frank Tinsley, syndicated by McNaught. Yank is a United States Marine Corps captain, his full name being Yankee Doodle. This is straight adventure, having little to do with humor, sense of design or beauty of appearance.

However, "Captain Yank" must be credited with well arranged, vivid suspense and excitement, as well as unusual authenticity of detail. When Tinsley shows a P.T. boat with the camouflage superstructure of a Japanese lugger, you can be sure that such a thing is strictly possible and has been carefully checked. This is something one can say of comparatively few strips, and "Captain Yank" is a job definitely on the side of education.

We have our technically accurate naval strips, and we have our technically accurate aviation strips like "Smilin' Jack," put out by the Chicago *Tribune*–New York *News* Syndicate.

Zack Mosley could easily be Jack of "Smilin' Jack." In other words, he puts his own experience, as almost every good author does, into his strip. Smiling Zack has been as busy as Smilin' Jack, and in the recent war they both worked hard in the same cause, the final victory of America over her enemies.

We quote from an article written during that war by Captain Art Keil of the Civil Air Patrol, appearing in *Southern Flight*.

"Everybody is always asking Zack: 'How do you do it?' Meaning, how does he fly patrol, draw a daily adventure strip, a Sunday page with color, create squadron insignia for the CAP and many Army, Navy, and Marine units; serve as a 'Pro.' attached to National Headquarters of CAP; as wing Public Relations Officer for Florida, entertain visiting firemen on his own and for CAP; keep up his contacts with all branches of aviation, give and attend parties, and still keep his health.

"Just now he is improving the modus operandi. Not satisfied with living just off the end of the runway, he has built an auxiliary studio on the upper right-hand corner of the hangar at his CAP base. He doesn't want to miss a thing. From the 'control tower,' as the new studio has been dubbed, he can smell 100-octane all the time. To keep in complete character he should have a brass pole like the firemen. That's the sort of life he is leading these days.

"On the serious side of the business, Zack has a tough job keeping up with the career that brings him grits and gravy. Fifteen million avid readers

can't be wrong and neither can Zack. Let him make one little technical error in the drawing of a plane, even if it's just rolled out of the factory ramp, and he'll get a mess of critical letters."

As this quote shows, "Smilin' Jack" is famous and very well liked by millions of fans all over the world, but that doesn't prevent its art work from being one of the most painful jobs to look at in the business. If this is public taste, the public ain't got some. Of course Mosley's women, despite the drawing, are of a bursting lusciousness. But the crudities of this job, the way a character who's addressing someone else is supposed to look inward and is drawn sideways; the terrifying perspective, so near, and yet so far from reality; the lack of any design or arrangement which might gratify your eye—all these things in a widely popular strip seem to show that art appeal means very little in the comics. How could any one take such childishly drawn objects seriously? And yet, we must credit this strip with correctness, from a technical, if not from an artistic point of view. Perhaps the very simplicity of the drawing gives a homy sensation to the readers, as if they had done it themselves.

The two strips, "Way Out West" by Vic Forsythe, and "King of the Royal Mounted," bring us face to face with the leathery core of this hemisphere's adventure stories; the North American West. The heart of this windy theme is a single story which, repeated in a thousand movies and a million magazines, has established a pattern from which even the most up-to-date workers cannot wholly escape.

It seems that Tess, lovely black-haired (or blonde or red-headed) Tess, is struggling to lift the mortagage on the home ranch. She has scraped together $10,000 (always $10,000 and neither more nor less). But as she kneads the dough into a little bundle and starts hopefully on the long ride to the bank, a mysterious stranger rattles into town. He pulls up in a cloud of dust before the Lone Star Saloon and—but you all know the rest. There is the sheriff, the hard-riding gang of cattle rustlers, the slightly harder-riding posse. The mysterious stranger turns out to be a beautiful young ranger. Everybody rides at mad gallop; they all specialize, crooks and law alike, in tearing up the sides of hills against the sky. (Odd: they tell you that in the Army only greenhorns so silhouette themselves.) There are a great many shots, none of which hit any target. Then there is a moon. The money is in the bank, the cattle are home on the range, the crooks snugly in jail. There are lo-o-ong kisses. Way off somewhere, one senses babies coming, plenty of them.

One can laugh at Westerns, but one can't laugh them off. There is a health in them. The wide prairie, the open sky—these words may become clichés, may sell shoddy products in mass-production drugstores, but the

sky and the wind are still there, still moving and beautiful, still good for man. All healthy adventure stories respond to a good craving for robust life. The normal boy takes to the open by a God-given instinct, and we should be thankful that so much of his reading matter is taken up with galloping horses and windy prairies.

Zane Grey is a good example of the expert workers in other mediums who marched in, a few years ago, to take over one half of the "funny" sheets. Everyone is familiar with his name and typical Western stories. In "King of the Royal Mounted" he has moved his tradition northward over the border, and it is a fine thing for good-neighborliness among the nations to have a foreign hero so widely read and so widely understood. King has all the energy and drive we associate with our own masculine idols, and in him we have a stirring example of how much alike men really are. Change his Mountie's uniform to a red shirt and a black mask and you have The Lone Ranger. There are so many points of similarity between these two King Features strips and they stand for such a definite type of comic that we will consider them together, realizing that our findings will apply to many others.

King first appears in the *American's* color sections in 1935; "The Lone Ranger," by Fran Striker, illustrated by Flanders, will be found in color in the *Journal* by 1939. The time difference explains, perhaps, the distinction between the two styles: "The Lone Ranger" is drawn with a more sophisticated and sharp touch.

The reader who looks at these strips with a fresh eye may smile patronizingly at first when he comes up against the structure of the old horny Western plot we have mentioned, which crops out everywhere. Reader, beware. If you think how easy it would be to follow along with another, read the plots for six months. You will discover something which any writer of modern strips must reckon with. You may take a familiar pattern as a theme, but you must continually pump fresh, startling, new ideas into it. If your ideas are stale, out you go. The modern color section is a boiling, frenzied competition; the artists are straining themselves to the utmost to arrest the eye; anything and everything goes, provided that you can startle, shock, or create a thrill. Jaded, used-up ideas are trodden down.

All strip men work their heads off to get new ideas. They are continually listening to people talking; reading anything and everything, or simply looking with fixed eyes at the ceiling; and all the time they are fishing for new ideas. They will draw in their nets every now and then and look over the take. The minnows of triteness and repetition are thrown back; a fairly good six- to eight-inch idea is apt to be accepted. But what they are really after, what sends them rushing to their drawing boards, without even

turning on the radio, is the brand-new thing: the big, flopping, freshly landed, two-pound idea, its red-gold scales flashing in the sun.

All fishing is not such good fishing. The strip must go on. The professional understands that, failing to get an idea, he must use an old one; but he also understands that his salvation lies in three words: the new slant.

Example: King and his boy-pal, Kid, arrive at the usual mine and find the usual mine owner's daughter, although she is a little more gorgeous, green-eyed, and big-breasted than is customary. There are the usual robberies going on; King arrives at the quite obvious conclusion that Miss Green-eyed-wasp-waist is back of it all. Kid, really only a boy in knee pants, falls desperately in love with the hard vixen; worse, much worse, she encourages him. One trembles . . . Kid goes to the extreme of socking the Mountie, who is his hero; an agonizing cry is torn from him, a naïve protest against the strange arrangements of nature: "No one so beautiful could be a crook!" The plot is immediately compelling, and boredom vanishes. One is worried, one must find out . . .

New slants can be simpler than this, merely ingenious turns of plot. The Lone Ranger is galloping to unravel a desperate situation involving the life and (ah, yes) the honor of lovely spirited Miss Girl-of-the-Moment. Back of the bushes, carefully lining up the gallant figure in the sights of his rifle is—no, reader, not the villain. 'Tis none other than the Sheriff himself, the limb of the law. Is he drunk or crazy? No, reader, this is a new slant. The poor Sheriff is being forced by the crooks, who have captured his lovely dewy-eyed daughter, and have sworn to do her in, unless that ranger falls to her father's marksmanship. Of course the Sheriff's daughter is the same girl the ranger is galloping to rescue. But will the Sheriff save his daughter at the Lone Ranger's expense? Yes. As the red-shirted, black-masked figure gallops by, the Sheriff draws his deadly bead. Crack! The red-shirted figure, hit, goes down. However, the tense situation that follows is completely taken in hand by the Lone Ranger, who gallops up at the last moment as usual and distributes his knuckles on the appropriate chins as usual. How come? New slant, reader. The first Lone Ranger was not he, 'twas his Indian helper, Tonto, in disguise. Strip characters have amazing recuperative powers; a dash or so of iodine and soon the gallant Tonto will be back aboard his red and white mount, Scout, galloping behind the Lone Ranger as that worthy "gives" with his famous battle cry, "*Hi ho Silver! Away-y-y-y!*"

Notice that the final wind-up of the plot is none too veracious. There is an almost irresistible temptation to the strip writer to explain past events in the flimsiest manner. The plot action of the strip has gone roaring by;

who is going to care for the silly little consistencies? The readers are already on the edge of their seats (if the writer knows his job) with the build-up of the next suspense. So one gathers up the loose threads and knots them in the most perfunctory manner—yes, this writer too, is admitting something. He pleads guilty to having done it. Somehow, winding up plots is the most awful bore.

Another highly typical Western is "Red Ryder," drawn for NEA Service by Fred Harman, and now appearing in the New York *World-Telegram*. If the drawing is somewhat crude, yet there is a rough action to it. Long-faced Red is very much the man; there is a gratifying absence of Hollywood.

A very original treatment of the Western theme that has hardly had a rival was "White Boy," which ran in the New York *Daily News* in the middle 1930's. This was beautifully drawn by Garret Price in a style at once decorative, tender, and with the true feeling of the open air. It was concerned with the adventures of a pioneer boy, an Indian girl, and the animal life of the Western woods. The stories had an imaginative, dreamy character, with such themes as how the snowshoe rabbit got his fur, and similar tall tales.

In July, 1935, this strip changed both its name and its spirit. "Skull Valley," "White Boy's" successor, was the usual melodramatic, conventional Sunday supplement stuff of masked men and battling dinosaurs high up on the lost mesa. There was more lost than the mesa. It was a shame to have lost "White Boy." One more argument, perhaps, that the public does not like good art work, for reasons apparently best known to its own great, mysterious self.

By 1935, "Skull Valley" had dropped out of the *News*.

In the backwash of Western strips, another little Indian perhaps does more to preserve the dignity of the race than Swinnerton's latter type. This redskin is Big Chief Wahoo. Wahoo is kind but simple. He has enormous wealth, but none of the avarice or greed that usually accompanies it. There we have one of the mainsprings of the over-all plot; for every crooked person the chief encounters thinks it will be easy to fool him and take some of his money. It is no great tribute to Wahoo that quite often he is not even aware of the evil intentions of others, but it shows how essentially good people find it hard to believe others bad.

This strip appeared in 1936 and reached New York in the *Post* for January 25, 1937. Publishers' Syndicate had asked Elmer Woggon to create a comic strip based on the world's best known windbags. The result, a character by the name of The Great Gusto, had a remarkable resemblance to W. C. Fields. The new strip was launched, under that title, "The Great

Gusto," and had to do with a medicine show. Old-timers will remember that all medicine shows had Indians, and Chief Wahoo was Gusto's. Shortly, it became apparent that Wahoo was stealing the show; the name was changed to "Big Chief Wahoo," and the Indian has been featured ever since.

Allen Saunders writes the continuity for the strip and Elmer Woggon does the art work. Because Saunders was once a cartoonist also, he is able to make the rough layouts, which he sends directly to Publishers' Syndicate. They make any changes they wish and send the work on to Woggon, who finishes it. While in the Western strip tradition, Wahoo has not remained in the West. His sweetheart, Minnie-Ha-Cha, has been an entertainer in swank New York night clubs, and Wahoo, in company with his friends Steve Roper and Gusto, has had many adventures, covering a large part of the country.

"Brutus" was another strip flavored with the West, but this, oddly enough, was a really comic strip. It was done by Johnny Gruelle and ran in the Sunday *Herald Tribune* from November 17, 1929, to February 27, 1938. The setting was a place called Hot Dog Ranch, and the strip was full of the amazing feats of a little man called Brutus, who had alarming strength, and the doings of his hired hand, Sampson, and Sampson's sweetheart Sooky. The strip was a weird combination of fantasy and foolishness; its people and animals all said "Gleeps!" or "Skoon!" or other equally expressive words. Sampson used to have a lot of trouble with his horse, named Lilly Hoss. Once she got in the habit of breaking eggs, until Sampson thought of a way to cure her. He took all the chickens into town and sold them. Another time Lilly Hoss drank some hair restorer, and for many weeks went around in the strip looking like an old English sheep dog. After nine years the strip was dropped, perhaps because, though parts were very funny, much of it was hard to follow and make sense of.

Another moral: Keep it simple.

We can't talk long about the West and strips without coming to the name of James G. Swinnerton. Remember how his California bears helped to start the strips on their mad path in the very beginning? Remember, too, how he had come East and started the very successful, very funny and acid "Little Jimmy"? We promised to carry his story further, and here it is. In his style he does not fit with the strips in this chapter, but it can't be helped; Swinnerton saturates a history of comics. There are other wonderful old-timers still alive and working today: Daddy Dirks and Bud Fisher, but these have clung to their original inspiration. The remarkable fact about Swinnerton is that he has changed as the course of strip history changed; his individual history has been nearly that of the strips themselves. And

he has drawn aspects of Western life, many of them, which have remained unexplored by others, yet which are really and deeply true.

James Guilford Swinnerton and his "Little Jimmy" went back home after working in the East for a few years. The high pressure East had been too much; Swinnerton had had a nervous breakdown and had been given up for lost by Eastern doctors. But when he got his big feet back on the Arizona desert, as he puts it, he "forgot to die." This was happy thoughtlessness; the comic readers gained years and years of fun, and the West a new and skilled interpreter.

As we said before, the typical Western story or strip is a mechanism, the only flavor we can detect in it is that of horse sweat; the only smell is that of gunpowder. Little more, as a rule, is shown to us; yet this is the big country which has supplied wonderful legendary heroes and mythical animals; the country of the tall story that becomes a folk art, the country with a native music. It is also the country of the Indians, who possess a culture and an art sense very superior in many ways to our own, and from whom we might learn the joy of craftsmanship, the satisfaction of good design.

Then, too, it is the country of very genuine, warm and human people. The counterfeit, the phony, stand out sharply in the West, contrasted with its big direct spirit, and since there are a few phony things everywhere, they are very conspicuous in the land of the yellow desert and the purple mountain. These are all interesting materials for an artist to work with—much more so than blazing six-shooters and thundering herds. In the comic world, it was Swinnerton who took an excursion through this material, from one end to the other, and back again.

"Little Jimmy" fitted in naturally at the beginning of this excursion. In the earlier chapter we noticed Swinnerton's strange talent for drawing the very minute, and Jimmy's new Western associates are as minute as he, or smaller. Jimmy's bulldog, Beans, stays faithfully by. He has two more companions: Pinky, who for a pet has a stylized fighting cock named Poncho, and a wise little Indian trailed by a bear cub. It is not these tots, however, who create for us the wonderful sense of the West. It is the absorbing, magic figure of Somoli.

Somoli is a kind of Indian, fairy godfather to Jimmy and his friends; he occupies somewhat the same position that Mr. O'Malley does to *PM's* "Barnaby." And no greater contrast between the races could be made. Floods of words pour from bumbling O'Malley, who is always mouthing them for the pleasure of their taste; Somoli prefers to remain silent. With crossed arms, standing very erect, and eyes regarding the ground, he communes with others, makes important decisions, or simply seems to listen to

the vast, and to him very perceptible, voices of nature. A sense of his dignity is conveyed in every gesture or pose; and it seems part of this dignity that he assumes the same in every other living thing. When Somoli "talks" to the animals in wordless exchanges, which are "translated" by the Indian tot, one becomes aware of a kind of spiritual fluid coursing through all things in common. These sequences are very moving, and according to this writer's personal definition, because of this they are art, whether in a comic strip or not.

In spite of his super, or rather extra-normal senses, Somoli is no sentimentalist. The business of living has dignity for him, and usually his talk with the animals has a very practical resolution.

Though recent (1935), this phase is really from the old days; quiet, dreamy, and without bitterness. But Swinnerton was living in the modern West; he could not fail to notice the contrast between such wise, grave sweetness and the commercialization that was turning so many honest Western things into drugstore symbols. Irony he has had from the earliest days; now a tide of accumulated sarcasm welled up and changed his work completely. We must say goodbye to Somoli, many of us with profound regret, for with him the sense of wonder and legend vanishes, and who is left to carry on in his place? He was one of the greatest figures in our comic history.

Now comes the modern epic of the "Bar None Ranch." Swinnerton has pulled out his old ironic pen and polished it up, and what happens is so amusing that we are tempted to forget our losses. The noble red man is about to appear in a far different role. On February 19, 1938, a sandy-haired, freckled, buck-toothed Lem Quigley is addressing the revised Indian. Somoli's ghost will need all his inner calm to stomach this latter, for he is the rolled-up essence of degeneracy; a fat Indian, all uselessness and with lazy, bowed legs; an exhibition piece for Eastern eyes, a man parted by the sign of the dollar from all the past dignity of his race. No greater contrast to Somoli's self-respect could have been achieved. Lo, the poor Indian; low, indeed.

Swinnerton treats himself to three years of satire and sharp characterization. Like the drawing of this period, the text also had much fascination. An example of Swedish speech is a pleasure to quote. Mrs. Hansen is speaking.

"Hullo, Massus Pepper, ah'm goin' into das cuuking business an' ay bring may cuuking pot over. Can I leave it haar?"

Fine as this is, there is a symbolical sadness here to one who has followed the distinguished career of this master. The quote is from one of the very last pages of the first version of "Little Jimmy," for James Swinner-

ton is at this time about to make another and far more radical about-face. He is going into "das cuuking business."

By this we mean that Swinnerton on August 23, 1941, ended his forty-year stretch as a true comic artist, picked up the horny Western story, added the, for him, completely new business of suspense, and even made his satirical style into an approach to the illustrative.

This writer does not know the motives back of the start of "Rocky Mason, Government Agent." In spite of the story, now so worn, the master's distinction and true feeling survived; like all his work, it stood out of the supplement, it was still the real West, rawboned, simple, and

© *King Features Syndicate, Inc. Reproduced by permission.*

FIGURE 70. A delight to strip fans was the return of James Swinnerton's famous comic kid "Little Jimmy" whom we see in this fragment of a 1947 Sunday page, as fascinating as ever.

the landscape had a big, mural quality. But Swinnerton seemed too good a man to bend his talent to an essentially cheap pattern.

Many readers missed the old Swinnerton—and then came—the dawn. This story has a happy ending. Victory brought a lot of old-style things back to America, among others "Little Jimmy," now running again in all his tiny bigness in the Sunday New York *American*, syndicated by King Features. It was a happy inspiration on Swinnerton's part. Now we Swinnerton fans have only one more thing to hope for: give us back our Somoli!

James Swinnerton remains one of the most sizable, most fascinating figures of our strip history. People say, "No man has a mean thing to say about Jimmie Swinnerton." Like Will Rogers, who had the curious quality that, while strictly local in spirit, he yet belonged to every part of America,

Swinnerton has done more than entertain. He mirrors the bigness of the country; whatever new or old turns he may have for us, he will always do that, and we will be grateful.

Leaving the acrid dust of the plains, if you like salt sea air deliciously spiced with gunpowder; if you like your silvery-haired, spice-cookie-cooking, sock-knitting old grandmas contrasted with the latest thing in sweater-wearing, jeans-bursting girls of our current period, "Cranberry Boggs" is the strip for you. It combines some ancient appeals.

For many a long, well financed year, the novels of Joseph Lincoln portrayed a romanticized seacoast which lifted millions of Americans out of their ordinary lives. "Cranberry Boggs" is simply a clever use of this appeal, with a few charming escaped murderesses thrown in. Cranberry himself is a seagoing Li'l Abner. He is all loose pants, knee patches, scrawny neck, and diffident stutter, "Y-yes indeedy, g-gorsh." But terrible things are about to happen:

"The rear-vision mirror [of the speedboat] forewarning her of the dastardly deed about to be committed, Kandy leaps at Toni, 'Y-you *witch!*' Pilotless, the motor launch races crazily toward a channel buoy." Then *crash!* We see Cranberry's feet sticking out of the water in genteel helplessness, while the Battle of the Females is on! Just a rootin' tootin' routine day.

This exciting sea venture started on January 8, 1945, in the New York *Mirror.* Don Dean, its creator, credits Charles V. McAdam, president of the McNaught Syndicate, with being the guiding light of the strip.

This well drawn strip is still too new for one to be sure of the final pattern. It will be interesting to watch its development; meanwhile: shift that gunpowder keg a mite to the right, will ye? Things is a-poppin' over to the fish factory.

Professor Zuk, phrenologist, is shown in a recent Saturday *Journal-American* interviewing a seedy little bag of bones called Pete the Tramp. "You have the brachycephalic formation. The protuberances show you have great fortitude—no obstacle could stand in your way—a born fighter and leader—twenty-five cents, please."

Result, Pete goes out and looks up his favorite cop; bops cop, gets bopped by cop; then, dizzy, beaten up, reviewing situation in his mind, goes back to phrenologist, who is seen in the last box with the finest collection of assorted bumps on his own head that had ever probably shown up in his striped tent.

"You better get those bumps interpreted, professor, before you go misadvisin' *other* people," growls Pete, stomping off in a furious puff of cigar smoke, bursting out of toothbrush whiskers.

The professor Zuk hadn't been entirely wrong in his analysis "Pete the

Tramp," a King Features strip, has shown great fortitude in the way he has kept on entertaining *Journal-American* readers over a long stretch of time. He is an inheritor of one of the very earliest comic traditions; the pathetic bum whose sad life stirs our sense of pity while his personal character in some way interests us. Pete, this naïve and attractive character, was once shown as, with his yellow dog, he was ambling through the swanky part of town. Suddenly he stops and pulls out a little handkerchief. The surprised dog finds himself blindfolded. Now Pete walks past a board fence, holding one hand over his eyes. The fence is filled with holes. There is a large sign which says, "Elite Nudist Camp."

Readers of the New York *Post* will remember the wild action and intrigue of the color page "Miss Fury," which has some of the technical aspects of the smart approach, with an added touch of the outré, the lurid.

Retailing the blood and thunder adventures of "Fingers" Martin, Era of Brazil, Gruen of the Gestapo, Dan Carey, Bruno, and big-eyed, black-haired Miss Fury, it is drawn by a woman, Tarpe Mills, something once unknown in the comic-strip business, and now apparently something of a trend, with Edwina of "Tippie," Hilda Terry of "Teena," Odin of "Dickie Dare," and Virginia Clark of "Oh Diana." It is now handled by the Bell Syndicate and may be seen in the Boston *Globe,* Dallas *News,* St. Louis *Globe-Democrat,* Lincoln *State Journal,* Savannah *News,* and many other papers.

Various straight strips which we have reviewed are all of a certain grade; they are fair to middling to good to very good. But there has been a recent job which, at least from the technically illustrative viewpoint, takes a bold step for a comic page. Now we will find added to the achievements of the comic artists vivid and brilliant illustration of the book type.

Once upon a time (February 13, 1937, in the color pages of the New York *Journal*), the King of Thule was so hard pressed by his enemies that he and the small group who had remained faithful were forced to the very beaches of his land, fighting with desperation in a crisscrossing fury of lances and swords. Such was the vigor of this final stand—even the King's little son was working a man-sized bow with a man-sized determination—that the attackers fell back, giving the King a chance to escape in a near-by fishing vessel. Even the sea seemed to have turned against the royal unfortunate, and when at last his party was driven against looming chalk cliffs, wild and threatening warriors appeared to bar this last haven of escape. The King well knew who they were; the Britons, primitive but powerful fighters. It was land or die; they landed, for the hardest fight of all. Astonished by the fury of these invaders, the Britons fell back, but shortly

appeared again with a force of men which made further fighting only suicide. The King had his Queen and his little black-haired son to think of. A parley was arranged, and the King of Thule was given a hard choice: fight and die, or withdraw to a certain island far out in the desolate, mysterious swamp country called the fens, where he and his men could live at peace. Wisely, the King chose the fens.

So began the maturing phase in the career of Prince Valiant, as the King's son was called, and here was a lad who earned by sweat and trouble and with force of mind and body his right to such a difficult title. Teamed with a British lad of his own age, he grew up, able to cope with the dangers of the fens by his own wits and powerful young body. His future was once foretold by Horrit, the witch woman: "You will confront the unicorn, the dragon, and the griffon, black men and yellow. You will have high adventure, but nowhere do I see happiness and contentment."

What were such words to a high-spirited young fighter, the son of a king? Come on, you unicorns, you dragons, you men black and yellow! And back home again, with this cumulus cloud of princely ambition building higher and higher in his soul, Val found his surroundings dull and uninspiring. He was now a man, he must break from the nest! And with his father's sad consent he embarked one day in his tiny boat. There was, people said, a wonderful land close by, where men with proud faces rode high on horseback, clothed in smooth and shining steel. Every instinct told him that here lay his future.

It did indeed. Landing, he found himself in a fight right away—he had encountered a simple-looking but sturdy lad, armed with a wooden cudgel. By a swift instinct of boyish fair play, this lad gave a similar weapon to Val, and the two boys fell to fighting with the furious appetite of youth.

A man's laugh made Prince Valiant glance up from his cudgel lesson; made him gasp with joy. He was looking up at a mounted figure of noble bearing, of flowing red hair and strong haughty face, panoplied in the full splendor of a Knight of the Round Table. Sdeath! It was Sir Launcelot.

Even this vision of magnificent manliness could not cow Val's spirit. He himself was the son of a king, and he made it very plain in reply to this remark by the famous knight's squire:

"When you address Sir Launcelot, sirrah, say 'sir'!" The knight's squire was spurring forward, one hand raised with the intent of landing a hard slap on the impudent youngster.

"When you address a king's son, varlet, say nothing," shot back Val, ducking under the blow and seizing the foot of the squire, who came tumbling to the ground, the Prince on top of him. Now Val's deadly knife was out, but his arm was stopped by Sir Launcelot's lance.

> THE WIND IS AS A LASH THAT WHIPS THE GREY OCEAN TO FRENZY AND, IN ALL THIS WELTER OF RAIN AND SPRAY, THE TWO SHIPS AT LAST FIND EACH OTHER!
> FOR A FLEETING INSTANT VAL LOOKS INTO THE DRAGON-SHIP OF ULFRUN, THE SEA-KING, THEN THEY ARE LOST AGAIN IN THE MIST!

© *King Features Syndicate, Inc. Reproduced by permission.*

FIGURE 71. Yes, this stirring picture is a box cut from a comic page. The page is Harold Foster's "Prince Valiant," and appeared March 23, 1947, in color.

"Ye gods, but this lad has a taste for bloodletting," laughed Launcelot truthfully, and the two rode away, leaving Val staring after them, the vision of his future in his happy eyes. A knight errant and his squire! This was what he too would be, and not in some future time, but at once! He was not even dashed by the practical country boy's question, how could he become a knight without a horse? He would get a horse now! Where were horses to be found?

It was an impossibility to find one, it seemed, without much money, something Val did not possess. Of course there were wild horses . . . That settled it. With fierce energy, Val went about the long, difficult business of becoming a self-made knight. Every resource of his rounded abilities had to be used; but in the end, months afterward, he rode away, his haughty young head encased in a leather helmet of his own manufacture, his horse painfully trained and broken.

Val humbled himself sufficiently to become the famous Sir Gawain's squire. His good sense told him that he had much to learn, and that there was a great opportunity. A wise decision, for shortly he found himself looking at the towering, castellated walls of the fabulous center of his dreams: Camelot. The life of high adventure stretched before him. As to the loss of

peace and contentment, such, for him, lay only in the fierce, hissing song of the sword.

It is hard to believe that this is only a comic strip, originating in the pages of the New York *Journal* and syndicated by King Features, although, on February 13, 1938, it appears in the full-size comic section of the New York *American,* where young America can drink it in, in all its richness. It is much more than a comic strip—or perhaps more truthfully, we should say that the comic medium has been stretched by "Prince Valiant" to include almost the ultimate in absorbing and realistic illustration. It would be of high quality among the high-priced children's illustrated books, and here it is, all yours for a dime. "Prince Valiant" is well written, too; and millions of readers were carried far from the bitter, modern world as they watched Val becoming one of King Arthur's knights; meeting and falling in love with and marrying a yellow-haired maiden; fighting and laughing and singing his way through desperate difficulties by land and on the swaying old robber-bearing sea. Absorbed in rereading the story, this author had to force himself out of it to come back to business and ask himself, just what place this strip has in the story of the comics.

Harold Foster was the first artist of "Tarzan." Already a well known and successful illustrator, he put on the uniform of the strip artist. True, he could not swallow certain strip conventions. Balloons shattering realism were not for him; his text is written below, allowing his pictures full play. Foster's influence has been vast; as we have noted before, if one man can be said to have started illustration in strips, it is he. Most of his followers did not have the driving conscientiousness; none had the pure drawing ability of Harold Foster, and therefore much vulgarity has sprung up in the ground he plowed. Against this should be contrasted a very important new factor in strips, which "Prince Valiant" is constantly working to consolidate and spread: the true picture of historic events, done without the scholastic touch; done through the picture medium, which attracts us because we don't have to think. Here is the modern fruition of an educative tendency that began in 1922 with Ed Wheelan in his "Minute Movies" but took little effect until this time. It is education in history without a struggle—and, like it or not, people don't want to struggle, at least with their heads.

"Prince Valiant" re-creates the authentic flavor of the days of King Arthur perhaps more truthfully than it has ever been done. It is true that Foster made a few historical boners at first, such as dinosaurs surviving until medieval times. But with this exception the young readers of "Prince Valiant" are learning authentic things about an actual period and this means that a new source of true culture has been opened to comic

readers. Who knows what richness of knowledge may be so opened to the kids of the future? And one point of veracity is of particular importance: Val is not sentimentalized. He is stiff-necked, arrogant, ruthless—in addition to that feature of utter courage that makes him such a hero. And the display of these frankly brutal qualities casts a light on our calendar-card conception of the knight errant; it makes thinking people realize the great turn in human history since the age of so-called chivalry.

The knight in shining armor is the most startlingly obvious picture of heroism which man has yet conceived; yet the knight has nothing to do with the little people, the heroes of our present day. He belongs to the old age of civilization when one individual's personal force had legal status. He took on causes and quarrels and officially settled them by bursting the breast of his opponent with his lance. If there was life still left in the other fellow, he would shear off a leg or arm with a sweep of the sword and end with a dagger thrust. That proved his cause morally right.

But the Christian, democratic germ was alive, if dormant. With a mighty swing, the despised varlets took things in their own hands—of what value now was the ancient conception of the knight in shining armor? Yet at this late date it is still with us, and we see one of the most modern and up-to-date strips still absorbed in it. Here is the point where we may thank Harold Foster for his hard veracity, for truthfully showing "Prince Valiant's" path strewn with slashed corpses. The knight has been so stamped on human thought as a symbol of courage that courage-worshiping youth will undoubtedly long demand its representation. Truly presented history will, however, help us to discover our new and better human paths. "Joe Palooka" is the new democratic knight, but let us realize that with "Prince Valiant" reality has supplanted sentimentalism. We can stand any amount of that.

Recently, a new strip has been produced by King Features, carrying on the development of comics which present historically correct stories. "Dick's Adventures in Dreamland," written by Max Trell and drawn by Neil O'Keefe, developed from a suggestion by William Randolph Hearst to J. P. Gortatowsky, the president of King Features Syndicate, on December 28, 1945.

"I have had numerous suggestions for incorporating American history of a vivid kind in the adventure strips of the comic section," Hearst wrote. "It seems to me that some which told the youthful life of our American heroes and how they developed into great men and their great moments might be interesting."

The New York office went to work, and over the period of a year telegrams and letters shuttled back and forth and began to weave the pattern

> A FEW MOMENTS LATER THEY ARE AT WHARFSIDE! HERE A BUSTLING CROWD OF STEVEDORES IS ALREADY LOADING A THIRD SHIP! "LOOK," CRIES DICK, "WE'RE ALMOST READY TO SAIL!"

© *King Features Syndicate, Inc. Reproduced by permission.*

FIGURE 72. One of the most recent examples of the tendency of real history to work its way into the strips is "Dick's Adventures in Dreamland." This is from a Sunday page of June 1, 1947.

of a new comic. First, the dream device was decided upon, and the feature was tentatively named "Dick and his Dad." However, the job of bringing up Dick's father looked difficult, and so the kid was allowed to dream on his own and to pass from one thrilling historical sequence to another without the interruption of waking life or responsibilities. Dick's dream began January 12, 1947, and there will be millions of boys who will dream with him and be enabled not only to feel the slippery slanting deck of some old caravel under their feet, but to know with whom they sailed, and why and where; and that knowledge will be true.

Chapter XVI

THE STAR-STARTLED MANNER

"Sure I understand, A. G., we want speed. How about a supercharged interstellar vacuum-cupped rocket? Might have been sent earthward by Baron Blunkheim, the villainous interstellar crook. Perhaps we need more action; let's make him King Tusk of the planet Mars— Now I've got it, the mechanical Martians are bent on wiping out the planet Earth. How? . . . Cigarette, please. An enormous atomic bomb plane, capable of wiping out an entire continent—this is terrific, gentlemen. Get that artist on the job. Want a quick visual to help us with the plot. O.K., so the plane is all ready to shoot, but—"

"No buts, Frank! Don't pull any punches, *please!*"

"O.K., A. G., then it's off. Indicate color effect on that sketch—that orange looks dull."

"Sorry, Mr. Banks, it's the cream of the printer's ink."

"So what, dope! Smash a bright blue up against it; this page has gotta scream—wot-I-mean, scream. All right, gentlemen, we've got that atom plane headed exactly for the town hall in Sandusky, Ohio, or is it Idaho? Who has any ideas from here?"

"Well, Mr. Banks, a couple of stratosphere bombers could pick it up, lose their own skins setting if off just in the nick of—"

"Gentlemen, gentlemen! *Please.* I asked for *thrills!* Action! Kindly remember this is the year 1946; we are working on a modern comic strip."

"O.K., A. G., we'll invent a Captain Crash. See, he's disguised as a ladies' hairdresser. Got his tongs right in the middle of some lovely's blond curls—"

"Why 'some,' you dope? She's the only girl—"

"O.K., A. G., sure—why, she's snooted him all over the lot, see, and now he's going to use his professional skill to doll her up so's she can take over his rich rival— Boy, *whadda plot!* And then they hear the plane coming— or does some scientist flash them from his new bite-sized walkie-talkie? So what—a detail. Point is, Captain Crash rips off his white apron and— right through the window—no, the roof!—in his black and orange suit. Say, a new slant! There's a big flash symbol on his chest, something like a star,

rockets go zipping out of each point of it. At fifty-five thousand feet he meets the plane head on—"

"Now, Frank, this is a bit ripe. A plane capable of blowing up a whole continent, and you have one man—"

"Listen, boss. Of course it's ripe. *It's gotta be ripe.* You said it yourself; this isn't a handbook on beetle-raising for profit and pleasure—*this is a comic strip!*"

An imaginary fragment of a comic conference, yes; but it gives the flavor of one of the main streams of gaudily colored lava the modern comic volcano has spewed out. We and our children are buried under tons and tons of this matter; the news stands groan with it. It is a specialized stream, different from those we have studied, yet branching from them. "Tarzan," with its realistic drawing, was one parent of the star-startled manner; the other was "Buck Rogers," which appeared in the same year, 1929. The latter opened not one, but thousands of new worlds to conquer, and the straight illustrational style proved to be the right medium to plant the new thrills a paying distance inside the reader.

The force back of the eruption of fantasy in modern strips is simple; it is the continuing need of humans for the use of one of their most characteristic qualities, imagination. This is a thing that we all, especially when young, must have. Our minds must be stretched; the process of thinking demands it. Back of all literal, down-to-earth accomplishments was that moment when known factors were rearranged in the mind in a new way. Without imagination there would have been no tools, no art, no language, no civilization. Vulgar, no doubt, some of these strips are; but, no matter how low-browed, they have points of similarity with the highest-browed tendencies. Buck Rogers stemmed, in his tiny way, from Galileo.

The basic ideas behind "Buck Rogers" were emerging before 1900. Science had piled up an enormous amount of data about our little world and the big, chilly universe in which it swings; but scientists stick generally to observed facts, and it took two very unusual men, Jules Verne and H. G. Wells, to put this knowledge to imaginative use. The English scientist, James Jeans, also used his specialized talents in painting a terrifying picture of the world's future, in which the moon explodes, annihilating the life of man on its neighbor, earth. As the bubbling of the little brook outside the door compares to the foam of Niagara, so compare the puny stories of individual men to these cosmic crack-ups and catastrophes. It seems strange that people love to shudder so much. But a good shudder they must have to straighten out their day, and the shudder quotient of the new imagination was terrific. Someone was bound to set up shop retailing it.

Pulitzer and Hearst, specialists in thrills, moved into the new field first; filled their big color sections with elaborations on scientific facts. To connect this kind of thing with the new medium of the strip, which had already absorbed the continued suspense story, was an inevitable step, and John F. Dille, president of the National Newspaper Service of Chicago, was the man who took it. His friend, Lieutenant Dick Calkins, who worked with him for many years and who draws "Buck Rogers" today, also helped to dream up the strip. It is interesting that "Buck" nearly appeared with the scene laid in the remote past, instead of the remote future; for the past appealed to Calkins; he had a passion for dinosaurs. But once broken from the present one skips airily among the infinities. Dille's ideas won out; Calkins easily switched from a stone club to a rocket gun.

Although John Dille is responsible for the name and idea behind "Buck Rogers," he does not write the strip. Syndicated by the National Newspaper Service, it is produced by a group of five men, including a well known meteorologist. Although at first sight it seems thoroughly wild and impossible, these men work hard to keep the pseudoscientific flavor alive. It might happen, they insist. It is not a supernatural strip depicting things that couldn't happen. Buck bears out this distinction, being an ordinary-looking young fellow, and more attractive because of it. So "Buck Rogers" can hardly be accused of breaking with logic. And, of course, the history of the last few years should teach us to beware of dismissing these little imaginative comic strips as nonsense. We print an illustration of a "Buck Rogers" strip, making the comment that it deals with the subject of atom bombs and was run in 1939, some six years before Hiroshima.

The text of a "Buck Rogers" page will exhibit the mechanics used by most writers working in the star-startled manner. It is melodrama, of purest rocket-ray serene. The hard-driven writer must work fast; the last sequence must be hurriedly explained so that new thrills can be jammed in, one on top of the other. Real reactions of real people, of course, have no place in this whirly-burly. In spite of this, in spite of the stiff, awkward English and lumbering explanations, one is forced to recognize the professional punch in the plot. Can one honestly resist the impulse to look up "Buck Rogers" next Sunday?

One thing the critical reader must have noticed: the stylized comic convention of an exclamation point at the end of every sentence. Attempting to keep up a head of steam every second, strip writers slip into this without, perhaps, noticing it. It creates an English strikingly different from the normal! One wonders whether it serves the purpose it was intended for! Despite the steam leaking out from the cracks between the sentences, it is monotonous! *So strikingly monotonous!*

© *John F. Dille Company. Reproduced by permission.*

FIGURE 73. This "Buck Rogers" strip appeared in 1939. Digest that, then read the first sentence. It will prove that comics are sometimes uncomfortably accurate in their seemingly wild predictions.

An interesting point about "Buck Rogers" is that, while all the characters flirt constantly with death, no death is shown in the strip. Dille, Calkins, and company have an honest scruple about this; they do not wish their strip to have a brutalizing effect. It's good to see some of these people, who have their fingers on the pulse of America, a little interested in the impact of their work on growing children; a little concerned with something other than hard cash. "We are not running a crime school," says Mr. Dille. We must honor the "Buck men" for this attitude.

The draughtsmanship of "Buck Rogers," while illustrational in a straight, awkward way, has none of the brilliance which we have noted in its early teammate, "Tarzan." It is the combination of these two tendencies, the ideas of "Buck," the drawing of "Tarzan," which has given us the modern

illustration-fantasy strip, and we move on to study "Flash Gordon," the most striking product of that union, and certainly one of the most important and remarkable strips to be considered in this book.

Alex Raymond was a kid of only eighteen or so in 1929, working in a Wall Street office; he watched with fascination as the little figures on the ticker tape, already inflated, swelled and swelled until they burst. When they burst, he lost his job. And his faith in a future on the street. But this kid, whose destiny was to unite brilliantly the two tendencies we have spoken of, did not at once conceive of himself as a comic artist. He tried soliciting renewals on mortgages. People looked at him coldly.

Here Fate took over. Russ Westover, creator of "Tillie the Toiler," was a neighbor of the Raymond family in New Rochelle, and the disillusioned young business man was glad of a chance as assistant on that strip. Most comic artists have arrived by way of one of two routes: the staff newspaper job, or the assistant's job. Alex Raymond is a conspicuous example of where the latter may lead an intelligent, driving young man. He learned much from Westover and, fascinated by the game, became an art department assistant at King Features. More knowledge was gained by another assistant's job with Blondie's boss, Chic Young. The big chance came with a competition which was held by King Features. They had decided to produce the adventure strip "Secret Agent X-9," and young Alex walked away with the bacon. He was a success, and in a remarkably short time, too.

Here comes the first hint of the drive in this youngster, the hunger for the top of the mountain. "Secret Agent" would have been enough for most comic artists to chew on. But when King decided to add a strip of the "Buck Rogers" type to their list, Raymond's mind blazed with red and blue fire. He conceived and drew "Flash Gordon." It was accepted.

Drawing two strips, however, is almost impossible. Raymond was wrapped up in his own strip, "Flash," and soon dropped "Secret Agent" to devote his whole time to high-pressuring among the planets. The unique character of the strip became evident at once. To understand its sharp brilliance, we must remember that Raymond was not connected with the earlier, burlesque tradition. He was a modern, streamlined from the start.

"Flash Gordon" is the story of a blond young hunk of man and his black-headed girl Dale, who pursue their lively amours on a distant planet, deliciously hindered by bearded tyrants and seductive redheads. Not a unique plot this, nor is Raymond's style unique, being taken over bodily from the before-mentioned pulp illustration school. What is unique is the degree of realism achieved in the drawing, the conscientious clarity and brilliance of line. In its super-finish there is nothing to compare with it.

© *King Features Syndicate, Inc. Reproduced by permission.*

FIGURE 74. "Flash Gordon" is one of the most conspicuous examples of the illustrative tendency which brought realism and depth into the comic strips. This is from a Sunday page, February 23, 1947.

Like Foster, Raymond created the illusion of depth. And Raymond draws amazingly well, from a realistic point of view. Unlike Rex Maxon's "Tarzan," Raymond's figures are not muscle-bound. Referring to Michelangelo's tendency in this direction, the painter Renoir once cracked, "The

FIGURE 75. This example of Alex Raymond's daily strip "Rip Kirby" shows the same brilliant draughtsmanship which he brought to "Flash Gordon." The date is April 9, 1947.

poor things could never get about." Raymond's figures get about; there is the lithe-stepping spring of youth about them.

There is little doubt that Raymond is one of the most able draughtsmen of our time. How many fine-arts painters could really compare with him in that most difficult of tests, the drawing of figures in action? It seems strange

253

that with all this ability, his "Flash Gordon" remained essentially a pulp product. One big reason is, that like most other illustrational strips, the appeal is only that of melodrama. These lithe, sexy young people, if apparently made of flesh from the outside, have an empty look—one feels that a cross-section would show little inside their hearts and heads. The strip has had a vast influence on other comic workers. If it has pulled up the general level of strip drawing, it has also been partly responsible for the deluge of handsomely vacuous strip characters with which we are at present afflicted.

Alex Raymond's work on "Flash Gordon" was interrupted by an event which brought the artist back from the planet Mongo to his own earth: the war. As a captain in the Marines he was soon in action overseas, while a capable artist carried on "Flash Gordon" back home. At war's end, Raymond approached King Features with a new idea. He had a new conception of a strip hero. It was to be a returned Marine officer turned detective—a detective with some pretense to cultural background. He would be dispassionately interested in science and music. He would have money.

So arrived Rip Kirby, who, when faced with difficult problems, likes to putt a golf ball into a drinking glass, indicating a certain skill of approach. As yet the strip is in the dailies only, appearing in New York in the *Journal-American*.

With "Flash Gordon's" appearance, the comic volcano formed by the union of imagination and illustration is in full eruption. The old days of the Hearst-Pulitzer wars had nothing on this. A formula had been found to startle the customers, get their attention, and hold it. Strip after illustrational strip erupted into the newspaper air; the unfortunate heroes were confronted with a combination of lurid threats previously undreamed of. Villains (schooled by modern science) went at them with a naked sword in one hand, a death ray in the other. Huge mechanisms reared upon them, spouting flame, reaching out with hideous, mechanical hands to grab their high-breasted sweethearts. It was a tough time to be a hero.

The heroes, however, had a last, desperate, but very successful card to play. The odds against them were getting to be too much, so they inflated their giant chests, ground their handsome jaws, and became supernatural. Right away they began to feel much better about everything.

"Brick Bradford," the New York *Journal's* interplanetary by William Ritt and Clarence Grey, another King Features comic, contains hints of this tendency. For instance, upstanding Brick, dressed in his specially designed cosmosuit, a startling compromise between riding breeches and bell-bottomed trousers, is racing through space in a figureheaded dragon-ship, equipped, of course, with the very latest in planet-hopping machinery.

"Higher and higher through the supersphere rises the dragonship, a charred silhouette against the brassy glare of the flaming sun . . . In the intense heat, the ship's outer paint liquefies and drips away in great, yellow tears . . ." In other words, things are hotting up.

Inside, conventionally dressed Vikings are swooning away. ". . . Though huge air vents flood the ship with electrically chilled oxygen, the men drop, one by one . . ." The head Viking appeals to Brick, who is steering the ship with some kind of superduper steering gear.

"Brick—for the love of Loki—Send this ship down! End this fiery torture!"

© *King Features Syndicate, Inc. Reproduced by permission.*

FIGURE 76. Here history is about to be unwound. This imaginative top spot is from a "Brick Bradford" Sunday page for March 30, 1947.

This is sissy-talk. Our gallant hero pays not the slightest attention. "Bran falls and now Brick, alone of the ship's company, remains conscious . . ."

Brick, however, has not reached the full status of the supernatural. "At 360 miles above sea level, just as Brick reaches the edge of collapse, the frightful heat begins to abate . . . At 370 miles the mercury has fallen to 100 degrees Fahrenheit . . ." Bran is struggling to his feet; Brick, though dripping with sweat, is grinning.

"O.K., Skipper? When you've your strength back, wish you'd spell me at these controls!" Now Brick, straight as a ramrod, is toweling his handsome head. "I'll bet the boys are happy we're out of the hot belt!" It is time to apply the universal adventure strip formula, for we are at the last box on the page.

"Happy! They soon will be mad with fear—for that means we approach the ultra-sphere, the domain of the demons!"

Sweet reader, you ain't seen nothin' yet. This has all been a build-up. Suspense, illustration, the hero's simple solution of his hideous problems by adding supernatural powers, these have yet to be shown combined at their apogee.

What's that we see hurtling through the air? A bird? A comet?

Yes, it's Superman. This has been a super age. We have had (ah, me!) super prosperity, super slumps, super salesmen, super cars, super peanut butter and super flypaper. Superman was an inevitable concept, the obvious top to the super trend. People should have seen it coming. It does not reflect credit to the perspicacity of syndicate editors, who are supposed to be sharp fellows, to tell the story of how "Superman" went knocking around their offices for five long years. The millions they threw away . . . But then editors, too, are human. Their minds run in grooves like the rest of us.

Jerry Siegel and Joe Schuster are the master minds behind this comic skyscraper. They were high-school kids in Cleveland when the faint, crackling blue flame of inspiration hovered over their heads. It was Jerry Siegel who grabbed the new character out of the air. Joe Schuster drew it. These kids were smart, and they knew they had a winner; the trouble was, no one else did. Editors shuffled papers and acted bored. The letters said: "At this time we regret . . ." These editors were to regret, all right.

So the long years dragged by. These, however, were tough-minded kids. Remarkable as it was, they wouldn't give up. If the syndicates were so cold, thought they, why not try the comic magazines? J. S. Liebowitz had been one of the first to start the comic monthlies; they shipped "Superman" off to him. He grabbed it.

The idea was given a tryout in *Action Comics Magazine* in the June issue of 1938. When the circulation of the magazine doubled in a few months, editors shook the moths out of their ears. The McClure Syndicate got there first; newspaper syndication began in January, 1939. As appearing today, it is distributed by National Comics Publications.

Like the star-sparkling rush of Superman himself, the strip zoomed into the heart of the mass reading public. Papers fell into line by the hundreds; in two years 20,000,000 people were rooting with almost hysterical enthusiasm. The fellow had a semimonthly magazine of his own with a circulation of 1,400,000. On February 12, 1940, Superman took to his native element, the air. It was a huge success, and now Paramount Pictures, Inc., took him on for the movies, and he whips around in animated color shorts produced by the Max Fleischer Studios. He is a national figure, perhaps the most worshiped and adored of our time.

It seems almost superfluous to analyze the reasons for such popularity. But there may be a single reader, immured on some stylitic mountain top, who has not heard of Superman, and the following is addressed to him.

The simple and marvelously effective idea back of "Superman" was to take one of the interplanetary heroes who, as we have seen, had added supernormal powers to their sex-bursting physique, and allow him to whip through the setting of our place and time. So we find a modest, bespectacled, diffident reporter named Clark Kent, dressed in smart-fitting but normal clothes, functioning in the usual manner. Ah, but when various forces of evil or danger impinge on this reporter's life, watch for the thrilling change which millions upon millions pant to see. Off come the glasses, the modern clothes; the diffident manner is gone in an instant; out comes the most gorgeous male of all time, bull-necked, gigantic in chest and arms; dressed carefully in the accepted interplanetary costume of tight-fitting blue, with red cloak and star boots, an enormous S emblazoned on his bursting breast. Like old Maud, the kicking mule of earlier comic days, things instantly happen at this point. Fists flailing, Superman takes off after the threat of the moment. Gangsters tumble in terror and rush screaming away as those huge arms work with the deliberate efficiency of a mowing machine.

Of course, fisticuffs are puppy stuff to Superman. When in the groove, he likes to pick up enormous crates with one hand and hurl them fluffily about (to block the exits of some warehouse, for instance—the subversive agents will then get theirs at leisure, accompanied by sarcastic cracks by The Man of Tomorrow). Again, this is nothing. A real workout might be the propping up of some skyscraper (for one of the strip's most fascinating aspects is that Superman whips in and out of business offices, dressed in full regalia), or forcing a roaring waterfall to back up against itself, or choking the ten-ton dinosaur *Tyrannosaurus rex*, which has, perhaps, been brought back to life by some bungling assistant at the American Museum of Natural History and is now roaming Central Park, its appetite sharpened by a sleep of fifty million years. All this, and God knows how much more, is duck soup to Mr. Superman.

This, then, is the climax of the star-startled manner. We have always worshiped heroes, and Superman is only a modern cousin to Paul Bunyan, who once took an annoying tornado by the dark, fast-twisting, deadly tail, and cooped it up in a homemade cage, where it roared and whistled all summer. It was a hot summer, too. Paul simply turned the cage in the direction of his sweating lumber gang, and the growler blessed them with its revivifying breath. Then the gang worked so hard that their axes got red-hot, which caused the river in which they cooled them to boil. It was a break for the camp cook. The fish floated up, ready to serve . . .

Copyright, 1947, National Comics Publications, Inc.

FIGURE 77. Here is a forceful example of how a famous comic character can attack social evils. These boxes were selected from a "Superman" Sunday page of December 23, 1945.

There is, of course, a deeper reason for Superman's present, enormous popularity. The world, life itself, has come to be fearfully difficult for millions of people. When one considers that millions of people of Jewish ancestry were despotically and deliberately destroyed by Hitler, it is obvious that tyrannical forces have been in operation which make Caspar Milquetoasts out of such mild little tyrants as Hannibal, Genghis Khan or Napoleon. The body of the great public is highly disturbed; it would like to do something about it, but it doesn't know what to do. The individuals who make it up feel their own smallness, their soft brains and bellies—then along comes Superman. A vast, nation-wide sigh of relief and delight:

"This is it; here is the one who will do a job for us. Yippee! Get crackin', kid; sock that Japanazi in his yellow slats . . ."

The odd, pathetic thing about it is, that people have such a respect for anything that gets into print that they actually believe the enemies of democracy or the law are being tumbled over backwards by these ball-pointed heroes. However, the activities of Superman are by no means all in the world of make-believe. The owners and creators of this strip have very wisely turned the big guy's enormous influence into a number of socially useful channels; he has taught young people to keep clean and healthy, and he has held up our national ideals in a very definite manner, a proof of which is our illustration. As to his huge popularity, we shall understand the real degree to which the strip "Superman" has impressed the collective consciousness when, a little later, we look at the latest and gaudiest bloom on the comic tree, the comic books, where we will find not one, but a whole tribe of super-creatures, all stemming from this super-original.

In 1934 the *Journal-American* had an idea to build circulation. It had been struggling along with the ordinary full page of comics, but from now on it would double their space allotment. This extra page would be called a thrill page. Why not have the readers write in and tell about their most thrilling experiences? The ones that were the most exciting would be published, and prizes awarded. Whom would they get to judge? Why, Floyd Gibbons, of course. That was taken care of; but the new comics—what kind should they be? Adventure strips, of course.

Thus, on June 11, 1934, we find Floyd Gibbons's Daily Page of Thrills and Mystery and, along with other new adventure strips, "Mandrake the Magician."

The first strip was done by Lee Falk and Phil Davis, and they are doing the strip today. The art work and the continuity of this early strip are very shaky and insecure. Mandrake is not introduced until several days later; the opening sequence is concerned with some papers that, if stolen, might plunge the whole world into war. In the strip the papers were recovered all right, but, from the looks of the world today, someone must have stolen them later when Mandrake wasn't around.

The success of this King Features strip gives us an interesting sidelight on the reason certain plots grip people. Mandrake is such a good magician that no situation can ever arise which he cannot trick his way out of in the long run. He can suspend people upside down in the air, cause walls of flame to appear and turn men into beasts. Knowing this, why are the fans still interested when new threats appear which they know perfectly well are going to be solved? The answer is, they want to see the trick. Mandrake's

tricks are unusual and fascinating, as our illustration shows. They have a certain concentration and intensity. There are many varieties of strip appeal, but each must be singled out, high-lighted in order to succeed.

What is the mechanism of the tricks? We are shown no concealed wires or false-bottomed hats in "Mandrake." Most of these stunts are qualified by the words, "it seems." Apparently, then, there is a hypnotic element. In the strip, Inspector Sheldon of the United States Secret Service once remarked: "If you had lived in the Orient as long as I have, you might understand such things." Since few of us can shift our base to the Orient, we'll just have to take it at that.

© *King Features Syndicate, Inc. Reproduced by permission.*

FIGURE 78. How is it done? Well, h'm, let's see . . . Study "Mandrake the Magician," from which this 1947 sample trick is taken. And let us know if you get the answer.

Lee Falk joined with Ray Moore to bring out another new King Features strip on February 17, 1936, called "The Phantom," which appeared in the *Journal-American.*

Although this strip also is written by Lee Falk, it has had a different continuity from the start. The whole story of the Phantom is, in one sense, opposed to the superman theory; the Phantom is not a superman in the wild, modern meaning of the word; he happens to be able to outfight, outrun, outswim, outjump, outclimb, outshoot, and outride everyone else in the world. But the Phantom, if shot neatly and completely between the eyes, would, presumably, drop dead. The bullet isn't going to ricochet; it will penetrate his skull. Fortunately this has never happened yet; but if it should happen, there would still be a Phantom to carry on.

The strip once explained how it happens there is always a Phantom available when one is needed. To understand, we have to go back to the

boyhood of a Phantom. Shortly after birth, the father (the Phantom) begins to instruct the lad in the art of hunting, running, and other occupations. It will be good for the boy to know when it's time for him to fill his father's mask. This is in Africa, among a tribe of pygmies. Later the boy, with a pygmy warrior as escort, is sent to America for schooling. In America there is always a certain amount of furor caused by the sight of a white boy and a savage running around together, but, by the time the boy is in high school, he is starting to break every sport record he attempts. Unfortunately, he is called home; his mother is ill. He arrives in time to be by her bed when she dies. He and his father hunt together for a while, but his dad's days are numbered; it is only a matter of time until his father is killed in a hunting accident, and the warriors of the pygmy tribe crown a new Phantom. A Phantom never dies in bed. It is now up to the new Phantom to get back to America, look up that girl he liked so well in school, start a whirlwind courtship, see if she would care to be an African Queen (they always do), and then return with her to his kingdom. In due course one child, always a boy, is born and the supply of Phantoms is assured.

All these star-startled developments were sensational enough, but the roaring tide of modern imagination had more startling figures yet with which to dazzle the public, now a bit jaded from an overdose of pure scarlet and green.

A psychologist, William Moulton Marston, was retained by the Superman—D.C. group of comics publishers to determine, if he could, ways of improving the quality of the comics then being circulated. He decided that the comics' worst offense was their bloodcurdling quality; that a woman —since her body contains more love-generating organs and endocrine mechanisms than the male—would make the ideal protagonist for the strip of the future. However, the strong qualities should be brought out, too, and so arrived a new creation, a super-she, something wonderful, "Wonder Woman!"

Early in 1944 King Features signed a contract for the new strip. "Wonder Woman" started to run in the New York *Journal-American* in the early days of June, 1944. However, this strip had been in the comic books for some time, having first appeared in *Sensation Comics*, January, 1942. At one time the total magazine circulation of "Wonder Woman" was around two and a half million, and it looked as if Mr. Marston's startling thesis, that it is women who should rule the world, was about to come true.

So! Well, boys, it was a good life while it lasted. Still, the days of fiery males were not yet entirely over.

"Who Are They?" a hard, shiny, new newspaper strip screamed about a couple of eerie figures, a hooded man with pointed ears, and a masked

Copyright, 1947, National Comics Publications, Inc.

FIGURE 79. "Batman and Robin," four boxes regrouped from a 1943 Sunday page. This illustration is a good example of a tendency which for awhile seemed to be swamping the world of comics.

boy with the now thoroughly approved costume of the future. "This is Bruce Wayne, who poses as a society playboy—and this is his young ward, Dick Grayson (who grins, "Gosh, Bruce has even me fooled with that act of his!"). "For that indolent attitude only serves as a disguise for that nemesis of crime, who, with his daring young aide, forms the dynamic team of Batman and Robin."

Bob Kane is the young man back of this strip. About it, he writes:

"Being an ardent mystery fan, I visualized 'Batman' as a mysterious figure of justice symbolized by the hooded Bat costume, designed to instill fear into the hearts of the underworld. Robin, Batman's juvenile aide, was created to capture the imagination of the younger set."

"'Batman' first appeared in the May, 1939, issue of *Detective Comics* magazine. Less than a year later, in April, 1940, it was published in *Batman,* a complete, new magazine devoted to 'Batman and Robin' exclusively. In the same year, 'Batman and Robin' also appeared in a special magazine for the New York World's Fair; when the Fair closed, publication was continued under the new title, *World's Finest Comics*. In late 1942, Columbia Pictures translated 'Batman and Robin' to the screen in a fifteen-episode serial. In October of 1943, the feature had its first appearance in the newspaper world. Its New York paper was the New York *Daily Mirror*. It appeared both daily and Sunday." Although discontinued since October, 1946, as a newspaper strip, "Batman and Robin" enjoys wide popularity in the comic books.

Why figures of justice should be hooded in the United States of America will always be a mystery to this writer. Our whole system is set up on the principle that we must respect our orderly, established processes of law.

However, this strip is not the only one to use this hooded or masked symbol, and as Bob Kane says, "Batman" was designed to "instill fear into the hearts of the underworld." Here's hoping he does it.

Chapter XVII

TERRY AND THE PALOOKA

THE ASSOCIATED PRESS, in New York, used to be at 383 Madison Avenue. Here, one day in 1932, two capable-looking, black-haired AP men met for a conference in the Feature Service Department. Later, these men were both to leave for individually brilliant careers with other organizations; but this conference started a new comic strip on its way, which in turn led, by another step, to something sharply new in the comic world, which will carry our story far beyond straight illustration, beyond even the wild ink orgies of the supermen.

The strip born in that conference was "Dickie Dare," the men were feature editor Wilson Hicks, now executive editor of *Life* magazine, and Milton Caniff, later to shine as creator of the famous *Daily News* strip, "Terry and the Pirates."

Caniff is a dramatist as well as an artist. Grease paint was his first love, and his feeling for drama passed into his pen people and had much to do with their success. But he decided that his co-ability, drawing, would carry him further, last longer, and feed him better. He began as office boy in the Dayton *Journal* art room one day in 1921.

These being the days of great strips, it was natural that the driving, intelligent kid should get strip into his head. Caniff says that the fact of a comic artist being able to work in his own studio was a powerful stimulus. As he moved through a series of art staffs, those of the *Journal, Herald*, Miami *Daily News,* and Columbus *Dispatch*, the idea grew, and he made a number of unsuccessful efforts. He decided that he must come East. He landed in the wire service, art department of the AP, and when an opening arose for a panel featuring human interest cartoons, he got the job. Now at last he could buy a paper and read "The Gay Thirties," by Milton Caniff. Still it wasn't a real strip; it didn't allow him to retire to that fine studio he had been furnishing in his mind's eye all those long years.

Shortly after, however, editor Hicks called him to the conference we have mentioned. The AP had decided it needed a good adventure strip; again the able young staff artist landed the job.

Caniff's early connection with "Dickie Dare" is interesting because it

enables us to span the development of a remarkable career. Destiny seemed to be shaping him to interpret his age in a very special way; to capture its flavor as Clare Briggs had captured the flavor of his own period a few decades before. From Caniff's take-off with "Dickie," one can see every step in the path which led to his remarkable pictorialization of modern war; to the superlatively sharp realism which has added still another dimension to comic strips. The early "Dickie," however, foreshadowed this development only slightly. "Dickie" was conceived as a normal, active boy, whose longing for faraway places and adventure led him to devour boys' books in his local public library. Dickie passed into these adventures, and became the pal of certain heroes of the past, such as Robin Hood. A year or so of this, and Caniff became bored. This artist is essentially a realist, at home in the sharp, modern world. His genius is in making matter-of-fact things romantic; he deals rarely with symbols, and is not imaginative in the "Krazy Kat" sense.

So began a series of adventures which enabled Caniff really to get his teeth into the work for which he was naturally fitted. Dickie and his big friend Dan were swept into the modern world of planes and submarines. The Caniff touch emerges. There is drama, edge-of-the-chair suspense, and something else: the beginning of sophistication. Caniff's Dickie is a nice kid, but there is something wise, knowing about him; he senses things beyond his age; he is alert, down-to-earth. No more day dreams now. . . .

Technically, these strips are entirely different from present-day "Terry." Caniff drew with outlines, filling in with patches of gray and black afterwards; a reputable, but hoary method. In the faces, however, one can see the germ of his present style. Each line (done with a crowquill or 290 pen) is rhythmic, highly expressive and is done with a changing pressure; starting with utmost delicacy, it swells, dies off again. Extremely delicate touches around the cheekbones and nose are telling. Caniff in this early work perceives and is interested in the basic structural differences between heads; he is breaking away from the old convention of drawing all characters with the same "doodle."

When, one day, comics-king Captain Patterson of the *News* found himself in the very unusual situation of actually laughing at a comic drawing in a panel called "The Gay Thirties," he decided he must have this man for his personal collection and offered him a job. Caniff was ready. The AP was O.K., but—this was it, with the combined circulation of *News* and Chicago *Tribune*, over four million, and then all the other papers . . .

Captain Patterson's strip specifications, which might have floored a less experienced or vigorous man, brought out the gypsy in Milt Caniff. The Captain wanted everything: kid appeal, adult appeal, sex appeal, humor,

wild action . . . O.K., he would get it. Both the Captain and the Kid (pardon us, Mr. Dirks) had in common a liking for the plausible and the actual. The thing was to paint the present in the brilliant, romantic colors loved by the public. It meant a location where one of the old story appeals, like piracy, was still being practiced. Why not piracy, modern piracy? Along the Chinese coast, remarked Patterson, piracy was still going strong, in a setting of flashing, jewellike color, ancient costumes, the suggestion of subtlety, mystery, Conrad . . . It was perfect.

Caniff's decisions were fast, brilliant. Dickie and Dan had proved a sound pair, since the kid could interest the juveniles and the man provided something for the girls to run after, in the strip and out of it. He would, of course, change them over so that there would be no competition between the strips; he could have this new boy grow up almost at once, thus removing any resemblance. So arrived a blond kid, whom Caniff named Tommy Tucker, and handsome, curly-haired Pat Ryan, who had a straight nose in place of Dan's up-curving one. Now for the villains, particulars of whom had not been decided in that first conference. Here inspiration struck at once, hard.

There had been a woman pirate on the Chinese coast. . . . Make her smooth, cold, cruel, with slant eyes; yet, of course, highly desirable. Open up on the torso. . . . The Dragon Lady arrived, hip over hip. Her real name was Lai Choi San, which meant "Mountain of Wealth." She was just that to Milt Caniff.

In starting a new strip, one must consider means of arresting the customers at once, for a new strip catches on slowly. Caniff decided that striking pictorial appeal would do this in the shortest possible time, together with the movie approach: distance shot, then flash to full close-up. The most dramatic continuity possible, then illustrate it with all the eye-catching force one could slam down; solid blacks opposed to open whites, making that headline contrast that forces attention, like it or not. Then as to details: Strips (so Caniff must have thought in those easy-going days), are very lazy jobs when it comes to authenticity. He changed all that. But people are not so dumb; the kids are a lot wiser than their parents. They know the difference between a feeble pen and ink approximation and the real thing, the smart modern gadget or plane that gives one the smooth awareness of swift modernity. Contrast this with authentic Eastern local color and the strip would jump out of the page. Bursting with enterprise, Caniff dug into every source of information on these subjects he could find in New York, and they were, of course, plenty. He says he was on friendly terms with every Chinese laundryman in the city.

Captain Patterson had insisted on humor; suggested a special burlesque

character to give comic relief, something a bit lacking in the earlier strip. Again, just the right inspiration danced in blue smoke over the man with the ink in his hair.

Is miriclement! Is hotsy-dandy! Comes Chinese goofer all spread-eagled between the ears; allee-time hot goggle talk, catch cash customers neatish in belly-chuckle section. Plenty wise head-clocker belong like Confucius . . . that's it, Confucius. Name: George Washington Confucius, shorten it to Connie. Job: number one boy to Tommy and Pat. Ears and teeth: both huge: Head: bald. Dress: Connie got aspilations for alleetime China-seas playboy. So dress him accordingly. Heart: solid, heavy gold.

The plot . . . well, this man, the man with the ink in his hair, was initiating new trends these days. Camera-eye angle, lure of the low but lovely, real drawing and authenticity; it was plenty. It is not to be wondered at if at first the plot was none too remarkable: a voyage up a river after an inherited gold mine. Anyhow, behind the bushes the Dragon Lady was laying on lipstick, ready to strike. When she took over, everything would be, and was, all hotsy-dandy.

It was an excellent job of work and it got over. Patterson O.K.'d it, but reasonably enough, he balked at the sweetish name of Tommy Tucker. Caniff got to work again and sent in a list of fifty names. It came back with the name "Terry" circled; after it was written: "and the Pirates." Publication began in October, 1934.

It was a good-looking strip from the start, but had little suggestion of larger, oncoming events. It was simply another, better drawn, more exactly detailed kid-thriller. Neither Terry, nor Pat, nor Milt Caniff himself could have surmised where that river trail was to lead; could have foreseen that the kid-thriller plot would merge by degrees into actuality, that the artist would become the best illustrator of the biggest adventure the world has ever seen.

Perhaps the first signs of the strip's unique quality were the Caniff women, from the start a new and fascinating breed. Burma, she of the blonde hair and faultless wisecrack, was even more jammed full of sex than the Dragon Lady. These two expressed a fact somewhat suppressed in strips at that time: bad women can be beautiful. They contributed to the development of one of Caniff's chief talents, which is for hard, sophisticated reality, with the rose-tinted glasses left off.

This quality was emerging, in many ways, in the new strip. Authenticity of detail, which the artist had decided on as a drawing card, was developing rapidly and interesting the customers as he had planned. Now, bit by bit, the technique of "Terry" began to change. The pen outlines of "Dickie" days gave way to a brilliant use of the brush; to the employment of sharp nickings of shadow, which can define the detail of a gun or a tree more

realistically than can a solid outline. That the expressions of faces might register clearly, Caniff drew these with his earlier pen technique; but he began to cut loose on the figures, to slash in big areas of solid black where shadows fell, often covering half a figure with skillful shade. Of course this was not unique in essence, being a manner of working adopted earlier by the "Tarzan" illustrational school, but Caniff carried it to a startling pitch.

These approaches hit the young generation just where they were living. A Caniff character is worldly-wise; knows slightly more than he or she is supposed to know. Kids, growing fast, admiring the next age period, felt themselves in the know as they sucked in the Caniff patter which was as

© *The Chicago "Tribune"—New York "News" Syndicate, Inc. By permission.*

FIGURE 80. The boy and the style both grew up. Contrasting single boxes from (left) a "Terry and the Pirates" strip of early 1935, and (right) a strip of the same feature in 1944.

carefully up-to-date as his snappily drawn machine guns. The plots were rapidly becoming more real and, especially, more intricate. Still and all, the strip is still comic opera. A quote of a conversation between Burma and Captain Judas on November 7, 1937, will illustrate this, for there is a flash of the old tin dagger in this villain's threats, even if Burma forces us to look life directly in the torso:

"You are a bright young lady, Burma! The one foolish move you made was to prefer this Ryan to me!"

"If it's any pleasure to you, Pat Ryan doesn't know I exist! And if it's my affections you want, I guess you have them coming!"

"Ah, no, my sweet! Once spurned, Captain Judas does not come sniveling back with his heart on his sleeve—what I cannot conquer, I destroy!"

"How brave of you! It must make you feel like a great guy to beat down a defenseless woman!"

"Call it what you will—but rest assured I will not insult your superiority with just ordinary methods."

"You're just *too* good to me."

Comic opera or not, this stuff pulled. The intimate connection between Caniff's characters and the young American public was once demonstrated by an extraordinary tribute: After he had taken the bold step of actually killing off Raven Sherwood, 450 students lined up on the campus of Chicago's Loyola University and solemnly faced east for a full minute of silence.

Another smart note was the growth and adolescence of Terry himself, for the color, pink, suddenly breaks into the strip as a little Southern cutie, named April, wakens the man-dawn in his heart; and for a while innocence gambols as these two little ones coo to one another. This fluttering of ribbons is contrasted, of course, with plenty of hard reality, spats, jealousies, and the green color of wicked women.

The truth was that dramatist Caniff had, during these years, built up an extraordinarily effective medium for giving a rounded picture of modern life. What was lacking in these years to 1938, was size in the plot structures. The more the artist-writer piled his strip high with wealthy planters, colorful villains, and so forth, the more nervous the little plots became. It seemed as if Caniff was preparing himself for something bigger than melodrama; as if he sensed some tremendous event was about to break for him. It did. The bigger plot had arrived; it was gathering about the precise spot, China, which had been early chosen to be the scene of his new adventure strip.

Milton Caniff was being dealt an extraordinary new hand of cards by fate; they were those printed with the likeness of the Emperor of Japan.

It was 1937. As the Japanese flooded over China and grabbed with violent hands the rich fertile land lying near the sea coast, Caniff was busy with his tight, impacted plots concerning Normandie Drake, Pat, and the snarling husband, Sandhurst. It was a plot, a drama in itself to Milt Caniff. Here were these other pirates; what should he do about it? A lesser man might have been tempted to pick up his characters by their well inked in necks and make for some less confused arena where the old hokum could go on forever. Not so this man with the ink in his hair, who had such a passion for veracity and for real life, even if it stank of gunpowder.

First he allowed the fact of the war to be mentioned. His latest, most baroque villain was a certain General Klang, whose place in the picture is defined by Terry in January, 1938: "He's the monkey who stole the food from these village folks while their young guys were away at war!" Terry tangles

with this petty brigand and shows up his mean, cowardly nature by provoking the General to a duel, choosing as weapons loaded automatics, each to be pressed to the other's heart. When the General finds he can't go through with it, a true drama moves into the boxes of "Terry and the Pirates"; the beginning of reality, the point where the hokum fades before the rich colors of authentic events. This army of hi-jackers was formally commanded by that lean, lovely thug, the Dragon Lady. Now she appears, a little shadowy about the cheekbones, but still that woman whom her men always address as "master." As Terry and Burma look on, she makes an impassioned speech to her former men.

"Without a commander, you will be a rabble! Follow me against the invader who threatens to engulf China!" Her old grip is working.

There are cries: "We fight for Dragon Lady!" "What she speak is true word." "We march with Dragon Lady against foreign army."

With folded arms and proud look, the "master" surveys this satisfying spectacle, not all of which can be ascribed to pure patriotism, as she immediately makes plain. "So! Power again electrifies the Dragon Lady's words! It is well!"

An opening instantly taken advantage of by Burma, who rarely misses a chance to heave a verbal dart, especially when the target is the pretty skin of another woman: "Right in the old form, aren't you, little corporal? You sell these poor dopes on fighting for China because, if the enemy wins, there'll be too many military police for your pirating! Big-hearted Susie!"

But the Dragon Lady, whom Terry once saved, pays off by swallowing these insults for her young friend's sake. Her army winds off as Terry watches.

"There goes th' Dragon Lady's 1938 crusade! Quite a sight, huh?"

Burma: "*You* look! I've seen enough of that she-bandit to last me for keeps."

This is hardly an instant taking of sides. It is almost neutral, with its suggestion that a Japanese order might be effectual in the preservation of peace, in preservation from petty thugs, at least. Yet here is action being taken against an invader. As the usual polychromatically colored plots go on, it becomes evident that the author-artist is enlisting himself on the side of China's mighty, old civilization; further, that he is a man who, in spite of his talent for sophistication, has a heart.

During 1938, the year of the taking of Austria, the year of Munich, the war in China became a definite part of the plot of "Terry and the Pirates." It is true that the Japanese were referred to always as "invaders"; but this ironic delicacy of touch, dictated by America's position as a neutral, only

strengthened the backing that one of America's leading strips was giving to the cause of freedom.

It is one of the turning points in this history. Very cautiously, a new dimension of the strips was being discovered and tried out—the dimension of social usefulness. It was magnificent.

As we have pointed out, this was suggestion rather than propaganda. The main weight of the strip is still made up of the melodrama of Caniff's tropical group of characters, who continue with their make-up on. But by the middle of the year, highly realistic scenes of the Chinese armies begin to be introduced, and gradually sympathy grows with the heroic, tough nation. The same sympathy grows through 1939, a far more terrible year, when the mad paperhanger moved on Danzig, when Blitzkrieg astonished the world.

"Terry," in 1940, is much more definitely a war strip.

Behind the curtains of the world theatre a new stage set was preparing; when those curtains rolled up on December 7, 1941, Americans looked at its terrible features of rolling smoke, sunken ships and dying men, at first with incredulity, then with united, white-hot anger.

As for Milt Caniff, he was standing right there, a unique weapon of his own making in his hand. The whole situation was—right up his alley. He piled in.

What followed immediately, illustrates a point about strips of which most people are unaware—they are drawn well in advance of publication and so cannot reflect instant changes in world events. "Japan at War with U. S." This was the *Daily News's* banner head on December 8th, but "Terry," for the life of him, can produce nothing more startling than a mild little plot about one Sammy the Tapper, a slick, contented young thug, who is busy putting the bee on Pat's charming secretary, April Kane. There is a war connection; the Tapper is operating for Japanese agents who are after the flying schedules of planes carrying gold shipments, schedules accessible to April. So the Tapper has rigged a fake yarn about April's brother, Dillon Kane, who is in India: either she comes across with those schedules or Dillon winds up in a chain-gang.

There is a certain inertia about the two months or so of "Terry" which have to unroll before Caniff has a chance to react to Pearl Harbor. It has a frustration, a weariness; it reflects the hopelessness of millions of good American people, who were burning up with a wish to help in these wars of ideologies. As 1942 came in, and men could talk with steel instead of cotton, the man with the ink in his hair went swiftly into action.

Pat is shown as one of a group of American business and professional men who are being evacuated from a threatened Chinese city. But their

plane has not enough gas to take them from the danger zone; they have to wait for help in a little village and keep carefully under cover. Here there are few soft-bellied comforts. The situation has a fine symbolism; it suggests the choice: comfort or liberty.

"I don't see why we have to sit here and suffer!"

"Yeah—we picked up and left everything we owned to come to this mess!"

"Mr. Sandhurst says we could get a message to the nearest enemy unit—they'd treat us better than we're faring now!"

It is Sandhurst, the man who married Normandie, who planned this basic appeal to stomach over conscience. Pat sums up the issues with power. This Sunday page of February 22, 1942, is an example of a comic strip paying off part of its debt to its country. It was actually not the group of wavering white-collar business men, but millions upon millions of all types of the American people that Caniff addressed this day, by virtue of rolling presses and the powerful developments of national syndication.

It is one of Caniff's strongest points that he isn't a professional preacher. He does not rub righteousness into your ribs to the point where they no longer respond to the tickle of lightness and gaiety.

Consequently, we will not find steady indoctrination of the type illustrated. Pat has talked; now for action. The Japs have captured the little group of Americans, and Pat languishes in an improvised prison camp for a short time before a friend gives him a boost over the wire and he falls cheerfully on the lone sentry's neck, who is popping away at a marauding plane. This is March 15, 1942, and Pat is in the war forthwith. He outfits himself with an abandoned Japanese tank and goes off sputtering and roaring into adventure.

Immediately Caniff demonstrates the virtuosity in war drawing and war patter built up by those years of dress rehearsal with the "invaders." While the other comic artists, dazed by the grim new subject matter, were poking around in their files to find out what machine guns looked like, and coming out with archaic clippings of Al Capone days, the man with the ink in his hair was giving most expert and up-to-date lessons to America in all the little details of combat. No dry paragraphs from the manual on "cover and concealment" could punch it home as well as Pat did, with his tank whose tracks lead one way, while the tank itself was off in the opposite direction, all carefully and satisfactorily worked out and explained. Worried, the other comic artists wondered if they could ever catch up. They never did. As a single example we quote the following, which will probably impress the civilian as pure gibberish, but which will leap out to any G.I. ear as an amazingly accurate piece of sharp ear reporting:

Plate 3. An abbreviation of a famous "Terry and the Pirates" page which ran October 17, 1942. A number of boxes have been dropped for the sake of scale, but the sober realities of war, caught amazingly well, are still there.

FIGURE 81. Nostalgic to ex-G.I's will be this sample 1945 strip of "Male Call," which Caniff drew during the war for army camp newspapers.

"Un, t', three, four. Un, two, three, four. Column laa-ft-HURCH! Cump-nee h'lt! . . . Un, t'!"

As for Terry, he had taken off into the interior in a search for his sweetie, April Kane, and had managed to get in the way of some Jap shrapnel. So he finds himself, a civilian, recuperating in a remote hospital staffed by Americans. Here, with tremendous enthusiasm, Caniff introduced still another new set of characters who are exactly fitted to carry his realism a notch beyond; who represented America at war more vividly than anything we saw in print.

273

Taffy was the first. Some time back, while talking about the "Gumps," we drew attention to the fact that the "funnies" provide a strong, tasty dash of bitters, which tends to balance the pollyanna of the magazines, where all girls glow with fragrant perfection and all men swing gorgeous shoulders over lithe hips, except for the character specimens, who play assorted parts to specification. Taffy is one of the grateful, real strip figures. She ain't no beauty, fellas. Her nose is like a button on an instrument panel; she's puffy-eyed with a rather ugly mouth, an aggressive shove to the lower lip. Yet, Taffy is perfectly swell. She appears first as a Red Cross nurse whose Army commission as lieutenant hasn't caught up with her, owing to the business at Corregidor and what not. Taffy's appearance was one of the best arguments for a girl becoming an Army nurse that could have been put across by anyone. Caniff, characteristically, went to the Army for exact material on the minutiae of the nurse's life; more, he made a heart beat in the middle of this wealth of detail about uniforms, insignia, customs, and woman-problems. There is no ducking this last; button nose and all, men instinctively head for Taffy—and she pins their ears back.

"What're you doin' tonight, Taffy?"

"Same thing I do every night, dog face . . . which is *not* going out with you."

We are getting restive when the one pair of ears without pin marks is happily revealed.

Everyone knows that Colonel Flip Corkin, of the whole ears, has an original in actual life—Colonel Philip G. Cochran, Army air hero. Cochran is an old friend of Caniff, and certainly this is a case in proof of the result that can be obtained by basing a strip character on real life. Daredevil Corkin comes zooming out of the sky, a combination of raciness and tempered experience; in defining his appearance Caniff had his usual inspiration, plus. Corkin's black hair is grizzled; it is almost white at the temples, a simple, extraordinarily effective symbol of the aging process of the fighting pilot's life, studded with death. Flip Corkin speaks plenty flip, but there is a grave, informal dignity and weight about him, a soberness. As his story matures in the strip, the man advances in his sense of the deadly nature of war. He is a character beyond Pat and almost all other strip heroes; the medals and decorations seem to mean little, the lives of good men gone mean more.

Although Terry has actually had years of hair-raising adventure back of him, he contrasts, at first, with Flip Corkin as the kid's adventure story contrasts with the tremendous drama of real war; he is abashed into insignificance. He becomes almost a blank, and the smart aleck quality, which was the most annoying characteristic of Caniff's prewar pen actors, is replaced

by humility. He is ashamed of being a civilian. He does not long remain one.

Terry's first war job was as special investigator for the Chinese Government, but he soon won his wings and became Flight Officer Terry Lee. Meanwhile Pat had graduated, as well, as Lieutenant of Naval Intelligence. It is Flip Corkin, instead of Pat, however, who is Terry's great hero in this period. The stage is all set for an epic set of air adventures, and the stops are pulled out. The strip air is a roar of diving planes.

"Let's take a walk, Terry . . ."

"Yes, sir, Colonel Corkin!"

Milton Caniff, dramatist, is not going to let himself get caught asleep at the strip. The sky-ripping opportunity for adventure in this total-war period might easily have blotted out more subtle feelings and approaches, but Caniff develops steadily; he is never happy unless he can add some new dimension to the expressiveness of his work. These quotes are the start of a remarkable Sunday page which we have illustrated in part. It is a summary of the sober, serious spirit of the air forces, set in the colors of modern talk. It is wise, and sad. It looks back, and forward. It is democratic. This page achieved something unique in comic history; it was read into the *Congressional Record,* and well it deserves to be there. It is good, live stuff with the bark on. Representative Carl Hinshaw of California made the suggestion that it be so preserved. He said it was "deserving of immortality." A historian 500 years later could find the real savour of our period in it.

In spite of war realism, the old baroque of Caniff's melodrama still feeds into the boxes of "Terry and the Pirates," and this ripe touch runs richly through Caniff's war period. You may approve of it or not, but soldiers love Miss Burma; are willing to wink at a certain laxity she sometimes suggests. To please them, and without payment, Caniff started a special Terry strip which was used by hundreds of Army camp newspapers. Burma was the chief attraction in this strip. However, the *News* Syndicate decided that the two strips were conflicting; therefore the change to the name, "Male Call," and the appearance of a new strip-teaser, Lace, whom the Army took at once to its millions of bosoms.

Looking at the span of Caniff's career so far, certain things stand out. He took, first, illustration and suspense and modernized them, added sophistication—angles, both in speech and drawing, that made his strip a much truer reflection of modern men than the others. He took the very bold and important step of letting real events blow through his boxes; in so doing he gave added value to the illustrational approach, which had threatened dreary years of empty-headed planet-hopping, or mechanical detective stories made

by the mile and chopped off by the ten inches. He plugged against tyranny.

On the other hand, many will find certain criticisms to make. On the whole, the strip suffers from smart aleck; it must be a fearful strain to be a Caniff character, to have to speak and think in that carefully exact, young patter, which is only a substitution of new clichés for old. Then there is something static about the figures; they are "pop-ups," usually standing vertically, with arms hanging at sides. It is their tongues which are in action. Often his plots are ropy—so covered with artificial trappings and so snarled that one gets a bit weary. On the other hand, perhaps it's good for the readers to get a bit of work to do in this predigested medium.

A more important criticism: the strip has a disillusioned air, as if innocence had vanished; but then again, perhaps it has. It is a hard and grimy period.

Milton Caniff is always one for a suspense ending. He can contrive, too, a suspense beginning, as when in July, 1945, an announcement was made about him which set the comic world to vibrating with excitement. In two years' time, according to an article in *Time* magazine, Caniff's contract with the *News* would run out, and he would move over to the Field group, who publish the Chicago *Sun*.

Since the old contract had nearly two years to run, an almost unbearable suspense had time to build in the fans' minds. What would the new strip be like? Equally intriguing, who would carry on "Terry" for the *Tribune-News* Syndicate?

A long, lanky, quietly handsome strip hero, bobbing up in the New York *Mirror*, January 13, 1947, supplied the answer to the first question. He was back from the war, a flier, and he personified the mood of the fighting man who has been through hell and is not boasting about it. Steve Canyon is young in years, old in experience; he has a reserve, a sadness which, added to the sophistication characteristic of nearly all of Caniff's characters, creates an unusual sense of reality. The setting in which he functions suggests the old melodramatic days of Terry in China; the hollow-cheeked vixens, tough guys, impacted plots, are all there. But Steve moves through them as a being superior in human values, worthy of respect.

Shortly before the beginning of the strip, Caniff sketched the outlines of his new project to Helen M. Staunton of *Editor and Publisher*, from whose column the following quotations are made with her permission:

"'Actually this isn't an airplane strip at all,' said Caniff. 'That's merely a means of getting them somewhere. . . . Essentially this is a novel . . . a picaresque novel.' . . . Steve Canyon, explained Caniff, would be in business for himself after having been a couple of years in college and during the war in service as a captain in the Air Transport Command. . . .

© *Field Enterprises. Reproduced by permission.*

FIGURE 82. This "Steve Canyon" strip appeared February 17, 1947. It shows the mature brilliance of Caniff's style, which has influenced modern comics more than any other.

277

'He's a sort of modern Davy Crockett,' Caniff added. 'He knows the tower operator at every field or the chap who'll get you there. It's strictly high echelon stuff. Canyon never makes much. . . . His secretary is always after him for the rent. . . . One of those long guys that'll never put on weight. . . . My plots are complicated,' he went on. 'And that was Captain Patterson's idea, too. You've got to read it every day so that you'll know what happens— Make it so they can't stand it.'"

Precisely as the New York *Mirror* began to display "Steve Canyon," the new version of "Terry" appeared in the New York *Daily News*. Thousands of fans and cartoonists read the name George Wunder and said (sighing slightly, if cartoonists), "So *he's* the man." "And a darn good job," almost all of them added. Like Caniff, Wunder was at one time a staff artist with the Associated Press; also, like Caniff, he writes very well. But the special feature of the new Terry-man is his distinctive style, which, while carrying on the Caniff tradition, does not slavishly copy all its little style points. Wunder's line has a rhythm and flow of its own, and his characterizations are sharp and sure.

On January 1, 1931, in the New York *Mirror*, people saw a new strip in square form.

They went on reading this new strip. Why? No "carefully exact authenticity of modern detail" here. No "Eye-catching optical contrast of light and dark." Then why? Easy to read, maybe. They wanted to find out about this guy. Seemed he was somebody everyone knew. "Joe Palooka," it said in big letters over the strip (fitted easily between the teeth) by Ham Fisher. Not Ham Fish. No. Joe was the guy in the car.

Next day: "The mysterious black monoplane that eluded the mobsters landed at a gas station ten miles outside the city and took off again. Stand by— Oh, here's a flash! Its lone pilot was Joe Palooka, world's heavyweight champion, who has been missing for two weeks."

"*Good heavens!* Knobby!"

The unfortunate Knobby, a little, bald-headed, racy "gink" who is Joe's manager, has passed out cold with the excitement of this radio announcement. He is still out and still cold as his co-worker holds him up, fully dressed, under the shower.

"Please come out of it? C'mon, old pal? At least we know he's alive!"

In this second release people at least knew he was alive, and wanted to see him, very much. Skillfully, Ham Fisher kept his ink fighter under wraps as the customers got more and more hopped up. Each day they looked for the champ and got, instead, shots like those of gangsters picking their teeth:

"Ferret, youse arrange a nice buggy ride for Knobby Walsh wit' a finish

FIGURE 83. Handsome spotting, clear characterization and rhythmic line make George Wunder's continuation of "Terry" attractive. This was the daily strip of April 5, 1947.

somewhere in d' canal! Now dat everyt'ing's settled, I'll arrange d' first match wit' Packy Derm in Chi, an' one fer d' Garden right after dat."

In "Palooka," real places and often real people are named. The mobster party that followed ended on exactly the right note, or notes:

"You're da flower of me heart, swee-Tadoline."

Of course, after arousing the comic appetite you must give, give.

January 10: " 'Twas a night in the winter, and all through the house not a creature was stirring, except Palooka." The champ, a big, graceful, simple-

looking young guy with spouting hair, in lurid pajamas and unlaced shoes, is discovered at last, necking an icebox.

"Oh, boy! Col' chicken!"

Meanwhile, outside, Bobby and the minions of the so-called law are preparing to rush the establishment, for 'twas there the fleeing thugs with their captive fighter had gone to earth.

"Ready, boys? Let's rush it!"

Cops on one side, Palooka on the other gnawing the whole chicken in one hand and waving his famed right with an expression of happiness: "Holy smoke, burglars!"

Good? Good.

Next day: "When we last saw Joe, he was standing at the door, waiting for what he presumed to be burglars, breaking in. The Balone gang are apparently asleep upstairs."

"They've turned the light out," says a cop as they crash in.

"Stick 'em up! The game's up!"

A faint voice behind door, "Tee-hee."

The next box is black, with stars, clouds, bang, sock, "Tee-hee," smack, "Look out, *I'm* here!" "Tee-hee," sock, smack, sock. "Guess I'll put on the light and finish my chicken."

Entirely satisfying picture of the damaged, black-eyed law and "Well, for goodness' sake! Knobby! When'd you come back from Noo York?" Palooka keeps working on his chicken as Knobby, *plop*, collapses. Good? No, swell—wonderful!

People followed the new strip, but it was no overnight sensation. It started as a daily only; the *Mirror* dropped it for a while, but it had a deep, solid appeal and came back as a color page. Soon the daily was back again. At last "Joe Palooka" was a solid, established success. It had been a long, tough road for Ham Fisher.

Ham was born in 1900. He determined, firmly and finally, on a career as a cartoonist in the year 1905. There are obstacles a five-year-old cartoonist finds placed in the way of a complete dedication to his art, such as education. Little Ham tried the device of getting thrown out of one class in school, only to find he had landed in another. He had to swallow education, but he wouldn't stomach his father's plan of a business career; anything, even college, rather than that. He tried college for two weeks, spending, he says, most of his time in night clubs, for this Ham was a racy young man with a touch of sawdust in him; he had the instinctive feel of the boxing and wrestling world, a sharp nose for the various smells of politics. Earthy guy, Ham.

After World War I he got a job as all-around cartoonist for the Wilkes-

Barre *Herald;* about that time his cartoonist passion crystallized into a firm determination to do a comic strip.

"Joe Palooka" came to Ham Fisher suddenly, but quite naturally, one day. He had been interviewing a mild-hearted, childlike prize fighter, a type not uncommon in the fight game, for a man who knows he can lick practically anyone he meets is likely to develop a bland tolerance of spirit. He started at once; the strip was immediately turned down by all the syndicates. Fisher wouldn't give up and kept on working at Wilkes-Barre, even starting a newspaper himself. The paper folded. Was he discouraged? Certainly; but very wisely he determined that he would keep driving ahead with the real thing in which he was interested, "Joe Palooka." He took his continuity and drawings and arrived in New York in 1927, with $2.50. An old, old story.

Fame, in real life, is extremely hard to come by. Once more Fisher's old pattern was repeating; apparently it was a permanent one. He had a beans-and-coffee job in the advertising department of the New York *Daily News,* and his spare time was spent in resubmitting "Palooka" to the syndicates and being turned down again. A clever move that demonstrated his political talent was the real turning point. He got a job at McNaught Syndicate. Here he was only a few feet from the office of Charles V. McAdam, general manager. It worked. Ham was a salesman, among other things. McAdam, a bit reluctantly, gave in; said he would try out "Palooka," later.

Not good enough. Fisher, with the taste of success in his mouth, determined he would go to the actual newspapers and sell "Joe" to them the hard way.

Huh, so he thinks he's a salesman!

O.K., he would prove it; he took another strip, "Dixie Dugan," which at that time had only two papers, and took to the road. In forty days he had landed over forty papers for "Dixie." All ready now for "Palooka"—but then another nasty shock, perhaps the worst jolt yet.

"Boy, you *are* a salesman! O.K., go right on selling! Of course—not that 'Palooka' thing; you've got to give 'em something they can use."

That was a rough one. Ham's strip was, however, about a fighter, and Ham is a fighter. He'd been through too much to go anywhere but straight ahead. He used a bit of the old generalship, waited until the boss went off to Florida on a vacation—then *bang, sock,* he was out on the road with "Palooka," selling for his life in all directions. The boss came back after three weeks to find "Palooka" sold to twenty papers. The long battle was over. The syndicate went right to work, and all over America the rolling presses printed the two new words, soon famous. With the strip's full emergence in the New York *Mirror,* Ham Fisher had won his first battle.

His *first* battle. With almost all cartoonists, this great moment of success is the last time they tilt a lance with fate. They work hard, very hard, but it is repetition—and golf, or possibly horse racing. A complex of qualities in Fisher's nature, aided, perhaps, by his long arduous battle, prevented him from lying back and lapping the gravy. He had a strip, a great strip, but it was not enough. The guy had ambitions. He and "Palooka" were going to explore a new neck of the strip woods; a place where strips could and should go, but where no one had had the heart or the boldness, or both, to take them before. And many millions of people were to call this, for their money, the greatest strip in the world.

It doesn't appear to be if you glance at it casually. Fisher's style is a sort of Irish strip stew, there is nothing smart or eye-catching about it; it is just the old comic business, a little Bud Fisher, but none of that wild joy; lately a dash of illustration, but no Caniff camera-eye, nor any trace of that brilliant man's art sense. No matter. It is the greatest strip in the world, say its fan millions. They have some very solid evidence for this strong statement.

As you ramble back among the papers of the last decade, you see that the strip starts off with the newly accepted suspense formula; the same chopping off of the story, the same little interest-traps for the reader and his two cents to walk into. And then you see he has begun to drop it; not entirely, of course, but he has found something better; he was, in a way, working backward over the strip story we have told in this book.

Strips, we said, started funny, found suspense and illustration, and grew serious. Ham, beginning his work at a time when suspense was sending more and more strip characters out over the cliff, discovered in himself the earlier appeals, and demonstrated their tremendous pulling power. One thing, he was a natural "funny" man.

Ham Fisher's humor is quieter than some of that of the old timers, such as Bud Fisher and Rudolph Dirks; it is the rippling chuckle rather than the belly scream, but it is there.

Fisher rolls ripe language around for the joy of it. There is a Jean Bateese, unrecognized champion of Canada. This raw wolf is discovered with a sweet leetle cookee sitting in his lap. She worries about his ambition of tangling with Palooka.

"Nom de chien! If those Palooka hurt you, mon petit, I am cry wiz angree."

This makes you feel very good. We are laugh wiz happee. A bit later, Palooka and Knobby, sitting in a movie house, find themselves looking at the horrifying features of those Bateese, who is giving an exclusive silver-screen interview.

"You h'ask me say some t'ing? H'okay! Palooka, she's afraid to fight me!

Behol', m'sieu'! Eef she's accept my shallenge I, Bateese, pool heem leemb from leemb, by Gar!"

Knobby is working to by-pass this fight. Palooka, however, has his temper thoroughly up; it goes high when it goes.

"But, Knobby, he called me *she*. I been insalted!"

This good funny stuff, while rich and tasty, is not the unique quality which, gradually developing, flooded into "Joe Palooka" and made it the achievement it is. The setting for this achievement prepares for the achievement itself; the setting is one of uniquely close contact with the average man. Although heavy-weight champ, Joe is strictly one of them, fundamentally humble. Awful simple fella, Joe.

Says like, "Kin ya 'magine?" "Aint we gonna play baste ball?" Lazy, comfortable Palooka. With his graceful, gorgeous figure and his joy in action, goes a simplified headpiece; no Einstein he. The whole strip is easy-going, worn, comfortable, an old shoe of a strip. Not smart aleck. No strain of speaking like the hard-driven Caniff characters, who must even think in refined wisecracks, each carefully and exactly tooled for the situation.

This easiness wormed the strip deep into the American public consciousness; an enormous, a record syndication followed, and here was Ham Fisher all set to play the great card he had up his sleeve. This was the ace of hearts.

The great quality that lifts the strip to the very top is simply the heart in it, the human love. All people of, if not in, the democracies, know that it is love that makes men rank above the brutes, but it is exceedingly difficult to write about or speak of this precious business, without assuming the righteous attitude, the smallest hint of which sends the public scampering. That is for church, not strip, people feel. In this respect Ham does resemble Caniff; neither spoils his work with preachiness. Things just happen in the life of Joe Palooka; he doesn't go out of his way to be good, it's just in him. He reacts with greatness because he can't help it. The events of the strip before the war unrolled in a setting of sophistication, the build-up to big fights, the earthy rattle of the ring world—whose inhabitants are not angels and more nearly resemble Mr. A. Mutt than St. Francis. Palooka is of this world and entirely comfortable in it; against the earthy colors of this background his humanity sparkles with happy brilliance.

Palooka may be far ahead of us physically, but his mentality brings him down on the level ground and gives us a glow of superiority. Invited to a party in a New York penthouse, he attempts to define such a place: "That's where they keep people that's got measles and things, ain't it?" And at this party he gives one of those inconspicuous, bashful examples of his healthy living habits, which do no harm to the millions of American boys who

FIGURE 84. A full daily strip of "Joe Palooka" March 15, 1947, with a fragment from the fight itself. Joe's real enemy, however, is not the other boxer. It is arrogance, meanness, race hatred.

pattern themselves on this wide-shouldered fighter: he declines cocktails with a polite, "Er—ah—no, thank youse; but if you got ice cream I'll have some, if ya please."

It was elegunt. Simple people were taking as an ideal the big, graceful guy with the thunder in his fist and with humility in his heart. They liked the way he said, "Than-kyou." They secretly admired his preference of ice cream to cocktails. He was one of them, and they followed right along, day after day, Sunday after Sunday, their numbers spreading by the million, the strip fanning out beyond America, over the round world: "Joe" in Zanzibar, "Joe" on the fringe of the Arctic, brightly colored "Palooka" pages being used to wrap up packages of tropical fruit or American chewing gum in distant African trading posts. It was elegunt.

For these battalions, regiments, divisions of new readers were having a new, gentle, quiet, strong message tapped day by day and strip by strip into their hearts: race does not matter to Palooka; to Palooka all of you are equal in the right to live and love and have a good time. Comfortable, lazy Palooka, wolfing down a whole cold chicken out of the icebox in the middle of the night: he would like everybody to be able to do that. Palooka, not so easy-going when someone stepped on a pal's right to a good time (and all decent people are pals to him); the quick anger and intensity of his fierce resentment, and then when he had taught the mean one a lesson, somehow they would always end up good friends. Not a bad pattern of living for people, kids, to be quietly watching, thinking about; perhaps dreaming of applying to the actual problem of the real world . . .

And always good fights. Wonderful, long drawn-out fights: "Palooka's hurt . . . That one connected to the mid-section. . . . He's down on one knee. . . . He's slumping to the ground."

And then the bell and Knobby's hoarse whisper: "I got him figgered, Joe. Ride out this round—box 'im—keep away."

And Joe, faintly: "O.K., Knobby, I'll do just like you say. Than-kyou." Wonderful fights.

People liked "Palooka" so much that fantastic things became possible. Real people had been a feature from the start, but it hardly seemed possible that a strip artist could borrow the President of the United States for a strip character. Bold Fisher did it.

Joe was in Africa, having enlisted in the French Foreign Legion after a rare tiff with Knobby. He had lost the championship; the clamor rose, in the strip and out of it, that he be given a chance to redeem it. However, he was bound by his enlistment and Ham couldn't figure how to get him back. What would happen in real life? There would be only one way. So, one day, the President's secretaries, Stephen Early and Marvin H. McIntyre, were approached by the artist. Would it be possible. . . . There were conferences. It would. And one day, in the strip, Knobby, who, like Ham, stops at nothing, made a call on an inked-in President Roosevelt. He would like a letter to the President of France, requesting Joe's release. With a grin and a high cock of the famous cigarette holder, his wish was granted. Soon Joe was home, and the country was rocking on its seats, for these fights had gotten so real one couldn't believe in the ink.

This was national and international adulation, but Joe and Ham Fisher pay their debts. The big chance to do this was on the way. It was 1940; the world was burning with a horrible charred smell. America, at last, was making up its slow mind to pick up a bucket and help the free peoples of the world put that fire out.

Joe and Knobby were depressed in the late summer of that year. There was nobody left to fight; Joe had taken to refereeing—he was disgusted, for he'd been tricked into a job for a women's wrestling bout. Too much was too much, and the pair cleared out for Cuba, where they had been offered an exhibition match. When the local boy, violating the rules, went in to kill, all Cuba let out a roar, demanding a go at the title. Here at last was some cash showing up over the "busted" horizon. "We can guarantee tereefeec monee."

Knobby, whose nose is ever cocked for the smell of green: "Say, that don't sound so dumb."

But Joe Palooka puts on his coat. It is a turn in his life; a turn in thousands of his followers' lives. The edge of reality is cutting into his story; his pattern is always to drop profit if larger duties tap him on the shoulder: "Sorry—but I got other plans."

"*What plans?*" Knobby is hurt to the very bar-pin. It is always *he* who moves the pieces on the chessboard of the Palooka career.

"I'm gonna enlist in the Army."

"But, kid—if they want ya they'll take ya. Ya got plenty of time for that, you registered."

"I know, but I'm goin' anyway."

It is characteristic of Knobby that reflection brings out generous impulses in him, too. "I—I would, too, if they'd take me." Now all his energies are bent to give his fighter the best possible time before he enlists. Off by plane, they stop at Miami to see Joe's girl, a charming, faithful creature from the distant social world, named Ann Howe, whose story weaves gracefully and tenderly with Palooka's, a very sweet, natural business. Knobby is madly jealous of her. Choking it down, he uses all his administrative talents to arrange that she and Palooka have every minute of time together. Everyone seems to think that Joe, with his world fame, will make some very fine rank. An admiral or captain, is his little sister's idea. Now he is home on the farm for a family goodbye. Joe's decision has no strings, however.

"No, I ain't gonna be a officer, Rosie; jist a buck private. I don't deserve t' be an' don't know enuff t' be." The actual enlisting is a simple but very touching scene.

All this was not done by Fisher without difficulty. Many "Palooka" papers were sharply isolationist; a number had been against meddling in the little affairs of other nations across the world. But Palooka and Fisher had their minds made up, and they are a wonderful team. Palooka's action, well in advance of the draft, had a very definite part in persuading young Americans to climb into uniform. This fact was fortunately noticed by the Army authorities; the strip, henceforward, proceeded with their cooperation and became a mouthpiece through which details of the life in camps could be

shown to America. Fisher undertook a tour of the camps to get the exact flavor of them. Enlistment and soldier morale both went up following Palooka's camp training, and the Army bigwigs conceived of the plan of explaining the workings of the Officers Candidate School through the strip. But this idea, involving a commission for Palooka, was firmly turned down by Fisher. His fighter represented the little man; he must keep him on the right-wrong side of the tracks. A happy compromise was to devote a group of Sunday pages to the intricacies of O.C.S.

A year of intense Fisher activity followed. Palooka was working in close connection with the morale department of the Army, holding an ideal before the nation of clean living, tolerance, utter devotion to duty. Only the blind could fail to see that still another dimension had attached itself to the lowly comic strip—that of *usefulness*. Even Knobby, poor old Knobby, overage and left behind, found himself with a defense plant job, and a job in the strip of tackling the weak spots of such work: absenteeism and tardiness.

Then came Pearl Harbor. What happened then made the rest of his life just a build-up.

Action came in mid-Atlantic: Joe and Biff Williams were giving an exhibition bout; Williams lost his balance and went over the side, Joe after him. A submarine rose under them, and the two fighters went furiously into action.

Sunday pages, because of certain technical requirements, are drawn farther in advance than daily pages. It was therefore not until February 15, 1942, that Fisher was able to get Sunday Joe into The Scrap. But this page, which shows Palooka already in action on some undesignated battlefield, reveals that the author is about to tackle more than the actual fighting; his aim is nothing less than to show a soldier who clearly understands the basic reasons why he is called upon to risk his life and to undertake the dreadful business of fighting his fellow man. A devastated, tottering remnant of a house lifts itself above the battlefield. Scraps of conversation drifting out from it give us to understand that Joe and a pal have been given the dangerous job of shooting German snipers from this tottering perch. Punctuated by their effective fire, the big issues are defined by these two simple soldiers, very quietly, without rancor.

"Yeah, Joe, I was an isolationist. I really believed I was right then."

"A man's certainly entitled to 'is b'lifs, George."

"But when the big test came I realized how wrong I was—"

They break it up, seeing some moving Germans. The job done, the quiet talk goes on.

"I like how labor an' employers is workin' *t'gether* now—we gotta *depend on them* as much as *they depend on us*."

Out of the mouths of babes and strip characters . . . Here is a clear statement of the Fisher philosophy: You help me; I'll help you. Some may call this a political stand. To many others it just seems like the condensed practical wisdom of all the ages and religions.

The one thing these boys can't take is to see the efforts of small people who insist on trying to break up the overwhelming growth of democracy for their own benefit. Now they are talking of fifth columnists in the warring country where they are. "A lot of 'em are pro-fascist, and their present flag-waving can't be trusted, just like some back home!"

Ambitious Ham Fisher. Going on from one battle to the other, never quite satisfied; shoving the service of his strip to his country and the world always one notch further, bold fella, Ham. His Palooka was in the scrap, but it still wasn't enough. This is a world fight, there are lots of other peoples who feel the way we do. Make America understand that. What could do that better than a world-syndicated comic strip? What could do it as well?

Palooka's subsequent adventures flash by like a vivid kaleidoscope of a world soldier's life. He acquires a soldier-manager, Jerry of the red topknot; they are commandos—land on the French coast, become guerrilla fighters helping the French underground—the dangerous night sail back to England —captured by the English home guard, they are unable to convince them of their identity: "This one would double for Joe Palooka the American boxer."

"By George, 'e would, too! They're *tricky* awright!"

Joe is furiously disgusted to find his outfit is in North Africa, *without him!* He's "insalted." Then there is a furlough; he meets Ann, and the lovely one is a Red Cross worker. Another character from the old days comes back, Big Leviticus, of the original comic hillbilly family. Palooka is taken into British Intelligence, with his famous, outcropping hair-do brushed smoothly back, gets at last to his own outfit, and continues the scrap in Africa, where—*Holy smawks!*—he meets a wonderful guy named Big Mike, all hot from Pittsburgh, U.S., the very essence of the foreign-born American, who equally burns with us all in this defense of liberty, and Nada, the fascinating Serbian girl. In 1944, in March, he is back home on furlough, *home*, the grave soldier kissing his dear Mom and Pop, too—delivering a tragic message to a pal's girl: "He said to tell you he—he was proud to die for the right of other men t' justice and democracy."

"Thank you. I'll always be grateful to you."

So "Joe Palooka" reported back into action, serving mankind and country till wars end, and after. And always the presses, the rolling presses of America, that kept on and will keep on repeating his message; the presses rolling day and night in little and large towns, rolling in ink and cheap paper the

song and story of love for humanity; the steady, ceaseless message tapping, strip by strip, deeply and permanently into all these people; these people with imperfect bodies and partly completed hopes who, in their hearts, are all really the same, and who have more sense in their collective wisdom than anyone else; these people who, chewing, weeping at night, running or laughing, kissing and making love, are America. And who, in their vast approval, seem to send back a simple message to Joe Palooka and the man who makes him: "Than-*kyou.*"

Chapter XVIII

THE SMART SET

ALL THROUGH the history of comic art, or any art, we find groups of workers appearing whose work bears a generic relationship; and if Milton Caniff was the bright star of such a comic Pleiad, he also had comic ancestors. The truth is, a school of sharp, sophisticated ink-slingers was emerging under a crisscrossing of influences. An interesting study of this can be made in the Associated Press feature, "Scorchy Smith."

Scorchy was founded on the idea of Charles Lindbergh. He was, one may recall, a national hero after his famous flight. When the Associated Press decided to produce comic strips of their own, as a service to their vast chain of papers, a curly-haired, bashful, boyish pilot appeared in the comic world. An appealing figure, he was right there when courage or fast gun play was the word; awkward and modest elsewhere—especially with the girls, who made after him with many a lithe wiggle, and who never *quite* caught him. The implication of the strip was, that to be caught would be the last, irremediable disaster, and much suspense was built around this theme.

"Scorchy Smith" was one of the original AP group of strips, which first appeared in March, 1930. As it was illustrational and accurate in spirit from the start, it will be clear that there we have one of the original pioneers of the modern manner, for as the reader may remember, Edgar Rice Burroughs's "Tarzan" had started the illustrational ball rolling only the year before.

The creator of "Scorchy" was John Terry; but in 1935 his job was taken over by Noel Sickles, and a new era in strip art work began. Although Sickles is no longer in the comic game, his influence has spread far and wide, and many modern comics are indebted to him for stylistic approach. This man was one of the most brilliant workers the strips produced. He drew with a natural ease which gave duck fits to his rivals. Sickles is an impressionist. He really stems from Claude Monet, who had introduced a dimension of sight that profoundly affected the pictorial work of the early twentieth century.

Impressionism is the substitution, in drawing and painting, of the ap-

pearance of things rather than work based only on knowledge of their structure. As an example, consider a steel girder on a railroad bridge. A worker in the old manner, knowing its rigid form, would rule out all the parallel lines, count up the rivets and draw them with careful, exact little circles. He would end by producing a diagram. In nature, however, light and atmosphere play tricks with forms, and the eye sees something that doesn't resemble a diagram at all. Sickles would see in the girder a pattern of sharp shadows; he would get the feel of those rivets by the little nick of black shadow which lies away from the light; suggesting this with an incisive touch of the brush, the whole rivet would leap with startling reality into life. Often the line defining the light side of the form could be left out entirely if the shadow was well enough suggested—and this is one of the greatest secrets of the illustrational approach. It can be used in a million ways. Sharp, well drawn shadows under the folds of a man's trouser, and the whole leg is there. Of course it takes powerful knowledge to be able to do this well. One sees many examples, in the strips and out, of artists who try the suggestiveness without the knowledge—in which case an enormous contrast will be found. There will be either a man's smartly trousered leg, or just blots of black ink.

Sickles's work on "Scorchy" at first was aggressively loose and sketchy; later he added more real sense of form and developed a very fine-looking strip. He was perhaps the greatest master in the use of the artificial gray called Ben Day, after its discoverer, that the strips have developed. If there were criticisms to be made, they might be that the strip lacked a strong decorative use of black, and that Scorchy was a rather lugubrious character; he rarely smiled and went through life as if with a perpetual grouch—a tradition that the subsequent "Scorchy" artists have not been able to dig out from.

Milton Caniff, signing on with the Associated Press, became a close friend and great admirer of the brilliant Sickles. It was he who brought the impressionism of Sickles into balance with his rich feeling for black and his truly remarkable ability of expressing the shades of human character and expression. So it will be seen that if Caniff has been the major influence of this school, which we designate here as the Smart Set, his own work was brought to the boil over the Sickles stove, and certainly these two men have both benefited by their cartoonist friendship. Happily, Sickles's work is still appearing before the public. He did some of the most telling picture war-reporting—for *Life* magazine—that has been produced, and his illustrations for army training booklets are classics of vivid and useful brushwork.

Sickles left the AP, and the next artist of "Scorchy Smith," Bert Christ-

man, although his story is not dramatic from the art-work side, provides us with possibly the most moving and splendid episode in the history of the comics. A thoroughly capable artist, he carried on the Sickles tradition exceedingly well. This was a man, however, with more in his blood than black ink. Here he was drawing an air hero, a young man who was never content unless he was zooming from under the whiplash of actual adventure. This was 1938, and out in China mighty events were stirring; out there there were real flesh-and-blood pilots fighting for a flesh-and-blood cause, human freedom.

Back in America this kid, Bert Christman, was hunched over a drawing board pulling "Scorchy" out of hot spots. He knew about planes; he was a graduate engineer. He could fly planes. If he were in a jam like this—if these were Japs instead of crooks—if the cause was just—China's cause was just. And groups of American Scorchy Smiths were actually out there—while he—a china dog sitting on a mantelpiece— He got up suddenly from his drawing board. Of course he would need training . . .

What happened is tersely noted in a letter to the author from Zachary Taylor, sympathetic, one-time comic editor of the Associated Press:

"Bert Christman quit the AP to become an air cadet at Naval Air School, Pensacola. After training on fighters, pursuits, bombers, and on carriers, the next AP Features heard of Bert he was in the AVG's, battling the Japs along the Burma Road—a Tomahawk pilot.

"His record must wait the end of the war, but Bert got into many a tough battle; was slightly wounded once. On January 23, 1942, the Japs sent seventy-two planes against Rangoon. The Yanks shot down twenty-one—but Christman was missing at the conclusion.

"Fair-haired, slender, about five feet eight, he was only twenty-six, with a fresh, boyish look. A writer said: 'He must have looked like a crumpled child when they found him in a rice paddy—his machine-gunned body still harnessed to his parachute. A methodical Jap flyer had shot him down after he bailed out.'

"Not many weeks ago, his effects reached his mother at Fort Collins, Colorado. Among them was his scrapbook of sketches of Burma, flying pals, insignia designs."

Salute to you, Bert Christman. You have gone to join that "ghostly echelon of good guys," as Caniff puts it. The rest of us, in our trade, only wish we could have done as well as you.

Artist Howell Dodd was the next to take up the adventures of Scorchy, and his successor, Frank Robbins, provided another chapter in this unusual strip story. The germ of the modern style, the strip artist turned hero—this latest episode was to be something entirely different.

From a standpoint of style, the effect of Robbins's tenure was as if the Associated Press had changed the penpoint with which it was producing "Scorchy Smith." From Sickles down, even with the sharp shadows, the line itself had been airy crowquill; with Robbins it was a clotted stub. His strips were black, heavy, impacted; needed space was apt to be filled up with zebralike slabs of light and shade. The figures and expressions at first were heavy and monotonous, but as time went on they picked their feet out of the ink. Robbins had a fine feeling for action from the very start, and his backgrounds and planes were always effective. If he borrowed certain approaches from Caniff, as Caniff had borrowed from Sickles, this

© *AP Newsfeatures. Reproduced by permission.*

FIGURE 85. Seems like one adventure, in this half of a "Scorchy Smith" strip of 1946, is about over. But that girl—watch yourself, Scorch!

heavy-handedness produced a special distinctive effect; there is now a distinct Robbins style with disciples of its own.

It is not in the matter of style that Robbins contributed significantly to the "Scorchy Smith" saga; it is in his story: for here again is a turning point in strip history, the sign of an advancing awareness of the brotherhood of peoples, a contribution to international good will, and another exhibit in the case of strips versus their critics, showing once more their emerging usefulness.

The early "Scorchy" sequences had been pretty imperialistic. Scorchy was a mercenary in the old days; he would be hired by some wealthy planter to shoot up local trouble makers, and natives, such as Mexicans, were apt to be shown as an ineffective, greasy lot, with the battle equivalent about ten

Mexicans to one white man. Robbins, however, once for all, restored this balance; he shows Scorchy going into battle alongside the once despised Russians, those fellows who were supposed to have no souls, to know of nothing but beards, Bolshevism, bombs and butchery. The first Russian continuity started on December 23, 1942. Although preserving their original reservation about the Russian system, most Americans welcomed heartily this symbolism. Can we ever estimate just how much we, as a nation, owe to Russia?

Robbins hit his full stride at this time. It is true that Scorchy is still the heavy, unsmiling, worried young man of the Sickles period; that the reader cries sometimes in his soul for a touch of lightness—give the poor guy a rest,

© *King Features Syndicate, Inc. Reproduced by permission.*

FIGURE 86. Half of a daily strip of March 26, 1947. Not all of the hazards in "Johnny Hazard" can be settled with gun or fist. Sometimes he just has to kiss his way out.

get him drunk; anything for a change that would pick up the unhappy, drooping corners of his mouth.

But the sweep of thunderous events more than makes up for this convention. Robbins's Russia has a formidable reality; it creates the sense of deep snows, it is full of bitter, bloody struggle, of the passionate dedication to the national effort of throwing those haughty Germans to Kingdom Come, in which effort Scorchy, the girl-pilot Lusya, and the men, women and children of Russia merge their identities and pull as one mighty team.

Lately Robbins has had that curious strip seal of approval placed on his work, which has been in operation since the far-off days of The Yellow Kid. Hearst has taken him over. Now his work appears in the New York *Journal* under the title of "Johnny Hazard." His new hero is another pilot,

not very different from Scorchy in appearance, although the strip has lightened in line and become very Caniff-like.

"Scorchy," of course, went on; this time under the pen pilotage of Ed Good. On April 22, 1946, the last chapter in the "Scorchy" saga, to this writing, opened as Rodlow Willard took over. Willard has drawn cartoons for *Collier's,* and other magazines; has edited comic books and ghosted "King of the Royal Mounted" and other strips for King Features. His "Scorchy" has a lighter line than his predecessors'; it has spirit and action, and best of all, he shows a tendency to allow poor old Scorch to smile occasionally, a feat which still seems a strain, after all those dour years.

© *Publishers' Syndicate. Reproduced by permission.*

FIGURE 87. She's landed her man, "automatically." Half of a "Kerry Drake" strip of November 11, 1946.

Perhaps the brightest of the bright boys who splash ink in the Caniff manner is Alfred Andriola. He was mighty Milt's assistant back in 1935, and knows every flick of that smart wrist from scratch. By 1938 he was off on his own, doing a comic strip version of "Charlie Chan" for the McNaught Syndicate. This was an adaptation of the adventures of the Chinese sleuth, a character created by Earl Derr Biggers, which had appeared in movies and story magazines.

Andriola had a healthy and understandable ambition to make a lead character of his own, and in 1942 he pulled away from "Charlie Chan" and went shopping around to see what might offer. Chances to do the well known strips "Secret Agent" and "Scorchy Smith" showed up, but these were open to the original objection. Then came a call from Publishers' Syndicate, distributors of "Dan Dunn." Dan was to run for one more year.

If he would turn that strip out, Harold Anderson promised, he would be given a chance to continue with a strip of his own. So began Andriola's own strip "Kerry Drake," which we now find running in the New York *Mirror* and many other important papers.

Andriola is one of the sharpest of the new draftsmen. His stuff has sparkle and life. His boxes are direct, full of action, and uncluttered; his patter smart and smooth. He has an ability to delineate character vividly; perhaps enthusiasm has led him to overplay his hand in this respect, for at least in one instance he cooked up an overlurid characterization which led parents to protest. This is Stitches, a beast of a man with a skull face stitched along the side, who, through the course of a number of strips, tortured hero Drake by such pleasant little devices as turning on live steam while the victim is strapped in a tub. Is this what the public wants? Some editors may think so. Many of us doubt it. The strips have come quite a way from the old harsh days of the Yellow Kid. Disney has proved that one can entertain without inculcating a sense of bestiality.

Another disciple of "Pow and Powder," as he describes it, is Mel Graff. Under his lithe line emerges the history of Phil Corrigan, more familiarly known to gangsterdom as "Secret Agent X-9."

X-9 is sort of third uncle to a kid by the name of Patsy, whom we have auditioned elsewhere. Mel conceived Patsy in 1934 and did a fine job on her until 1939, when he shifted to the G-man strip.

"Secret Agent X-9" was first executed by Dashiell Hammett, of *The Thin Man* fame, and Alex ("Flash Gordon") Raymond. A succession of writers and artists followed. Flanders, of "The Lone Ranger," drew it for a time, as did Austin Briggs. When Briggs started drawing the daily "Flash Gordon," Mel Graff started X-9.

Graff at first only drew the strip, but the syndicate finally gave him a crack at writing also. From Eustis, Florida, Mel writes:

"In the past, X-9 was never a warm character. You were supposed to love him because he wore a badge and carried a gun. He never fell in love. I'm changing all that. I've already got him engaged to his lovely steno-secretary. Don't know if I'll ever let them get married. Also, I've finally given the guy a name. After all, an agent who is supposed to be secret, doesn't have everybody yelling 'X-9' at him. And so he will be known as Phil Corrigan from hence on.

"Like most of the guys in the craft, I am behind schedule and it is usually necessary for me to drive my work to Orlando (thirty miles) to catch the air mail. Les Turner ("Wash Tubbs") and Roy Crane ("Buz Sawyer") live in Orlando and frequently all three of us meet in the post office, hair matted, eyes bulging, nerves on edge and packages of drawings clutched

in our ink-smeared fingers. Some day all three of us will probably collapse in a heap after making the mail."

On December 1, 1941, one week before Pearl Harbor, a new thread in our national history was about to be woven in, and a new thread in the strip pattern was first woven in on this day. The new thread was the strip "Vic Jordan," appearing in New York's new newspaper, *PM*, and its originality lay in the fact that it showed the working of the underground movements in Europe. Vic was part of the natural tendency of strips to reflect the real events in which their readers were engaged. It is certainly of historical interest to see American comic strips crediting European democrats

© *King Features Syndicate, Inc. Reproduced by permission.*

FIGURE 88. A lot of situation for only two boxes clipped from a daily strip. This is "Secret Agent X-9," in 1947.

with their brave and long part in the struggle. The strip was written by two newspaper men under the pseudonym Payne, and the first artist was Elmer Wexler, who enlisted in the Marines in 1942. He was followed by Paul Norris, who also went off to war in the fall of 1943. Norris was succeeded by *PM's* staff artist, David Moneypenny, who in turn was succeeded by Bernard Bailey.

Vic was originally the press agent of a French show which was closed down by the Nazis. Among the cast was a girl who was acting as a British spy, whom Vic set out to rescue, and in so doing, mixed with the French underground. The story of sabotage in the factories was clearly shown, and as a climactic adventure, the Gestapo tried to liquidate the underground by introducing one of their own agents into it.

In *PM* of Monday, April 30, 1945, John P. Lewis, the editor, writes:

"The victory in Europe has been reflected on our comic page. 'Vic Jordan, our first comic strip, which was devoted to dramatizing the fight against Fascism in the underground of Europe, has bowed to the fact that military victory is at hand. In the Sunday paper Vic made his exit. He was wounded, you remember, and has come back home for a rest."

Jack Sparling, the kid who originated "Claire Voyant" for *PM*, started life as a sports cartoonist on the New Orleans *Item*. It was while doing this that he made a clay caricature of President Roosevelt in fishing togs. One of the reporters on the paper sent a picture of the statuette to the President, who made evident a desire for the original. Sparling took it as a command to appear at the White House, promoted a pass on the air lines to Washington, and convinced the paper that a picture of him shaking hands with the President would be good publicity. In Washington, Marvin McIntyre smilingly explained that such a picture was impossible, but that he could meet the President at a press conference. This he did, and while still walking in the clouds he accepted a job with the Washington *Times-Herald*. He stayed there two years, until the paper was sold to Mrs. Patterson and a lot of the fellows were relieved of their responsibilities. It was at this time he linked up with Drew Pearson and Bob Allen to draw "Hap Hopper." Writing about the beginning of this strip, Sparling reveals a cogent insight into the workings of a newspaper editor's mind: "'Hap Hopper' first saw the light of day on January 29, 1939. After suffering from having a dumb reporter, the strip got off to a flying start. Since every editor started as a reporter, very few cottoned to the idea that there are goofs for reporters. We soon changed this, and the strip began to pick up papers."

Sparling soon started to suffer from that Hawaiian disease so prevalent among comic assistants, "lacka owna strip." He naturally determined to do a feature of his own. He writes:

"In announcing this to the wife, her face fell a little. It wasn't because she doubted my ability, but whenever an artist or writer says he is going to create something, that means his health is going to fall off; he sits and stares into space; he misses the point in conversations; he goes to movies and doesn't watch the picture; the little lady must shoo the kids around him quietly because he's thinking; and until the bum comes up with something, there's no living with him.

"Thus 'Claire Voyant' was born. I picked a girl hero here, because it has appeal in the papers. I picked a girl with amnesia, because we were in the middle of the war and I didn't want to give her any family ties until after the war was over, when we would know more about what this old world was going to look like. And so on May 10, 1943, my heroine was picked up

Copyright, 1944, Field Publications. By permission.

FIGURE 89. An example of the strikingly individual and decorative effect which Jack Sparling often produces in "Claire Voyant." A daily strip of 1944.

at sea from a lifeboat, without any knowledge of who she was or where she was going."

Sparling's advice to aspiring young cartoonists who have an idea that will mint them a million is: "Work at it, learn to draw, learn to write and learn your characters, then go ahead. Remember only one thing. It's not a nine-to-five job at five days a week. In this game you even work in your sleep. If you don't believe me, ask my wife. She says I talk about Claire Voyant running in and out of situations in my sleep."

Sparling is perhaps the most artistic worker in the newer Smart Set. He

has the capable drawing of the rest of them, the attention to detail, the movie approach. But in addition to these things he has a decided feeling for simplicity, for attention to mass rather than irrelevant detail. He has a special convention for rugged male heads, a liking for Roman noses and vigorous torsos. He uses Ben Day in a telling manner. The device of spotting completely grayed figures against a white background has come to be a sort of personal trademark of the strip. Claire Voyant herself is not too remarkable a character in appearance; it is the group of men, heroic or crooked, who revolve around her which make this strip stand on its handsome feet.

"Debbie Dean, Career Girl," is a girlie-girlie of the Smart Set. Showing

© *The New York "Post" Syndicate. Reproduced by permission.*

FIGURE 90. The two last boxes from the first strip of "Debbie Dean," January 11, 1942. The overall plot is already very clear.

the influence we have mentioned before, Debbie appears with all the poise and polish of the most modern of generations. Created by Bert Whitman, and distributed by the New York *Post* Syndicate, Debbie is a skillful blending of adventure and humor. Bert Whitman was an office boy for the Chicago *Herald-Examiner* and the Los Angeles *Times*; then, like so many other strippers, he became a sports cartoonist in Detroit. From there he went to New York where he did "The Green Hornet."

The strip first appears on January 11, 1942. It explains, "Debbie Dean, heiress to a fabulous fortune, tires of the life of a debutante." The start is somewhat conventional. Debbie gets a job as reporter through influence; the city editor, young and eligible, makes things tough; Debbie, against orders, goes out and gets a good story—fade-out as everything is forgiven.

Fortunately for followers of the strip, Mr. Whitman grew tired of this

routine and had Debbie spend her vacation in a town called Deansburg. The mayor of Deansburg is her uncle, Gunga Dean, a crotchety old man who refuses to believe his forty-five-year-old son has grown up, and who is gasping his last breath, supposedly, when Debbie arrives in town. It is the custom for all Deans to anticipate their own demise and rouse long enough to make one last, world-shattering statement. Gunga is no exception; his last words are, "She's a better man than I, Gunga Dean!" Fortunately, the uncle doesn't die; he meant by his last words that Debbie would make a good mayor of Deansburg in Gunga's place. And so we have Debbie as a girl mayor, and her work to get the city out of debt and earn it its rightful place in the promotional sun. For this it is necessary to call in her advertising-man boy friend. Cozy, but full of unexpected twists.

This is one of the more satisfying of the soap opera comic strips of today. While things are handled quite often in a strictly pictorial approach, it is pleasantly spiced with definite comic figures. Gunga Dean has a walrus mustache, a twinkling eye, and when he is well pleased with himself, he emits a satisfied "Yk, Yk, Yk."

In 1932 Martha Orr, niece of the Chicago *Tribune's* political cartoonist Orr, presented a fascinating old biddy by the name of Apple Mary to the comic-strip world. It was about the time that a popular movie featured a character of the same type, and the prototype of Mary could be found in any large city.

Miss Orr did the strip very capably for seven years. At the end of that time, marriage and approaching motherhood forced her to request a release from her contract, which still had three years to run. At that time Dale Connor, a young lady who had been Miss Orr's assistant, and Allen Saunders, combined to do the strip. They took their two first names to make "Dale Allen," which was the name they used for the by-line. Dale and Allen switched the continuity from the "tear-jerker" type; made Mary Worth the pivotal figure, changed the title to "Mary Worth's Family," and featured young people in the modern manner.

When Dale left the set-up, Ken Ernst, a Chicago artist, stepped in. The name was further shortened to plain "Mary Worth." Saunders, who must be a very busy man, continues to do the story. That makes Allen Saunders the writer of "Chief Wahoo," "Mary Worth," and in addition, comic editor for Publishers' Syndicate.

The art work by Ernst is in the smooth, smart, dressy modern style. Some of the trademarks are very nice. Ken Ernst has a trick of showing a group of people in a box with absolutely no background, just white space; but by clever use of shadow, the figures leap out of the box.

"Mary Worth" is on view in New York in the boxes of the New York

© Publishers' Syndicate. Reproduced by permission.

FIGURE 91. Above: half of an "Apple Mary" strip of 1938. Below: the same Mary brought dramatically up to date in "Mary Worth," 1947.

Post. This paper, with "Debbie Dean," "Scorchy," and "Mary" appeared, at one time, to have reached the sophisticated limit. As a group these strips, in spite of the virtues one might individually find, were beginning to get a bit tiresome. The same young man with his sophisticated forehead-wrinkles and Hollywood coat seemed to walk through a whole lot of strips, past the same hotel piazza, with the same, dark-haired slick-chick lying in wait ... But no, it wasn't enough for the public, who had developed an astonishing appetite for hair oil and the romantic problems of high-torsoed, young bachelor girls. Once in a while our eyes blurred with the sameness and the smoothness and we longed for the excitement of a Krazy Kat page.

So it was that, when we picked up a copy of the New York *Post* a year

302

or so ago and opened it to the comic section, we gritted our teeth. There, looking smoothly up from the color pages, was the most damnably orthodox Smart Set strip since Caniff commenced the craze.

This latest addition snapped its crisp line before the public on March 25, 1945, buried inside the comic section. In a very few weeks, however, it had nudged its way around to the front page, and, from all indications to date, there it will remain for some time. This new strip, "Bruce Gentry," beginning from a standing start on the 25th of March, had, by the 25th of July, picked up thirty-five newspapers, totaling almost seven million readers.

Bruce is an airline detective working on the establishment of a new route in South America. To quote Glenn Adcox of the New York *Post* Syndicate: "'Bruce Gentry' is not a strip with social significance. Mr. Bailey has no axes to grind. He is in hopes the comic will improve relations between North and South America, because he is making a conscious effort to have the characters authentic, and not limiting all the virtues or all the faults to either side of the equator."

"Bruce Gentry" is not just an ordinary well drawn strip, it is a job of very high technical skill, even if the pattern it follows has been used before. Anyone who thinks it is easy to imitate this pattern will shortly be disillusioned. Exact perspective, high flexibility of expression, and a feeling for drama, such as Ray Bailey has mastered, requires an understanding of the principles back of them. These elements of drawing are needed in their full intensity by the Smart Set comic artist and they must be fused in the white-hot drive to meet the dead line. Six dailies and one Sunday of the grade of "Bruce Gentry" will take the starch out of everyone but the born cartoonist.

Ray Bailey, the creator, script writer, and artist of "Bruce Gentry," is the son of Ray Bailey of the New York *Sun*, and young Ray was affiliated with Milton Caniff of "Terry" for a period of two years.

Bailey says he feels that the readers are tired of battles, hence he has none; hence he has neatly sidestepped the rough period of reconversion.

Of course there are excellent reasons for the popularity of these strips. The flood of radio soap operas, which engulf the entire United States almost all of every day; the sophistication of style in a world technically minded after years of war, these factors placed the Smart Set at the top, aided by that will-o'-the-wisp, fashion. One result has been that strip artists have had to draw for their lives in a pen-race between realistic draughtsmen. But fashion and fate are flexible, changeable things. The war, with its insistence on grim detail, is behind us.

The story of the strips is on the move again.

Chapter XIX

WE STILL LAUGH

It seems that when Joe E. Brown—the comedian whose idiotically patient and beautiful face unhooks you somewhere deep inside—went on a tour of the South Pacific for the USO, he found many soldier communities which had been cut off from humorous entertainment for what seemed endless time. The craving for fun and laughter had been building up inside these men to the extent that the single mention of the word "Brooklyn" (of course through Joe's indescribable face), would release a grade of explosive laughter which made the best civilian product Joe had heretofore built seem like the dry rattling of leaves.

It shows that humor had been there all the time, and that a rich stratum of it lay under the sadness of war. We have seen the strips reacting to the war preoccupations of their readers, following the young men of America in their overseas job, and we have seen how well literal illustration was equipped to handle this new topic. With victory there was a decided change; not so much the feeling of new paths to explore, but more that of a return to the old, the familiar, the happy. It was like looking down on a countryside from which the clouds had rolled off; that was lit with sunlight again. And the interesting thing is that the kind of strip best equipped to depict this normal feeling of the enjoyment of life is the old easy-going slapstrip of earlier days.

Perhaps the editors had been secretly grooming new "funny" men as war's end came in sight; perhaps the strip artists, like everybody else, felt a resurgence of hope and happiness; however it was, new strips sprouted over the comic pages in 1946, almost all of the funny type, and the old gag strips themselves seemed to take on fresh luster. Almost symbolically, the "Saturday Home Comic Section" of the *Journal-American,* a comic top spot, appeared with its front and back covers occupied by strips of basic hilarity and in the strict comic tradition: "Popeye" and "The Sad Sack."

Of course this doesn't mean that literal strips have gone out on their smartly drawn ears; there are many signs that these will stay with us, if perhaps in a reduced proportion. How deeply the radio soap opera, for

Plate 4. One of the highlights of our history is George McManus's "Bringing Up Father." This comic started in 1913; yet here it is as of today, fresh and sparkling as ever.

instance, has slid its slippery self into America is shown by recent figures: forty presented daily, 20,000,000 listeners, and in the four major networks ten out of the thirty-six hours of the broadcasting day are devoted to them. A great many of the listeners are strip readers who have had their strip preferences conditioned by this vast national habit; therefore we have a number of strips smelling heavily of soap. Soap operas, remember, are not funny; they are literal, even gloomy, and when translated into the strip medium, are almost always illustrated in the Smart Set manner. Such a prodigious daily habit will go on, and require its quota of snappy comic artists, and the same thing is true of western and detective stories.

But the big point we are making is that there is a much better market for gag strips these days, as is shown by a glance over the make-up of the New York comic pages since V-Day. The *Journal-American* Saturday comic sections as of May, 1946, show a roster of twenty-one comics. Of these only three are straight adventure, and three fantastic adventure; the remaining fifteen are all based on laughs and three of these, "Herkimer Fuddle," "Hubert," and "The Sad Sack," were quite recently added. The same general picture shows in the Sunday sections of the *Journal-American*: two out of twenty-three comics are fantastic; five are realistic stories, and sixteen are funny—of these three, "Dinglehoofer," Walt Disney's "Uncle Remus" and "Colonel Potterby," are comparatively new, and all are humorous pages.

Similarly, the *Mirror* shows five humorous strips as against three straight and one fantastic; the *Sun* has four funny strips to only two straight ones, with three funny panels as well; and the *World-Telegram's* humorous panels tip the balance of its comics page to the happy side. *PM* has three funnies to two straight.

A more even balance is that of the *News*, which in its Sunday section balances seven humorous against seven straight strips, although the daily is decidedly more serious, with only four out of ten strictly humorous. Although the New York *Post* has recently added the laugh-around-home "Dotty Dripple," it remains the most serious paper of them all, with only five real laugh-makers among its twelve strips. Despite this, the total of our round-up is fifty-eight laugh strips to thirty-one straights and seven fantastics, which clearly shows the new backward tendency.

Another title for this chapter might have been "The New Masters." The strips in it are prominent laugh-makers which have appeared in the last ten or fifteen years. If we do not give as much space to some which have appeared since V-Day, it is not because there may not be great strips among them; it is that we need more acquaintance to estimate their importance. Occasionally a strip shows up with such a fresh, vital angle that one can

predict its greatness right away, and we will start off with one such which seems to this writer the most significant newcomer of the last ten years.

Cushlamochree! "Barnaby" is wonderful! Here's a moment in our history when there's no use to be calm—it's a great moment for a pro-comic historian—for the critics were getting pretty nasty; were growling that the movies had ruined comic art. And then along came "Barnaby." The critics are very busy taking it back.

"I think, and I am trying to talk calmly, that Barnaby and his friends and oppressors are the most important additions to American Arts and Letters in Lord knows how many years."

This from Dorothy Parker, in a piece entitled "A Mash Note to Crockett Johnson"—the artist, who drew, to be printed with this note, a special picture of Mr. O'Malley remarking, "Mrs. Parker is a woman of rare discrimination, m' boy."

The Philadelphia *Record*, in Charles Fisher's beautifully finished, hand-rubbed prose, sums up the attitude of the cognoscenti toward "Barnaby": "We believe, very seriously, that it is in every sense a major creation."

Of course, this is back a few years ago, for "Barnaby" first appeared in the New York paper *PM* in April, 1942. Some of the original shouting has died down, and "Barnaby's" audience does not compare, numerically, with that of the top, mass-appeal strips. But it is a very discriminating audience, which includes a number of strip artists themselves, and so this strip stands a good chance of remaining to influence the course of American humor for many years to come.

Another group of readers have also discovered that "Barnaby" is in every sense a major creation. We mean the kids themselves. Their reaction to the strip surprised even its creator, Crockett Johnson: "I never aimed at the kids," he writes; "they must miss most of the gags." But kids are much more knowing than anyone suspects. They accept the wonder of living as being a natural part of the facts of life; as a pay-off to living itself; a pay-off which is often lost as we grow older. It is Barnaby's matter-of-fact and practical attitude towards the intoxicating mysteries around him which rings one of the purest-toned bells in this little masterpiece.

The whole epic began when Barnaby's mother was reading him a story about a star, a castle window, and the Prince's Fairy Godmother. "Very neat," commented Barnaby. "I don't suppose I've got a Fairy Godmother by any chance?" In bed that night, a fuzzy star shines through his window. "What this house needs is a couple of good Fairy Godmothers," he is thinking. "Anyway, I wish . . ." The star swells to gigantic size; an object like a small, bulky helicopter comes whirring through the window.

"Cushlamochree! Broke my magic wand," says the little, tubby man,

FIGURE 92. This little high spot is from the first years of "Barnaby," when the strip was written and drawn by Crockett Johnson.

looking ruefully at his broken cigar. "Lucky boy, your wish is granted; I'm your Fairy Godfather. Yes, m' boy, your troubles are over; O'Malley is on the job."

The next morning begins that fascinating conflict between Barnaby and his parents about the existence of Mr. O'Malley, which is the basic plot of the strip, and in which the factual-mind Barnaby is quite reasonably backing up the evidence of his senses. He had found cigar ashes next to his bed. He accepts his parents' stupid disbelief in O'Malley as part of the lowered intelligence, which, for some reason, is characteristic of adults.

"I suppose Mr. O'Malley runs into this attitude all the time," is the way Barnaby adjusts himself.

Jackeen J. O'Malley is not only the impresario of a world of pint-sized wonders, of little people from the old fairy lore fitted into a modern setting, but O'Malley is also one of the great actors of our time, a symbol of ineptitude, of the inability to integrate the flood of facts which pour about us, into a coherent or meaningful pattern. The O'Malley "bumblingness" is particularly well illustrated in his use of his supernatural powers, and it is part of Crockett Johnson's genius that he shows these powers as faint and flickering. O'Malley's little miracles are cute and cozy—and generally work in reverse.

One day O'Malley was explaining the nature of a leprechaun to Barnaby. "The average person's ignorance and misinformation about leprechauns is shocking, Barnaby," he remarks, in that ornamental flood of words with which he pours out his complex of observations. "Of course no dependable data of any sort exist, and no scientific field work has been done on them. But there's one of them now, on that toadstool."

"I don't see a leprechaun, Mr. O'Malley."

"He's made himself invisible because you're here, m' boy. But he's there, posturing on that silly mushroom. No leprechaun ever thought of sitting on a mushroom until a lady in Sussex had them do it in a kids' book. Now they always do it—feel it's expected of them."

"Pipe down, O'Malley," comes a sharp voice from the blank white above the mushroom, "Ain't you never hoid about gas rationing?"

The obstinate leprechaun, "A very representative specimen named Launcelot McSnoyd," according to O'Malley, refuses to make himself visible. But when the pair walk off, McSnoyd follows, wise-cracking from the rear. "Make yourself appear, or I'll make you visible against your will," snaps O'Malley.

"Noitz."

Now Mr. O'Malley is up against one of those recurring crises, when he is forced to come across with some magic or definitely lose standing in his little world. "Well, here goes." He waves his magic wand-cigar. "Your fairy godfather is a little bit rusty at this kind of thing."

It is the purest O'Malley that, through some bungle in the use of his supernatural powers, it is not McSnoyd that he forces into visibility; it is himself who is forced out. He takes it very philosophically and discovers that there are certain advantages.

"John! The upstairs is flooded! You left both faucets on full and the stopper in the basin!"

"I did not."

And: "You left something burning on the stove! The kitchen's full of black smoke!"

"I haven't lighted a single burner yet!" Poor Barnaby's parents—theirs is a long confused road.

How Crockett Johnson maintains his steady inspiration, as evinced by the literally wonderful new characters which he introduces in this strip, is a matter of delighted puzzlement to the fans. The finest is Gorgon, the dog O'Malley produced for Barnaby to give his father for Christmas. A news item read by Mr. Baxter gives a hint of the O'Malley technique in this case. "Listen to this: 'Doubtless imbued with too much Christmas spirit, someone broke into the A.S.P.C.A. shelter last night and freed all of its 216 canine inmates and 93 cats. Authorities are puzzled.'" We illustrate Gorgon in one of his great moments; of course we all of us know that dogs talk, sometimes.

Then there is Gus the Ghost—a most magnificent piece of business, to speak very mildly; a timid, gentle, suburban ghost that they found haunting a house. "But I had to give it up—two nights in that terrible place wore me to a shadow! Doing a good haunting job, even under the best of conditions, is difficult. On one's feet all hours of the night—dragging heavy chains—up and down dark, drafty hallways . . . And one is expected to keep a clean, white appearance, mind you. Why, the laundry problem alone—" What finer moment in comic art is there than the one in which Gus and a gangster accidentally meet face to face—and Gus faints. "That awful face," he quavers, as helpful Barnaby revives him with a pitcher of water. "I'll see it in my dreams!"

That underlying the fantasy there is a sharp, razor-edge of social satire in "Barnaby," is known to those who follow it consistently. Sometimes this doesn't have to be read between the lines.

Critical and sharp as this is, most of us follow "Barnaby" for the essence of great wonder that is in it, and for the gags, which have not been surpassed in comic strip art.

One day O'Malley announced that he had solved the paper shortage. "The Newspaper Publishers' Association will be delighted with my simple plan. It merely calls for the elimination of comic strips."

"Will that save enough?"

"M' boy, statistics show that 96 per cent of the readers peruse the comics. And will it be worth while to print the remainder of the newspaper for the other 4 per cent? . . . No . . . So, the presses can be sold for scrap—you see, I think of everything—"

Crockett Johnson did a lot of things after studying art at the Cooper Union in New York. He worked in Macy's art department, he carted ice, he played professional football. Then, after working as a free-lance cartoonist, he began a feature for *Collier's* called "The Little Man with the Eyes." He has, like so many other strip artists, a convinced idea that he is the laziest man on earth; so he decided to do a comic strip, about the hardest job on earth.

His sample strip got the cold shoulder until he showed it to smart, intelligent Hannah Baker of *PM*. In April of 1942 it appeared, and made a very definite hit. Syndication followed, and as intelligent people all over the country began to find this strip a necessary part of their lives, the strip broke into book form. But this was something entirely different from the comic book; these were real books with the strip boxes spotted two to a page in staggered fashion, an effect entirely new and very handsome. These books, published by Henry Holt, appear every Christmas—and may they go on to the end of time. Recently we had another innovation, a smaller, paper-bound book of the same type produced four times a year, which also promises to be highly successful. New names are now signed to the "Barnaby" epic—Jack Morley and Ted Ferro. Does that mean that Crockett Johnson has given up his interest in the wonderful little world which he created? It is a relief to know that he has not. He has simply turned over the drawing to Morley and the writing to Ferro, while he retains the control and sits in on the story conferences. The result is a happy one: the creative touch of the master cartoonist is still there, and the producing team are doing an outstanding job.

Hats off to "Barnaby." It is a patch of cheerful, sunny green in the scorched-dust color of our times.

But dust color can have its beauties, too; especially when it's a color laid on from an honest down-to-earth approach, as contrasted with stickiness and sentiment.

From this last angle, many brain upper-crusters have been going around saying that cartooning was dead. The movies killed it, they say. All gush and goo. No irony. "Try to imagine a Cruikshank, a Daumier, emerging out of the tinsel and postcard cartooning of the present!"

Step up, gentlemen, and take a look at our nomination for cartoon immortality in the satire field, Sergeant George Baker.

Baker was born in Lowell, Massachusetts, in 1915. He knocked around at a lot of things, almost went into professional baseball. In his last high-school year he came to a definite decision to become a cartoonist, college being financially out of the question. For a month he was an enrolled student at the Chicago Academy of Fine Arts, but he came to the conclusion that

> Gosh. I know you've fixed everything, Mr. O'Malley. But when are they going to start making shoes....?
>
> By atomic power...?
>
> Jack morley
> ted ferro
> 2-18

> Didn't I tell you? They began last night— But there was no fanfare— Leprechauns are pragmatic fellows. They won't believe the atom is all it's cracked up to be until their production graphs sky-rocket...

> Which is sensible of them.
>
> Mr. O'Malley! Look...!
>
> ATOM PLANT NO. 1

Copyright, 1947, The Newspaper "PM," Inc. Reproduced by permission.

FIGURE 93. Evidently the Leprechauns *have* decided that the atom is what it is cracked up to be. This Morley and Ferro version of "Barnaby" ran on February 18, 1947.

cartooning was something that couldn't be taught, at least to him. He worked on his own, and then took a step which advanced him far ahead— he joined Disney's studio.

"At Disney's," he writes, "I came under the influence of Don Graham, who was an art instructor in the evening art class run by the studio for men interested in improving, or who went to the class for relaxation from their daily work. It was the foundation I needed to give my work solidity. The emphasis in these classes was on fundamentals and this was responsible for my deviation from the clichés of cartooning.

"Disney's of course had a great deal to do with a development of my

sense of depth. In animation, the third dimension is demanded on one's work to give the illusion of space *around* the character."

Then war. But Sergeant George Baker went on drawing. A contest for artist-soldiers was on and Baker had an idea. Perhaps even he did not realize what a great one it was.

He drew a little soldier lying apathetically on his disordered bunk which was littered with clothes and candy wrappers. This was the first picture. Successively, the little dogface gets up, makes his bed, puts away clothes, shines shoes, presses uniform, shaves, polishes brass and so on. He stands snappily at attention as the fierce inspecting officers sniff around and then, these passed, collapses on his bunk, amid a complete disintegration of the sparkle and the order. The litter, the candy wrappers, all are now as before. It was not remarkable that Baker won the prize. He had caught not only the military routine; in this cartoon he had caught the irony of life, wherein we perpetually struggle with the forces of disintegration and decay, and are not always the winners. It was depth again; this time, depth of idea, of satire.

Out of the combination of this mordant sense of truth with the wild, bursting humor of Baker's cartoon approach, emerged the greatest figure of World War II, the Sad Sack whose extraordinary realism was instantly appreciated by his prototypes—for this first cartoon was printed in a great many camp newspapers, and the first issue of the Army magazine *Yank* bore the "Sack" proudly on its G.I. breast as its first permanent feature.

"The Sack was originated in the first few months I was in the Army," Baker writes. "To me he was the pictorial representation of the humility and resignation to abuse the civilian feels on entrance to the gigantic machine, the Army. The little 'Sad Sack' came from a longer expression, derogatory in nature. The two words 'sad sack' took on a totally different and odd connotation in my mind; it was to me the perfect description for my character, through implication and sound."

The Sack leaped instantly into a million G.I. hearts, for in spite of his bashed-down exterior, he has a very great spirit, and in no time at all tanks were crawling through blistering fire bearing his name, and planes labeled "Sad Sack" were sacking it to the enemy, and raising hell. There was something about the guy that typified the war; the inoffensive man caught in a huge, hideous machine of destruction which he didn't create, and yet drawing the most amazing courage out of his puffy eyes and chicken-thin bones. He crawls out unhesitatingly to rescue some huge, fat, two-ton, wounded man, and then, of course, a powerful big soldier comes in lightly and unctuously bearing a featherweight colonel, and all the war correspondents with their cameras rush to photograph the big soldier,

FIGURE 94. George Baker is the satirist of our times. That his "Sad Sack" is a universal symbol as well as an eminent war figure is shown in this 1947 page, which appeared in color. © *George Baker. Reproduced by permission.*

having paid not the barest of bare attention as the heroic Sack inches his great burden by under their despicable noses.

It is a cry of the injustice of life, of the fact that to the wolves go the rewards. Of course, it's a little hard on the army actors that Sergeant Baker chooses to personify the wolves. They are drawn not veraciously, but as portraits of the feelings that the dumb, pathetic little Sack has about his superiors. As such, they are amazing and unforgettable. There's the buck sergeant. He's liable to have a head shaped like a turnip and the physique of a gorilla, for he is a man of action. He manhandles the Sack physically. Then there's the first sergeant. He is almost always of gigantic belly, for this is the daddy of the outfit, who looks after the domestic affairs of his little darlings. He therefore manhandles the Sack's attempt at home life; he specializes in interposing his giant and authoritative bulk between the Sack and rest, comfort, sleep, food, warmth; such things, his actions suggest, are really not good for the Sack. Such things, of course, are always essential to first sergeants. Then there are those officers. The officers! They specialize in manhandling the Sack spiritually. They are of an appalling, refined leanness, and for them Sergeant Baker usually reserves his most horrifying and expressive doodle, that of a long, low, lantern-jawed, pompous and yet truly menacing wolf. They get everything—girls, warmth, food, respect, adulation, and glory. And they are often the cutting steel point of that irony which is the ever-recurring, sad and yet wildly funny theme of this masterpiece.

This strange, loose, wild, half-woodcut technique has, in addition to originality and extraordinary expressiveness, a savage beauty.

With no technical resource other than the simple, childish line of the old-fashioned strip artist, Baker hews out figure forms that have a most startling existence in *depth*. He carries expressiveness not only up and down and across but *in*. This is where he touches Daumier most closely. Like Daumier, Baker turns clothes into an expressive part of body form. Who can forget the gloriously artistic structure of the Sack's legs, with great, whittled-out kneecaps and feet of enormous pathos, or, especially in helpless situations, the way the Sack's hands have of amalgamating with the arm in one monkeylike and sadly rhythmic form?

With this strip, two great cartoon tendencies join for the first time. Baker builds his Sack with the most classic of classic comic conventions. His head is the purest comic strip doodle. The feet are super strip. The dearly beloved "whams" and "pows," the action lines, knockout stars, sleep z-z-z's, sweat drops (very familiar to the unfortunate Sack)—these purely strip inventions are all there. To these "comicalia" has been added the sharp, fierce expressiveness of cartooning of the far earlier days of Cruik-

shank, Hogarth, and Daumier. The comic-strip medium, which in the light of our full story we see to be pure elastic, has been stretched once again, to let a master ironist aboard.

At first, this comic was largely for soldiers, but civilians had a good look at it through the wonderful *Sad Sack* book which appeared in 1944. Late that year, this book was retailed piecemeal, by the Bell Syndicate, in the pages of the New York *Sun*, losing a good deal in reduction. When V-Day came, a great question was uppermost in Sack-conscious minds: Would the Sack go on, and where? Perhaps he was a figure of the war only—we were worried for fear Baker might lose his harsh intensity in the comparative politeness of civilian life. Then, on May 5, 1946, "The Sad Sack" burst out in glory all over a full-color page of the New York *American* and the fans sat back and swallowed with relief. Their Sack, still handled by the Bell Syndicate, was as good as ever.

At this point it is clear that Baker has a great comic figure and an immortal theme. His first sergeant is as fat behind as ever, only this time he is the landlady. The diabolical lieutenants have turned into civilian overlords equally triumphant in their grasping, glutting careers. The entire epic is intact.

The satire of this strip is not completely original; we are reminded sometimes of the earlier period of the Gumps. But that's one of the distinctive points of Baker's work—it's traditional. George Baker has bent the pliant comic-strip medium far back to the early masters of the almost lost art of satire.

We noticed before that the New York *News*–Chicago *Tribune* group of strips, outstanding as they are, have a somewhat lower percentage of pure laugh-makers. Most of their story strips, however, slip in plenty of good gags, and the two which are devoted entirely to the "wild bust of lafter," are both classics in their way. One of these, "Moon Mullins," we have looked at before; the other has a special niche in our history; it carries on a type of humor almost extinct nowadays. As we turn the Sunday *News* pages, this comic stops us with its uproarious, confused gaiety.

Clang—Fire belle (girl's face, crazy ringing attachment controlled by string) Holy H. Smoke! It's a four-alarmer, chief! That's Flooky's farm, over near petticoat road—on the outskirts— Hey! Ain'tcha coming, boss? Picture on wall labeled "Ham an' ax." (And that's no baloney.) No, I think I'll sit this one out, you kids go ahead— Hey—what's wrong with the chief? Yeh, he never gives the cold shoulder to a hot fire! Those flame flunkies have been gone two hours! They oughta be back by this time! (Clock on watermelon—The Watch on the Rind.) Here they come now, Clang Clang (Ceiling Wacs) z-z-z Chief was asleep, is now high on flag

pole, higher, can't go no higher, firemen, each head with five stylized bumps in angry red and hacking at pole—master point—big bump on ax handle, you insect! Why didn't you tell us that was a bee farm? A cat: That was a honey of a fire.

This is not a stream-of-consciousness sample from some Western writer attempting to absorb the comic strip spirit; it is just an impression of a recent "Smokey Stover" page. Real old-time gaga strips are "foo and fa" between, but thanks to that loose nut, Bill Holman, and the perspicacity of the Chicago *Tribune*–New York *News* Syndicate, his screw-ball brand of humor is found in the Sunday pages of a great many papers.

The sample shows Holman's fiery reliance on that ancient laugh-provoker, the pun. Puns may be down these days, but they are not out.

© *The Chicago "Tribune"—New York "News" Syndicate, Inc. By permission.*

FIGURE 95. This little fragment of "foo" bubbled in the "Smokey Stover" Sunday page of March 30, 1947.

"A trio grows in Brooklyn"—that's from "Silly Milly," the one other modern laugh strip that puns heavily.

It seems to be true that the unadorned fact that one word may have two meanings is no longer as funny as it used to be; and the kids will groan and look reproachfully at Dad when he pulls one that smells of 1910. But "Smokey Stover" and "Silly Milly" get away with it because their puns are embedded in a wild, joyous world of fantasy. Why not have a good time with words? And it isn't words alone which tickle us in the present instance. The sharp, alive quality of a Holman figure is enough to make you glad it's Sunday morning, even if Aunt Hattie is coming over for dinner.

This wild burst of foo—Holman's special word for bubbling life, which he has been using for ten years and should be in the dictionaries—first foamed over on March 10, 1935, and so far, the foo is far from out. Smokey Stover and Chief Cash U. Nutt are the slap-happy smoke-eaters of this

funniest of all fire houses. Even the cat kicks the gong around. But as long as this strip is around, we can't kick.

And while we're talking about the "punnies," the "punniest" one of all has yet to be introduced. The New York *Post* has sponsored some classic strips, such as "Nancy" and "Cap Stubbs," and here's another of their group, a unique job which has no competitor; it is in a quivering, jelly-like class all by itself.

Coo, the Gertrude Stan of America! A rose is a rose is a rose is Stan MacGovern of the New York *Post,* and we're saying this all very seriously, being a great admirer of "Silly Milly," the rococo, girlesque epic which hiccoughs daily a strange assortment of young talk, current events, and the local flavor of the little town of New York.

Since Gertrude Stein's writing makes a break with the literal meaning of words, their strange overtone associations tickle our minds with new mental colors ("Toasted Susie is my ice cream"). The same thing in a simpler form makes "Silly Milly" a refreshing change from the dull literal world. Maybe "Milly" is aimed at the young, but there are a great many of us older mildewed specimens who like to bite MacGovern's edible words and feel the juice squirting down our necks.

Silly Milly is a cross between a turtle and three cashew nuts. She has no feet, but occasionally sports a mouth and a kind of nose hole. She is drawn with that aggressive MacGovern childishness which sometimes draws a pained cry from us; in the language of two young ladies who one day visited him in his own strip:

"C'mon—this guy is but simply nuts!"

"But like a fruitcake!"

The fruitcake side is the lively gagging, the bold, decorative quality which makes MacGovern's work stand out from the painfully detailed and labored strips of the illustrative school, and makes us feel he belongs to the classic tradition of the true funnymen.

MacGovern has some claim to being considered one of the old-timers, as he was doing a strip—which he describes as "very corny"—called "Dumbell Dan" for the New York *Sun-Herald* in 1925. The beginning of his current strip was in the New York *Post* on June 8, 1938, and it was named, at first, "Extra, Extra." It was concerned with news items in somewhat the same manner as the lively sputtering daily cartoon of Johnstone in the *World-Telegram*; but it approached this material in a new manner. The special language of swing had become the language of the young things of both sexes. As MacGovern got more and more in the swing, the title of his strip changed to "Swing Out the News"; that was just what he was doing,

© The New York "Post" Syndicate. Reproduced by permission.

FIGURE 96. This gorgeous, girlish, gigglish is composed of a complete "Silly Milly" strip of 1942 and part of another of 1939. The stuff dripped (hic) in the pages of the New York *Post*.

adding words and homy little inventions in the casual, free manner in which one improvises on a swing theme.

Then Milly, always silly, grew in importance, and now we all know her glad cry, Yuk, Yuk, Yuk; her own nutty version of the Wild Bust of Lafter.

One of the very high laugh-average comic pages is that of the New York *Sun*. With a small roster of about nine or ten features (there have been changes in this page), we'll find good old time laugh stuff. The two panels, "Toonerville Folks" and "Uptown and Down," with the more recent "Bobby Sox" by Marty Links, are good for a daily smile, and we'll find among the *Sun's* strips some high spots in any history of the comics. The first we consider is unusual in a number of ways.

America generally exports her comic strips; but in one case, at least, a foreign import released by the Bell Syndicate has competed with the best American product and more than held its own. This is J. Millar Watt's "Pop," a most unusual piece of work.

England has for very long been a producer of the very best in cartoon

© *The Bell Syndicate, Inc. Reproduced by permission.*

FIGURE 97. Good gags are always popping in J. Millar Watt's "Pop," as this illustration shows.

and illustrative drawing; Albion's soul seems to like to express itself in vivid and humanly penetrating line. One has but to skip backward in thought and the big names flash out: Hogarth, Cruikshank, Rowlandson, Leech, Beardsley, and in our own day David Low, probably the greatest living cartoonist. J. Millar Watt has brought to us a measure of this high cartoon quality carried out in our own comic strip form, and in addition to being grateful to him for a swell strip, we have plenty to learn from the little fat man and the enormously long Colonel, whose doings daily disprove the conventional American idea that British wit has to be soaked overnight before using.

Watt was born in 1896, in Greenock, Scotland, but was educated in London, at Westminster School, St. Martin's, and then at the famous Slade School of Art. He did cover and illustration work, exhibited landscapes at the Royal Academy, and fell in love with the American invention of the comic strip. The London Daily *Sketch* still runs "Pop," and in America

probably the most important "Pop" newspaper is the New York *Sun*. "Pop" is an elder member of the *Sun's* comic page and goes back to 1929, a time when the conservative *Sun* was experimenting somewhat hesitantly with the brash new medium. Perhaps the flourish of silk hats and lanky chambermaids which made the setting for "Pop," helped to give a certain gentility to this new medium, for "Pop's" other page mates were "Reg'ler Fellers," "Skippy," and Fontaine Fox's panel. It was the great period of Mickey (Himself) McGuire, and they were all shouting and yelling in the new American fashion.

If the setting of Watt's strip is in the conventional upper English manner, the lovable, dumpy little figure of Pop tumbles it all back to a common denominator. Pop is a universal type and might as well be a news-stand proprietor in Weedunk, Long Island, or selling fried clams on Cape Cod. He's folksy. Despite all that, Pop has a very tart way of lobbing back the ball in life's tennis game.

"What do you want, James?" he asks the butler.

Butler, whipping around: "Nothing, sir!"

Pop bustles off, light on his feet, like a fat snowflake. "Well, you'll find it in my cigar box!"

Pop's enormously tall foil, the Colonel, towers eight and a half heads high and impersonates the conventional idea of the bristly-mustached Englishman to the last inch of pink leather skin. He is an ornamental member of society, a "Norm of conspicuous waste." We saw him once slumped down like a fallen tree in an overstuffed chair.

"I'm utterly worn out, Pop! We've been working so hard on the commission."

Pop: "What's been done, Colonel?"

Colonel: "We've fixed the date of our next meeting!"

Of course in 1940 the pair were on the job in uniform and the distinction between them had grown enormously wide; for while the Colonel whips around in shiny, uniformed glory, poor little fat Pop is a pathetic private, another Sad Sack. It's hard on him. One day he was leaning, depressed, on his broom when a sergeant spotted him.

"What do you think you're doing?"

"Trying to lift my mind out of the gutter."

"Good. We *must* keep our gutters clean!"

"Pop" has much else to recommend it beside the sprightly gagging and the warmth of its lead character. In its form of presentation it is refreshingly original and artistic. Watt did not take the more or less fixed form of the American comic strip too seriously. He added a couple of very successful innovations of his own.

One of these was to disregard the rule that the frame line limits the action of that particular scene. In "Pop," characters reach into the next box, and get away with it, and there is a lot of talking back and forth between boxes. The scene is shifted freely, and the reader has to make some new adjustments with his eye. With a cluttered strip this would probably be an intolerable demand; but "Pop" specializes in the intelligent use of empty space, and the figures are placed with such balance that there is never the slightest confusion. In the gray of the news page a "Pop" strip literally does pop, and it is the empty white space that does it.

The delayed kick is another amusing convention which American strip makers might study with profit. In "Pop" a gag usually is completed in the third box; in the fourth, its impact on some strip actor will be shown, with the actor usually seated on his behind, on the floor, and the reader gets a fine chance to taste the joke. Finally, "Pop" is outstanding in pure, expressive drawing ability. In the too rare cases when Watt introduces children, he shows, in addition to his decorative sense, a fine feeling of life and action, and that refined and clean, beautiful line which he has inherited from the English drawing tradition. No one can make the crack about him that was made about poor Pop a while back. It was in some small military interior, a tin shack, perhaps, lit by a skilfully drawn candle, the shadows from the figures fanning out in decorative, handsome shapes. Pop is posturing dramatically.

"Then I was knocked senseless!"

A sour, kilted Scotchman in one corner: "When do you expect to recover?"

Americans like boldness. When a strikingly bold, new strip suddenly popped up on their comic page on March 5, 1934, the commuting readers of the New York *Sun* blinked pleasantly and looked interested. Their paper was coming out in a rash of strips and they were very happy about it. The year before they had had only four: "Reg'ler Fellers," "Homer Hoopee," "Pop," and "Scorchy Smith." Now had appeared the grand, floppy "Napoleon," whom everybody loved on sight, and the unctuous "Olly of the Movies," which was also making a hit. Below the bold new strip was a blurb which promised blood-curdling suspense, soon to arrive with "Winslow of the Navy." The new strip we are speaking of, the bold one, gave out no glittering promises, but went instantly and sharply to work in its own special, silent way. It was called "Silent Sam."

Sam is being led toward his public in his first strip by a painfully drawn, but dangerous, lecherous-looking devil. Sam is a small, tubby man who reminds you of a cork; his whole body seems to be designed to fit in a bottle, and indeed it is toward a bottle, several of them, that the devil is leading him.

In the background is a counterpart of himself with wings, a heavenly Sam. This one looks sad but resigned. Must have seen it happen before.

How can we define the curious expression on Sam's face? Reservation, familiarity with living, something like that. Well, these two, Earthly Sam and the devil, sit down amid a lot of bottles and liquor up. Careful study of the strip shows that five full bottles were consumed.

The end box packs the surprise. It is the devil who can't take it, who has slid to the floor, blotto. Sam is walking quietly away, not a trace of a stagger. Who could resist it? How we love the unexpected turn, like drinking the devil under the table! Then, too, we had to respect Silent Sam for his Unfathomable Quietude.

Even Heavenly Sam turned out to have that lovable streak which early identified the new strip with its customers. Earthly Sam is smoking one day with inner satisfaction. He whirls around, shocked to see Heavenly Sam giving him an ugly frown. Down goes poor Earth Sam's cigar, for he knows when he's licked. Been smoking too much, it's true. But when he looks up for approval, what's happened?

With Unfathomable Quietude, Heavenly Sam is smoking the cigar.

A very bold, artistic strip, this. Like the absence of speech, the absence of background gave it weight and importance. There is something strong in being able to place only the outline of your idea on display. A man is willing to meet a very severe test, then. Jacobson, Sam's creator, succeeded because the idea which was outlined was almost always good. His was a reverse sense, a distortion of the ordinary. For instance, Sam has a dog that closely resembled one of those Mexican pottery pigs. Dog sniffs at lamp post. Big cop points at him, eyeing Sam accusingly. Sam has an enormous ball of string under his arm. Sam attaches string to piglike dog. He walks away unrolling the string. The strip ends with the cop looking helplessly at the dog, which is standing still on its pottery feet. Far away Sam is walking off, still unrolling the string.

What did it mean? It's a laugh—and something more—a pulling of your mind in a new direction.

In 1936 a new name appeared over the last box of the little acter-out of life's ironies; Henry Thol succeeded Jacobson.

Thol's job was extremely good. His line was clearer and more precise; perhaps it was a shade less artistic, but his ideas preserved the eerie mystery, the imagination of Jacobson, as well as the ring of offstage laughter.

He could show Sam running in football uniform with a pack of gigantic tacklers after him, Sam tumbling, and the tacklers looking down a hole into which he has vanished. The referee is standing with his whistle, uncertain how to call the play.

In mid-1944 another major change took place in the career of Silent Sam. The strip is now drawn by Jeff Hayes. This marked the first break with the early Sam tradition. Backgrounds, a certain amount of balloons and lettering appeared; Sam's world changed. The strip was apparently verging toward a more commonplace approach, but happily, this tendency seems to have run its course. The simple, early style is emerging again. Sam's fans are glad. We like that portentous gravity; we like to see Sam smoke his cigar in his Unfathomable Quietude. "Sam" is syndicated by Consolidated News.

A top-notch worker of the "mind-stretching" school is Otto Soglow whose famous "The Little King" used to appear in *The New Yorker*. His work is an offshoot of that smart magazine, whose laughs are airy rather than literal as with most funny strips.

Soglow's work has refreshing purity of appearance. His clean lines make a diagram for a funny idea to brew itself in, and this idea often leaps out of the drawing and broadens our minds—one of the rarely achieved aims of cartooning.

His first comic, "The Ambassador," appeared in 1933 in the color pages of the *Journal-American*. The Ambassador bore a strong likeness to the sabled ruler of *The New Yorker*, and was replaced by this monarch in person on September 9, 1934.

The Saturday color "funny" section of the *Journal-American* was also given its Soglow: the page "Travelin' Gus," a kind of Toonerville trolley. Gus took his trolley everywhere, with the most unexpected travelers, and always to the country where laughs come from.

But "The Little King" remains as Soglow's central achievement. We enjoy this satire on the humble role of royalty in our time, and it feels good to have our minds washed clean by the unexpectedness of the tiny plots.

"His Majesty, in order to better understand his subjects, has decided to go forth among them in various guises, to study them more closely," announces a proclamation one day. And the red squash-bug monarch is reminded: "Today, your Majesty, you are scheduled to go among your people disguised as a bell-hop."

The Little King is funny in his tight, bell-hop costume, and enters into his role with enthusiasm. In the Yippy Hotel, he takes two big suitcases from Doozle the Magician, whose name is marked on one suitcase. Arrived in the room, the Little King scratches his head. There is now no Doozle. The King leaves sadly, and we enjoy the balloon over his head, a glittering tip— his Majesty had this in mind all the while. After he has left, the marked suitcase opens and out climbs Doozle, who smugly opens the other suitcase, out of which climbs—the Little King, hand outstretched for tip.

© *King Features Syndicate, Inc. Reproduced by permission.*

FIGURE 98. The clarity of Soglow's style is proved by the fact that this large 1947 "Little King" page could be reduced to such dimensions and still remain readable.

The King displayed his remarkable talent on his very first appearance. Huge crowds had gathered to welcome him and we have a chance to see the banners, the merry-making, the huge parade, and the King leaning out the window of his coach. Then, on the balcony, he greets his subjects, but, carried away completely by the momentousness of the occasion, the King grabs an umbrella, leaps up and does a tight-rope walk on one of the ropes supporting his welcoming banners.

"The Little King," like "Henry," another King Features strip, never talks, but what he does is worth looking at.

"Peter Piltdown," by Mal Eaton, is a good, goofy strip, definitely "out of this world." It first appeared in the Sunday *Herald Tribune* on August 4, 1935. It began as a rather accurate stone age "Skippy," but soon got hilariously frothy, and now we never know quite where we are, and are very happy about the whole thing. "Innaminnie" we'll tell you about Pookie, but first about Peter himself. We're not quite certain where he came from or who he is, and the truth is he isn't always around these days. He's a funny little prehistoric kid who does things like this: When Shadrack the hermit is fishing, Peter walks into the water on stilts. Shadrack bawls him out as Peter

walks around without saying anything. Finally, as Peter walks up the bank, you see that he has two fish neatly speared on his stilts.

Your mind is stretched again. You get the little "bop" on the head that Krazy Kat used to get from Ignatz's brick, and little hearts spray out from you all over the place.

The characters in "Peter Piltdown" are Inna-Minnie, a sort of little Indian girl, who is "squooshy" about Peter, who in turn maintains a healthy interest in little blonde prehistoric Daisy; Shadrack, the hermit; Oofty Goofty, a fat boy; and Oofty's cousin, Pookie, who in recent years has stolen the show. It's no wonder, for he's the nicest of all these warm little people. He likes to do such foolish things as, on a boiling hot day, walking round and round repeating, "I won't git outin th' sun." Well, probably he won't; he's got too good a grip on his readers. This is proved by the fact that when Mal Eaton substituted for "Peter Piltdown" a new and quite similar feature, "Tizzy," which now runs in the New York *Herald Tribune*—and like all Eaton's work, is syndicated by that paper—little "Pookie" continued in a color strip all by himself under his own name. He's good. Long may he "pook."

One day in October of 1936, when the writer was passing the comic editor's desk at the Associated Press, he noticed some new strips lying on it. "That's our new comic," the editor explained. "This time we got hold of a comic that is comic," with a somewhat bitter look at the writer. Studying these first drawings of Ralph Fuller's "Oaky Doaks," one got the impression that there was real fun in it, and this impression has deepened as Oaky has solidified his grip on a wide circle of readers.

The theme of "Oaky"—A Yankee in King Arthur's Court—has long been proved an interesting one, and Fuller brings it up to date with refreshing punch. Oaky, an appealing simple-minded peasant, quite unaware of his own strength, started out with a home-made tin suit of armor and chivalry rang with a brand-new note.

Oaky will never live in history because of his mental powers, but he might make the grade because of his enormous chin and jaw structure. It might have been caused by chewing too much tobacco as a child, but it appears to indicate determination, and determination is what Oaky has, whenever knighthood in flower is called on to save some fair damsel . . . the intense red of his blushes sometimes betraying his position to his enemies.

Like most bashful strip heroes, Oaky, because he doesn't like beautiful women, is constantly surrounded by them. When King Arthur was trying to get Oaky to propose to his daughter, the Princess Elaine, he tried to maneuver Oaky by saying that he would give him anything in the world he

© *AP Newsfeatures. Reproduced by permission.*

FIGURE 99. When gags are as well arranged as this, the villains may drop, but reader interest won't. "Oaky Doaks" for September 7, 1946.

wanted. Oaky was a bit bashful, but he finally admitted he would like a new sword.

There are some things about Fuller's art work which may well be recommended to comic art students. Rarely have comic characters been set so solidly in the little theater of the strips. One can tell the exact location of each figure in space, and the perspective is never confused. In spite of a general art approach which gives a certain old-fashioned quality, there is a modern snap to the expressions and gestures; altogether, very good work.

There is another comic-strip artist whose work is very familiar to *New*

326

Yorker readers: Hoff, of the tubby tenement dwellers. Strip fans are glad that Hoff ran away to the wicked, low-down "funnies," for "Tuffy," which appears in the New York *Journal-American* (in the daily comic page only), has a distinctive and artistic style all its own, as well as such funny stuff as the indescribable draping of Poppy's black mustache and the two little marks on top of his roll of stomach. It is the drawing, here, that retains the *New Yorker* touch of artistry; the gags are good, but in the simple style which is familiar to all strip followers.

"Would you finish my homework, poppy, please? I'm going out to get myself another vote for class captain! Little Edith is stuck with her homework and I'm going over to help her!"

This is a strip the writer would select as one to be long with us—that is, among the newer strips. Although Hoff has been doing "Tuffy" some six and a half years, he obtained a New York window only in 1944. This is a King Features strip.

How very American the comic strips are is shown by the fact that of all the strips mentioned so far, all are products of the United States except "Pop." Now comes another exception.

"Patoruzu" (pronounced Pat-o-roo-tsoo) is much more than an amiable bit of explosive burlesque; this Indian is a personage of prestige and importance—he is the South American Popeye. He is a genuine import, and his creator, Quinterno, is a top-ranking South American artist. A casual glance might not reveal the special status of this wild Indian, whose long repulsive nose, dangling in front of a face usually distorted in violent emotion, suggests an evil character. The opposite is the truth.

Promotional material supplied by "Patoruzu's" distributors, the George Matthew Adams Syndicate, explains:

"The Adventures of Patoruzu begin in far-off Argentina, where elders of the Tehuelches tribe witness the coming of age of their new chief, Patoruzu. But his fabulous inheritance of gold, lands, and cattle carries the obligation to win the three tribal feathers; the first by his defense of the oppressed, the second by his power to right wrongs, the third by his humility.

"Patoruzu, bolas swinging from his waist, returns happily to his great pampas ranch. As he descends from his faithful horse, his eyes are caught by the splendor of a giant Clipper plane. Fired by its swift flight, he decides to embark immediately on his adventures.

"The next day finds him in the great city of Buenos Aires. As he jumps from the plane, he notes with satisfaction the good omen of the Clipper's three portholes. Losing no time, he sets out to find one who knows the world and its pitfalls, a partner and a friend.

"Patoruzu turns naïvely for help to the wandering gypsies, just as young

© *King Features Syndicate, Inc. Reproduced by permission.*

FIGURE 100. With such modern strips as "Tuffy," here illustrated, comic art has returned to the gay, conventionalized treatment of earlier days, and to strips complete in themselves.

Renaldo, recently booted from a job, visits these wandering mendicants for counsel on his future. The wise cosmopolite takes Patoruzu under his wing as this Robin Hood of the pampas sets out in strange unfamiliar surroundings."

The full impact of the relationship is not at first apparent. Renaldo, interested only in material things, cheats himself of the truly epic friendship offered him by the Indian. Renaldo sees their relationship simply as a chance to better his own lot.

There is a confusion at times, in the layout of this strip, that makes it a bit difficult to read; the characters, too, have over-burlesqued faces; noses, chins and ears are squashed around with extreme freedom. Yet after a while the character of Patoruzu comes across; you begin to understand what he is doing and you learn the language of his artistic conventions. Then you begin to like him very much. He is one of a great company of heroes who, possessed of great strength and simple mind, travel out to right the wrongs of the world. He is a symbol of democracy, of the power of the people.

Recently Patoruzu and Renaldo were given a magic flute by the chief of a tribe of western North American Indians. The flute has the power of making anyone who hears it do good. When Patoruzu plays a trial trill, Renaldo comes blushing up, his hands full of trinkets: a few little things he had taken from the tribe.

Back in civilization, Renaldo's little meannesses are continually being frustrated by flute playing, and down in hell, the sounds disturb the peaceful rest of the devil. Drawing a cloak around his handsome body, the devil, spats, top hat and all, invades the upper regions. "By *the horns of Satan*, I shall have to travel to the earth and destroy the flute!" This is the kind of basic plot around which good comedy situations can be built.

Patoruzu's relationship to Popeye is not only in the goodness of his nature; it is also in his enormous strength. When fighting a bull, he stands solidly in its path; with a roar the bull has passed, but its horns remain in the Indian's hands. On the next charge the unfortunate bull loses his hide, and looks very pathetic as he tears off naked, except for his black tail.

"Patoruzu" was introduced to American audiences by the New York paper *PM* in August, 1941.

Catching up with the recently introduced funny strips has the curious effect of turning our history inside out; we're really back in the pre-"Mutt and Jeff" days. Some of these new characters remind us of Foxy Grandpa, or Lulu and Leander, or Yens Yensen, Yanitor, and the humor is of the same one-celled type. Quite a few new strips make their initial bows in the color sections, as in the days of the Yellow Kid and Buster Brown, and they tend to drop story-continuity completely. They send their customers away happy

with a complete snack of humor, including introduction of theme, characters and situation, build-up, climax, and a surprise, funny twist at the end. Such strips resemble a very minute play, and this is a useful conception for the strip artist to have in mind while constructing his plot.

"Doc," by Ving Fuller, which was introduced in the New York *Sun* a few years ago, distributed by the Bell Syndicate, is a strip of this type. The general impression is of an old-fashioned doctor with a mop of hair, high collar, and spats. It is interesting to inspect closely most of the heads of this strip: they are slight variations on the great, basic comic convention, or "doodle," originated by Bud Fisher for his immortal Mutt. Draw an egg with the point down. Add, at right angles, a frankfurter for nose, two poached eggs close together for eyes, or perhaps just two dots; slice into egg below frankfurter for the mouth. Add appropriate trimmings, and you can turn this "doodle" into anyone or anything, expressing any emotion. Such a doodle is the foundation of "Smokey Stover," "The Sad Sack," and many others.

A gentle, Foxy Grandpoppian kind of strip is "Herkimer Fuddle" by Eric Ericson, although poor Herkimer lacks the old gentleman's ability to prank back. Starting recently in the Saturday *Journal-American*, syndicated by King Features, this is one of the most attractive of the new comics and it contains a new "doodle" which makes it stand out. Here the egg-head is tilted sideways and the point drawn out to form a nose. With the mouth left out, an interesting new strip personality comes into being. The gag is almost always worth while, even if it lacks the mind-stretching quality.

"Hubert," by Dick Wingert, another King Features strip, also in the Saturday *Journal-American*, is, although only recently introduced, real old-time burlesque. It is sharply drawn, but one wonders whether tubby Hubert's personality will click in the long run. His enormous watermelon nose is repulsive; it would seem—yet, the public does like watermelon.

Several of the other new-timers are built on themes which are considered sure-fire because of the success of certain strips; "Blondie" is a conspicuous pattern. So we have a good-looking version of young married life appearing in *PM* entitled "The Berries," by Carl Grubert. "Ozark Ike," by Ray Gotto, starting in the *Journal-American*, is in the "Li'l Abner" tradition, though with original variations. Replacing the famous "Skippy" in the same paper is Bill MacLean's "Double Trouble," which is more tot-stuff, of a simpler, less sophisticated nature.

Looking back over our review of the strips, it ought to be possible to see a few conclusions raising their inky heads which might benefit new practitioners in the art or those who hope to become so.

Perhaps the most important is that the recent resurgence of the "funny"

FIGURE 101. A new laugh-maker is "Elmo," which Cecil Jensen started in October of 1946, and which appears in New York in *PM*. Jensen's humor has overtones, and his women ... the exact word is "sultry."

strip shows that a gay approach is a basic part of the medium. If you have frustrated laughter piling up inside of you, now is the time to get rid of it in strip form. This isn't easy, unless you are a natural "funny" genius. Yet humor, like everything else, can be studied and developed.

Another thing: home life, never far from the mind and heart of the masses, is back as a major preoccupation, probably because the boys are back with us again, and they all want marriage and kids. It may be that an overdose of pictures of young husbands with aprons will bring a revival of the longing for adventure in far places; but for the present these kids seem to have had all the far places they care about. The point is, that comics, to survive,

must reflect the public's own story very closely, and the wise comic artist studies the current chapter in this story with extreme care.

In artistic quality and appearance, recent strips have boosted the level of the comic page. One of the worst traits of the illustrative school is the tendency to pile up the strips with an amount of detail which makes them almost unreadable. Newsprint pages are gray in general tone; some of the illustrators forget that it is the simple area of black or white that makes a refreshing contrast and attracts the eye. The modern laugh strips make use of this valuable technique: "Travelin' Gus," "Barnaby," "Pop," are only a few in which the blank paper plays a handsome part.

In pure quality, the modern scene can offer an imaginative epic in "Barnaby," which is tops for any period of popular work, and a special satiric quality in "The Sad Sack," an addition as important as any of the finest old-timers. There is no successor, as yet, to "Krazy Kat"; it is in this field of highly artistic fantasy that there seems to be a vacant berth at the very top. This is the kind of thing which no formula can compound.

There exists the possibility, too, that actual beauty and design may play a greater part in this free medium as time goes on. In story strips, where the reader's attention is riveted on the tenseness of the plot, design, unless very unobtrusive, may actually be in the way of the story; but it is not so in the more leisurely laugh-maker, and this is the reason why the most artistic strips are usually the funny ones. Add to this that design usually goes hand in hand with an imaginative, non-factual approach. The highly realistic workers are usually too preoccupied with exactness of detail to worry about good rhythm, good spotting, or good color.

On the whole, our conclusion is that the "funnies" are really funny, after all: a cheerful conclusion. For if, as Lincoln said, all men should be free, it is also true that all men should laugh.

Chapter XX

COMIC BOOKS

W E HAD BETTER ADD comic books to the list of important discoveries made in the world in the last ten years. This hurts many people; it doesn't seem possible that anything so raw, so purely ugly, should be so important. Comic books *are* ugly; it is hard to find anything to admire about their appearance. The paper—it's like using sand in cooking. And the drawing: it's true that these artists are capable in a certain sense; the figures are usually well located in depth, they get across action . . . But there is a soulless emptiness to them, an outrageous vulgarity; and if you do find some that seem, at least, funny and gay, there's the color. Ouch! It seems to be an axiom in the comic-book world that color which screams, shrieks with the strongest possible discord, is good. Even these aspects of comic-book art are mild and dull when contrasted with the essence of it: the layout, the arrangement of ideas; and that goes, too, for the ideas themselves.

Take a typical comic-book cover of World War II days.

Scene, a Jap wireless shack, through whose open door is seen a vessel being dive-bombed and bursting into flames. Which side is that ship on? It isn't obvious. In the foreground a Jap is sending a message under difficulties; he screams, revealing hideous buck-teeth as he sends. A baseball bat swung by a tough youngster has smashed him on the head in a white explosion. Another Jap, with bloody Samurai sword in one hand, spitting gun in the other, has also been socked by a noble, hooded male in brilliant blue. Meanwhile a blood-red blond man is smashing the power plant with elegantly gloved fists—Hey! Look out! There's a green Jap splut-splutting at him with a machine gun! Yes, but see that blond, teen-age girl crouching on the pink table; she's got a blood-red ax; she's coming down on the Jap's head, *or is she?* A hideous, shaven crook is leaning through a porthole aiming a blowgun at her—Yeah, but see that youngster in the blue business suit jabbing a bayoneted rifle at the whole group—*But another Jap is reaching at him!* Ah, but a gorgeous superwoman with blood-red hair and highly stylized harlequin mask, through which peer blood-white eyes is strangling the Jap with one of her delicate arms, as with the other, she—oh, well.

The layout artist, on completing this page, probably looked hopelessly at

it, figured it was a failure. He had used up every inch of available screaming-space, yet, there was no block of ice enclosing a glorious, frozen girl about to be sawed in half by a ghoulish hell-scientist done up in white coat and pince-nez. Possibly the editor, looking at this cover, said to himself, "That layout guy Prangle is slipping. We gotta get *more action.*"

Yet the people who object to these things are always the adults. While they are busy frowning, the kids are busy reading the comic books. The children regard these as *their books.* Some of their simple little arguments are unanswerable. For instance, is there any other book they could buy for *their money*, a dime? Then, to a child, a comic book goes directly at the business of satisfying you in the most sensible possible manner. No long-winded text introductions, the action starts right off—and that's what you want; you want things to happen very fast and, of course, in pictures where you can see it all. The little writing put in hardly detracts from the pictures at all. And then they're in bright, gay colors, not like the silly, gray newspapers the grown-ups read.

Where does this reaction, in terms of growth, stop? It doesn't stop; it slows down. Here are the most reliable available figures:

Between the ages of six and eleven 95 per cent of boys and 91 per cent of girls buy comic books for a steady reading diet. Between twelve and seventeen, the figure falls to 87 per cent of boys and 81 per cent of girls. Between eighteen and thirty, the figure is 41 per cent of men and 28 per cent of women; after thirty, it is down to 16 and 12. But remember, these are steady readers. To estimate the occasionals, add another 13 per cent of men and 10 per cent of women. A startling tribute to the infiltration of the habit among adults was that in the recent war, at the post exchanges, the combined sales of *Life,* the *Reader's Digest,* and the *Saturday Evening Post* were exceeded by comic books by a ratio of ten to one.

It is quite clear that you can laugh at the comic books, but that you can't laugh them off. They are a startling addition to both children's and grown-ups' reading matter with which we all might become better acquainted—if only to understand what our children are looking at. The history of the comic books should help us come to grips with them. First, an important point about the present status of comic books.

We should understand that comic books are not, on the whole, appendages to the world of the newspaper strip, nor are they supported by advertising, like a good many other periodicals. They stand on their own pink and green feet as a separate, unique, publishing accomplishment. How this is possible is indicated by the fact that they have been selling at the rate of forty million a month. Comic books, therefore, are a self-sustaining business, a very profitable and important one.

In their history, the magnitude of such a development was unsuspected for quite a while after the books had appeared. The drama in the story came at precisely that wild and roaring moment when, into the lives of the matter-of-fact business men who were handling the books, burst an unprecedented blast of public demand, millions of voices all screaming at once, "Let 'em come!"

From the beginning, the public liked them and wanted more. Perhaps it was the childish appearance of the book which at first prevented the big executives through whose hands they passed from taking them very seriously. How little they realized, probably, the picture which would be presented by men of their own breed a few years later: the hushed, smooth dignity of the big man's inner office, the paneled walls, the faint reassuring clicking of distant typewriters, the battery of telephones; then the elegant, smooth secretary gliding into the office holding reverently in her hands a pile of—what? Of something screaming in wild contrast against all the smoothness and quiet elegance of the office. And the big man, carefully groomed for his powerful part as one of America's business kings, looks at a book he has picked off the top of the pile, called *Peter Pussycat*, all about roly-poly adventures with a villain named Sammy Skunk.

A picture with a certain element of humor to an outside eye—but it is life itself to the big man. As he looks with kindling eye at *Peter Pussycat*, you can see that he has enjoyed the fierce struggle to get the pussycat born and to keep it alive with the milk of human dimes. The conferences, the lunches, the intent telephoning, the astute estimating of reports, the competition with his equally big and extremely dangerous rival—perhaps it was only some split-second move which saved the Pussycat at all, some play in the interlocking chess game of modern business, all crisscrossed with directorates, brokerships, and people on and behind the scenes, pulling wires and signing lunch checks and keeping the brilliant ink spouting onto the whizzing color-plate rollers at the plant.

The exact date of the origin of this new business is extremely difficult to assign. Early in the century there were groupings of such strips as "Happy Hooligan"; possibly there were others.

In 1911 a little volume appeared which deserves the right to be called the first comic book issued in sizable numbers. It was not *the* modern comic book, however; in size, format, and use, it differed sharply from those we see today. This book was a grouping of "Mutt and Jeff" daily strips; it was eighteen inches wide by six high as compared with the modern dimension of seven and a quarter by ten and a quarter. Another difference was in the paper, which was of good grade. It was bound between gray boards and printed from the zinc plates used by the Chicago *American*.

This book had been thought up as a circulation stunt by Calvin Harris, who was promotion manager of the *American*. The Ball Publishing Company in Boston produced it with the idea that papers which carried Mutt and Jeff could offer it to their public for six coupons clipped from the paper, plus a few cents additional charge. But most of the papers in question were wary of the idea. To get Ball to print it at all, Harris had to place an order for ten thousand copies at a cost of seventeen and one-half cents each. The ten thousand copies arrived a week before the stunt was to be pulled, and they were piled up in the hallway outside of Harris's office.

Then things happened to the first comic book, just as in a comic book.

In the first box, if we imagine the story carried on in the technique we are studying, we find Harris looking at his stack of ten thousand comic books. Black worry clouds hover over his brow. Next box: well dressed Andrew Lawrence alights from a limousine. Carefully counting out a modest tip, the managing director of all the Hearst papers strides vigorously into the *American* office building only to (in the next box) trip over the huge stack of comic books. "What are these things? Who ordered them? What's going on here?" Assuming this was being translated into comic-book technique, the next dramatic incident might be the picture of a man in mid-air, the edge of the door, and Mr. Lawrence's kicking foot. Also a balloon, with Mr. Lawrence's words: " . . . and *stay out!*" Next, the inner sanctum of the *American*.

"But, A. L., it's too late; we've already announced it in the papers!"

Then the day after the sixth coupon was published: Scene (still in our imaginary comic book), the mailing room of the *American*. A wrapper, tying a knot in a bundle of comic books, with relief: "That's the last of the ten thousand! Thank God!" But through the door bursts a not-so-crisp clerk:

"Good Lord, the readers have ordered another thirty-five thousand copies!"

Back to the inner sanctum: "That's the set-up, chief. Disregarding additional circulation, the profits from the comic books amount to a little over $6,000 so far!" Presumably Andrew Lawrence then tilted back in his chair, finger tips touching.

Text: "H'm. See if you can contact Harris."

The last pages of the book, if this was to be in comic book form, would have been devoted to scenes of Harris celebrating. Actually, we do know that he was hired back by Lawrence at a higher salary.

Of course, all the other papers and publishing people caught on. Book after book appeared, until—but it didn't happen that way. This is a curious story. Here was the public panting for comic books, and with its hot breath scorching their necks, the publishers eased off their collars and did nothing about it—that is, until the year 1929. It is true that some other groupings of

well known strips appeared in form similar to the *"Mutt and Jeff"* book, but these again, were not the modern "funny" book.

It is 1929, and now our spotlight falls on George Delacorte of the Dell Publishing Company, one of the key figures of this story. This man's training and peculiar interests fitted him for his "comically" important mission. At Harvard he had burlesqued advertising, while at the same time studying the subject seriously, and shortly after graduation entered the pulp-magazine field as circulation director of a concern which dealt only in pulps, the New Fiction Publishing Company. But Delacorte had ambitions for a publishing house of his own, and he realized these in November, 1941, in company with William Johnston, the New York *World's* former Sunday editor, whose interest he later bought out. The first pulps from the new concern were *Sweetheart Stories* and *Marriage Stories*; others followed rapidly and Dell Publishing Company worked into a major position in the field. At the present time Delacorte publishes some twenty-three magazines and book reprints, with a total monthly sale of about fifty million. He had developed an extremely usable formula: find out what people want to read; put this into books; put the books where people can buy them. In the course of practicing the first point, Delacorte made a number of experiments, naturally not all successful, and it was one of these which we will notice now as an important influence in "funny-book" history.

This experiment was a publication the size of a newspaper tabloid. It was called *The Funnies*, was printed in four colors, and was placed on the news stands independently of any newspaper. It is this separation from newspaper support which makes *The Funnies* so significant. The books spoken of before were, as we have seen, reprints of newspaper strips. This was something else; the comics inside were written and drawn expressly for it, and since this is characteristic of the great mass of modern comic books, we have here a legitimate ancestor of them. But *The Funnies* was not in the comic-book format; it did not look like a book, but like a part of a newspaper from which the main body was missing, and this was probably responsible for its failure, for it ran for thirteen issues and then sank—not, however, without a trace. It had been printed by the Eastern Color Printing Company, of Waterbury, Connecticut, and certain men connected with this company did not forget it. They filed the idea away in their minds. When they took it out again, they made it into the form of the comics seen today, having been given an additional clue from still another direction.

It was 1933. Early in the year several men connected with Eastern Color Company considered the possibility of making comic books in a small format for the purpose of selling them to various manufacturers to be used as premiums. Here, it will be seen, the story turns back to the idea behind

the *Mutt and Jeff* books, to reward the public for its purchase of some other commodity. Probably the failure of the tabloid-size sheet, *The Funnies,* to make its way on the news stands, was responsible for the reversion to the earlier idea. That comic books had some kind of future, however, was quite clear to these men. An interesting technical point arose which pointed a bright-colored finger directly at this future.

Eastern Color had printed some broadsides for the Philadelphia *Ledger* Syndicate, which were reductions of the *Ledger's* Sunday comics. These plates were seven by nine inches, and someone in the print shop, whose name seems to have escaped history, made the comment that two of these would just about fill a tabloid-size page. The point was, that the four-color rotary newspaper presses of Eastern Color were already adapted to print the full-color page or the tabloid size, which is simply the full page folded over. If the tabloid size was folded again, there would be, for one large printed page such as are used in the big Sunday sections, four small pages of a little book which could be slipped into a pocket. These books could therefore be produced very economically and without any basic change in the color presses.

One technical problem that appeared difficult was to have the large sheets come off with the small pages in correct sequence. This was brilliantly solved by Morris Margolis of the Charlton Company, who was called in to do the binding.

There is a fogginess in the story at the point where these men were getting the comic-book format idea together. There are several versions as to who was responsible for what. One version credits Harry Wildenberg and George Janosik, both of Eastern Color, with meeting Harold A. Moore (who was not then with the printing company, but joined it later), and brewing the idea between them. On the other hand, M. C. Gaines, who had an important part in comic-book development, credits Harry Wildenberg as being the man over whose head danced the original inspiration. One thing all agree on: The Eastern Color Printing Company did produce the first comic books of modern type.

The small group of books so produced appeared in 1933 and looked like modern comic books of the milder type, on the outside at least. Inside, it is interesting to find that just as Eastern Color had gone back to the old *Mutt and Jeff* idea of a premium comic book, it had also gone back to the idea of reprinting well known comics instead of having the material specially made. *Funnies on Parade,* for example, reprinted "Joe Palooka," "Mutt and Jeff," "Hairbreadth Harry," "Keeping Up with the Joneses," and "Connie," and the other books, such as *Famous Funnies, Century of Comics,* and The Hecht Company's *Toy Land Funnies,* also followed the reprint pattern.

Some of the users of these books were Procter & Gamble, Kinney Shoe Company, John Wanamaker, Canada Dry, Wheatena, and Milk-o-Malt.

While this was the true start of the whole funny-book saga, there was a conspicuous absence of whoop and hurrah about it; it was only a mild reflection of the well established newspaper-strip reading habit. The books were printed in fair quantity, usually from 100,000 to 250,000, and were apparently well received, but the public had no chance to say anything with its own dimes. Yet, the possibility of news stand sale, if dormant, was not entirely dead; it was due for a revival.

During the premium-book period, M. C. Gaines had become connected with Harry Wildenberg, as salesman for the premium books. He tells an interesting story. He had been impressed, he says, with the public reaction to the comic books, and he, for one, did not see why they should not be sold directly over the news stands. Determined to test public reaction, he took several dozen of the premium-books labeled *Famous Funnies*, pasted a sticker which read Ten Cents on them, and induced a couple of news stands to carry them over the week end. Every one was sold out when he visited the stands Monday morning.

Now Eastern Color was an organization of printers; they had no magazine-publishing experience. Therefore, when the plan of trying out direct sales of "funny" books was decided upon, they approached Dell Publishing Company, the same organization which had produced *The Funnies*. Delacorte was sufficiently interested to agree to produce thirty-five thousand of the books, and to release them through the big chain stores; he was, apparently, even then, wary of the news stands. So there came into being a new book called *Famous Funnies*, which had been chosen as the most interesting of the premium-book titles. We are getting very warm now, but even this is *still* not our modern product, for it is a single book in itself, not a magazine. It was a kind of trial of the whole idea of direct sales to the public, and the printing sold out almost at once.

Again there comes into the story the curious and ironic note we noticed before. These astute and clever business men had in their hands a million-dollar idea, yet most of them failed to realize it. Several of these organizations picked up the idea, played with it dispiritedly for a while, then got out. The joke of it was that the books always sold out; always made a hit when they came into contact with the public. Apparently the pessimism came from the reports of experts. For example, Dell Publishing Company got this report from a survey of advertisers, whom they were hoping would support them in the venture. There were two chief objections to the books:

1. The paper was bad; it had no connection with regular printing.
2. The books were reprints; something the public had already seen.

Now we are in the winter of 1933–1934. George Delacorte of Dell Publishing Company was in Florida. Having just received the above report, he was gloomy about the whole venture. He was in a key position, for he held the option to the title and format of *Famous Funnies*. Janosik, of Eastern Color, looked him up and urged that they try to sell the news stands on the idea. They returned to New York, but the American News Company, which controlled the news stands, turned the project down.

Then something happened which changed the picture. The New York *Daily News* came out with a page advertisement crediting much of the success of its Sunday edition to the "funny" sheets. New York looked more seriously at the silly little "funnies" after that. According to one version of this story, it was Harold A. Moore who realized the dynamite in this advertisement.

That morning, as he tells it, on the train from Westchester County, he opened his copy of the *Times*—and was hit between his comics-conscious eyes by the *Daily News* advertisement. Believing, like Gaines, in the direct sales possibilities of the comic books, he knew what to do right away: wave it in front of the obstinate American News Company. Harry Gould, president of American News, read the advertisement thoughtfully. "I'll give you a ring," he told Moore. When he did, a few days later, it was to tell Moore that he was prepared to sign a contract for 250,000 copies of a comic magazine.

It seems very strange that even this success did not dispel the disfavor with which the owners of the lusty comic-book infant regarded their promising child. George Delacorte, with all his sense of what the public wanted, decided against comic books and released his option to the Eastern Color Printing Company, which then went ahead and produced what was undoubtedly the first comic magazine.

This book, which we illustrate, called *Famous Funnies*, with the cover marked No. 1, appeared in May, 1934, still using reprinted comics inside. It was not a sensational success at first. The initial issue lost $4150.60; but the figures moved steadily out of the red, and the seventh book cleared $2,664.25. Very cheering, indeed— Whoops, no, we're still in the wet-blanket stage of the story. Janosik, of Eastern Color, was hardly more enthusiastic than Delacorte had been. Neither of these men seemed to see into the future.

There were several others, however, who did. One was M. C. Gaines, who had given up his connection with Harry Wildenberg of Eastern Color and was preparing to go places on his own. Gaines had an idea; he had been studying the sensational popularity of the famous strip "Skippy," which in 1934 had just gone on the air. Gaines saw "Skippy's" sponsors and sold them

FIGURE 102. This is the cover of—not the first comic book, but the first American comic magazine in modern format to be placed on newsstands for sale, independently of newspapers or premium connections. It appeared in May, 1934.

341

the idea of getting out a *Skippy* comic book, one to be given to each kid who bought a tube of Phillips' Dental Magnesia. The comic-book idea was warming up, for this was a half-million copy job and, incidentally, the first comic reprint book in four colors to be devoted entirely to one character.

Still another precedent was set early in 1935 by Major Malcolm Wheeler Nicholson, who came out with a four-color sixty-four-page magazine called *New Fun*. The Major had gone back to the 1929 idea of *The Funnies*, for the contents of *New Fun* were original material. (It should be recorded here that original art work had appeared in a one-color book called *Detective Dan*, in 1933.) *New Fun*, as a title, was shortly changed to *More Fun*, and Major Nicholson added another magazine, *New Adventure Comics*. This group of magazines, with their original art and writing, started a very important trend in comic-book history—we shall shortly see how it became the central one. But the Major's magazines did not shatter the world at first. For a time, with Eastern Color's *Famous Funnies*, they occupied the field alone; yet, even as early as 1935, it had become evident that there was an unlimited demand for the little books. The comic-book volcano was distinctly rumbling. Just prior to the great eruption, a dramatic reversal took place; this time Janosik of Eastern Color Printing lost interest in the books, possibly because of ill health. He continued with *Famous Funnies*, but he could not be persuaded to go further. And it was George Delacorte of Dell Publishing who, this time, was the enthusiast. He was awake to the new trend now, and in the fall of 1935 he arranged with the American News Company for distribution of a new magazine, *Popular Comics*. This was produced for Delacorte to publish by M. C. Gaines, who by this time was connected with the McClure Syndicate.

Now things began to happen fast. In 1936 United Features came out with *Tip Top Comics*; likewise, the wise McKay Company of Philadelphia brought out *King Comics*, for they had made a deal with Hearst to reprint King Features Comics.

Smoke definitely started to pour out of the comic-book volcano the next year. Major Nicholson had sold out to Harry Donnenfeld. The new owner of *More Fun* now took the significant step of starting a comic book with a definite editorial policy—that is, a book devoted to one particular subject. This book, *Detective Comics*, starting January, 1937, looked and felt different from the others. It marked the beginning of the time when the comic books were to leave the newspaper strips and start something bold and sensational of their own.

At the same time a tendency was working its way up through the newspaper strips that was ready-made for the comic books: startling, incredible, fascinating, horrifying—everything that could grab, grip, chill, thrill, and

sell you! It was the world of the incredible, the strips which we looked at in Chapter XVI, "The Star-Startled Manner." These newspaper stars, however, were to be written off as sissies by the new hero of the comic books, who was to lift the whole comic-book industry in his immense arms and blow it into an extravaganza new to publishing, new to America, and new to the world. It wasn't a bird, it wasn't a bee, it was *Superman!*

In Chapter XVI, we told the story of the bleak years spent by Superman's creators, Jerry Siegel and Joe Schuster, while their strip went crisscrossing through the country's post offices in search of sympathetic editors. These turned out to be two producers of comic books., J. S. Liebowitz and Harry Donnenfeld, who shared, with the others we have mentioned, in the shaping of the early history of the comic books. *Superman* first appeared in June, 1938, in the first issue of *Action Comics.*

M. C. Gaines tells of first seeing *Superman* when he was getting out *Popular Comics* for the Dell Publishing Company several years before. He turned it down, but in December, 1937, he says, while still working with McClure Syndicate, he wrote Siegel and asked for the material again. He had an idea of using it in a weekly tabloid, but this idea was also dropped. Then the publishers of *Detective Comics,* which Gaines had been printing, decided to bring out another book, named *Action Comics.* They queried Gaines on what material he had available, and he suggested *Superman.* At long last the man of steel had penetrated the soft but deceptive surface of pulp paper.

In January, 1939, the McClure Syndicate began syndication of "Superman" in the daily newspapers, but it was in the comic books that this young bullet-head performed his most remarkable publishing wonders. He could literally be said to have turned the comic-book world upside down. No longer was it to be a cozy little business where one took a pair of shears and put old, used newspaper comics together; it was to require staffs of highly trained, specialized artists, writers and research men whose mission and aim was to shock, to outdo, to dazzle. *Superman* went to work at once to produce this change.

Within a few months, the circulation of *Action Comics* was doubled; in May, 1939, appeared *Superman Quarterly Magazine.* With Superman a radio star as of February 12, 1940, and with his appearance in the movies, the whole super idea roared into the sky; book after book came out with imitations; a legend of super people grew to such vast extent that it seemed as if American kids were thinking of little else. The entire appearance of the comic books was affected. You had to do wild things in this super battle; get the most lurid colors together, boys; exaggerate that perspective, Mac; make it *scream!*

The top of the comic-book volcano had blown off. The books shot up into the air and landed on the news stands by the hundreds. The actual figures are: in 1939-1940, sixty; in 1941, one hundred and sixty-eight. An amazing number of these were imitations of *Superman,* and there were all sorts of other lurid people: Batmen, hooded men, hooded girls, super twins, wonder women, anything and anybody that could shock or thrill. The very names of the books, now produced by many companies, gives the flavor of a lurid publishing era such as we are not likely to see again, and a few of which, selected at random, we quote: *Sensation, Star, Green Lantern, Batman, All Flash, Bullet Man, Captain Marvel, The Human Torch.*

The kids were now dreaming in terms of flaming humans and star-studded superboys, and so perhaps little noticed a poignant moment in the affairs of the publishing world which was devoted to their interests: *St. Nicholas,* the *Youth's Companion,* and the *American Boy* folded their honorable pages and went to rest, apparently unable to meet the new conditions. Many readers of these magazines were now to be seen with comic books in their hands.

Of course, World War II provided a most natural habitat for these super people to whip around in. Jap and Nazi spies were roped in by the thousands as the super men tore around America, cleaning it up.

Naturally the paper situation during the war was a difficult thing for comic books. They weathered the storm, however, amazingly well. Figures compiled in the summer of 1942 show that the volume of comic books published had fallen from the peak in 1940 of 168 to about 100, but the circulation, which was about 150,000,000 a year, or 12,000,000 to 15,000,000 a month, had not dropped. The annual revenue was $15,000,000, of which about 75 per cent came from the children's own purchasing. Readers per month (four to each magazine) totaled 50,000,000—not a bad public at all. During this time a trend countering the extreme and the lurid was being set in operation. The story is part of comic-book history, and this tide shows every sign of affecting that history in the future. It was quite natural that educators, clergymen, thinkers, parents, should resent the comic book's violent challenge to the quieter reading matter to which they were accustomed. Sterling North in the Chicago *Daily News* on May 8, 1940, did much to bring such objections to a head. He labeled the comic book "a poisonous mushroom growth." North's criticism applied much more to the comic book than to the newspaper strip, and this distinction will be found in most fulminations directed against the comics.

Critics of the comic books, however, found that their thunder was without much notice by the public, and especially without any notice by

the children, whose millions of noses remained buried in the books as before. Rather regretfully, perhaps, the more thoughtful of these critics decided that the books were here to stay, and so they had better get into the business and try to improve them. If the present form had to be accepted, perhaps the content could have some value to the millions of young people who had deserted other forms of reading matter.

This movement is still under way, still in its infancy. Even in its short span of a few years, however, the history of useful comic books presents a most brilliant spot in the whole story of the comics. If the welfare of man has any importance, any value, surely this budding way of reaching people at their most formative period is of first importance from the educative viewpoint. Not all people, of course, like to see comics used in this manner. The viewpoint of such people was summed up well in an editorial in the Burlington, Vermont, *Daily News*:

"Every once in a while this paper gets literature promoting 'wholesome' magazine comics to wean the younger idea away from the lurid picture magazines portraying murder, mayhem, thievery, conspiracy, intrigue, cannibalism, barratry, malfeasance, nonfeasance, and felonious assault.

"The promoters would like to have us say something pretty about the 'wholesome' magazines, which offer the lives of 'real' heroes supposedly as laden with deeds of inspiration and derring-do as the best efforts of Superman.

"Somehow we don't react. This writer in his brattish days grew fat on a diet of scalps, knives in the back, Indians biting the dust, blood-curdling screams at midnight, slinking and sinister Chinamen, haunted houses a-clank with chains, and all the other paraphernalia of the old-time thriller, which certainly needs take no back seat for Buck Rogers or the Phantom.

"The leading sequence in the current 'wholesome' offering is a pictorial life of Franklin D. Roosevelt. We have a good deal of respect for F. D., but Mr. Roosevelt can't leap a thousand feet into the air and bring down a warplane with his bare fists. Superman can."

The people who were opposing this kind of argument did not deny its forcefulness; for it is certainly true that blood and thunder had been children's diet long before the comic book appeared. But they replied that the present world was the sad result of this kind of diet, whether given by comic books or not. Perhaps, they argued, if less horror and violence were given to children, the children would not come to regard horror and violence as a natural part of living. The criticism levelled at the comic books was also aimed at the movies, which were steadily piling on the sadism, at the same time that crime was increasing.

The leader in this field is Parents' Institute, which started *True Comics*

in 1941. The publisher, George J. Hecht, thus sums up his attitude in producing it:

"We believed that by offering comic readers a magazine that looked like the others, but was informational as well as entertaining, we could fight fire with fire. In other words, parents and teachers can offer this new comic, made up of stories from history and current events, as a substitute for the less desirable comics. Psychologically, such substitution is better than a prohibition of all comics while they are so very popular." *True Comics* carefully avoids the pedantic approach. "Give children, in the format they like, what they ought to get, without preaching."

Such is their editorial policy, as set forth by the editorial director of Parents' Institute, Elliott Caplin.

In addition to true adventure stories, *True Comics* has produced some of the best work in that tremendous field open to comic art, that of using the medium to further our national ideal of tolerance and justice to all people, regardless of race. "They Got the Blame" was the story of the scapegoats of history, races of men who had been kicked around for no fault of their own. This as well as "There Are No Master Races" (from the Public Affairs pamphlet "The Races of Mankind"), first appeared in *True Comics*.

It should be noted here, however, that a number of comic-book publishing groups cooperated helpfully in the war and the issues involved. National Comics Publications published in the comic book, *Comic Cavalcade*, "The Twain Shall Meet," which argued for tolerance between races. The East and West Association, of which Pearl Buck is president, cooperated. The same company produced a wanderer through the ages, the Hawkman, who points the moral of justice to all. *The Master Comics*, published by Fawcett with the cooperation of the Writers' War Board, have shown Negroes working with whites on equal terms, which, the various progressive groups feel, is the best way to approach this problem.

Other important groups, in addition to the publishers, have been discovering the unique appeal of comic books and have begun using it. The educational department of the CIO brought out a series of strips and a comic booklet, *With Victory*, and helped spread the book *Scapegoats of History*, attacking race prejudice. "We find," that department stated, "that information presented in this form makes a more popular appeal than the same facts presented in pamphlet form, as is evidenced by the 1,000,000 distribution of a comic strip, as compared to the 125,000 distribution of our most popular pamphlet."

During the war, the United States Government used the comic-book form to carry the message of its ideology to far places on the earth. It was this writer's privilege to work on one such job, and he will never forget the

peculiar feeling, the thrill, of seeing a comic book printed with Chinese characters. It seemed, in a way, as if one were looking from Columbus's ship, through a telescope, at the looming shores of the New World. For, while these characters meant nothing at all to the writer, the pictures told the story very clearly in its large aspects; and it gave him the sudden sense of a medium of communication which is common to every man on earth, the medium of the picture, here used for the purpose of binding the world's peoples together. How this tremendous use of comic books will be developed remains to be ticked out on history's teletype, but that it will, seems so certain that when you pick up one of these ugly little books you may be sure you are looking at the crude ancestor of something great.

Another very striking development has been supplied by one of the men most responsible for the development of the comic book, M. C. Gaines. There is a decided touch of drama in his story. He edited and produced a number of comic books, among them some of the most sensational. But before entering this field he had been a schoolteacher. In the end, the schoolteacher won out; he could not but sense the enormous possibilities of the new medium, and he sold his interest in the older type books and began producing comic books which could be used in schools. Perhaps his most startling contribution is *Picture Stories from the Bible,* a 232-page book priced at fifty cents, which is strictly in the comic-book technique, yet with sensationalism left out. At first, there was much protest, but 800,000 copies of this book were sold in the first two years, and it became evident that the churches were accepting it, quite gracefully, many of them. Other books produced by this group deal with history and science. Both in Gaines's case and in that of *True Comics,* it has been proved that children will accept and read stories with educative meaning, if dressed in the form they have come to love.

These educational comic books have been produced with care and thought. For example, Gaines has produced a teacher's manual to go with *Picture Stories from American History,* one copy of which is supplied free to all teachers who have ordered a quantity of the books to use in their classrooms. This was written by Dr. W. W. D. Sones, Professor of Education, University of Pittsburgh, and Katherine H. Hutchinson of the Falk School of that institution. It contains highly practical suggestions for supplementing the comic books by maps and globes, by developing a "time scale" on the blackboard which will locate the events, constructing sand tables and so on. Each story is accompanied by such useful material.

Many people, of course, will feel that the quality of literature which young people receive through the comic books is going to kill their taste for good reading. There may be truth in this, but tests made do not seem to

show that the kind of children who will be the ones to understand good writing will have suffered any damage by reading comic books while young. There seems to be no doubt that less intelligent children make acquaintance with literature and history faster through the comic medium than without it. These questions, however, remain to be settled more thoroughly by exhaustive research.

Yet it is quite true that the tremendous poetic value—to speak of only one—of our heritage of literature has not been developed in this new medium to any extent. Perhaps it will be a child who one day will make a childishly simple suggestion, "Then why not write the great poetry right in our comic books?" Well, why not?

One reaction to the tons of criticism which have been heaped on comic books was supplied by the publishers of the ones most under fire. It consisted of getting together boards of prominent educators and experts, who study the material before it is published, and pass on the suitability of such for childish minds. We find the prominent and powerful National Comics Group, publishers of *Superman, Batman,* and *Wonder Woman,* among others, with a board composed of Lauretta Bender, Associate Professor of Psychiatry, School of Medicine, New York University; Pearl S. Buck, well known writer; Josette Frank, Consultant on Children's Reading, Child Study Association of America; Dr. C. Bowie Millikan of New York University; Dr. W. W. D. Sones of the University of Pittsburgh; Dr. Robert Thorndyke of Columbia University, and Gene Tunney. The Fawcett Advisory Educational Board has a similarly brilliant roster.

The use of these boards has been criticized in some quarters on the ground that they make a distinguished excuse for a very cheap product, and that since these people are connected with the magazines, their investigations are necessarily one-sided. Champions of the boards reply that the standing of the individuals involved, most of whom are connected with large colleges or study organizations, is a guarantee of good faith. The point is, they go on, these experts realize that comic books are a part of American life, and they intend to do their best to see the scientific approach applied to them. It is interesting that all of them agree to the need of a child for imaginative reading matter and for fantasy.

Dr. Lauretta Bender, for example, has pointed out that children read comics because of the need for experimenting with reality and its problems. In his own life, she says, a child cannot have the opportunity to meet any but a few of such problems; in his fantasy life, using such symbols as comics present, he may meet and adjust to a wide variety of the world's trials and difficulties. Children's fantasies she therefore regards, not as an escape from reality, but as a constructive approach to it.

The points of view of these pro-comics experts are gathered together in the December, 1944, issue of the *Journal of Educational Sociology*—given over to an examination of comic strips and comic books.

A survey which was made in 1946 showed a comic book circulation of about forty million a month, an all-time record. Their format is forty-eight color pages, seven by ten inches. The leading publishing groups from standpoint of circulation are: Superman D.C. Comics (known as National Comics Group), Fawcett Comics, Parents' Institute, Timely Comics, Dell Publishing Company, Street & Smith, Famous Funnies, Quality Comics, United Features, and Educational Comics. There are a number of other smaller groups which produce from one to five books, and these produce about half the total number of books; but the larger publishers control approximately five-eighths of the forty million.

There are approximately one hundred and fifty comic books which jam red-and-blue elbows together on the news stands, fighting for space to shriek in, and this factor may keep the number from expanding to any great extent. Mortality is high among new comic books; the business is now highly organized and very technical. An example of this is the way in which they are produced; they have staffs of artists and writers who function as specialists, each performing one step to speed the finished book to the color printer. A writer pounds out the story, his typewriter ribbon dripping; then an editor tears it apart. The writer starts again; it goes to a layout man, who pencils in the full horror of it; then to the editor again, and so to the inking artists. The color is the work of certain specialists in the printing plant, who have very individual ideas.

Apropos of color in comic books: this is certainly one of the things most objectionable in them to the sensitive eye. Yet there is a technical reason for the use of the raw primaries. These books are printed at great speed, from 20,000 to 22,000 sheets come off the rollers an hour. The problem is to have the ink dry at a speed to prevent smearing, and this is possible only if a thin layer of color is transferred to the paper. Deep, subtle colors would require one ink over the other and this pile-up would not dry fast enough—at least not with present techniques. Harold A. Moore of Eastern Color Printing Company, an expert on this subject, predicts that within the next decade this problem will be solved by the makers of the inks who have been experimenting for some time. Quite understandably, this progress was held up by the war.

The comic-book field is quite naturally one to which the young artist turns, usually with the shining goal of a syndicated newspaper strip of his own to spur him on. It is one which develops great self-discipline and in which one is forced to acquire a control of line and a sizzling speed, which

often does lead to bigger things later. The art work on those books which make their own is not paid at a rate to compete with the salaries of the newspaper artists. These comic-book men have, often, no by-line or individual recognition. They are usually paid by the page, at $15 or $20 per page, and therefore a man's salary depends on the speed of his hand. Strong lines are requisite to enclose the color areas—vague, sketchy drawings won't do—and for this reason a comic-book artist does develop definite ability. A thing that is hard on the more creative of these artists is the rigid groove of style they must set their work in. There are a few acceptable modes, such as the Disney animal and the realistic, flashy type, but one sees very little else, a condition which tends to hold down the level of artistic output. There are still quite a few comic books which cling to the first idea of using reprint material, and here the artist has a less hectic role; he adapts old Sunday pages to the book size, often relettering them at home, with his little radio comfortably spouting baseball games in the corner.

Comic books differ sharply from most other publications in that they use only a small amount of advertising. Most of them limit advertising to the back cover, the inside back and front covers, the last page facing the inside back cover, and the breaks between stories. Advertising people, however, regard the possibilities here as important. Brand names can be very efficiently stamped, almost branded, into fresh young minds.

Our history of the comic books is nearly complete, but there is one last turn to be noted. It is a happy and cheerful one. For, in spite of all the learned arguments of those college professors who endorse the lurid form of the comic book, the great mass of American people have been getting thoroughly annoyed at the alarming mass of cheap sensationalism their children have been buried under. These human torches and hornet men seem to have little connection with the sound values which the American people, generally speaking, strive for; and it seems that the people, in a number of ways, have been gradually making this clear to the publishers.

An example of the thing so many people object to, for instance, is the army of hooded and masked men, women, boys, and even girls, who were threatening to push the normal heroes off the stands. Why, in the name of a free republic, is all this hooding necessary? True, these people are always on the side of right, of democracy; but democracy's justice does not need to mask itself. From the picture point of view—and this means a great deal in comics—such hooded people suggest the Ku Klux Klan more than anything else, the very reverse of the process of democratic law. Protests of many kinds, from many sources, have poured in, to the point where at last a change is taking place; the furious sensationalism of the super-people is not as popular as it was. A new and healthier trend is on the way. The big

news of the moment is not the emergence of a new supercreature; it is the growing popularity of the gay, animal comic book of the general Walt Disney type, and the various titles devoted to teen-age interests.

These tendencies should silence most of the criticism. Teen-age comics are very normal and healthy as a rule. In addition, the animal group can develop fantasy, can supply that experimental adjustment to life through childish symbols, which the educators advise as good for the young mind.

Another happy point—these are funny books; the super-screamers were not. And to laugh is one of our greatest national habits, one of our finest talents. Bob Hope tells of the tidal wave of humor he found washing over the world with the spread of the American forces; he quotes a simple but satisfying example. He asked a soldier on beach patrol in the hell-hole of Attu if he had to walk very much. "I don't know; but when I enlisted, I had feet."

Quite possibly, as we have seen, comic books may emerge as the most natural, the most influential form of teaching known to man. They may jump boundaries of language; they may help to bind a broken world together. Yet, admitting the value of such contributions, surely they would be justified if only to keep alive our priceless national art of laughter. For if they do this, they will swing back into the great tradition, they will become a happy chapter in the whole, gay story of the comics.

EPILOGUE

COMIC STRIPS are read by 83 per cent of male newspaper readers, by 79 per cent of women readers. Two-thirds of all children over six follow the daily "funnies," and about 40,000,000 people, all told, use the Sunday sections for their fun. Lumping dailies and Sundays together, they have roughly an audience of 70,000,000, which means that over half the people in the United States are steady readers. Statistics on the comic books, in the last chapter, show with the same clarity America's passion for its new entertainment.

To get a perspective on comics which will give us at least some idea of their future, let us summarize their history in brief.

1896. Comics began because modern newspapers had begun to cater to the great mass of people, and had discovered the public's love of pictures, rather than words. Comics were aimed, at first, at the kids.

1910. Then the parents, reading surreptitiously over the kids' shoulders, began to find themselves grinning back from comic pages. It was a humorous and sarcastic picture of American suburban life, yet a picture of a prosperous period, which was presented. Remember that these first readers were people connected with cities, and with such interests as golf, fishing, and marriage spats.

About 1915, the development of nation-wide syndication began to carry the comics to the small towns, to the villages. The general form of the "funnies" remained unchanged: they were largely humor, largely pictures of family life; there were few continued stories.

In 1929 came "Tarzan" and "Buck Rogers" and an abrupt change: illustrated suspense stories soon occupied one-half the space given to comics.

In 1933 came the comic book, and while it swamped the nation with sensationalism, it became gradually clear that here was one of the most remarkable educational potentials yet discovered in man's history.

With World War II grew a preoccupation with grim reality in comic strips. High-lighted by "Terry and the Pirates" was an era of sophistication; the strips also absorbed the amazingly popular form of the radio soap opera. Laughter sank to a record low. People went about saying that the "funnies" would never be their cheerful selves again.

Almost at once, after V-E Day, another change became evident. People

wanted laughter again—and they got it. New strips burst out, nearly all of the old-fashioned gag type. The old form, it seemed, was still loved by most of the people. Another striking development was the emergence of Bobby Sox comics, which (to some people's surprise) showed a very steady and reasonable side of life, and some of the least lurid and soundest art work the strips have had on display.

There are several self-evident conclusions to be drawn from these high lights, which should enable us to plot the section, at least, of a curve which can be projected forward, which will help us to grope in the mist of the future and to find out where, "comically" speaking, we are headed.

(1) People read comics because they find themselves reflected in them.

(2) Once the comics, by national syndication, became the possession of the greatest part of the American people, it became clear that their history was to be a gay reflection of the people's history. An important reservation must be made, however, before we credit comic strips with too great veracity as faithful mirrors of social events. By their presentation, because they are put out by large and powerful groups, which generally have the corporation point of view, certain very vital social aspects of our day are taboo; hence the picture presented by the comics is, in some ways, a distorted one. For example, hundreds of thousands of American families' lives center around trade unions, but we will rarely find the word "union" appearing in the strips. It belongs to that group of ideas called "controversial," and generally ruled out by the syndicates. The same thing is true of religious interests and occupations, and politics.

(3) We can expect strips, therefore, to follow closely popular preoccupations in the future—even if we may not discern in them all pressures and strains which will shape that future.

(4) As we have already seen in our fifty years of history, popular interests change suddenly and very unexpectedly. We can look forward, it seems, to many more changes.

(5) Allowing for these, however, it seems that the original, uproarious gag strip, the type of the old masters, will remain and flourish; for here the medium is most itself and performs its most native function.

Side-stepping for a moment the principal fact, that the strips are successful because they are popular entertainment, is any artistic and literary development possible? The answer is *yes*. We have suggested that true literature and poetry may materialize in comic books. It is entirely conceivable that with a mellowing civilization higher standards in the arts may affect comic strips. The harsh, painful colors may pull into harmony; the rich possibilities of black and white may appeal to some artist gifted with the sense of design, and he may make a dent in the public mind, may

set a new and more beautiful style. The reason that this is possible brings up a point in the structure of strip business that people often forget.

Strips and comic books are not true folk art. You can call them "folksy" perhaps, in the sense that the "folks" certainly do pass, every day, on their right to survive, do make choices and indicate favorites. But the people do not create them. The strips are of the people and for the people, but they are not by the people. They are written and drawn by individuals with individual ideas, or by small groups with small-group ideas. The public can pass only on the ideas which are presented to them—and the public taste is startling, sometimes. No one can guess it, exactly. Who knows, therefore, to what new idea it might take? It will be seen that the real initiators of the new trends are the artists and writers themselves. This is why the new medium presents such a challenge to American artists and American authors. In few other mediums can these creative people come so close to the tides which creep up and down history. Through the strips they may have their part in this history; they may help to mold it. Gradually, perhaps, these people will begin to perceive something that will give them a pride in working with comic strips; will make them realize that they are identified with the future.

For in the old days the artists and writers and craftsmen were not writing at the behest of the people, but to please small powerful groups, the kings and lords and chieftains, who drew the talent of the time inward towards them and kept it circumscribed within the bounds of their castles and baronies. Much of the fine art of today remains alive only through a similar connection.

Yet, taking civilization as a whole, this ancient process is now in reverse. There is an outward movement. Pictures, entertainment, fun, are beginning to be seen as the rightful possession of all, and the comics join in and reflect this spreading democratization. And if the people's standards are at present lower than those which were set by workers around the seats of the mighty, the people's artists will have the satisfaction of knowing that they are identified with a vast and forward movement, which is giving to everyday folks their right to laugh and flourish under the sun.

INDEX

"A. Piker Clerk," 27–28
"Abbie an' Slats," 218
"Abie the Agent," 65–66
"Ace Drummond," 226
Action Comics, 256, 343
Adams, Franklin P., 168
"Adventures of Patsy," 128
Ahearn, Eugene L., 171–73
Alan, Jay, 146
"Alec the Great," 130
Allen, Bob, 298
Allen, Dale, 301
"Alley Oop," 169, 186
Alice in Cartoonland, 160
"Alma and Oliver," 46–47
"Alphonse and Gaston," 36–37
"Ambassador, The," 323
American Boy, 344
American Humorist, 6, 10–11, 22
American Weekly, 144
"And Her Name Was Maud," 22, 36–39
Anderson, Carl, 125–27
Anderson, Harold, 296
Andriola, Alfred, 295–96
Anthony, Edward, 154
All Flash, 344

Bailey, Ray, 30–33
Baker, George, 31, 312–15
Baltimore *News-Post*, 35
"Banana Oil," 50
"Barnaby," 63, 152, 155, 167, 237, 306–10
"Barney Baxter," 219–20
"Barney Google," 51–54, 56, 226
"Barney Google and Snuffy Smith," 54–56
Barton, Ralph, 145

Batman, 263, 344, 348
"Batman and Robin," 262–63
Batsford, 126
"Beautiful Babs," 101
Bellows, George, 7
Bender, Dr. Lauretta, 348
"Benny," 169, 183–84
Berndt, Walter, 85–86
Beroth, Leon A., 227–29
"Berries, The," 330
"Betty," 120, 139, 149
"Betty Boop," 141
"Big Ben," 93
"Big Chief Wahoo," 235–36
Biggers, Earl Derr, 295
Block, Rudolph, 11
"Blondie," 47, 100–04, 108, 150, 200, 225–26, 251, 330
Bloomington *Sun Eye*, 88
Blosser, Merrill, 180–82
"Bobby Sox," 150, 318
"Bobby Thatcher," 169
"Boob McNutt," 49
"Book Taught Bilkins," 23
"Boots and Her Buddies," 100, 141, 150, 169, 173–75
Boston *Globe*, 34, 150, 241
Boston *Record*, 35
Branner, Martin Michael (Mike), 91–92
"Brick Bradford," 254–55
"Bridge," 76
Briggs, Austin, 296
Briggs, Clare, 27–28, 69–74, 79, 109, 118–19, 229
"Bringing Up Father," 40, 47–49, 106, 112, 226, facing 304
Brinkerhoff, Robert M., 184
Brisbane, Arthur, 65

355

Brother Jonathan, 3
Broun, Heywood, 168
"Bruce Gentry," 303
"Brutus," 236
"Buck Nix," 29, 88
"Buck Rogers," 224, 248–52, 345
"Bug House Fables," 54
Bullet Man, 344
"Bungle Family, The," 110–11, 169, 226
Burroughs, Edgar Rice, 221–22, 290
Burvik, Mabel Odin, 214, 241
Busch, Wilhelm, 11
Bushmiller, Ernie, 137–39
"Buster Brown," 8–9, 16, 18, 22, 115, 123, 152, 193, 329
"Buz Sawyer," 179–80, 296
Byrnes, Gene, 115–16

Cady, Harrison, 152
Calkins, Dick, 249–50
Caniff, Milton, 9, 29, 119, 140–47, 190–91, 213, 264–69, 271–72, facing 272, 274–77, 278, 282–83, 293, 303
"Can You Beat It," 169
"Cap Stubbs and Tippie," 125, 129–32, 317
Caplin, Elliott, 346
Capone, Al, 203–07
Capp, Al, 203–07
"Captain and the Kids, The," 43–44, 114
Captain Marvel, 344
"Captain Yank," 231
Carlin, George A., 222
Carlson, W.A., 109
Carpenter, John Alden, 59
Carr, Gene, 21
Carroll, Ruth, 154
Carter, A., 116–17
"Cat Who Walked, The," 155
Century of Comics, 338
Champs, Bill, 146
Chaplin, Charlie, 50, 57, 163, 184
"Charlie Chan," 295
"Charlie Chaplin's Comic Capers," 193

Chicago *American*, 27, 94, 193, 217, 335–36
Chicago *American and Examiner*, 72, 96
Chicago *Daily News*, 27, 74, 116, 344
Chicago *Evening Post*, 120, 193
Chicago *Herald-Examiner*, 72, 96
Chicago *Inter-Ocean*, 74
Chicago *Record Herald*, 227
Chicago *Sun*, 34, 276
Chicago *Tribune*, 23, 72, 80–81, 88, 94, 96, 109, 118, 143, 158, 218, 229, 265, 301, 315–16
Christian Science Monitor, 7
Christman, Bert, 291–92
Churchill, Winston, 207
"Cicero's Cat," 26, 33, 154
"Cicero's Sap," 111–12, 169
Cincinnati *Post*, 74
Circus, The, 50
"Claire Voyant," 298–300
"Clarence," 105–06
Clark, Virginia, 146, 241
Cochran, Colonel Philip G., 274
"Colfeeto, the Monk," 40
College Humor, 147
Collier's, 295, 310
"Colonel Potterby," 305
Columbus *Dispatch*, 264
Comic Book Readers, 334
Comic Books, 333–51; circulation, 344, 349; color, 349; early, 335
Comic Calvacade, 346
Comic Magazine, first, 340
Compleat Angler, The, 73
Congressional Record, 274
"Connie," 338
Connor, Dale, 301
Conselman, Bill, 140
"Count Screwloose," 50
"Cranberry Boggs," 240
Crane, Roy, 128, 176–80, 296
Crosby, Percy, 123–24
"Curly Kayoe," 169, 190

"Daffy Dan," 135
Daily Mirror, 34, 81
Daily Worker, 84

d'Alesio, Gregory, 149
Dallas *News*, 241
"Dan Dunn," 295
Daumier, Honoré, 83, 314–15
"Dave's Delicatessen," 50
Davis, Phil, 259
Dayton *Journal*, 264
Dean, Don, 240
"Debbie Dean, Career Girl," 300–02
DeBeck, Billy, 51–54
Delacorte, George, 339–40, 342
Denver *Post*, 74
Denver *Republican*, 74
"Desper't Ambrose," 122
"Desperate Desmond," 65, 126, 211
Detective Comics, 265, 342–43
Detroit *News*, 150
"Dick's Adventures in Dreamland," 245–46
"Dick Tracy," 81, 214–18
"Dickie Dare," 209, 213–14, 241, 264–65
Dietrich, Marlene, 147
Dille, John F., 249–50
"Dingbat Family, The," 58
"Dinglehoofer," 305
"Dinkey Doodle," 230
Dirks, Rudolph, 3, 10, 11, 14, 22, 37, 42–43, 45, 47, 282
Disney, Roy, 159–61
Disney, Walt, 154, 159–66, 305, 311, 350–51
"Dixie Dugan," 141–43, 150, 281
"Doc," 330
Dodd, Howell, 292
"Dolly Dimple and Baby Bounce," 153–54
"Donald Duck," 152, 162–66
Donnenfeld, Harry, 342–43
"Donnie," 128
Dorgan, Thomas Aloysius (Tad), 22, 28, 58, 68, 74
"Dotty Dripple," 305
"Double Trouble," 330
Drayton, Grace G., 153–54
"Dumb Dora," 101, 141
"Dumbell Dan," 317

Dumm, Edwina, 130–32, 155, 241
Dyer, Bill, 129

Eaton, Mal, 324–25
Ed, Carl, 93–94
Eddy, Mary Baker, 7
Edison, Thomas, 3
Editor and Publisher, 276
Edson, Gus, 88–89
"Ella Cinders," 140–41, 225
"Elmer," 118, 226
Elser, Maximilian, Jr., 222–24
Ernst, Ken, 301
"Etta Kett," 150

Falk, Lee, 259–60
"Family Upstairs," 58–59, 83, 110
Famous Funnies, 338–42
Fantasia, 165
Farber, Manny, 138
Feininger, Lyonel, 23
"Felix the Cat," 155–56
"Ferdinand Flipper," 3
Ferro, Ted, 310
Fields, W.C., 235
Fisher, Dudley, 120
Fisher, Ham, 26, 242–43, 204, 278–88
Fisher, Harry Conway (Bud), 25, 27–33, 35, 39, 42, 49, 63, 282, 330
Flagg, James Montgomery, 122
Flanders, Charles, 296
"Flash Gordon," 251–54, 296
Flowers, Don, 144–46
Folwell, Arthur H., 73
"Foolish Questions," 49
"For Better or Worse," 68
"For This We Have Daughters," 40
Forsythe, Vic, 232
Foster, Harold, 212, 222, 224–25, 244, 252
Four Methods of Flush Riveting, 165
Fox, Fontaine, 119–22
Fox, Fred, 140
"Foxy Grandpa," 17–18, 115, 329
"Freckles and His Friends," 169, 180–82

"Fritzi Ritz," 136–39
Fuller, Ralph, 325–26
Fuller, Ving, 330
Funnies, The, 337–39, 342
Funnies on Parade, 338

"Gags and Gals," 147
Gaines, M.C., 338–43, 347
Gallopin' Gaucho, 161
Garbo, Greta, 147
"Gasoline Alley," 81, 95–99, 106, 119
"Gay Thirties, The," 254–55
Gibbons, Floyd, 259
Gibson, Charles Dana, 122
"Glamor Girls," 146
Goldberg, Reuben L. (Rube), 49–50
Golden, John, 9
Good, Ed, 295
Gotto, Ray, 330
Gould, Chester, 214–18
Graff, Mel, 128–29, 140, 296
Gray, Clarence, 255
Gray, Harold, 83–84
"Great Gusto, The," 300
"Green Hornet, The," 300
Green Lantern, 344
Grey, Clarence, 254
Grey, Zane, 233
Gross, Milt, 50
"Grossly Exaggerated," 50
Gruberts, Carl, 330
Gruelle, Johnny, 152, 236
"Gumps, The," 29, 81, 86–89, 109, 274, 315

Haenigsen, Harry, 149–50, 169
"Hairbreadth Harry," 65, 126, 211, 338
Hall, Richard, 129
"Hall of Fame on the Air, The," 226
"Hall Room Boys, The," 18, 22–23, 63–64
Hamlin, V.T., 187–90
Hammett, Dashiell, 296
Hammond, Carl E., 227

"Hank," 214
"Hap Hopper," 298
"Happy Hooligan," 22, 36–38, 335
Harlow, Jean, 147
Harmon, Fred, 235
Harmsworth, Alfred (Lord Northcliffe), 80–81
"Harold Teen," 81, 92–94, 141
Harris, Julian, 136
"Hawkshaw the Detective," 40
Hayes, Jeff, 323
Hayward, A.E., 152
"Hazel, the Heartbreaker," 63
Hearst, William Randolph, 6–7, 21–22, 83, 100, 173, 179–80, 193, 245
Hecht, George J., 346
"Henpecko, the Monk," 37, 40
Henri, Robert, 7
"Henry," 125–27, 149, 324
"Henry Peck, A Happy Married Man," 50
"Herkimer Fuddle," 305, 330
Herriman, George, 42, facing 48, 57–59, 61, 63, 83, 110, 154
Hershfield, Harry, 65–66, 211
Hess, Sol, 108–10
Hicks, Wilson, 264
Hoff, Syd, 327
Hogarth, Burne, 224
Hogarth, William, 3, 315, 319
Holman, Bill, 316
"Homer Hoopee," 11–13, 321
Homer, Winslow, 7, 118
Hoover, Ellison, 73
Hope, Bob, 351
Howarth, H.M., 22
Houston *Chronicle*, 116
"Hubert," 305, 330
Huckleberry Finn, 118
Human Torch, The, 344
Humor, 304
Hutchinson, Katherine H., 347

Illustrated Daily News, 81
Illustration, 212, 221, 225–26, 291
"In Animal Land," 169
"Indoor Sports," 68

358

"It's a Great Life if You Don't Weaken," 115
Ivanhoe, 212

Jacobsson, Oscar, 322
Janosik, George, 338, 342
Jazz Singer, The, 161
Jeans, James, 248
Jennet, Norman E., 23
"Jimmy," 115
"Joe and Asbestos," 34–36
"Joe's Car," 169, 190–91
"Joe Jinks," 169, 190–91
"Joe Palooka," 84, 142–43, 178, 245, 278–88, 338
"Johnny Hazard," 294
"Johnny Quack," 152
"Johnny-Round-the-World," 226
Johnson, Crockett, 306, 398–410
Jolson, Al, 161
"José Carioca," 162–63, 165
Journal of Educational Sociology, 349
Judge, 3, 24
"Just Kids," 116–18

Kahles, Charles A., 211
Kaiser, Bill, 159
Kane, Bob, 262–63
Kansas City *Star*, 145
"Katzenjammer Kids, The," 10–11, 16, 22, 37, 43–46, 114–15
"Keeping Up with the Joneses," 338
"Kerry Drake," 296
King Comics, 342
King, Frank, 95–98, 109
King News, 27
"King of the Royal Mounted," 226, 232–35, 295
Kipling, Richard, 155
Kirby, Rollin, 168–69
Kling, Ken, 34–36
Knerr, H.H., 43–44, 114
Knight, Clayton, 226
Knott, Jean, 68
Knox, Colonel Frank, 229
Knoxville *News-Sentinel*, 129

Koenigsberg, Moses, 27
"Krazy Kat," 29, 33, 41, 45, facing 48, 57–62, 63, 66, 154–55, 265, 325, 332

La Guardia, Fiorello, 45, 207
Lake, Veronica, 207
Lambdin, R.L., 145
Lariar, Lawrence, 32
Lasswell, Fred, 54
Laugh o'Grams, 159
LaVarre, William, 226
Leatherneck, 55
Leff, Sam, 190
"Lefty Louie," 84
Leonard, Frank E. (Lank), 229
"Let George Do It," 21, 46
"Let the Wedding Bells Ring Out," 67, 106
Liberty Magazine, 143
Liebowitz, J.S., 256, 343
Life, 3, 24, 131–32, 156, 193, 264, 291, 334
"Li'l Abner," 200–07, 330
"Li'l Mose," 8
Lincoln, Abraham, 95
Lindbergh, Charles, 290
Link, Stanley, 94–95
Links, Marty, 150, 318
"Little Annie Rooney," 126, 128, 226
"Little Bears and Tigers, The," 3, 12, 151
"Little Jimmy," 12–13, 22, 84, 115, 236–39
"Little Joe," 84–85
"Little King, The," 226, 323–24
"Little Man with the Eyes, The," 310
"Little Mary Mixup," 126, 167, 169, 184–86
"Little Napoleon," 169
"Little Nemo," facing 16, 17, 19–21, 115, 220
Locher, Fred, 11–13
London Daily *Sketch*, 319
"Lone Ranger, The," 233–34
"Looey Dot Dope," 169
Los Angeles *Times*, 158, 300

"Louie the Lawyer," 92
Louisville *Herald*, 120
"Luke McGluke," 93
Luks, George, 7–8, 23, 114
"Lulu and Leander," 17, 22, 141, 329
Lyon, Leonard, 45

McAdam, Charles V., 240, 281
McBride, Clifford, 156–58
McCay, Robert Winsor, facing 16, 17, 19–21, 220
McClure, Darrell, 126, 128
McCormick, Colonel Robert Rutherford, 81
McCutcheon, John T., 172, 118–20
McEvoy, J.P., 142–43
McGill, H.A., 23, 63–64
McManus, George, 21, 46–47, 106, 206, facing 304
MacGovern, Stan, 317
Machamer, Jefferson, 145, 147
MacLean, Bill, 330
Mager, Gus, 37, 39–40, 58
"Main Street," 40
Male Call, 9, 275
"Man in the Brown Derby, The," 74
"Mandrake the Magician," 259–60
Margolls, Morris, 338
Marriage Stories, 337
Marston, William Moulton, 261
Martin, Edgar (Abe), 100, 173–75
Martinek, Frank V., 227–29
Master Comics, The, 346
Max und Moritz, 11
Maxon, Rex, 224, 252
Melville, Herman, 61
Mendelsohn, Irving A., 20
"Merry Marcelene, The," 21, 46
"Metropolitan Movies," 168–69
"Mickey Finn," 229–31
"Mickey Mouse," 155, 159–63
Miller, Frank, 220
Mills, Tarpe, 241
Minneapolis *Times*, 34
"Minute Movies," 3, 211, 244
"Miss Fury," 241
Moby Dick, 61
"Modest Maidens," 146

Monet, Claude, 290
Moneypenny, David, 297
"Monkey Shines of Marcelene, The," 23
"Moon Mullins," 81, 88, 90, 315
Moore, Harold A., 338, 340, 349
Moore, Ray, 260
More Fun, 342
Morley, Jack, 310
Mosley, Zack, 231–32
"Mr. and Mrs.," 47, 71–73, 152–53
"Mr. Gilfeather," 203
"Mr. Tweedeedle," 152
Murphy, James E., 106, 108
"Mutt and Jeff," 16, 22–33, 155, 168, 335–39
Mutt and Jeff, 337–38

"Nancy," 138–39, 317
"Napoleon," 156–58, 321
"Naps of Polly Sleepyhead, The," 152
Naylor, Bob, 220
"Nebbs, The," 108–09, 112
Neebe, Joseph H., 222
"Nervo, the Monk," 37, 40
New Adventure Comics, 342
Newark *Star Ledger*, 34
New Fun, 342
"Newlyweds, The," 21, 46
New Orleans *Item*, 298
New Republic, The, 138
New Spirit, The, 165
New York *American*, 9, 17, 22, 29, 43, 47, 49, 54, 67–68, 74, 101, 106–08, 110, 112, 125, 128, 133, 152, 154, 155, 163, 173, 225, 233, 239, 244, 315
New York *American and Journal*, 22, 36–37
New York *Daily Mirror*, 263
New York *Daily News*, 33, 80, 85, 88, 94–95, 118, 235, 271, 278, 281, 340
New Yorker, The, 24, 36, 200, 323, 326–27
New York *Evening Journal*, 22, 39–40, 58, 63, 67, 88, 163, 193, 195
New York *Evening Sun*, 18

360

New York *Evening World*, 136, 139, 169, 184
New York *Herald*, 8–9, 17, 19, 21, 23, 64, 92, 136, 151–52, 264
New York *Herald Tribune*, 74, 106, 115, 139, 147, 152, 168, 231, 236, 324–25
New York *Journal*, 6–9, 11–13, 22, 40, 44, 46–47, 50, 57, 66–67, 71–72, 74, 126, 167, 180, 193–94, 198, 225, 233, 241, 244, 254, 264, 294
New York *Journal American*, 22, 43, 116, 118, 146–47, 149, 240–41, 254, 259, 261, 304–05, 323, 330
New York *Mail*, 49
New York *Mirror*, 35–36, 126, 139, 150, 167, 202, 206, 219, 225, 240, 276, 278, 280–81, 296, 305
New York *Morning Journal*, 22
New York *News*, 85, 88, 91–92, 94, 96, 100, 218, 265, 275–76, 305, 315–16
New York *Post*, 33, 43, 45, 110, 130, 139, 235, 241, 301–02, 305, 317
New York *Sun*, 18, 92, 120, 122, 144, 150, 158, 167, 229, 303, 305, 315, 320, 330
New York *Sun-Herald*, 317
New York *Telegram*, 139, 168, 169, 180
New York *Times*, 18, 168, 340
New York *Tribune*, 18, 72–75, 77, 120, 136, 149, 152
New York *World*, 1–3, 6–7, 18, 21, 32, 29–40, 43–44, 46, 50, 74–77, 80, 110, 122, 137, 139, 168–69, 337
New York *World-Telegram*, 128, 139, 167, 169, 173, 175, 180, 183–84, 187, 190, 235, 305, 317
Nicholson, Major Malcom Wheeler, 342
Nize Baby, 50
"No Wedding Bells for Him," 22
"Nobdody Works Like Father," 21
Norris, Paul, 297
North, Sterling, 344

"Oakey Doaks," 129, 325–26
Oakland *Herald*, 135
Oklahoma City *Daily Oklahoman*, 217
"Oh, Diana," 146, 241
O'Keefe, Neil, 245
"Old Doc Yak," 88
Ollendorff, Julian, 144
"Olly of the Movies," 144, 321
Opper, Frederick Burr, 22, 28, 36–39, 42, 58, 206
"Orphan Annie," 81–85, 126, 155
Orr, Carey, 229
Orr, Martha, 301
"Our Bill," 149
"Our Boarding House," 169, 171, 173
"Out Our Way," 169–71
Outcault, Richard Felton, 1–10, 14, 18, 193
Owen, Ruth, 71
"Ozark Ike," 330

"Panhandle Pete," 21, 46
"Pantomime," 143
"Patoruzu," 327–29
"Patsy," 128–29
Patterson, Capt. Joseph Medill, 81–82, 88, 91, 94, 100, 218, 265–67, 278
Payne, 297
Payne, C.M., 122–23
Pearson, Drew, 298
"Penny," 139, 149
"Penny Ante," 68
"Percy and Ferdie," 18, 64
Pershing, John J., 69
"Pet Peeves," 96
"Pete and Pinto," 92
"Pete the Tramp," 240–41
"Peter Piltdown," 324–25
"Peter Rabbit," 152–53
"Phantom, The," 260–61, 345
Philadelphia *Bulletin*, 34, 116, 150
Philadelphia *Daily News*, 35
Philadelphia *Inquirer*, 44
Philadelphia *Ledger*, 338
Philadelphia *Record*, 306

Picture Stories from American History, 347
Picture Stories from the Bible, 347
"Pinheads," 152
"Plain Clothes Tracy," 218
Plane Crazy, 161
Plumb, Charlie, 140
PM, 197–98, 214, 297, 305–06, 310, 329
"Polly and Her Pals," 16, 40–42, 133–34, 174
"Pop," 318–21, 332
"Popeye," 41, 192, 195–200, 207, 211, 213, 304, 327–29
Popular Comics, 342–43
"Positive Polly," 40
"Potters, The," 143
Powers, T.E., 22, 28, 58, 67–68, 106
Price, Garret, 145, 235
"Prince Valiant," 224, 241–45
Pulitzer, Joseph, 6–7, 21–22, 80, 168
Pusey, J. Carver, 169, 183
"Pussycat Princess, The," 154
"Puzzlers, The," 169

Quinterno, 327

Raab, Charles, 128
"Radio Patrol," 226
Raymond, Alex, 251–54, 296
Reader's Digest, 334
"Rectangle," 96
"Red Barry," 226
"Red Ryder," 169, 235
"Regl'ler Fellers," 115–16, 123, 320
Remington, Frederic, 212
Rigby, 23
"Right Around Home," 120
"Rip Kirby," 253–54
"Rising Generation, The," 47
Ritt, William, 254–55
Robbins, Frank, 292–94
Robinson, Paul, 150
Rock Island *Argus,* 93
"Rocky Mason, Government Agent," 84, 239
"Room and Board," 173

Roosevelt, Theodore, 17
"Rosie's Beau," 47
Roth, Herb, 168
Rowlandson, Thomas, 3
Rowley, George, 124

Saalburgh, Charles W., 1
"Sad Sack, The," 304–05, 312–15, 330–32
"Salesman Sam," 169
San Francisco *Bulletin,* 135
San Francisco *Call,* 135
San Francisco *Chronicle,* 25, 27–28, 49, 135
San Francisco *Examiner,* 3, 29
San Francisco *Globe,* 135
San Francisco *Post,* 135
Saturday Evening Post, 126, 149, 334
Saunders, Allen, 236, 301
Savannah *News,* 241
Scapegoats of History, 346
Schmidt, Charlie, 226
Schultz, "Dutch," 50
Schultze, Charles E., 17
"Scorchy Smith," 290–95, 302, 321
"Secret Agent X-9," 128, 195–96, 251, 295–96
Segar, Elzie Crisler, 192–95, 198, 200, 211, 217
Seldes, Gilbert, 45, 57, 96
Sensation Comics, 261, 344
"Sergeant Pat of Radio Patrol," 226
Seven Lively Arts, The, 57
"Seventeen," 94
Shakespeare, William, 61
Shaw, Bernard, 207
She Done Him Wrong, 50
"Show Girl," 143
Shuster, Joe, 256, 343
Sickles, Noel, 290–91, 294
Siegel, Jerry, 256, 343
"Silent Sam," 321–23
"Silly Milly," 149, 316–18
"Silly Symphonies," 162
Sims, Tom, 200
"Sinbad," 131
"Skippy," 123–25, 330, 340
Skippy, 342

"Skull Valley," 235
"S'Matter Pop," 122–23, 169
"Smilin' Jack," 81, 231–32
Smith, Sydney, 29, 88–89, 95, 109
Smith, William, 207
"Smitty," 81, 85–86
"Smoky Stover," 82, 315–16, 330
"Snapshot Bill," 152
"Snookums," 47
"Snoozer," 21, 46
Snow White, 162
Soglow, Otto, 323
Sones, Dr. W. W. D., 347
South Bend *Daily News*, 142
Southern Flight, 231
Spark Plug, 51–54
Sparling, Jack, 298–99
St. Louis *Cyclone*, 70
St. Louis *Democrat*, 70
St. Louis *Globe-Democrat*, 241
St. Louis *Post-Dispatch*, 193
St. Louis *Republic*, 46
St. Nicholas, 344
Star, 344
Staunton, Helen M., 276
"Steamboat Willie," 161–62
Steffens, Lincoln, 68
Sterrett, Cliff, 40–41
"Steve Canyon," 216–18, 277
Stop That Tank, 165
Storm, 129
Strieble, John H., 142–43
Striker, Fran, 233
Sullivan, Ed, 226
"Superman," 226, 256–57, 259, 343–45, 348
Superman Quarterly Magazine, 343
Suspense, 208–12, 221
Sweetheart Stories, 337
"Swing Out the News," 317
Swinnerton, James, 3, 9, 12–13, 22, 42, 46, 84, 115, 151, 235–39
Syndicates: connection with comics, 27, 80, 113–14; definition of, 80
Syracuse *Herald*, 34

Tad, 22, 28, 58, 67–68, 74
"Tailspin Tommy," 225

"Tarzan," 212, 221–25, 244, 248, 250, 255, 268, 290, 352
Tarzan of the Apes, 22
Taylor, Rand, 113
"Teena," 149, 241
Temple, Shirley, 128
"Terrors of the Tiny Tads," 151–52, 154
Terry, Hilda, 149, 241
Terry, John, 290
"Terry and the Pirates," 4–5, 16, 29, 81, 119, 125, 147, 178, 213, 267–71, facing 272, 273–76, 278, 303, 352
"That's My Pop," 50
"Their Only Child," 46–47
"Thimble Theatre," 193–94, 211
Thin Man, The, 164–65
"Tillie the Toiler," 133, 135, 226, 251
"Tim Tyler's Luck," 100, 224–26
Time, 276
"Timid Soul, The" 76–78
Tinsley, Frank, 231
"Tiny Tim," 94–95
Tippie and the Circus, 132
Tippie's Tunes, 132
Tip Top Comics, 342
"Tom, Dick and Harry," 229
"Toonerville Trolley," 119–20, 123
"Toots and Casper," 47, 106–08, 133, 226
Toy Land Funnies, 338
"Travelin' Gus," 323, 332
Treasure Island, 212
Trell, Max, 245
"True Comics," 345–46
"Tuffy," 327–28
Tulsa *Democrat*, 217
Turner, Leslie, 177, 180, 296
Tuthill, H.J., 110–11
Twelvetrees, C., 152
"Two Gentlemen and a Lady," 131

"Uncle Remus," 162, 305
"Uptown and Down," 318

Van Buren, Raymond, 145, 218
"Vanilla and the Villains," 126

Variety, 92
Verbeck, 151–52
Vermont *Daily News*, 345
Verne, Jules, 248
"Vic Jordan," 297–98
Vogue, 186
Voight, Charles A., 120–21, 139

Wallace, Henry, 207
Walsh, Brandon, 126
Walton, Izaak, 73
Washington *Star*, 34, 116, 150
"Wash Tubbs," 128, 169, 175–80, 296
Watt, J. Millar, 318–21
Waugh, Coulton, 213–14
"Way Out West," 232
Webster, H.T., 69, 74–76, 79, 118
Wells, H.G., 248
Western Penman, 70
Westover, Russell C. (Russ), 49, 133–35, 151–52, 251
Wexler, Elmer, 297
Wheelan, Ed, 211–12, 244
"White Boy," 235
Whittington, Larry, 136–37
Whitman, Bert, 300
"Why Mothers Get Gray," 171
Wildenberg, Harry, 338–40
Wilkes-Barre *Herald*, 280–81
Wilkinson, Gilbert, 145

Willard, Frank, 90
Willard, Rodlow, 295
Williams, James R., 169–71
"Windy Riley," 36
Wingert, Dick, 330
Winner, Doc, 118
"Winnie Winkle," 81, 91–92, 136
"Winslow of the Navy," 227–29, 321
With Victory, 346
Woggon, Elmer, 235
"Wonder Woman," 261, 348
Woolcott, Alexander, 131
World's Finest Comics, 263
"Worry Wart, The," 171
Wortman, Dennis, 168
Wunder, George, 278

Yachting Magazine, 126
"Yanitor Yens Yensen," 18, 329
Yank, 312
"Yellow Kid, The," 1–10, 12, 16, 18–19, 23, 27, 37, 114–15, 294, 296, 329
Young, John P., 28
Young, Lyman, 100, 225
Young, Murat (Chic), 100–01, 103, 225, 251
Youth's Companion, 344

Zaboly, Bela, 200